The Art of Place

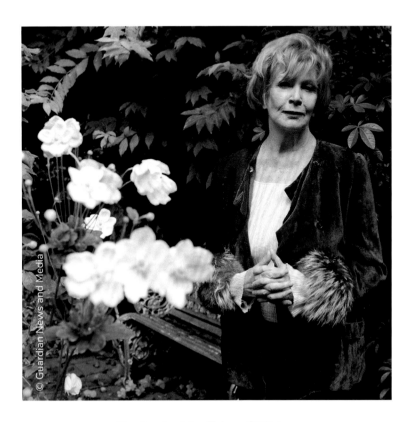

Dedicated to Edna O'Brien

Cloontha it is called – a locality within the bending of an arm.
A few scattered houses, the old fort, lime-dank and jabbery and from the great
whooshing belly of the lake between grassland and callow land a road, sluicing
the little fortresses of ash and elder, a crooked road to the mouth of the mountain.
Fields that mean more than fields, more than life and more than death too.

from *Wild Decembers*

The Art of Place

People and Landscape of County Clare

Editors **Peadar King and Anne Jones**

Photographer **John Kelly**

The Liffey Press

Published by
The Liffey Press Ltd
'Clareville'
307 Clontarf Road
Dublin D03 PO46, Ireland
www.theliffeypress.com

A catalogue record of this book is
available from the British Library.

ISBN 978-1-8383593-9-3

Design by Edmond Krasniqi
www.edmondkrasniqi.com

Printed by W.G. Baird in Antrim, Northern Ireland

Contents

Origin & Acknowledgements..vi

Editors...vii

Photographer...viii

Réamhrá..ix

Introduction... 2

Thomas Lynch ... 6

Rachael English...18

Brian Mooney..28

Tommy Hayes...32

Sarah Clancy..42

Niall Williams...54

Naomi Louisa O'Connell...64

Gearóid Ó hAllmhuráin..70

John Gibbons...82

Mick O'Dea..92

Isabelle Gaborit..102

Tim Dennehy...112

Godknows Jonas...122

Kieran Hanrahan...132

Eavan Brennan..142

Susan O'Neill..148

Jessie Lendennie...158

Harvey O'Brien..166

Ruth Marshall..176

Shelley McNamara...180

Geraldine Cotter...190

Michael McCaughan..200

Frank Blake...210

Martin Hayes...220

Mary Hawkes-Greene..232

Mark O'Halloran..240

Sharon Shannon..250

Michael D. Higgins..260

Jack Talty..264

Gerald Barry...274

Peadar King..282

Origin & Acknowledgements

Origin
The seeds for this book were sown in 2012. A group of artists explored the idea of place and its significance in their lives and in their work. The event was organised by Ealaíon an Chláir: Chairman Liam Ashe, Seán Conlan, Ciana Campbell, Phil Molony, Richard Collins, Dermot McMahon, Anne Jones and Peadar King.

Acknowledgements
We wish to thank David Givens of The Liffey Press for his unfailling courtesy and attention to detail in bringing this book to publication.

Graphic designer Edmond Krasniqi's seemingly inexhaustible patience, professionalism, care and due diligence was invaluable.

Kevin Haugh was instrumental in the development of this project.

We wish to thank Siobhán Mulcahy, Clare County Council Arts Officer and Pat Dowling CEO, for commissioning and funding the photography in the anthology through the Per Cent for Arts Scheme.

We wish to thank the following patrons who have made this publication possible:
- Allen Flynn, Old Ground Hotel
- Clare Tourism
- Cllr Johnny Flynn
- EKO Integrated Services Ltd and its principals
 Eugene Keane, Dr. Yupeng Liu and Elizabeth Neylon
- Limerick and Clare Education and Training Board
- Shannon Chamber of Commerce
 Stephen Keogh, Helen Downes and Dympna O'Callaghan
- Zagg Operations Shannon

To those who facilitated the photoshoots and gave generously of their time and knowledge, we say thanks. Thanks also to Doolin Ferries and the OPW.

This book has been five years in the making and the timelines in the stories reflect this. All views expressed in the anthology are those of the individual authors.

Anne Jones

Anne has been involved in media and communications for over three decades, having previously worked as a secondary teacher. Anne is editor of *The Scattering*, a photographic book that testified to waves of emigration from the late 1920s. She is also editor of *Salty Faces & Ferocious Appetites*, *The People's School, Education and Community in Scariff 1941-2002* and is co-editor of a publication to accompany the *McMahon Archive Collection 1611-1959*. A native of Scariff, she now lives in Kilnaboy.

Peadar King

Originally from Kilkee, Peadar is a documentary filmmaker and non-fiction writer. For the past two decades, he has filmed in over fifty countries across Africa, Asia and The Americas for the award-winning RTÉ Global Affairs series *What in the World?* His latest book, *War, Suffering and the Struggle for Human Rights*, was described by *The Irish Times* as 'a call to humanity in a world full of atrocity'. He is currently Adjunct Professor of International Relations in University College Cork.

Editors

John Kelly

Photographer

John is a professional press photographer
with *The Clare Champion* newspaper. A
recipient of seventeen PPAI awards, the
Photographic Society of Ireland Millennium
Award and the John Healy Photography
Award, he is a two-times winner of the
GAA McNamee Photographer of the Year
and was Local Ireland Photographer of
the Year in 2020. John's photographs also
feature extensively in book publications
and on book covers for Bloomsbury and
Transworld Ireland. John is a native of
Mullagh but lives in Ennis with his wife,
Loretto and three children.

Réamhrá

Liam Ashe

In answer to the oft-asked question in Connemara Irish *Cé dhár díobh thú?* (Who are you of?), I can safely say I am of Clare. My paternal roots are in Kerry but I am of Clare. In Kerry there is a related question, perhaps an even more existential question, *Nach tú?* (Isn't it yourself?). In answer, which self do I acknowledge? Admit to? Within us all, there are many and sometimes conflicting selves, each competing with and jostling for pre-eminence over the others. It's not as if we live linear lines. At best, it seems to me, we live in the intersectionality of all of those selves, more Venn diagram than straight lines, all of which is evident, I think, in this eclectic and wondrous anthology.

The following, however, I know.

I am a 1940s child. A West Clare Child. A Doonbeg child, Mountrivers to be precise, one of over 60,000 townlands that make up this island of ours. This is my place, *mo cheantar*. These are my places, *mo cheantair*.

Beyond that, it's hard to say.

When asked that most Irish of questions in Munster Irish, 'Conas atá tú?' or in Connacht Irish, 'Cén chaoi a bhfuil tú?' or in Ulster Irish, 'Go dté mar atá tú?', the expectation is that beyond the few words you don't answer. Not in any meaningful way. Not in any revelatory way. Certainly not that. Nothing beyond 'Tá mé go maith', or the abbreviated 'Go Maith' or, if in the mood for some rhetorical flourish 'Ar fheabhas'. And on you go. In a sense the question we have asked all thirty-one of the contributors in this anthology is *Cad as duit? Ceisteanna agus ceisteanna breise. Conas atá tú? Cén chaoi a bhfuil tú? Go dté mar atá tú?* in the expectation that each of the contributors will go above, go beyond, go within.

And they do.

I like to think of this anthology as a kind of *bothántaíocht* (a visit to a neighbour's house). Here we sit with thirty-one *seanchaithe* (storytellers) as the sounds and silences flow in this most ancient art of *scéalaíocht* (storytelling). Perhaps too, our visit will live on after daylight hours, into the *airneál* (night visiting) in the expectation of entertainment and music, of which there is much in these pages. This anthology offers us fragments, stories, tantalising glimpses of lives lived

or once lived in County Clare. We are the listeners. The privileged ones. The invited guests. *Éisteoirí ciúine* (the silent listeners). My hope is that you will carry these stories with you wherever you live and that they will live with you and in you. That you will be enriched by the reading your eye will catch, and by the beautifully crafted photographs that lie within.

Placing place goes to the heart of this anthology. In so doing, our intention is to go within the spaces that places occupy, beneath topography, beyond physicality but that from whatever vantage point we view this place that we too can enjoy and exult in the gorgeousness of the topography, and experience its physicality. And in doing so we enter into the unique soundscapes, smellscapes, touchscapes, tastescapes and sightscapes of County Clare.

Perhaps, and not for the first time, it is to the Irish language that I need to turn to truly express what I want to say about this anthology. In doing so, the word *dinnseanchas* comes to mind. A word for which it is hard to find an equivalent in English, but a wonderful word, a word within which the echoes of *breath* and *lore* are to be found.

Perhaps that is what this contemporary anthology holds, *the breath of old lore*. To each and every contributor who has taken the time to make this what it is and to those of you have taken the time to read this anthology, *míle buíochas*. It has been my joy to have been a part of it.

Beir bua.

Liam Ashe

Liam was a secondary teacher of history, geography and Irish and taught in St Flannan's College, Ennis. He is the author of several editions of second level textbooks in geography. He is a co-director of a school in Kolkata, India since 2006.

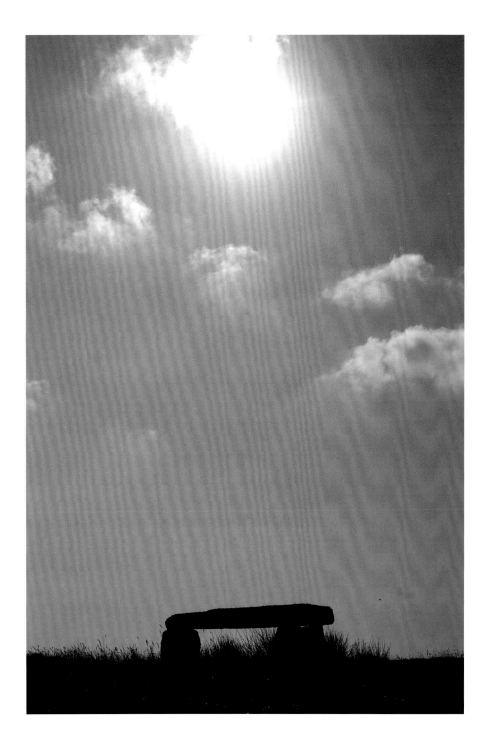

Introduction: Unmasking Place

Peadar King

All of us have our own stories to tell. Indeed, we have multiple stories to tell reflecting our many, diverse, contradictory and even contrary selves along with the many interpersonal entanglements we encounter across our lives. We are not one indivisible being, even though we might imagine ourselves as such. There is not just one 'I'. 'I am a woman, a musician, researcher, wife, mother and grandmother' (Geraldine Cotter). We are, as W.B. Yeats reminds us, the wearers of many masks. 'I hid behind all sorts of facades and masks' (Sarah Clancy) and storytelling allows us to wear the mask of the moment; to create masterful images, 'the alchemy of images' (Mick O'Dea), all that we want to portray to the world. And he who once described County Clare as 'a cold hard rock' or, as imagined by Shelley McNamara, 'the heroic rocky landscape of County Clare' should know.

Yeats. The master of masks. In old age he might have believed that his creativity, his 'circus animals', deserted him, but all of us, in our own unique way, shepherd our own circus animals to engross the present and display to the world our own arc of creation.

This is what we set out to do in this book. Make things visible to ourselves – and to others. Wrinkle out some truths. 'Puberty is about knowing who you are in your body. That's when I went: "I am black. Oh my gosh"' (Godknows Jonas) while acknowledging that we are not immune to our own fabrications, the fantasies of our own lives. In this anthology, we are engaged in the act of unmasking inner worlds. Probing the nooks and crannies of our lives. Whether to reveal another is, in itself, another story. Digging for words. Finding words. To tell a story about ourselves. 'The Irish language shaped and gave meaning to the ground beneath my feet, word-shapes and sounds with roots going back two thousand years' (Michael McCaughan). The moments of our lives. Lived and re-lived in their vastness that extend beyond the moment of their happening. Long gone but ever present. 'My mother would put me on her lap ... sing songs and read stories to me, and best of all, she used to scratch my back for what seemed like hours' (Sharon Shannon).

Place: '... [T]he most local of localities, the garden in Kiltumper, is enough world, enough earth, for a lifetime' (Niall Williams). The tabernacle of memory. A host

to a host. 'I played host to a party of women on a tour of the island's past.' (Ruth Marshall). Of half-remembered as well as ineffaceable memories that will never fade. 'A place to be. A place to plant and grow seeds' (Tommy Hayes). And the importance of naming that place. And the people who inhabit those places. Naming the experience. Naming emotions. 'I had held it together until then, but tears streamed uncontrollably down my face' (Mary Hawkes-Greene). Location, and dislocation too. 'I have always felt the want of belonging somewhere' (Eavan Brennan).

This anthology is all about the 'I'. The 'I's' have it. This is personal. 'I look back from this crackling body to the half-held-together memories formed from photographs and stories about wellies and wet grass' (Naomi Louise O'Connell). To tell or part-tell a story; to pick up the bits and pieces, the flotsam and jetsam washed up on the 195-kilometre-long Atlantic coastline and 168-kilometre-long estuarial freshwater river of lives once lived in or currently living in County Clare. 'There is a connection there that never goes away' (Martin Hayes). There is, of course, no one story. We may be unreliable narrators of our own lives but hey, it takes courage to begin that narration. And there is courage aplenty in this anthology. 'At fifteen, I was tall. Tall and lanky. Tall, lanky and a loner' (John Gibbons).

Trying to place 'place' or trying to unmask place is as intangible an undertaking as chasing the elusive Johnny Lanterns of past childhoods. This is quicksand territory. Ever-changing and highly contested. Notwithstanding its elusive quality, place continues to beckon. 'My preoccupation with my native county and its influence on my creativity could be cynically dismissed as some kind of fetishisation...' (Jack Talty) and stories of place continue to be told in the hope that within each story, a kernel of truth can be found. Perhaps even some solace too. 'And we shall find sanctuary in this place too tight for the wind to comb out' (Brian Mooney).

That in the telling, the tellers are in some way true to themselves. Polonius's advice to Laertes in Shakespeare's *Hamlet*, 'This above all: to thine own self be true' may be a maxim worth living. But the question is: which self? A question Liam Ashe too poses in his *Réamhrá*. *Cé dhár díobh thú?* A question Shakespeare conveniently, if unhelpfully, does not answer. Perhaps there are no answers. The Self. That fleeting, shadowy, uneasy entity that constantly calls on our attention. 'All human beings have three lives,' Gabriel García Márquez told his biographer Gerald Martin in *A Life*. 'Public, private and secret.' Our own blessed trinity. Perhaps, it is not possible to attend to all truths in our tripartite lives for in all our

lives there are good days and bad days: wholesome and not so wholesome days. Days of contentment and discontentment. Days when we can't recognise one life from the other.

There is also another trinity which French philosopher Michel Foucault calls the 'triple edict of taboo, nonexistence and silence'. And we have known all three in this country, in this county too, 'the seam of darkness that runs through my town and every town' (Rachael English). And we have deliberately and consciously unknown all three in this country, and in this county too. This story tells of the knowness and unknowness of all three.

Memory. That vast messy archive we all carry within ourselves. Where certainty gives way to uncertainty. Where the emotion is more important than precise circumstance. 'I remember one evening in particular. It must have been winter time, perhaps early spring...' (Kieran Hanrahan). The unshakeable things that cling to us. 'I even remember watching the last full-time residents leave Scattery Island,' recollects Harvey O'Brien.

'History cannot have its tongue cut out,' John Berger, the English art critic, novelist, painter, poet and 1972 Booker Prize winner reminds us in what is as violent an image as history itself. 'It's not the going into battle that is most difficult to imagine. It's the coming back.' Steeped in history, contemporary history, as this book is, this anthology is not concerned with history, at least not overtly. It's not that we are indifferent to or unscathed by history. Far from it. 'Relics of colonial hubris continue, however, in hunts and hunt balls, parties and receptions at various gentlemen's club houses around the town' (Gearóid Ó hAllmhuráin). Rather, it's the memory of history.

Memory and imagination. 'My earliest memories are flying through clouds and the floor of Fawl's Bar in Ennis' (Gerald Barry). Specific times. Specific memories. 'What matters in life is not what happens to you, but what you remember and how you remember it.' Márquez again. While hope and history might rhyme at least once in a generation, the same cannot be said for memory and history. Memory, that which causes us to remember things that may never have happened. Memory that allows us to construct our own narrative. That which allows us struggle to live in the greyness, to live in that night in which all cats are grey. And in that way bring our truth to light and life. Or a version of that truth.

In trying to tell our own story, we are merely sifting through the old and the discarded. 'Old kettles, old bottles, and a broken can / Old iron, old bones,

old rags' those Yeatsian images. Sifting too for signs of hope. 'Of how the harsh winter … that holds its own purpose … Makes way for new life' (Michael D. Higgins). Healing. 'There were also personal difficulties … I looked for a place where I could have space to breathe spiritually and emotionally' (Jessie Lendennie).

In this anthology, thirty-one people have taken on the task of sifting through different shades of grey, in search of words and elusive metaphors to tell a story about themselves and others: their inner worlds. Sifting too outer worlds in which inner worlds live. Not that the past is ever past. Rather it is, as US feminist philosopher Karen Barad reminds us, 'always open, alive in the thick moments of the present and is yet to come.'

Stories within stories within stories. Love and loss. 'Tom was my best friend, had been my lover, was an incredibly important artistic touchstone in my life. When he died it was shattering' (Mark O'Halloran). Fear: 'Surely now, I would leave myself over-exposed to bullies and be savaged in the schoolyard' (Frank Blake). Sounds: 'The first time I ever heard Gospel, I knew and felt this was my sound' (Susan O'Neill). Tastes: 'Come in,' she said, 'you're perished with the journey. Sit in by the fire. We'll make the tea' (Thomas Lynch). And smells: 'I catch the smell of salt in the air and I have to go there, go to the west' (Isabelle Gaborit). Moods too. 'Dark, black clouds overhang the mountain, matching my morning mood, the landscape drenched in driving rain' (Tim Dennehy). Days we remember: '4 April 1964' (Peadar King).

Tactile memories that occasionally and unexpectedly leak out from those deep crevices of memory and half-memory. Of people, places and events longed for and half-forgotten. Sometimes welcome, sometime not. People, places and events that colour our memories and that have in themselves been coloured by memory, which in turn have coloured all of our subsequent lives. Memories that draw some of us back to that place of origin and birth, a touchstone of our sense of ourselves, of what we are and of what we have become. Memories too of people and places and events that drove some of us away and keep us away. Never to return.

All stories speak of and to the heart. The soul, too: 'Soul clap its hands and sing, and louder sing.' Something Yeats instinctively understood. The heart: 'The foul rag-and-bone shop of the heart.' The ultimate arbiter of all our stories.

This story is just beginning.

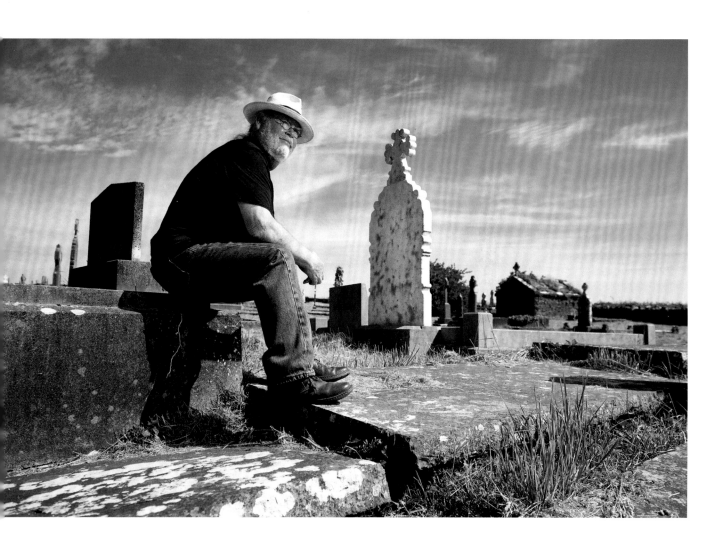

The Sad and Well Done Thing

Thomas Lynch

By getting the dead where they need to go, the living get where they need to be. This seems, after half a century of undertaking, the essential brief, the task most manifest, the *raison d'être* of a funeral. If these outcomes are not accomplished, whatever else takes place, however pleasant or wretched, meager or sumptuous, is of no real consequence. The accessories amount to nothing, the requiems and mum plants, the shaky brace of pallbearers, coffin plates and monuments, five stages of grief, seven deadly sins, ten commandments, umpteen eschatologies and apostasies, if the essential job's undone. To deal with death we must deal with our dead, to get our riddance of the corpse, beloved though it might be, and get ourselves to the edge of the life we will be living without them. And this is coded in our humanity: when one of our kind dies, something has to be done about it, and what that something becomes, with practice and repetition, with modifications, is the *done thing* by which we make our stand against this stubborn fact of life, we die.

By bearing the dead to their abyss, by going that distance, the living hope to bear the loss of them. By processing the mortal remains we endeavor to process mortality's burdens and heartbreaks.

And here some sort of motion, some movement and tasking, some shifting of conditions and circumstance are implicated. Where, the discerning reader will likely wonder, do the dead need to go? Where indeed! And here let me say that what the dead most need, in the moment of their death, is to be gotten, coincident perhaps with hurried and heartfelt farewells, en route to their riddance, their oblivion and abyss, whatever form it takes, the ground, the fire, the sea or air, that elemental disposition which assures they will not embarrass themselves further by putrefaction or decomposition or any of the postmortem indignities that creatures of bone and blood and meat are prone to. And whereas, the Mother of Jesus was assumed into heaven, a feast in mid-August in the western church, most of us will find the opened ground or the chambered fire or tomb, sufficient to the task of final disposition, a word the etymologist will inform proceeds from dispose, which itself proceeds from the Latin *disponere* meaning 'arrange', influenced by *dispositus* 'arranged' and Old French *poser* 'to place'. Which is to say we must arrange to place them elsewhere, thus the shoulder and shovel work, the pecking birds that pick the dead thing clean of its rot, the fire,

7

the depths, the tree's high branches: each an end of the done thing somewhere. There are others, we know, but in their final dispositions they are all the same.

I first landed in Clare on 3 February 1970. The inky, oval welcome in my first passport has long since dried; still, I get a glimpse of it again, every time I pass through Shannon or Dublin now, as I've done many dozens of times in the intervening years, going half a century now, though we don't feel the time going.

The man in the customs hall in Shannon chalked an X on my bag and waved me on saying, 'the name's good.' I was twenty-one and possessed of a high number in the Nixon Draft Lotto, a surreal exercise in the existential that had been drawn a couple months before, giving me a pass on becoming fodder for the American misadventure in Vietnam. A lackluster student without goals or direction, I thought I'd better make a move, a gesture to put some distance between my effortless mediocrity at school and my parents' scrutiny. I'd read Yeats and Joyce and reckoned to reconnect with what remained of our family, 'on the banks of the River Shannon', as my grandfather had always prayed over Sunday dinners throughout my youth. His widow, my grandmother, a Dutch Methodist who converted to 'the one true faith' as she called the idolatrous superstitions of the crowd she'd married into, still sent Christmas greetings to 'Tommy and Nora Lynch, Moveen West, Kilkee, County Clare,' which is what I told the taxi man in the big Ford idling outside the arrivals hall.

'Can you take me here?' I asked him, proffering the places and names scribbled in my grandmother's sturdy cursive.

I remember Nora Lynch, nearly seventy then, in the doorway of her home, shoulder leaning into the jamb, arms crossed, a study in contemplation, figuring to what use she might put this young yank on his holidays. Her brother, Tommy, was holding back the snarling dog. I was dressed like a banker's apprentice in my one black suit, polished wingtips and my dead grandfather's watch-fob, trying to make a good first impression, a little hung over from the drinks on the plane and the compression of a night crossing, and despite my efforts, I was as disappointing a yank as ever showed up in Clare, without property or prospects, cash or complete education. I had Yeats' *Collected Poems* and Joyce's *Dubliners*. They had a newly wall-papered room with a narrow bed and straight-back chair.

I was their first American cousin to return; they were my Irish connections, twice removed.

'Come in,' she said, 'you're perished with the journey. Sit in by the fire. We'll make the tea.'

Nora and her brother were living on the edge of Ireland and County Clare to be sure; the north Atlantic just over the road, the Shannon estuary below. Likewise they were, late in their sixties, at the narrowing edge of the lives they'd been given in the opening decade of the twentieth century. First cousins of my late grandfather, to my twenty-one year old self they seemed relics of another time entirely, Bruegelesque, pre-modern, ever, as Yeats claimed, 'the indomitable Irishry.'

Nora could not have seen her brother's death, of pneumonia, coming round the corner of another year, nor her own long and lonesome vigil by the fire that would come to a close twenty-two years hence. She could not see the trips she would make to Michigan or my many returns to Moveen, nor the family, immediate and extended, who would, in the fullness of time, make the trip 'home' with me. All of it was the mystery the future always is, rhyming as it does with the history of the past. The moment we're in is a gift, the bromide holds, that's why we call it the 'present'.

And in that moment, that grey, midwinter Tuesday morning in the yard in Moveen, gift that the present tense of it was, I could not see how it would change my life, to have followed the frayed thread of family connection back to its source and headwaters to this distant townland of Moveen West, a thousand acres divided by families and hedgerows and ditches, the open palm of treeless green pastureland, dotted with shelters and stone sheds, haybarns and outoffices, stretching from high cliffs edging the Atlantic down-land to the grey, shingly banks of the Shannon estuary.

In time I would learn all the place names, find the wells and scenic routes, flora and fauna, the mythic and epic accounts of things, how Loop Head was named for the mighty leap the Hound of Ulster, Cuchulain, made with Mal the Hag in hot and lecherous pursuit of him; how the montbretia which blooms up the boreens and ditchbanks, coast roads and villagescapes, through July and August leapt over the stone walls of the Vandeleur landlord's walled estate in Kilrush like liberty itself, like water, escaping every effort to keep it in, propagating by mighty nature, a new reality.

The leaps and tributaries of reconnections that I pursued all those years ago were bound to place and people and the ties that bind. In Tommy and Nora I found

the last and steadfast remnant of a family sept that had remained while others sailed out of Cappa Pier in Kilrush and Cobh in Cork, a century before when a nineteenth century Thomas Lynch crossed the Atlantic on a steerage fare and found his way from Clare to Quebec and Montreal, thence to Michigan where he'd heard of a place called Jackson where the largest walled prison in the country was being built and maintained by the unskilled, gainful labor of poor immigrants. 'Tom Lynch Wanted' it read on the tin case he brought his worldly possessions in. He gave that case to his son, who gave it to his son, who gave it years later, now empty, to me.

'Tom that went,' said Nora Lynch speaking about the uncle she never knew, and handing me a glass of whiskey, 'and Tom that would come back. So, now for you.' She admired the circularity of time and happenstance. The way what goes around, etcetera.

And nodding by the fire after the welcome and the whiskey and the talk, so brogue-twisted and idiomatically rich, I began to feel the press of hitherto unknown forces; cultural, religious, familial and new, like Dorothy in Oz, I was a long way from Michigan and suddenly and certainly home.

And it changed my life, those next three months hunkered over the sods, observing lives lived nearer the essential edge of things, keeping body and soul together, making sense of the elementals, the social and seasonal nuances, the register of imaginative and emotional dynamics, the stories and poems and songs and performances that everyone brought to the evenings' *cuaird*, that gathering of neighbors around hearth and table, each with a party-piece, a pound cake, tobacco or drink to add to the evening's effort to give thanks for another day that was in it. I belonged to a culture of isolates who gathered round our individual, glowing screens to connect with virtual realities. Tommy and Nora lived actual lives on life's terms, which included both the gossip and goodwill of neighbors, come what may. This was a time before country people could escape the contingencies of their geography, before the Fords and Vauxhalls lengthened their range of travel. In 1970 the ties that bind could only be slipped so far as 'shank's mare' or the Raleigh bike, the pony trap or ass and cart could take them. They married over the ditch, caroused within the townland or village, got their sacraments within the parish bounds and got their income from their hard labor in their land and the local creamery. That I had come from across an ocean many of their people had crossed and never returned, that I spoke with a Midwest American brogue, though I'd experienced things that were different from them made me momentarily a minor celebrity. But only momentarily. After a while I was just Tommy and Nora's 'yank.'

So when Tommy died the following year, in early March of pneumonia, Nora rode her bike into Kilkee to make the call to let me know. When I showed up the following morning to join the wake in progress in Moveen, it upped the ante of our connection.

'Most yanks,' a local bromide holds, 'wouldn't give ye the steam off their water.'

So a yank who comes running at the news of 'trouble', that deftly understated Irishism for a death in the family, seemed to them another thing entirely. But Ireland had taught me things about the ties that bind, the press of family history and place, all the rooted behaviors conditioned over generations.

And when Nora Lynch, in those first months that I spent in West Clare, took me to the graveyard at Moyarta, near the banks of the River Shannon in Carrigaholt, it was to the vaulted grave of our common man and the flagstone cut by Mick Troy with the particulars of that first grief eighty years before I ever landed.

> *Erected by Pat Lynch* (it reads) *In memory of his beloved wife, Honor alias Curry who died October 3rd 1889 Aged 62 years may she R.I.P. Amen.*

The erector named in the graven stone was Nora Lynch's grandfather, my grandfather's grandfather, thus, my great-great grandfather, thus, our common man. His wife Honor was a grand niece of the Irish philologist and antiquary, Eugene O'Curry, whence, according to Nora, any later genius in our gene pool. And it was Pat's wife's slow dying of a stomach cancer that gave him the time, in cahoots with his brother, Tom, to fashion this stone vault near the western edge of the burial ground, with the great flag stone to cover it giving the details of his wife's demise and his devotion to her.

They are all dead now, of course, the bed of heaven to them. And I am long since into that age when the wakes begin to outnumber the weddings and we think of ourselves as maybe mortal too. I mostly go for funerals now. Word comes by Facebook or furtive text or a call from the neighbors who look after my interests there; the house, the donkeys, the ones who come and go.

When I got word in June that the poet Macdara Woods had died, I knew I'd have to make another trip. He was an editor at the journal I mailed first poems to and he found them worthy and published them. Whereas my poetry had been entirely ignored in my own country, publication in a Dublin literary journal made me suddenly, internationally unknown. The tiny society of poets who write in

the English language would not overfill a minor league sports stadium. More people get chemotherapy every day than read or write poetry. So with some few exceptions, we matter almost entirely to ourselves. Some years ago on New Years Eve, I walked with Seamus Heaney behind the hearse and cortège who took the body of Ireland's most bookish man, the poet, critic and biographer Dennis O'Driscoll, from the church in Naas to St Corbin's cemetery where he was buried. Nine months later it was Heaney in the hearse and me riding shotgun from Donnybrook in Dublin to Bellaghy in Derry, three hours journey into the north to bring the body of the dead poet home, helpless as the few hundred who gathered round the grave, having gone that distance with the great voice of our time because it was all we could do, to be with him who could no longer be among us.

Last October it was a neighbor, woman's death by cancer, in June my friend, Macdara Woods, by Parkinson's then early in August I boarded the plane again in Detroit, making my way to JFK to connect to the late flight to Shannon and thence to Cork City because the poet, Matthew Sweeney, died of motor neuron disease. This year the catalogue of losses seems inexhaustible and I'm thinking it must be the advancing years that put me in the red zone of mortality. In February it was the poet, Philip Casey, who died in Dublin of a cruel cancer; in April my dog, Bill W., long past the eight year life expectancy of his furry mammoth breed, he was the only mammal over 100 pounds who could bide with me. He was going 13 when his hips and shoulders all gave out. I'd had his grave open for two years, plus, fearful of getting caught with a dead dog in the deepening frost of a Michigan winter.

And there's truth in the bromide that by going the distance with our dead, the principal labour of grief gets done, in the deeply human labour of laving the body and laying it out, lifting and lowering, watching and witnessing, having our says and silences. Which is why I'm flying tonight, a day late, alas, but nonetheless, to get my friend's body where it needs to go, from Cork City in Munster to Ballyliffin, in Ulster, six hours north where I once caddied for him. I have a hat I bought in the pro-shop on the day. I keep it in the clothes press in Moveen and I'll wear it to his obsequies on Wednesday. I've read with Matthew in England and Scotland, Dublin, Galway, Cork and Clare, Adelaide, and Melbourne and Wellington, Australia and New Zealand; we tutored together several Arvon Courses, at Lumb Bank and elsewhere and in Michigan. He's been on trains and boats and planes with me and to each of my principal residences in southeast and northern Michigan, and my ancestral stones in County Clare. My heart is fairly desolate these days, with a long-estranged daughter, a long-distance marriage, the low grade ever-present sense of what Michael Hartnett called the great subtraction.

I've been badly subtracted from these last few years. Only for the fact that I banked such friendships against the howling winter of age, that I did not miss the best years of their being and their beloveds' being and the times of our lives which we caused on purpose to frequently intersect. Two Octobers ago, Matthew made me lamb chops in my own kitchen on the south shore of Mullett Lake, where he sat up nights making poems that became the last ones in the last books he published this year. He called it 'The Bone Rosary' which was the name I gave to the rope of old soup bones I'd had the butcher cut from the femurs of cows and given to my dog, Bill W., to chew the marrow out of. I thought they would make a suitable memorial. The poem ties the dead dog and the dead poet together in my imagination.

The Bone Rosary

The big dog's grave is already dug, a few
yards from the lake, and all the bones he's
sucked the marrow from are strung on a rope
draped over the porch railing, a bone rosary,
waiting to be hooked to a rusty chain hung
from a metal post stuck in the ground, poking
out over the water. I can already imagine
the reactions of people in boats who'll pass,
what they'll think of the resident of the house.
there might be more to tickle their fancy –
I have a BB gun and ball bearings in a cupboard
that would kill as many black squirrels as I
wanted. And I might just commission a black
totem pole. And although there are no records
of anyone walking on the waters of Mullett Lake
I think I may visit a hypnotist in Harbor Springs
to see if she can facilitate this. I'd love to run out
into the middle of the lake, carrying the Stars
and Stripes and make all the folk in boats
I meet faint and fall into the water, maybe to
drown there, and befriend the big dog's ghost.

Matthew Sweeney, *My Life as a Painter* (Bloodaxe, 2018)

After his burial I came to West Clare where the summer is winding to a close for another year, the last of the holiday makers are walking the strand line in Kilkee, whale watchers peer through their telescopes at Loop Head, the dolphin boat and charter fishing boat take the last of their passengers out the estuary in Carrigaholt, the pubs are frantic with late season revelries.

The pope is coming to a nation that has changed religiously in forty years since the last papal visit. There are worries, after the hot, dry June and July, that there willn't be enough fodder for the coming winter. Round bales of hay and black wrapped silage and heaps of fodder are filling the barnyards, hopes for another cutting abound. Limerick wins the All Ireland Hurling match, a man in the townland succumbs to his cancer; we're passing through life is what is said. We're passing through.

In many places they've lost the notion of the done thing and try to reinvent the ritual wheel every time a death occurs. Dead bodies are dispatched by hired hands, gotten to their oblivions without witness or rubric while the living gather at their convenience for bodiless obsequies where they 'celebrate the life' as if the good cry and the good laugh, so common at funerals, had gone out of fashion or lost its meaning. But the formula for dealing with death hasn't changed. It is still essential to deal with our dead; to reconfigure but reaffirm the ties that bind us, the living and dead. It was the Irish connection that convinced me of that.

The reading of poems and sharing remembrances over Matthew's dead body in its oaken box in Cork was good to be a part of, likewise to close the coffin lid at the wake the following morning in Ballyliffen at the other end of the island nation which was his home place of the many places he'd called home. I rode in the hearse with his corpse to the grave in Clonmany New Cemetery between showers and the tributes of friends and family who stood out in the rain to see the poet's body lowered into ground.

It is the done thing here, the only thing that we can do in the maw of rude mortality, the shoulder and shovel work, the words work, wailing, waking, watching and witnessing, the walking behind, the hold and beholding, these sad duties occasion, the stories we remember before we forget. These ties that truly bind, these sad and well done things uphold by focusing our diverted intentions on the job at hand, to wit, to get the dead where they need to go and the living where they need to be.

Biography

Thomas Lynch

Essayist, poet, and funeral director Thomas Lynch has written five critically acclaimed volumes of poetry, four books of essays and a book of short fiction. His most recent collections include, *The Depositions: New and Selected Essays* (Norton, 2019), and *Bone Rosary: New and Selected Poems* (Godine, 2021). A novel is forthcoming. Thomas Lynch has written for *The New York Times*, the *Times of London*, *The Irish Times*, *Newsweek*, and *Harper's*. His book *The Undertaking: Life Studies from the Dismal Trade* (1997) won the Heartland Prize for Non-Fiction, the American Book Award, and was a finalist for the National Book Award. He has taught at Wayne State University Department of Mortuary Science, University of Michigan Graduate Program in Writing and Emory University Candler School of Theology. His work has been the subject of two documentary films, PBS Frontline's *The Undertaking* and Cathal Black's *Learning Gravity*. He divides his time between his home on Mullett Lake in northern Michigan and his ancestral home in Moveen, County Clare.

Another Clare

Rachael English

If, as Frank McCourt famously put it, the happy childhood is hardly worth your while, then the town where I grew up was a failure. When I say that most of my childhood memories are positive ones, it surprises people. Outsiders tend to see Shannon as a place without a soul. A suburb without a city. They use words like 'bleak' and 'unfinished'. They call it grey and ugly. And, in some ways, they have a point. No one would make money selling postcards of Shannon Town.

But there are always other stories to be told.

I was seven when my parents moved to Shannon. Before that, we'd lived in the countryside. My mother says she can still hear the noise: the squealing and whooping and laughing of children at play. Unsure about our new surroundings, she decided we'd stay a year. Two at most.

In the 1970s, Shannon teemed with children. There were times when it felt as if every spare inch had been taken over by games; when the town became a messy patchwork of skipping ropes and makeshift football pitches. Occasionally, a local team would win a cup or a league. No matter how small the prize, the town would erupt in celebration. People would pile into Ford Escorts and Vauxhall Vivas and bomb around the housing estates with their lights flashing and horns honking.

Our house was in Finian Park, near the community hall. I remember the blistering-hot summer of 1976 and how crowds of teenagers in flares and platform boots queued for the disco. Later, I remember the neighbours who played '2-4-6-8 Motorway' by the Tom Robinson Band over and over again and the thwacks as boys perfected their hurling skills by hitting tennis balls against the gable wall. In my mind's eye, these images are always in washed-out colour, like a 1970s Polaroid. So, yes, there is an element of nostalgia about what I recall. But, unless your upbringing was particularly cruel, isn't that true of all childhood memories?

George Orwell argued that before anyone begins to write, they have acquired an emotional attitude from which they never completely escape. Even though it's a long time since I left Shannon, what I write is rooted in where I'm from and the attitudes I acquired there. The personalities that appeal to me, the stories that

fascinate me, the contradictions that intrigue me, are shaped by my experience of growing up in Ireland's newest town. They're moulded too by the fact that during those years the country was in a state of flux.

We came from everywhere. Many of us were the children of returned emigrants, drawn to Shannon by the promise of work at the airport or the adjacent industrial estate. It was a factory town, and the estate was dominated by a handful of large employers: EI, Lana Knit, SPS, Boart Hardmetals and the biggest of them all, DeBeers.

In spots, there were signs of earlier times. We walked to school along 'the Boreen', which, as the name suggests, was a narrow strip of pockmarked tarmac. It was bordered on one side by several acres of spruce trees where children built dens and teenagers smoked cheap cigarettes. Depending on which story you believed, walking the boreen after dark meant you'd be accosted by either a ghost or a flasher.

Almost every housing estate had its own playground with a row of swings, a set of iron monkey bars and a clanking see-saw. If you fell, and most of us did, you landed with a crunch on the tarmac. There was a swimming pool, a rare phenomenon in those days. And, in a small flat near the airport, there was a library.

We lived on the opposite side of the town, and on Saturdays, a group of us would walk there. Although Shannon wasn't particularly big, our legs were very short, and the journey there and back took up a considerable part of the day. If the weather was fine, we'd pause on the way home and find somewhere to sit and read. Getting through all of your chosen books within a fortnight was important. A two pence fine was levied on late returns, and we had far better things to do with our money.

Even as a child, when everything looked enormous, I knew that our library was tiny. I wondered if there were more books in the world. Or might that flat in Drumgeely contain everything there was? If so, I was sure to run out before I was old enough to be allowed into the grown-up's section in the adjoining room.

The best games were played in the many building sites. In those years, houses were popping up everywhere. A new church was built – and three new schools. Youngsters would clamber up and down half-formed staircases and launch themselves from walls in a way that seems unimaginable now.

In St Conaire's national school, the playground hummed with London and Birmingham accents. A sizeable number of boys and girls were from Belfast. Others were from Lisburn and Derry. All had been brought south by parents desperate to escape the Troubles. To this day, when I say I'm from Shannon, people remark about the number of people from the North. Looking back, it's clear that some children had been deeply affected by their earliest experiences. A girl in my class had skin grafts on one arm. There was a boy in our estate who didn't go to school and said very little. Mostly, those experiences weren't discussed. The only time I was conscious of the atmosphere changing was during the 1981 hunger strikes. After the death of Bobby Sands, black flags flew from many windows. I remember one of the boys in our class coming to school with a black armband. The teacher told him to remove it. He returned after lunch with a note from home saying he was to keep it on.

There were two girls from Chile in our class. Claudia and Jenny were refugees, their families forced to flee after the military coup. Not that we understood any of this. Neither did we properly appreciate the achievements of children who'd arrived with hardly a word of English yet managed to become an integral part of school life. *The Sunday Press* did a story about the unusual school with the children who'd come from all over the world. Scores of us poured into the yard to have our photo taken, delighted to get an unexpected break.

St Conaire's was chronically overcrowded. Classes were taught in the principal's office, in a store-room, in a pair of drafty prefabs, even in the community hall which was twenty minutes' walk away. The modern tables and chairs were supplemented by fading wooden desks handed down from who knew where.

A couple of years ago, I had the opportunity to return. One of the teachers from those years produced an old roll book. I began to recite the names, half expecting to hear a small voice replying *anseo* or a group bellowing out *as láthair*. Despite the passage of time, most of the names were familiar. 'Reemagh McEvoy,' I read, 'Niall Doyle, Martin Russell, Sandra Carroll.' The smell of lunch boxes and damp coats came back to me. I could hear the thump of Mrs. Foley's piano and see the mayhem in the yard as skippers competed for space with games of tig, elastics and red rover.

As I read, one of the school's current teachers joined us. She was taken aback by the number of children on the roll, our names snaking down the page. There were at least forty pupils in every class, more in some.

When I was fifteen, we moved to a different estate. The houses in Tullyglass Court were slightly bigger, the streets slightly quieter. By then, I was going to the Comprehensive School, or as everyone in Shannon calls it, 'the Comp.' It too was loud.

I don't believe that as teenagers we were as conscious of 'identity' as young people now, but the identity we did have was resolutely urban. You'll have to look elsewhere for Clare's flutes-and-fiddles heritage. There were Goths and Mods and Metalheads who, when AC/DC were played at the disco, formed a circle, dropped to their knees and banged their heads until they were dizzy. We spiked our hair, took in our jeans and hung around outside the record shop and the chipper. We walked to the Point – no true Shannonite says estuary – and to the airport. There's a video on YouTube called S.H.A.N.N.O.N. where a guy raps his way through those local rites of passage. It manages to be cheeky, sarcastic and affectionate all at the same time. I think it's a work of genius.

Each group viewed themselves as superior to the others, and elaborate insults evolved. The Metalheads referred to the Mods' Vespas as hairdryers or Kenwood Chefs. The mods told dark jokes about AC/DC's Bon Scott who'd died from alcohol poisoning (this news took at least a year to reach Shannon). Everybody made fun of the Goths who, for want of more sophisticated styling products, stiffened their hair with sugar and water and dyed it with food colouring. On Friday nights, we went to the GAA club disco, better known as 'the gah'. It was dark and crowded and when the DJ played something really popular like 'A Town Called Malice', it felt as if the entire building was shaking. The cool crowd started the evening with shared cans of beer at the Point. Everything short of sex was referred to as shifting. In contrast to today, there were relatively few drugs, and what was available was fairly basic: glue, Tippex thinner and the magic mushrooms that grew near the soccer pitches.

Although Shannon is equidistant from Ennis and Limerick, we rarely visited Clare's county town. Instead, lured by the bargain shops on William Street, the Carlton Cinema and the milkshakes in Burgerland, we'd thumb a lift into Limerick. We listened to Dave Fanning on Radio 2 and complained that we only had two television channels. In part, our self-image was moulded by the fact that so many of us had city roots. My friends went on summer trips to their cousins and came back with stories of new bands and fashions. 'Everybody's into The Smiths now,' someone would say, or, 'All the girls are wearing Doc Martens and fishnets.' Those returning from Belfast or Derry had especially dramatic tales.

And yet we never had doubts about our county allegiance. We were Clare people and bristled at any suggestion to the contrary. I still find myself snapping at those who ask me about being from Limerick.

The airport didn't play much of a role in our day-to-day lives. In those pre-budget airline years, flying was beyond the reach of most. We watched the departures screen flicker but never got to board a plane. What the airport did do was give our surroundings a certain exoticism. We were fascinated by the visiting Americans and by the Russians who worked for Aeroflot.

Like many from the town, I went on my first proper foreign holiday with the Soviet airline. If you were willing to take a circuitous route, you could fly almost anywhere in the world. Along with two friends, I went to Nairobi via Moscow, Larnaca and Aden. I have an Aeroflot timetable from the early 1990s and, when asked to name my favourite books, I usually give it a mention. I never did fly to Ho Chi Minh City via Tashkent or Accra via Malta, but knowing that this was possible gave me a thrill. It's difficult to grow up beside an airport without hankering for faraway places.

Here's something else about the town where I grew up: most people rented their homes from the local authority, Shannon Development. There was no stigma attached to this, no vitriol about 'ghettos' or 'free housing'. Perhaps this helps to explain the relative lack of elitism. (I say relative because wherever humans gather there will always be petty snobberies.) It wasn't until I went to college and heard other people's experiences that I realised how unusual Shannon was. Allied to this is the town's skepticism of showiness. While achievements are celebrated – hence the crazy scenes that continue to greet victorious sports teams – pretensions are not. If you want to live in Shannon, be prepared to shed your notions and leave your self-importance at the gate.

While part of me approves of this distaste for gaudy ambition, another part reckons we took it too far. I wonder if it didn't stymie my desire to write. As a teenager, I wrote all the time. I spent hours honing English essays while cramming the rest of my homework into twenty minutes in front of MT USA. I wrote self-conscious pieces about school in an old office diary. I scribbled notes about bands and books and everything that appealed to me. Did I want to be a writer? I don't know that I thought in those terms. Even wanting to be a journalist sounded showy.

The town had other, more serious, problems. Some families arrived with very little. Others had difficulty adapting to their new home. As a child, you take a lot on board but don't necessarily understand. Years later, you realise how poor some people must have been, how fractured their families, how difficult their lives. Classmates didn't wear sandals in November for the fun of it. They wore them because they had no other shoes. The dividing line between getting by and falling into poverty was narrow.

Many of the houses were small. Quite a few had troublesome heating; others, no heating at all. Some have aged badly. Their walls have become mottled and stained; their fascia boards, faded and warped.

In the mid-1980s, Shannon got a new library: a large glass-walled building with a special area for children and tables where older people could study or read the paper. By then, I was moving on from children's books. If you're of the same era, you'll know that this presented a challenge. Novels for and about teenagers weren't available in the numbers they are now.

I was directed towards the mystery shelves. At thirteen, I binge-read Agatha Christie. After that I found *1984*, *The Catcher in the Rye* and *Gone with the Wind*. I remember reading *The Country Girls*, and being amazed that it had been written by a woman who'd grown up a few miles away.

It wasn't just books that drew me to the new library. In the middle, beside the librarians' desk, there was a magazine stand with everything from the *Melody Maker* to the *Sacred Heart Messenger*. My book, *The Night of the Party*, has a character who spends her early teens in the local library, poring over old copies of the NME. It's not the music that interests her as much as the characters, the venues, the fashions. She likes reading about the Brixton Academy and the Hammersmith Palais, and dreaming that one day life will take her to such places. And, yes, that was me.

When I was seventeen, I left to go to college in Dublin. I went willingly, seeing the CAO form as more about adventure than education. Like many others, I was obsessed with the freedom and anonymity of the city. I wanted to walk down streets where I knew nobody and nobody knew me. I wanted to see rock bands and go to discos without slow-sets. Although I would never have admitted it, I yearned for the sort of glamour I didn't think Shannon possessed.

The funny thing was, the classmates I gravitated towards in the NIHE, now Dublin City University, tended to come from similar backgrounds. Some were

from large housing estates in Waterford and Dublin. Others were the sons and daughters of farmers. Mostly, however, my friends were from 'the town'; from Portarlington and Mountrath, Mohill and Athboy. While we lacked the sheen of privilege conferred by the capital's fee-paying schools, we didn't think of ourselves as rural. In our heads, we were a different species to the kids who'd got the bus to school. More sophisticated. More streetwise. We soon realised that Dubliners were blind to this distinction.

In the 1980s, you didn't dawdle. At twenty, I left college and started work as a broadcast journalist. My writing became confined to 45-second audio reports about hospital overcrowding and bust-ups at council meetings. I won't say I was too busy to write. That would be dishonest. It's almost always possible to find a sliver of time. The truth is, I enjoyed my job. In the 1990s, I moved from local radio to RTÉ. Those were good years to be a reporter. The country was changing. We had more freedom than today's young journalists. Oh, and we didn't have to listen to critics telling us that the old media was dying and that soon enough there wouldn't be any journalists left.

That wasn't all – and here's where the Shannon insecurity comes in. I came to feel that writing fiction was for others. It was for people from literary families or those with degrees in English or in-depth knowledge of the classics. Most importantly, it was for the immensely talented. I didn't fit into any of these categories, so, while I remained an enthusiastic reader, my writing habit slipped away.

Then, seven or eight years ago, a friend asked a question: what did you love doing as a teenager that you never do now? Her argument was this: as teenagers most of us are passionate about playing sport or singing or painting or something. Without thinking about it, we revel in being creative. But why shouldn't we get the same enjoyment from those activities when we're in our twenties or thirties... or even older?

What I hadn't appreciated is how addictive writing becomes. When you're working on a book, you lug it around with you. You carry it in your head and on strange jottings saying things like, 'Move paragraph on Paddy O'Grady to next scene,' or, 'Remember that Flan Varley lives in a bungalow.'

My parents still live in Shannon. My mother remembers her determination to leave – and laughs. In some ways the place has changed, in others it remains unaltered. Wherever you're from, the story's the same: the roads are shorter than you remember, the hills less steep. In my mind, the town will always begin at the Aidan Park traffic lights and the clusters of yellow houses in Ballycasey will

take me by surprise. Despite all practical evidence to the contrary, Finian Park will forever be a huge estate; Doyle's Shop will be beside the Aidan Park swings; there'll be a disco in the GAA club on Friday night.

Not that long ago, I met an old friend. We talked with fondness about our memories of growing up. But we spoke too of the harsher things that had happened.

In recent years, a girl we knew at school has had the courage to speak about how a group of boys raped her when she was fifteen. She'd thought they were her friends. At the time, she told no one. She was scared she wouldn't be believed.

Her experience has made me think again about the supposed innocence of those years – and of the seam of darkness that runs through my town and every town. Our relationship with the place we come from isn't static. We're constantly revisiting. Renegotiating.

There are always other stories to be told.

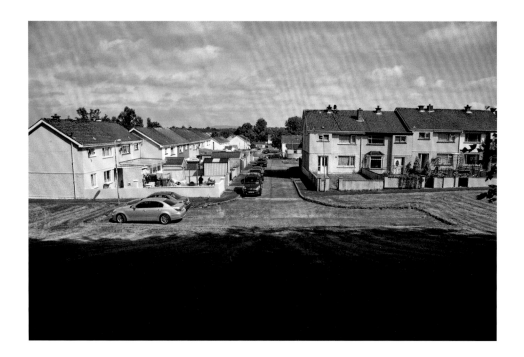

Rachael English

Born in Lincolnshire in 1968, broadcaster and writer Rachael English grew up in Shannon, County Clare. Her broadcasting life began on Clare FM and from there she moved to 2FM and RTÉ Radio 1. As presenter of *Drivetime*, she was the recipient of a PPI Award for her coverage of the September 11 attack in the United States and since then as presenter of *Morning Ireland* has covered all the major domestic and international events.

An enthusiastic reader, she started writing only seven years ago. Her first novel, *Going Back* (2013), was shortlisted for the most-promising newcomer award at the Bord Gáis Irish Book Awards and spent two months in the Top 10. Her subsequent books include *Each and Every One* (2014), *The American Girl* (2017), *The Night of the Party* (2018), *The Paper Bracelet* (2020). On her own writing she has said: 'Sometimes, I find myself thinking that I'm not suited to writing. I tell myself I'm an imposter who should stick to what she knows. More often I wonder how I managed for so long without it.'

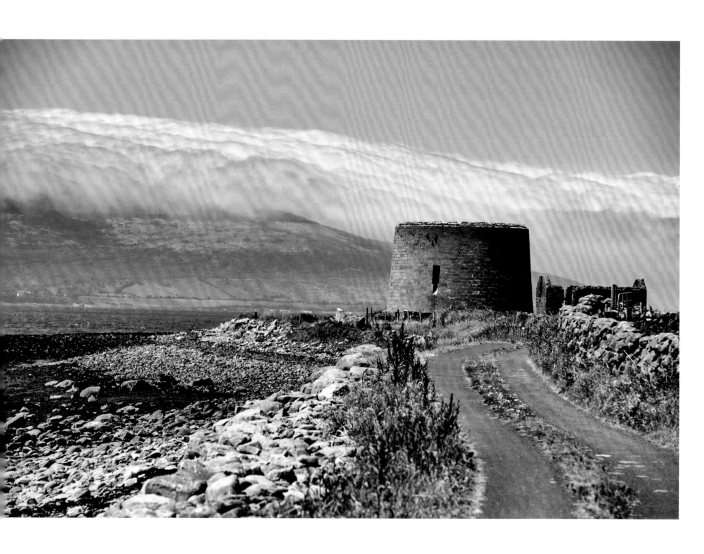

Finavarra

Brian Mooney

Finavarra[1]

And we shall find sanctuary
in this place too tight for the wind to comb out.
Feel the coiled wave gently
lave our face. Discover
in this wind-eddy, this
tidal-knot, the sea's contour.
As with its dotterel language
our love is the migratory ground,
the way of estuary. To be found
where locutory birds
are to be found, alive yet smarting
out of the ocean's sway.

1 Finavarra in the Burren was my place of sanctuary, a place of solace and comfort. This poem is dedicated to my son Brecan who drowned tragically in November, 2009. He is buried in Shanakyle, Kilrush (overlooking Scattery Island) and where I will join him when my days in this world end.

Biography

Brian Mooney

Brian Mooney was born in Dublin in 1935. He attended Clongowes Wood College in County Kildare and UCD where he studied English and philosophy. He taught English in Mungret College and Glenstal Abbey in the late 1960s. Intrigued by the unique Burren flora, Brian spent time learning the art of perfume-making in Grasse, France in the 1970s and returned to set up the Burren perfumery in Carron, which he refers to as his 'olfactory poem'. He also spent time on Inis Meáin and his early collections of poetry, *Island Awakening* and *Between the Tides*, were inspired by the landscape of Aran and the Burren. In the mid-1990s, he moved from the Burren to East Clare in order to devote more time to writing. In 2003, along with Arthur Watson, he founded the Clare Three-Legged-Stool Poets (Clare Collective) and they ran weekly meetings in Glór with an open-mic session. His most recent collection of poetry, *Image and Likeness (Dealbh is Cosúlacht)*, was translated into Irish and published in 2019 by Coiscéim Press. He is married to the West Clare academic and artist, Noirin Williams.

A Place Between

Tommy Hayes

I went to seventeen *fleadhs* in the summer of 1974. Seventeen *fleadhs*. I was nineteen years of age. That summer my green Mini Minor van was my home, if not equipped with all the necessities of home. At night, I pulled out my mattress. At that age, sleep comes easily. Breakfast was a sandwich from the local shop. I was always a tea drinker. At that time, the rest of the country was, for the most part, too. Except for Maxwell House and Nescafé, Ireland was a coffee-free zone.

All of this seems a long time ago now. The past, to quote from an oft-quoted quote, is a foreign country, 'they do things differently there.' This was also before breakfast roll man made famous by Pat Shortt's 'Jumbo Breakfast Roll' or David McWilliams's more erudite exposition of the full Celtic Tiger breakfast roll of sausage, rasher, hash brown, black pudding, tomato, egg and mushroom that swash-buckled its way through the first decade of this millennium. That was before it all came crashing down in 2008.

In my green Mini Morris van, I criss-crossed the country taking in *fleadhs* in Waterford, Macroom, Kilmihil, Ennis, Ballaghaderreen and more. It was a musical odyssey. I was drawn to the music. Music became my obsession. In Listowel, I was blown away by the *bodhrán* playing of Galwayman Johnny 'Ringo' McDonagh and the sublime tin whistle playing of Dublin woman Mary Bergin. But it was the *bodhrán* that caught and held my imagination. The musicality of it. That was my eureka moment. That was my epiphany. I wanted to play the *bodhrán*.

I don't remember when I first started playing the spoons. Des Costello, a cousin of mine, played the spoons. I learned from watching him and others. Playing the spoons was much more common then for all kinds of good reasons. They say basketball became the sport of black people in the United States because only small spaces were required; small spaces, a ball and a net. Perhaps the spoons were the poor person's Irish equivalent. Even the poorest of houses had spoons, if not dessertspoons. Simple stainless steel spoons. Silver spoons give off an overtone that drowns out any musicality. Not that silver spoons were commonplace in poor Irish households.

It is not that I came from a musical background. My father died when I was two years old but I never heard he was musical. My mother could sing but not

in public. My uncle Patrick Costello played the accordion for his wife who was a dance teacher. Nor was there any music in school although I remember, at least once, a small man arriving on his bicycle in our primary school with a cello strapped to his back. He played the Bach cello preludes and I remember he was completely lost in the music. I was lost in his playing. I also remember a travelling man, Kendall Husband, who came through town once every few years. He played classical music on a chromatic harmonica and conducted himself with his non-playing hand.

I went to a two-teacher school, husband and wife, not uncommon in those days. The husband attempted to play the tin whistle and managed only to do so, badly, even at the best of times. Insofar as there was music, it was in keeping with the dominant anti-British sentiment that was fostered in every national school in the country in the mid-1960s. The songs we sang reflected that. Songs like 'Roddy McCorley', 'God Save Ireland', 'The Minstrel Boy', 'The Merry Ploughboy'. 'Boolavogue'. And of course, 'Beidh Aonach Amárach (i gContae an Chláir)', a song of unrequited love although that we never understood. If the intention was to instill any nationalistic fervour in me, it failed. Green environmentalism is my politics.

No importance was attached to music in Kildimo in west Limerick, the village I grew up in. At the age of twenty-one, when I won the All-Ireland for the *bodhrán*, only one person in the village congratulated me. If that happened today in Tulla, Feakle or Scariff, there would be great celebrations. Ironically, I got properly introduced to Irish music in London in 1972. Along with a friend of mine, we planned to hitch around Europe. We got as far as London and did the whole building thing. Worked for McAlpine for a year. Living in London at that time was my cousin Kay Costello and her husband Roger Nicholson, very well known in the English folk scene. He played the Appalachian dulcimer, a beautiful little-known instrument made famous in later years by Joni Mitchell. If Johnny 'Ringo' McDonagh represented my baptism into the world of percussion, Roger Nicholson provided the confirmation. Twenty years of age and one year later back home, I went headlong into the music scene.

Ireland in the 1960s was not a receptive place for traditional music. In that respect, Kildimo was not unique. Ireland was modernising and traditional music was regarded by many as part of the past. This was the era of formica. Out with the old and in with the new. Of this time, the great Donegal fiddle player Paddy Glackin once told me 'you'd be hiding the fiddle, it wasn't the thing to be seen with one.' It was quite extraordinary. All that new-found energy came a

decade later, birthed by the musical flair and ingenuity of an astonishing number of audacious individuals and collectives. The Chieftains, Planxty, Dé Dannan, Clannad, Altan, The Bothy Band, The Fureys, Horslips. Within each, there were extraordinary musicians. All of this marked a seismic break from the showband era, although some great musicians honed their skills during this period, Arty McGlynn perhaps the most notable.

The showband scene was not for me. Shanagolden was the nearest big 'ballroom of romance.' And then there were the marquees that periodically sprang up all over the country. Not my scene. There was a different vibe going on there to what I was looking for. They were like cattle marts. People crushed together. I went only a couple of times. But they did introduce a different type of music to young eager Irish teenagers and older. Rock and roll introduced to Ireland by the back door. Not by the original artists themselves. In the 1960s and early 1970s, Ireland did not feature on world tours. That would come later. Ireland had to make do with cover versions. The nearest Irish people came to the music of Elvis Presley or James Brown, Chuck Berry or Little Richard, was through the Miami Showband, the Capital Showband, the Big 8 and the Royal Showband. But for all the mawkishness of the music of the showbands, and yes, I am a music snob, they became an employment powerhouse in an otherwise lacklustre economy, employing at its apex, according to historian Diarmaid Ferriter, 10,000 people, including 4,000 singers and musicians.

If the sixties was a musically barren decade, economically the seventies and eighties were tough decades for young people trying to make their way. Most couldn't, didn't and left. Fled the country. I was determined to stay and make my way in music. But music didn't pay back then and so, in 1974, I went to work in the Ferenka factory in Annacotty just outside Limerick City, one of the few places that offered employment. These were hard, grim, grinding years. It even seemed to rain all the time. An air of depression hung over the country. On its opening, Ferenka was presented as a kind of workers' utopia. A way out of spiralling unemployment. It was anything but. At its height, 1,400 people worked there making wires for tyres. A big noisy factory and not a very nice place to work.

The place became synonymous with dismal industrial relations. There were dozens if not hundreds of official and unofficial industrial disputes. Everything about the place ran counter to Irish sensibilities. Boring repetitive work in a highly authoritarian setting. Permission had to be sought and given for bathroom breaks. In that era, shoehorning Dutch work practices into Irish ways of working just didn't work.

Even the construction of the site was mired in controversy. A fairy fort was bulldozed to make way for the plant; many believed it was a bad omen. When the factory eventually closed, Maeve Hillery, wife of then president Miltown Malbay man Paddy Hillery, blamed the destruction of the fort for the company's later misfortunes. Those misfortunes included the 1975 kidnapping of its managing director, Dutchman Dr. Tiede Herrema by Eddie Gallagher and Marian Coyle, an event that convulsed and confounded the country. The company eventually closed in 1977 after only six years in operation. The unions were blamed. The workers were blamed. We were all blamed. We were seen as ungrateful. The closure also marked the end of my career as an industrial employee. Economically, the seventies may have been a miserable decade and the eighties were to prove no better.

What saved us or at least saved me was music. Long before Ferenka closed, I was playing with Kieran Hanrahan, Paul Roche, Tony Callanan and Maurice Lennon at various *Fleadhs*. I can't remember who precisely took the initiative but a traditional band competition was announced for Limerick and we decided to enter. At the time the band didn't have an identity; we didn't even have a name. The night before, we met in Kieran's house in St Michael's Villas in Ennis and tossed around possible names. We didn't want an Irish-sounding name. We were looking for something contemporary. One of the lads, I think it was Kieran's brother Ger, picked up Bruce Springsteen's album *Born to Run* released a couple of years earlier. In the track, 'Backstreets', there's a line that goes, 'Slow dancin' in the dark on the beach at Stockton's Wing...' That was it. Stockton's Wing it was. It had the contemporary feel we were looking for. The following day, we won first prize in the traditional band category. On the same day, a then little-known Dublin band called U2 won the best rock band category.

The speed with which Stockton's Wing took off surprised us all. Looking back now it is all a bit of a blur. We were playing in front of audiences of 2,000 to 3,000 people. In 1983, we did a tour of the United States in which we took 84 flights in 44 days and played 42 gigs. We did three gigs that year on St Patrick's Day. The first at noon in Providence, Rhode Island, at 7.00 pm, then we were playing in South Carolina and at 11.00 pm we were playing in North Carolina. Three flights in one day. Mad stuff. A lot of people make a living out of bands, managers, record companies, publicity people. We didn't. At the height of touring, we were earning £50 a week. A lot of that happened in 1983. I remember once doing a television gig with the wonderful button accordion player Tony MacMahon and getting £40. It was a week's wages in those days.

We drove all over Europe. Lived, ate and sometimes slept in the van. We had a mattress for the driver; the rest of us slept on our seats. Mike Hanrahan was the cook, a decent one at that too, and we tried to eat half decently. We had a pressure cooker and lots of stews and whatever Mike would put together. However, moving from country to country, from city to city, was hugely demanding. At times it was chaotic, even more so than in Ireland. The gear wasn't up to standard. But we kept going. We gigged in Italy, Holland, Belgium and up and down the UK. I remember playing in front of 50,000 people at the Nyon festival in Switzerland. There were memorable moments too. We played between the legendary Scottish singer songwriter Donovan and Osibisa, a British Afrobeat band consisting of four expat African and three Caribbean musicians who played a fusion of jazz, funk rock and R&B.

For all of that, the best part of touring was from the moment we went on stage. On a good night, there is nothing like it. The whole day's focus is on the moment you walk on stage. And on stage, the six of us working together, working off each other. Play, change into another key to heighten the sense of excitement. Dramatic pause, and then off again. Within that there are thirty seconds that all musicians recognise. That subliminal connection. That feeling of intensity. You feel it and you live it. No eye contact is required as the music flows with an intensity and awareness of each other.

Back home, the touring continued. Lisdoonvarna was a stand-out venue. An open field with a downward slope, a mile outside Lisdoonvarna. Conceived by Jim Shannon and Paddy Doherty as a folk and traditional music festival, it quickly morphed into a major international festival. This was a hugely professional operation. There was a massive sound system, a massive rig. Everything was on a scale never seen before in Ireland. We even had our own engineers for our sound monitors. And it was really good fun. All the great Irish musicians were there, Micho Russell, Seamus Ennis and of course Christy Moore. And these played between some of the biggest international acts of their day: American singer songwriter Jackson Browne; another American, the folk singer Loudon Wainwright III; the British folk-rock band Steeleye Span; from Birmingham, the reggae pop band UB40. Other great Irish musicians too: Rory Gallagher, Van Morrison, Paul Brady. It was, in retrospect, a male-dominated world. That was the world of music back then. American singer songwriter Emmylou Harris was one of the few women to feature.

There had never been anything like the festival mania that gripped Ireland at this time. But perhaps what was most transformative was what was happening off-

stage. Thousands of young people coming together unencumbered by the kind of church, state and factory (in my case, Ferenka) surveillance that was such a feature of Irish life. Thousands of people. At its height, Lisdoonvarna attracted 70,000 young people, many away from home for the first time.

Sleeping in tents or in tents and not sleeping. This was sex and drugs and jigs and reels. And it brought young Irish people face-to-face and closer to each other and other young Europeans, many of whom had long cast off or were never burdened with the inhibitions that so marked many of our childhoods. I have a very strong memory of one occasion in particular. A group of young European women and men skinny-dipping in the Owenmore River in Ballisodare during the festival there. I remember the priest standing on the bridge roaring at these young Europeans. Roaring. They simply ignored him. And as they ignored him, he became more and more enraged. He was apoplectic with rage. But he was also helpless in his rage. It wouldn't have happened ten years earlier. The country was changing. The power of the Church was beginning to fall away. A transformation was under way.

By 1983, I was exhausted from the touring schedule and wanting to try something new. Amicably, I parted with Stockton's Wing and spent the next six years in the United States. As a percussionist, I wanted to experiment. I moved to Portland, Oregon and embraced the jazz club scene there. Jazz for a percussionist opens up all kinds of possibilities that traditional music or indeed orchestral music does not allow. In the orchestra, the percussionists are always tucked away at the back. Unlike traditional music where the percussionist is seen as an accompaniment, in jazz, percussion is essential to the musical ensemble. Jazz requires a very different mindset. Intellectually, I found it more liberating. Jazz also provided me with an opportunity to meet people from very different class and cultural backgrounds, experiences and musical sensibilities. An introduction to African American culture. Very different from the Oirish view of Irish music that is so much part of Irish America.

Despite my immersion in Irish music, I have always felt the need to expand my musical palate by exploring other forms of music and incorporate those influences into the rich tapestry of Irish music. My involvement in academic work at the Irish World Academy of Music and Dance in the University of Limerick has enabled that expansion. In that context, I wish to pay tribute to the contribution of musician, composer, teacher and academic Mícheál Ó Súilleabháin who sadly died in 2018. Equally, as a member of faculty with the Dublin Institute of Technology, I was able to engage with other musical genres and in the process enrich my own musical practice.

Towards the end of the eighties, I decided to return to Ireland and eventually settled in East Clare. I had always liked the feeling of the place. There's a big alternative community here; people came from Germany, Holland, English people and Americans too, partially drawn by the Steiner school, partially drawn by the availability of cheap land and cheap houses. In the early eighties, it was possible to buy a house fairly cheaply in the hills between Feakle and Tulla. And these disparate worlds sit comfortably with each other, each enriching the other. I'm now living in the townland of Magherabawn in Feakle parish. Among the first people to welcome us here was Paddy Malley, a local man in his nineties who lived with his wife Kitty just up the road. Now, our road is an eclectic mix of people from all over the world.

On my five acres, we are pretty much food sufficient all summer long. I continue to play music, mostly with Matthew Noone who plays the *Sarode*, a North Indian lute. We play small gigs together as Antara, the Sanskrit word for the space between. I also get to play with the wonderful traditional musicians who live locally and with musicians who live in that other country in West Clare.

Perhaps that's what East Clare now offers me. After a peripatetic life, a place to be. A place to plant and grow seeds, a therapeutic place, a place of quiet healing, a place that continues to inspire me to make music.

I am here in East Clare now for twenty-one years. And while there are no guarantees, I'm probably here until the end of my days. Life. From birth to death.

In the meantime, this is a place between.

Biography

Tommy Hayes

Tommy Hayes has been at the forefront of traditional Irish music for over 40 years. Tommy has been a member of a number of ground-breaking groups during his career: Stockton's Wing, Puck Fair, Altan, Riverdance and has performed with the likes of Liam O'Flynn and Eileen Ivers. Altogether he has performed on more than 400 albums. He has also played on numerous films, amongst them *Titanic*, *The Devil's Own*, *Rob Roy*, *In the Name of the Father* and *The Field*. Tommy has a masters degree in Music Therapy from the University of Limerick and is a Fellow of the Association of Music and Imagery AMI. He is one of the founders of the Irish Seed Savers Association, a charity preserving agricultural biodiversity.

Between the Sea and a Hard Place

Sarah Clancy

It's 26 degrees and the sea is an unlikely blue that deepens to turquoise out in the channel where it is deepest. I'm two months into Ireland's coronavirus lockdown. I'm sitting, writing, on the back patio of the holiday house in Muckinish West, Ballyvaughan, County Clare, a rented home to my partner Anne and myself for the last three years. A cuckoo is driving me nuts. For the first few days the call made me think of childhood summers with days stretching endlessly, but it now grates on me like a distant car alarm. The incoming tide is quickly filling the lagoon-like area just below our garden wall. It comes in here about an hour later than it does on the rest of the coast. It arrives at Bishop's Quarter beach and makes its way through a narrow passage where opportunistic cormorants, seals, egrets and the occasional otter gather to take advantage of the funnel-like effect which makes for easy fishing. When it does arrive though, the tide flows past us as fast as a river, skirting Scanlan's Island and heading on across the petrol-silver mud flats to the pier at Bellharbour.

> **Swelter**
> … this weather is incredible
> and we don't know ourselves
> we have slipped the bounds of reason
> and are drifting away from any recognisable routine
> and in the insomniac dead night's belly
> we can't take it anymore
> we make a break for it
> and we are swimming
> through warm moonlight
> and silver black water
> and we may never recover
> from the beauty
> from the swelter
> from losing our anchors.
>
> ('Swelter', unpublished, June 29, 2018)

On its journey the tide has passed the Martello tower at Finavarra and the ruins of a matching pair of tower houses: Muckinish West and Muckinish East, both of which are slowly collapsing into the sea. Continuing inland as the crow flies, you'll

come to Corcomroe Abbey, further up the green fertile valley, a complex of ruined churches at Oughtmama; above again a holy well beside a twisted blackthorn and then finally, up where the open pasture changes to the typical limestone pavement of the Burren, a small insignificant-looking spring of water. This trickle of water is probably the reason that this green swathe which runs down all the way to Bellharbour contains such a rich history of settlement.

Projected maps of this coast as it will be in 2050 show that low-lying areas like this tiny peninsula will have been mostly reclaimed by the sea. Some days I can almost feel it happening.

I'm from Galway City which means I've spent most of my life looking across Galway bay at these hills and coastline. Like many Galway city dwellers, I escaped towards Clare on fine weekends when the changing light on limestone called me out. What actually brought me here to live though was much more prosaic than the light air and barefaced openness of the countryside. Having found myself almost unemployable elsewhere, I found a job in Clare.

Whilst not substantial on the scales that measure human suffering, I'd had a time of personal crisis in the years immediately beforehand. I'd returned, in my thirties, to education, having given it short shrift in my childhood. I'd been utterly obsessed with ponies and horses and decidedly not obsessed with attending school and so although I loved books and read voraciously, I lacked any formal qualifications. Most of my life up to then I'd stacked up year upon year without giving them much or any consideration. I'd lived in a helter-skelter ever-forward way from my mid-teens to my thirties without ever really wondering where I was going, or even what I felt or believed in. Education, confidence and a turn towards poetry were all things that helped me begin to change that way of living. It wasn't an easy process, each step towards writing poetry I took, the more I revealed to myself about myself:

> On this day of halogen and helium
> we are dodging shadows
> our eyes squinting against the late afternoon sun
> but it's with us despite the brightness
>
> ('It's the Dark' from *The Truth and Other Stories*, Salmon Poetry, 2014)

Although I stubbornly refused to deal with what it was I was uncovering, child abuse, my sexuality, my own responsibility for situations and relationships I'd made messes of, it eventually began to catch up with me. It got tricky.

Towards the end of those years, a whole set of circumstances coalesced; I made an attempt to hold the man who had abused me as an adolescent to account through the courts. It's hard to explain the effects of this to anyone who hasn't experienced something similar. For me it involved changing the story I had told myself about my life, the stories that I'd built my adult self and personality on. The best way I can describe it is that when one thing I'd held as true became untrue, then every other 'true' thing became riddled with holes. I felt as if everything I had held as fact was dissolving and as if this was obvious to anyone I met or spoke with or worked with. Describing it still gives me a slight feeling of panic, as if I am standing in the shower and can see myself start to swirl away down the drain and am powerless to stop it.

> … and I am on the air now
> whinnying, I'm twanging like a string plucked and echoing,
> out here I'm my own doppleganger. I am listening.
> Can you hear me listening and don't I sound just like myself?
>
> (from 'Doppleganger', *The Truth and Other Stories*, Salmon Poetry, 2014)

The financial crash hit when I was in the middle of this and to compound matters, I was forced to sell my house when my work as a freelancer dried up. I ended up pushing forty, living at home with my parents, out of work, with a small but for me unpayable tax bill and desperately trying to keep any sense of my own identity intact.

> In at the housing office the woman says
> if I need a house then I'll have to tell the council
> I'm homeless, or else bunk in with my parents
> and I feel the heat of tears in my eyes and let me tell you
> it's not sadness I'm feeling it's anger
> after all of these years insisting that no one
> will ever call me a victim
> in they come and do it from a whole different angle
> I never saw coming and they call it helping
>
> ('And yet we must live' from *The Truth and Other Stories*, Salmon Poetry, 2014)

For around four years I lived this way, taking the pressure off by working as a tour guide in the tourist season, living peripatetically in delicious anonymity in impersonal clean-sheeted hotel room luxury for one half of the year, and for the other, growing increasingly frustrated by living, infantalised, at close quarters with my ever supportive parents.

...The four tiny milk cartons
on the tea tray in my latest hotel room
fill me with my favourite type of loneliness...

('Hotel Room', *Icarus* magazine, 2016)

For the first time in my life I was qualified and experienced in the field I worked in, but still I appeared unemployable. The same human rights or social justice organisations which invited me to read poetry at their conferences didn't call me for interview when I applied for actual paid work. I was at a low ebb, living erratically and keeping company with people who were cast out somehow from society in general, although to be honest, by dint of a bit of middle-class privilege I had more safety nets available to me than they did. Some people I knew from then haven't made it this far.

Which of us?
... And the sun is marauding this morning –
breaking in through the curtains to wake me
when I could sleep forever,
when I would sleep forever
this sun is lacking compassion-
there's something vicious
in its insistence on rising
no matter which of us died yesterday
no matter which of us dies today.

(Unpublished, 2015)

During those years, though, I wrote like crazy. I wrote raw poems that seemed to resonate with people and the zeitgeist. Surprisingly to me, while it seemed all other aspects of my life were catalogues of failure and that in many ways I didn't even feel like I existed at all, I was having considerable 'success' as a poet. I was invited to read my work at festivals in Ireland, performing in places like Liberty Hall and the National Concert Hall and in other countries and continents. I was invited to perform at the anti-austerity protests that were becoming part of the backdrop to civic life. I experienced most of this in some disembodied way as if it wasn't actually happening at all or if it was secondary, a trivial decoration on the urgency of the poems I felt driven to write.

In a fit of near desperation I moved out of my parent's house to an en-suite room in a house shared with five others in Kilcolgan. I paid the deposit with a visa card cash advance that I'd no idea how I would pay back. This move cleared the air for

me and it gave me somewhere almost anonymous and hotel room-like in which to base myself while I finished dealing with the case against my abuser in court. It also brought me nearer to Clare. Within a year of moving I had finished the court case, with the abuser having been found guilty and given a five-year sentence (none of which he served, however; that is another story). Most unexpectedly I had also begun a relationship with my partner Anne who always jokes that she caught me at a vulnerable moment.

Not only that, but one of the job applications that I'd sent out finally bore fruit and I went from being unemployable to having a decent job as the coordinator of a county-wide network of community groups in Clare. Within a few weeks of getting that job, Anne and I, taking a huge risk in a brand new relationship (in stereotypical lesbian fashion) moved into our first house together just over the Galway border and into Clare.

To read my own work from those rough years, it is remarkable how often North Clare shows up. I had no conscious idea when I was writing that I would find my way here to North Clare to perch on the edge of the Atlantic, but obviously somewhere there in my subconscious I was already on my way.

> we squinted through sunglasses at Ballinderreen and Kinvara
> but didn't stop, turned for Fanore at Ballyvaughan, you leaning back
> feet on the dash singing along to the Indigo Girls and Johnny Cash,
> and asking me where we were headed, but messing about,
> I wouldn't say, I told you on a day like this, trust me
> it will all work out: we're going mermaid hunting
> and the signs are good for catching.

('Ringing in Sick' from *Thanks for Nothing Hippies*, Salmon Poetry, 2012)

In the four years since then, I've lived and worked here although I have come to have a few different relationships with the county. One is the fact that I have found a home here. The risky undertaking of moving in with someone I knew very little about, in precariously rented houses on the whims of absentee landlords, has given me a home, a compass point from which to venture out. Another is that restless impermanence that living close to the sea brings. It was possible for me to settle here like a wintering bird just lightly, feeling as if I am making no particular claim on the land or the community around me.

Prior to the sequestration caused by the Covid-19 pandemic, my commute to and from work in Ennis was like crossing a frontier between one world and another.

After night meetings in winter I'd drive home through the eerily empty dark Burren, seldom meeting another car en route.

In that other world of my workaday relationship with Clare, life is often frustrating. I skirmish with the 'establishment' and seemingly impermeable traditions and codes in order to exist on my own terms. On the one hand, I work surrounded by a small number of utterly inspiring comrades who constantly make the road by walking; they are feminists, disability activists, artists, musicians, environmentalists and refugees. On the other hand, I am in constant danger of becoming submerged in the suffocating, charitable, GAA-saturated, male-dominated, back-slapping public sphere that forms the main official backdrop for my work. I find all of this so alien. The way the man (it is always a man) who scored the point or the try or carried out the crucial foul thirty years ago still has to be paid homage to in utterly unrelated circumstances in some form of hierarchical ritual, really gets on my nerves. Worse again, the fact that the views of those men are deemed to be of particular importance in local policy making never ceases to underwhelm me.

It's not that I feel that Clare is insular or backward. In most respects for a rural county without a city it is the opposite; we have Steiner Schools, community-supported agricultural projects, a thriving if under-funded visual art and traditional music scene, farmers' markets, hipster restaurants, Christian surfers, community and local radio, apparently thriving local media and some of the best disabled people's rights organisations and environmental groups in the country. It's mostly just that Ireland, and particularly rural Ireland, are complex places: conservative but well used to certain acceptable eccentricities, authoritarian with a counteracting rural disregard for rules.

For some reason, in Clare I feel unintentionally larger than life in a way I never did in the small parochial city of Galway, even as a very minor 'public figure'. A throwaway comment from me in a meeting seems to quite often be something that shouldn't or usually wouldn't be said. It feels to me that in Clare I go around calling attention to myself even though, for example, a lot of the people I deal with through work don't know that I write or that I have published books. This is fine with me; there is a vulnerability about the creative process that would leave me feeling exposed if I had to discuss it at board meetings.

Other examples of the type of confusion I have met are the strange interactions I had with some of my thoroughly decent colleagues and acquaintances after I wrote an opinion piece on the Pope's 2019 visit to Ireland for The Clare

Champion newspaper. I had written mostly about my intention to participate as a poet in a counter event, 'Stand for Truth', organised for victims of clerical abuse, survivors of industrial schools, Magdalene laundries and LGBTQ communities. I had no sense of risk-taking or transgression when I wrote it. It's not a particularly revealing piece, and yet while most people were supportive of me, they seemed a little embarrassed that I would have publicly shared such a thing. For me as a writer and a person, this was just a tiny local part of a conversation we'd been having in Ireland since the days of the Kerry Babies and Anne Lovett. But it seemed that having published that piece in the local paper, I transgressed a code or boundary between public and private that made people uneasy.

> In case you'd managed to misremember
> how much our country hates us
> along comes another woman needing shelter
> because someone transgressed against her
> she needs help from us, just for the moment
> until all this is behind her
> and does she get the help she needs?
> do we make her welcome?
> Ah you know the answer
> do we hell, this country hates the likes of her...
>
> (from 'Women, This State Hates Us', published in *Autonomy*, 2018, edited by Kathy Darcy, New Binary Press)

I find all this confusing because it's not as if Clare hasn't a history of campaigning and activism or in fact outspoken poets. I can't put my finger exactly on what is behind the over-exposed feeling I have reached on occasion, but it seems to me that in rural Ireland you are supposed to be defined by one thing: Johnny the digger, Mary the axe, Lobster Pat, whatever. It seems that I could be a poet, or work with the council, or be a lesbian, or a hippy protesting things, or like fancy lunches in the Rowan Tree, or an abuse victim who might never be right; but being, like all humans, complex and many faceted seems to mean that in 'Clare', I often feel as if I am a poorly translated poem that has lost its meaning by being read in another language.

There is an almost religious pursuit of the positive story too in Clare, of keeping the good side out, and this extends from the work and community work sphere right across some of the cultural and activist territory too. It's a hard place in which to disagree or dissent from something. In some ways, it seems that criticisms or suggestions about policies are taken personally; speak of a drugs

problem in Clare and you are negative, speak of a charitable event or a way of picking up litter from the beach and you will be lauded. Speak of the fine tradition of music from the Traveller community and people will cheer; talk about the need for decent accommodation for Travellers and the ears that loved listening to that music are suddenly hard of hearing. It works on a more subtle level too though: I can't count the number of times that I've been told 'work with us', or, 'we work collegially in Clare', 'let's put our best foot forward', 'it would be better now to have a quiet friendly word'. These are all the subtle charms through which conflict is avoided and friendliness prevails, good things both, except they are also the way in which the status quo, which is conservative, is maintained.

Yet this place which I've just called conservative is the same county where some of its most rural townlands and parishes returned a resounding Yes vote in the referendum to repeal the 8th amendment and permit women to access abortion services. I was part of the group that canvassed a portion of territory that straddled South Galway and North Clare for that referendum, and we were convinced that we were taking one for the team and just getting out whatever Yes votes could be got. As the campaign went on, we got the sense that there was a Yes vote and a No vote, but that also there was a majority of people who wouldn't divulge which way they were voting to canvassers. When the results came, the figures showed that almost the entirety of the silent vote must have voted Yes. It tells me something that people here, where life is ordered by communions and funerals and christenings, still make their minds up themselves. It also tells me that, in general, what you see and hear on the surface here is not the full story, not the real story and in fact may only be one tiny part of many stories. A majority in Clare voted Yes, but for the most part they did not come out to state that Yes in public.

My four years in Clare to date have not been ones that have been particularly productive in terms of my life as a writer or poet, although that's something I'll only know in retrospect. I could end up writing the definitive poetic work on local government if I survive to tell the tale. However, I have never been so happy as I have been here. I have of course written and published new work, some of which I am very proud of and some of which I am less proud! But somehow as an artist, I find that I distrust the poems of comfort, and my life here, despite everything, is lived mostly on my own terms and is full of the beauty and wonder of the Atlantic coast and of finding a relationship that is sustaining and full of trust.

I came to Clare after having gone through transformative experiences that really had taken me apart and rebuilt me from the ground up. Experiences that had left

me with very little fear about my status or reputation, or in fact about what other people thought about my life or my work or my writing. Something about the idea that the place in which I live is slowly being reclaimed by the sea is comforting too though. It tells me that for all my arguments and causes and loves and interests, I'm only a tiny temporary part of what I know as Clare.

In the Distance

From the chin on hair mornings
we are diluted across
each blue, blue day
with our useless histories
as faint-hearted and wispy
as an afternoon moon.

Across the bay then
in the evening glowlight
childhoods wane,
and on just this type
of seeplight summer night
pale adolescence tangles
in our breath and we
are neither here nor there.

But later in the wanderdark,
and the redfade
of our warm bed
with its leg on leg on hip,
we let no other versions in,
we sleep oblivious
to the heron at the shoreline
to the one
illuminated car passing,

in ignorance of the fat moth
tricked by lamplight
and dying in the kitchen,
we persist,
on nights like this
we stretch out before ourselves
we stretch into the distance.

(From *Washing Windows*, Arlen House, 2017)

Sarah Clancy

Sarah Clancy is a poet, activist and community worker from Galway city, although she now lives and works in County Clare. She has published three collections of poetry, *Stacey and the Mechanical Bull* (Lapwing Belfast) *Thanks for Nothing Hippies* (Salmon Poetry) and *The Truth and Other Stories* (Salmon Poetry). She has been involved in many campaigns in Ireland over the years including campaigns for environmental justice, bodily autonomy, marriage equality, and most recently the ongoing campaign to end direct provision. Her poems have been published in Ireland, the UK, USA, Canada, Mexico, Slovenia, Poland, Italy and Nicaragua and broadcast on RTÉ and BBC Radio. She has a forthcoming poetry anthology of queer poetry, *Queering the Green*, and is currently working on a film–poem collaboration between IMMA, Poetry Ireland and the Adrian Brinkerhoff Poetry Foundation.

In Kiltumper

Niall Williams

Today, I have been thinking about the way we have been living our life.

It's not something I think of often. I'm too busy living to think of Life, is an answer I might have given if asked why. We have been here, Christine and I, for thirty-four years now. In that time there have been many books, from both and each of us, and these have seemed a natural expression and measure of our life in this place. But the measure I am thinking of today is the garden – or at this stage gardens – inside the ragged hedge that runs along the stonewall here in Kiltumper.

For some time of each day, in all seasons, we work in the garden.

And today, I have been thinking of the meaning of that, what it has meant and what it continues to mean to the quality of our living here.

I was thinking this while working outside in the ditch across from the front gate, rescuing a white fuschia bush that had been given to us years ago by Paddy Cotter. Hearing that Christine was a keen gardener, Paddy had arrived one day with a grin and a cutting from his own garden. The red fuschia was everywhere, but the white one, now the white one was special. A gardener like Chris'd appreciate it, Paddy thought. And he was right too.

By the unfathomable logic of gardens, the place where the cutting grew best was outside on the side of the road across from the gate, and each year it bloomed there, pinkish-white, pale and delicate, drawing small notice perhaps from those who passed. But we noticed. That's the thing. It was a thread in the fabric of the place, in its history was its meaning, and though Paddy passed on, the white fuschia retained a redolence of that spirit of community that informed a man one day calling to your back door with a smile and a cutting from his garden.

Now, as in so many places in Midwest Clare, in Kiltumper, wind turbines are on their way. In the near future they will be coming along the narrow road with several bends that passes the house, and to make way for them, for the one journey they will make, the road must be widened. The centuries-old stone walls and ditches on the southern side will be bulldozed and the margins expanded

to let two turbines pass. The bends will be straightened. That this will change forever the character of the road is an argument that convinces few. Change is the only constant in life. And most people say: Won't you have a nice straight road now?

If we didn't rescue the white fuschia, the digger would take it in a breath and, with it, it seems to me, Paddy's grin and the generosity of spirit we met so often in the old people when we first arrived here. That fragment of – I believe the appropriate word is history, that narrative of past events particular to a place – well, that would be gone.

So, as the occasional car or tractor passed this afternoon, I was teasing out the roots of the plant from where they had grown in and through the stones of the roadside. I worked diligently, and must have seemed an odd sight, man in the ditch, hands probing the mud for something in ordinary measure not that remarkable.

And that's what made me think about the way we are living here.

By the time I had brought the bush in three segments inside the gate, and planted them in three different places in the hopes that one would survive, a couple of hours had passed. And that's what I did with those two hours, I thought. That's what I would have to answer if anyone asked what I did this afternoon. I rescued Paddy Cotter's white fuschia.

And, somehow, I felt it mattered.

Now, I don't mean to seem fanatical, or present myself as an expert gardener either. Chris is the real gardener. She started the garden in the rain of our first April here in 1985, and has been out in it ever since. Being in rural West Clare, and living the quiet way we do, some days meeting no other person, it is a garden seen by few. So, it is not grown and cared for with the goal of display. It seems to me it is simply the natural extension of our living here, and as close as we get to having a relationship with the earth.

I mean earth not with a capital E, not the grand vast ungraspable wholeness of the thing that the steel turbines are said to be saving, but the actual earth here in Kiltumper, the portion of mud, clay and stone that we have been working for the past thirty years. I think it is certainly true that at this stage Chris knows each individual handful of the stuff, weeding, feeding, seeding and planting in

it. And it occurred to me today there must be some essential human goodness in this, in the idea that this parcel of earth has been in some small or large way enriched by our living upon it, and this is probably in the exact same measure as it has enriched us. I mean this not in a high-minded or self-satisfying way, but just the fact of tending the ground, feeding the worms I suppose, and that there is something absolutely right in this, and that the smallness of it, the most local of localities, the garden in Kiltumper, is enough world, enough earth, for a lifetime.

What is enough? is a question never far from me. What is it that is enough to be doing with your life? I remember the wonderful American essayist, novelist and poet, Wendell Berry, saying that a great life would be one that added an inch of topsoil to the ground you lived on. And that is something that keeps re-echoing in my mind these days. Another way of saying the same thing is his quote, 'I stand for what I stand on.' And maybe because of the turbines coming, all the traffic and change that will happen just outside the hedges, I am aware of being turned more than ever to the world inside them, and allow myself to adopt the belief that for us that is the world that counts.

No sooner had I planted the fuschia than Chris came to me with that gleam she gets that I know means she's seen something new in the garden. It can be small or large. It can be a first budding, can be a plant thought lost that has come back, the first song of the cuckoo or the return of the swallows to the roof of the open cabin where her great-great-grandfathers lived before the Great Famine, and probably theirs did too. Today it was a simple thing.

'I found two flat stones,' she said with a smile. She could have been her girl-self in the woods around where she grew up in Katonah, New York, hunting Indian arrowheads.

'Two flat stones?'

'Yes.'

'Where?' It was the least I could do to play along.

'Just past the polytunnel. They're buried a bit but they look good.'

I knew this translated as: Let's go and dig them up.

'Where do we need them for now again?'

'On the top of that wall.' She pointed to a dry stonewall we built that runs for five yards along the eastern end of the 'join' that goes between the end of the house and the 'Glasshouse Garden.'

I say 'built' while fully aware neither of us are stonewall builders in any real sense. But over time, Chris, with her artist's eye, discovered a kind of serenity in the slow work of making a wall from a pile of stones. And, in the early years, stones seemed to be what most of the ground was made of.

Now, that wall, to my, and I would think, most eyes, did not look like it was crying out for two flat stones to finish it. It didn't look incomplete, but completion is a vexed question for gardeners. It is both a joy and a woe that in truth no garden since Eden is ever actually done. And I knew it would be letting laziness answer if I said the wall was fine as it was. So instead, I looked at the wall, and considered it as a form, something like a sonnet that needed a final couplet, and let that defeat my reluctance to go digging.

'Alright so.'

I went and got the shovel. Chris showed me the place where the stones lay. I could see where she had unearthed the flat surface of each just under ground we had cleared when we put in the polytunnel for the vegetables. She had a There, now, look.

'Aren't they perfect?'

And here's a thing. When I looked at them, when I began digging them out, I fell into thinking that she was right, they were.

Soon enough though, I went further, and came to the strange and perhaps inexplicable thought that these two flat stones somehow belonged to the wall.

This is a feature of all imaginative work, I think. You're trying to find the words that belong to the story. It's a hard thing to explain to those on the outside of the creation, the sense that there is an inner order, a way the story or painting wants to be, and you are in some way trying to serve that. Sounds ridiculous when you say it out loud, and generally I don't. You spend two hours of a morning trying to find the right word or phrase. If you're me, in order to move on, you eventually allow yourself a near-miss, a word that's not quite right, but you'll come back to it later. That later might be mid-afternoon, or two afternoons later, when you're

out in the garden, digging up a white fuschia or a pair of flat stones, say, but your mind still has the knot of that word or phrase that isn't right, that doesn't belong. And eventually you find it. That's right, you think when you type it in. That belongs there.

And belonging is a key theme for anyone who, like us, has moved from where they were born to a new place. Thirty-four years ago, the West Clare we arrived in was not what it is now. At that time, a time of wind-up telephones, of hay-trams and 'giving a day' we seemed to be the only 'strangers' in the parish. Though we had moved into the house where Chris's grandfather was born, the idea of belonging here was not so easily accommodated. It needed to be made. So, it was not until Chris began making the first of the gardens, digging it day after day out of the miry brambles and nettles, both resurrecting and creating, that she came to feel some sense of being, well, at home. And, watching her work, I realized: this place is her. This is her proper place. This garden is where she belongs.

All this to say, I may have been predisposed to the notion that the proper place for Paddy Cotter's white fuschia was inside the hedgeline of the garden in Kiltumper, and the proper place of the two stones Chris found was on top of the dry stonewall near the house.

In a further step of magical thinking, while digging, I allowed myself to imagine that aeons ago, these stones had become separated from the others, that when we gathered the ones with which we eventually built the wall we had somehow missed these two. By lifting and placing them on top of the others now, we would be not building anew but restoring something older than we ourselves.

Which may well be nonsense. But the kind of nonsense I like.

These days I am aware of a need to come to a new accommodation with the garden, for each moment it shows me I am not as young as I once was. My way of working has always been fundamentally different to Chris's. Where she spends a kind of timeless time going from one small job to another – that she may only discover at that moment: 'Look at how the anemones need support in this wind' – I have tended to pick one large job and go at it full on until it is done. In this way, I have worked hard, effortful, in a kind of gardening combat, working towards getting-it-done, that moment when you have a cup of tea and sit on one of the seats against the house, look down the slope and think: There. That's done. This satisfaction, which I know has folded into it a bogus need for order, for

an illusory control perhaps, may be less to do with gardening and more my own battle with purpose. But, having passed sixty, I notice how the garden is teaching me to take it a bit handier, to find a rhythm in working that is not always bent on trying to get the thing done. There is something in this of time and ageing and the knowledge of your own mortality. In it too is the realisation that although every garden is always saying Now! Now! at the same time it is whispering Slow. Slow.

In this, I am lately reminded of Joeso, Chris's cousin, who was a quiet and gentle bachelor unhurried in all things. In our first April he came one morning to help us 'get in' the potatoes. He came back the road carrying his fork. The handle of it was the first thing you noticed, the handle had a sheen to it and had that all-over tan colour that evolves from the close relationship between man, tool, and ground when that relationship is balanced. (This was a time when one measure of my own foreignness to the life I had landed in was how often I bent the prong of a fork out of shape, a shameful thing it seemed because it showed lack of respect for tool and ground.) Well, Joeso came in his suit jacket and trousers and strong boots with new yellow laces, and looked at the ground that needed to be opened, and without taking off the jacket or laying a twine or otherwise marking the line he began with the fork, and with apparent effortlessness turned over the first sod, and the next, and the next. There was a mesmeric, metronomic quality to it. Along he went, a kind of Kiltumper maestro, opening the way. He did not say, Desperate ground, or, Isn't there a world of stones? He just did it. When he was done, he went back down the road to his tea.

And so, Joeso be with me, was my thought as I went digging out the stones for the wall. Take it handy. The stones were large but flat, and it was true for Chris that they were too handsome to be left buried. I unearthed them and brought them over to the wall. I didn't place them on it of course. I lay them on the ground and Chris came over and looked at them and looked at the wall, and then looked at both some more.

'Try that one there maybe.'

I did. We looked at it.

'A bit over there. That side out.'

I did that.

'Now this one, here. Try that.'

I did. We stood back and looked. It was the late afternoon. Nothing was coming or going on the Kiltumper road. In one way I was aware of the smallness of our act in completing the wall when measured against the many older stonewalls that would soon be bulldozed just outside the hedgeline. But in another, I had a quiet and deep sense of victory, the wall looked, well, better, and Paddy's pinkish-white fuschia was safely in the ground in three places.

This is what matters this day, I thought. This is the way we are living. We both stood and looked at the wall.

'Perfect,' Chris said.

Niall Williams

Niall Williams was born in Dublin. For the last thirty-six years he has lived in Kiltumper, Kilmihil, County Clare, with the artist and writer Christine Breen, writing books and making a garden. Their latest book is *In Kiltumper: A Year in an Irish Garden*. Author of nine novels (including a Man Booker longlist nomination for *History of the Rain*) and three screenplays, his first international bestseller, *Four Letters of Love*, was published in over 20 countries. His latest novel, *This Is Happiness*, was shortlisted for Best Novel in the Irish Book Awards and longlisted for the 2020 Walter Scott Prize for Historical Fiction.

Conversations

Naomi Louisa O'Connell

Allemonde could be anywhere, but it lives in the Burren once upon a time when the hazel trees were still thick and what was not rock was forest or coastline. Mirrored in this landscape, this is where he lives in me: Golaud, his ancestors piling up behind him, heavy in the faces of the limestone. I saw him there while I was out blackberry picking last September, alone on the green road, a muse moving slowly beside me underneath a grey, opening sky.

I look back from this crackling body to the half-held-together memories formed from photographs and stories about wellies and wet grass. Today you have brought the good with you, yes: the bright-green morning and the hill in Turlough that was mine. Good, good. I wonder... if I met myself as a child, would I warn her of the inevitable discovery? The divide between what is imagined and what is real, the unobserved moment it becomes an impenetrable border when for now all it takes is a push through a soft hedge crowded with characters from Saturday morning cartoons, or the voice of Eddie Lenihan around each corner hiding Fionn Mac Cumhaill. The moment when the four corners of our school desk lock down, definitive, the unused inkwell rubbed to a Brasso shine.

- This is mine. My homework.
- Good, good.
- My desk. My ruler. Myself? Do I end where my fingertips run out?

What is it in me that needs story to survive? The spinning, the drive, the ambition, the bells, the beauty of a simple song, the risk, the sickness and lure of it... The relief to be lost in a landscape, absorbed into a story wide enough to house anything.

A story: that thing without edges and only the clean dive into stillness and the dark.

I dreamed once that I was the unbroken line of a dawn horizon looking back at myself on the shore of Bishop's Quarter holding hands with my children not yet born. My father took me there once to go swimming at dawn, the water miraculously still and a lilac softness in the light that I have never seen since. Softness: we severed each in separate search of it.

I stand here now looking into a blurring middle distance with the words of Dylan Thomas playing through me, the echoes of his addiction drawing nails along my own.

- Maybe people with vertigo are the enlightened ones, to suddenly feel the speed of the earth's spin.
- And when gravity fails, what then? A slow casting-off as everywhere we rise, the birds shocked by new neighbours! Human debris.
- Should we be...?

Should: that word so laden with guilt even before it leaves the ground. *'To love is to think.'* I walk to get away from you and to talk with you, the wind here beside the Hudson a pale sister to the Atlantic gust across the limestone. I set out to write you a love story but you double back on me, wearing that same unbroken horizon I search for in myself. I've come here to say goodbye to you. I have been too involved with the seeming of life–the presentation to persons unknown of some curated, straight-edged reflection that is not me. I want to imagine you are talking to me and I divide you from myself–why? To keep at bay the knowledge that of course I am alone–as everyone is alone–that I talk here with myself and not with you. And yet this fascination with you has kept me company; my divided self associates all that is expansive and delicate with my idea of you. I sit alone in a beautiful place, writing to whom I wish to become, journeying towards acceptance of the limitation and scope of what is within me.

I live this one life–so short I am already sad to leave it behind. *'To love is to think, and from thinking of her so much, I almost forget to feel.'* I never expected to meet you here. It is as though we were children together in this place before boundaries and reality and grey. Where all is green. Curling around this idea, I rise again into a horizon line. Below, two move beside the limestone walls, shoulder to invisible shoulder.

You never sing alone.

(This writing contains references to Maurice Maeterlinck's play *Pelléas et Mélisande*, which is set in the fictional place of Allemonde. Golaud is one of the main characters of the play, alongside Mélisande and Pelléas. There are also references to the poems of Fernando Pessoa, translated by Richard Zenith, Dylan Thomas' prose-poem *A Child's Christmas in Wales*, and the stories of Fionn Mac Cumhaill by Eddie Lenihan.)

Biography

Naomi Louisa O'Connell

Hailed by *The New York Times* as 'radiant,' Naomi made her professional debut in 2012 starring on the West End in Terrence McNally's play *Master Class*. Her work encompasses both theatrical and operatic repertoire, ranging from straight plays to operas, recitals and cabarets to sound installations. Sought after for her interpretations of contemporary opera, she recently created the role of Mrs Van Buren in *Intimate Apparel* at Lincoln Center Theater, a development of the Metropolitan Opera/LCT commissioning program, returning to stages in 2022.

Naomi made her Irish National Opera debut in Brian Irvine and Netia Jones' *Least Like The Other: Searching for Rosemary Kennedy*, for which Operawire applauded her performance as 'in every respect outstanding.' Notable roles include the title role in Monteverdi's *L'incoronazione di Poppea* (Oper Frankfurt), Cherubino in Mozart's *Le nozze di Figaro* (Welsh National Opera, Atlanta Opera), Offenbach's *La Périchole* (Garsington Opera), and Mélisande in *Pelléas et Mélisande*, both Maeterlinck's play and Debussy's opera, with the Cincinnati Symphony. Lauded by *The New York Times* as 'a natural in the recital format' for her Carnegie Hall debut recital *Witches, Bitches & Women in Britches* at Weill Recital Hall, she has performed in concerts across the USA.

She was brought up in the Burren, studied in Ireland with Archie Simpson and Mary Brennan and is a graduate of the Royal Irish Academy of Music and the Juilliard School.

Retuning the Town for Trad
Music, School and Society in Ennis before the Sessions

Gearóid Ó hAllmhuráin

Long before cultural economics blessed it with *fleadhanna* and sessions, and Facebook carried its fame through the virtual world, Clare's county town on the banks of the Fergus was a provincial backwater, where traditional music was of little consequence. In its 800-year history – from Franciscan scholasticism in the High Middle Ages to Information Age science in more recent times – the town's 'cornucopia of trad' was an afterthought, a recent phenomenon, a by-product of the tourist industry aligning with musical pedagogies that blossomed in Clare in the 1970s. In short, Ennis owes its traditional music to its rural migrants – who brought the music from country house *cuairds* to urban classrooms, concert stages and pub sessions – not to the bourgeois culture of the town that traditionally saw itself as a cut above its country cousins.[1]

In the wake of Irish independence in the 1920s, sepia-toned Ennis, a market town devoid of book shops, art galleries or cultural academies, was dour and stagnant.[2] Poverty was rampant and the town, now stripped of its British garrison economy, struggled to survive. Its old Protestant ascendancy, diluted and frayed by the fallout from World War I and the revolutionary upheavals of 1919-1923, ceded its place to a rising Catholic bourgeoisie – snug farmers with a shrewd eye for opportunity and well-heeled professional and merchant classes. Relics of colonial hubris continued, however, in hunts and hunt balls, bridge parties and receptions at various gentlemen's club houses around the town. Beneath the veneer of unbroken ritual, Ennis continued to dispatch its young every year – to the mail boat and the civil service, to the faraway factory floor and the construction site. Others trod the concrete canyons of Manhattan or drowned their sorrows in the noisy pubs of Camden Town. The lucky left for teacher training colleges, nursing schools and universities in Dublin, Cork and Galway. Most would never again return to live in the town of their birth. Despite its famous 'Fleadh Down in Ennis' in 1956, Ennis, like other towns in post-colonial Ireland, did little to nurture its traditional soundscape – the street music of the travelling piper, the concertina music in the working class lane, or the fiddling of rural migrants who worked as servant girls and servant boys in the bourgeois homes of the town.

1 For a definitive study of Irish traditional music education in Ennis, see Geraldine Cotter, *Transforming Tradition: Irish Traditional Music in Ennis, Co. Clare, 1950-1980*, (Ennis: Geraldine Cotter, 2016). http://geraldinecotter.ie
2 See Seán Ó Faoláin, 'A Clare Journey, 1940,' in Brian Ó Dálaigh, *The Stranger's Gaze: Travels in County Clare 1534-1950* (Ennis: Clasp Press, 1998), 330-334.

Formal status was reserved for the music of the church, its light opera society, and classical piano taught in convent parlours to the daughters of merchants and strong farmers. Jazz, an 'immoral' cocktail that reached its zenith in America during the Roarin' Twenties, swung into Clare amid the chaos and euphoria of post-revolutionary times and thrived until the Dance Halls Act put the brakes on it in 1935.[3] Radio Éireann, with its limited signal from Athlone, brought middlebrow music to those who owned radio sets in the town, but state-controlled Radio Éireann was far from the ubiquitous conduit of popular music that distinguishes modern day radio.

Despite the efforts of piping enthusiast Seán Reid and teachers like Flemish organist Ernest de Regge, who taught choir in Ennis from 1923 until 1958, music was a second-class citizen in most schools in the town until the 1970s. While tonic sol-fa singing was taught in the Mercy Convents and the Christian Brothers, and carol singers enlivened the streets of the town at Christmas time, the music of the poor – especially old-style traditional music, song and dance – found no place in the schools of Clare's county town. This was particularly so at the Boys National School, which was an artless gulag even as late as the 1960s. Going inside the walls of this Victorian fortress was tantamount to passing through the portals of Robert Louis Stevenson's House of Shaws – except that paranoid Ebenezer, armed with a blunderbuss, was now recast as *An Máistir*, armed with a bamboo cane and an unpredictable penchant for sadism. Brian Kelly, known to townie schoolboys as *Mac Uí*, or simply, *An Máistir*, was feudal lord of the Boys' National School from 1946 until 1981. He had an MA in Maths from University College Galway, where the Abbey actress, Siobhán McKenna, was one of his peers (her father was Professor of Maths in UCG). To begin – and end – a career by bringing learning to working class Ennis in the postwar years was no small feat. Anecdotes suggest that Kelly arrived in Ennis when the National School was a haven of rowdies – many of them descendants of British army infantry men who spilled their blood for king and country in the Dardanelles and at the Somme. He quickly imposed law and order with an iron fist. His credo, *ní bhíonn an rath ach mar a mbíonn an smacht*, made him a legend of fear in the town.[4]

Perched behind a high wall that blocked all views of the town, the old National School was built in 1897. It was part of an architectural boom that peppered the British Empire with courthouses, prisons, sanatoriums, barracks and schools – a relic from the long and glorious reign of Queen Victoria and Lord Stanley's plan to

3 Gearóid Ó hAllmhuráin, 'Dancing on the Hobs of Hell: Rural Communities in Clare and the Dance Halls Act of 1935,' New *Hibernia Review*, Vol. 9, Number 4, Winter 2005 (St. Paul: University of St. Thomas Press), 9-18.
4 *Ní bhíonn an rath ach mar a mbíonn an smacht* translates as 'There is no prosperity (progress) unless there is discipline.' Jimmy O'Halloran, *Personal Interview*, Ennis, May 28, 1977.

produce 'good English children' in Ireland.[5] Towering above the town, yet hidden from it, all that could be seen from inside any one of its four rooms was the sky. Its outer wall came tumbling down – at least, three feet of it – in 1966. Now, taller boys could look out at the town. Nearby garage man Josie Broderick, sporting a Texaco overall and a roguish gimp, now became a star attraction. Likewise, Jacksie Darcy, a blacksmith at the top of the Market who busied himself shoeing horses and shunting farmers in and out of his ramshackle forge – a magnet of diversion for the incarcerated, glaring over the high wall on the Kilrush Road corner.

The early years in the National School were spent battling illiteracy in Irish and English, and unlocking the mysteries of arithmetic – unending tables of addition, subtraction, multiplication and division. Simple and compound interest followed, and then, reams of grammar – declensions, conjugations and parsing. Like thieves in the night, *An Tuiseal Ginideach, Na Forainmneacha Réamhfhoclacha, An Saor Briathar* and Subordinate Noun Clauses wormed their way into the subconscious townie mind.[6] History finally made its appearance in fourth class and George 'Laddie' Maloney really hit his stride when he got to Brian Ború's victory over the Vikings at Clontarf. Brian was one of Clare's holy trinity that included Daniel O'Connell and Éamon de Valera – the latter two who had left landmarks in the town. Laddie, a dapper *film-noir* style dresser and an officer in the FCÁ (Local Defence Forces), was a local artist. He fancied himself as an amateur magician. He often entertained the class by throwing paper bags into the fire and pulling them out as ten-shilling notes from the flames. He taught choral singing on occasion – and marching to the musically challenged. Instrumental music, art, drama and sport, however, had no place in this world of serious learning.

The final hurdle in the National School was the two-year stint with Mac Uí Cheallaigh that began with an induction in fifth class – a minefield called *Tír na hÉireann*. This was an encyclopedic hazing of Irish physical and political geography – rivers, mountains, lakes, islands, towns and industries – all learned by heart through Irish. Kelly's routine was to march the fifth class into *Seomra an Mháistir* to the tapping rhythm of the bamboo cane and line them up along the wall. They were his bait and, at times, entertainment for his pets in the upper classes – a smug cabal of doctors', civil servants' and shopkeepers' sons who belonged to the same bourgeois clique as himself. The map of Ireland, as *Gaeilge*, was hung over the blackboard and students were called up to identify various locations.

5 See John Coolahan, *Irish Education: Its History and Structure* (Dublin: Institute of Public Administration, 1981).
6 *An Tuiseal Ginideach, Na Forainmneacha Réamhfhoclacha* and *An Saor Briathar* may be translated as the 'genitive case', 'prepositional pronouns' and the 'free verb.'

Woe be to him who put his finger on the wrong side of the Shannon, or failed to distinguish *Cora Droma Rúisc* from *Cúil an tSúdaire*. The bamboo was quick to right the *botún*.[7] No quarter was given for dyslexia, or attention deficit disorder. Euclid, the *cigire* (inspector) or the parish priest made no mention of these. Like health education and the arts, these 'conditions' would gain no currency in Irish education for at least another decade.

Ironically, traditional music hovered on the edge of this gulag – albeit, out of sight and out of mind. Concertinas were played up along Drumbiggle, Old Mill Street and the Turnpike by men and women of no property – those who had moved to Ennis from the countryside to find work and, eventually, rear large families on the thin pickings of small town life in the Irish Free State. By 1960, the ghost of Joe Cooley, now living in Chicago, could still be heard in Tony MacMahon's house in the Turnpike.[8] Further up the road, concertina player John O'Loughlin played for his neighbours near McSharry's Corner. Nora Coughlan played her old German concertina for sets on Sunday nights, while her devout husband attended benediction in the parish chapel – his return carefully monitored from a kitchen window across the road.[9] Further up the hill, Jim Maher foraged through his box of timber flutes and whistles on Sunday afternoons, and Kitty Hanrahan was partial to a tune or two on the concertina at any time of the day, or night. Jim was known to play *Miss McLeod's Reel* on a half dozen different flutes, until he found a 'version' he liked.

Although Comhaltas Ceoltóirí Éireann was launched with great enthusiasm in Clare in 1954, its outreach in the town evaporated after the initial excitement of the 1956 fleadh. Townie musicians like Clem Browne, Tony Mahony, Pascal Hanrahan, Micho Ball and the MacMahon brothers, Flan and Michael, were non-conformists who played modern music, jazz and traditional dance tunes. Strict Comhaltas by-laws explicitly banned jazz musicians from its ranks. Hence, many townies failed to make the Comhaltas cut. Economic depression too added to the musical woes of town and county. Many Clare musicians joined exiled friends in London, New York and Chicago in the years after the fleadh. Neither the Second Inter Party government or de Valera's Fianna Fáil juggernaut proved capable of plucking the country out of the abyss. Hundreds of young women and men from Ennis and other parts of Clare were part of the lost generation of the 1950s.[10] Most would never again return home.

7 This portrait of the Boys National School in Ennis is based on the author's experience as a pupil at the school from 1962-1969.
8 See Flan Hehir, *The Turnpike* (Ennis: Clare Roots Society, 2016).
9 Máirín O'Halloran, Personal Interview, Ennis, July 28, 2019.
10 See Dermot Keogh, Finbarr O'Shea and Carmel Quinlan, eds. *Ireland in the 1950s: The Lost Decade* (Cork: Mercier Press, 2004).

The knock-on effects of depression continued into the 1960s. Eventually, the Lemass-Whitaker Plan found traction and the standard of living slowly curved upwards. The Shannon Free Airport Development Company (SFADCO) built factories and created jobs in Shannon. Small factories also came to Ennis to augment Braid's that employed half the town for decades. Housing estates were built and some emigrants came home. By the late 1960s, Ennis was on the mend. Its Kasbah-like slums with their hovels and floods (whenever the Fergus overshot its banks) were cleared to create car parks. In 1965, the Five Star Supermarket brought emporium shopping to Ennis. Breaking ranks with a legion of small shopkeepers, the Five Star introduced the novel practice of shopping to the sound of music – Herb Alpert and his Tijuana Brass and Andy Williams who crooned 'Moon River' through the speakers as customers hunted for bargains that were unavailable elsewhere. Economies of scale now replaced loyalty to the old corner shops of the town.[11]

The musical skies over Ennis also changed at this time. In the autumn of 1968, Frank Custy, a radical young teacher in Toonagh near Dysart O'Dea, presented a perfect antidote to the dour world of the Boys' National School in Ennis – long-awaited therapy in the form of traditional music. More interested in the 'Kilfenora Jig' than Pythagoras' theorem, he was the polar opposite to Brian Kelly. On Friday nights from September to June, several townie families made the five-mile trip to Toonagh to learn the music of the people that had found no place in the schools of the county town. These trips opened a portal to a whole new world of culture and tradition, brought joy to learning, and restored faith in the arts for many young musicians in Ennis and its environs.

Custy's journey into the world of Irish traditional music began on Friday night, November 22, 1963, as news of John F. Kennedy's assassination in Dallas filtered into Ireland. Frank had recently become principal of Toonagh National School, a quiet rural hamlet northwest of Ennis. He had struggled with music at St Patrick's Teachers College in Dublin a few years earlier and decided to give it a second chance, this time with the help of Jack Mulkere, whose course at the Ennis Technical School required neither an entrance exam nor an exit test. Mulkere was a renowned teacher and céilí band leader who had campaigned for thirty years to make traditional music part of the curriculum in Irish schools. Aware of his track record in music at St Pat's, Custy sat at the back of Mulkere's class at the Tech. It was an unorthodox gathering presided over by an older man in Wellington boots who had experienced some difficulty getting his course onto the roster of classes offered by the Clare Vocational Education Committee.

11 Gearóid Ó hAllmhuráin, *Flowing Tides: History and Memory in an Irish Soundscape* (Oxford and New York: Oxford University Press, 2016), 193-195.

A training school for apprentice bricklayers and carpenters, the Technical School was reluctant to sanction a class in traditional music. In June 1959, the Ennis branch of Comhaltas petitioned the Clare VEC for a room to host music classes. Flatly rejecting the request, the Chairman, Canon P.J. Vaughan, remarked abruptly that the 'application should not have been made at all. The Technical School is not for that. It's an unreasonable application.'[12] Within a few years, the VEC relented and sanctioned Mulkere's class – the first of its kind in Ireland. Although it attracted up-and-coming performers, among them accordion player Patrick O'Loughlin, its primary convert that winter was Frank Custy who soon spread Mulkere's gospel to other parts of Clare. What proved to be a night that shocked the world also proved to be a night that altered the course of music teaching in Ireland. Custy developed an enduring friendship with Mulkere, who had labored for years in schools and village halls in Clare and Galway.[13] A farmer's son of similar background to his mentor, Custy was young and energetic. He qualified as a teacher at a time when Ireland was emerging from a long period of conservatism and insularity. Within months, he was teaching by day what he learned from Mulkere at night, and Toonagh School became Clare's first academy of traditional music, where reels and jigs enjoyed parity with homework and hurling.[14]

In 1968, Custy started night classes for children and adults who were unable to attend his daytime classes. These were held in the old schoolhouse in Toonagh, a Victorian edifice with pointed gables and door stones proclaiming: *Boys Upstairs* and *Girls Downstairs* – tell-tale signs of the propriety of older times. On Friday evenings from September until May, scholars of all ages armed with fiddles and flutes sat on wooden *forums* that lined the rooms of this ageing school. Custy taught all instruments simultaneously. Tunes were written on the blackboard and the collective class played its way slowly through the notation. Although the cacophony took a while to get used to, even the most reluctant learners were eventually carried through the tunes by the massive swell of sound created by the class. When lessons were over, tea was served and the assembly pulled around the open hearth to perform their homework for Clare sets. Behind them, dancers battered out ancient sets on dislodged floorboards, their silhouettes animated by flames dancing from the turf fire.[15]

12 *Clare Champion*, June 13, 1959.
13 Jack Mulkere, Personal Interview, Crusheen, October 4, 1975.
14 Frank Custy, Personal Interview, Toonagh, December 2, 1975.
15 This portrait is based on the author's experience learning music in Toonagh National School from 1968-1972.

Custy's experiment in alternative music education eventually reached a large catchment area – Ennis included. He convinced people who thought they 'hadn't a note in their head' to give music a second chance. More importantly, he encouraged older players to share their music with young scholars. Shy flute players like Martin Mullins, who seldom left Toonagh, returned exiles like the Yank Cullinan and eager teens, like Kevin Houlihan and Cyril Cullinan, were all made welcome in the collective space of Custy's quiet revolution – without recourse to scolding, or the cane.

Custy's pedagogical innovation coincided with a new national curriculum that was introduced in 1971. This transformed the status of the arts in Irish primary schools. Mainstream subjects were now re-evaluated and 'marginal subjects' like music, art, drama and physical education became integral parts of the new programme. This philosophical shift created a climate of receptivity for evangelists like Custy. From 1970 until 2000, he taught music to hundreds of pupils. Some, like Sharon Shannon, James Cullinan, Seán Conway and Noel Hill, built professional careers in Ireland and in America. Others, like Garry Shannon, Tóla Custy and Cyril Lyons, followed Custy's example and taught music to the next generation. Custy's peers soon followed his lead: Martha Shannon, Brendan McMahon, and Father John Hogan. Kerry fiddler Tom Barrett (an Irish army sergeant based in Ennis) and Kilfenora fiddler Gus Tierney also began teaching music.

This synergy allowed traditional music to migrate beyond its rural roots and find new patrons; not least, among bourgeois families in Ennis, Kilrush and Shannon, whose cultural taste it once eluded. Secondary schools too opened their doors, especially St Flannan's College in Ennis, where a céilí band was formed in 1970. With players Frank Spillane, Gary Pepper, Michael Garry and Vincent MacMahon filling key seats, Flannan's won an All-Ireland céilí band title in 1972. After years of being out in the cold, traditional music finally made a breakthrough in Clare's bastion of hurling – and eclipsed a competitive void that even the Harty team could not fill in the early 1970s.[16]

Custy's programme ran parallel with the take-off of heritage tourism in Clare. By 1970, SFADCO (Shannon Free Airport Development Company) had set up its own tours and was marketing Irish package holidays in the US.[17]

16 This portrait is based on the author's experience as a member of St. Flannan's College Céilí Band from 1970-1974.
17 See Paul Quigley, 'Engineering for Tomorrow's Ireland: SFADCO – A Case Study in Regional Development.' Paper presented to the conference of the Institute of Engineers of Ireland, National Institute for Higher Education (NIHE), Limerick, 1987.

American tourists were now bussed around Clare, shown landmarks, and feted at medieval banquets in Bunratty and Knappogue castles that featured pageants, colleens, parlour songs and mead. Other heritage landmarks were also developed – holiday cottages (thatched, of course) and traditional pubs and shops, where visitors could escape to the past (albeit, momentarily) before returning home to their suburban lives in Dublin, London or New York. In Clare, heritage tourism was brokered by local developers, politicians and hoteliers with a wily eye on progress and the dollar. In time, these trends directly impacted a new generation of performers who emerged from music classes around the county. Their talents were employed in pub sessions, stage shows and re-enactments that were all part of Shannonside's preoccupation with cultural tourism.

Pubs and lounge bars now became temples of traditional music. Women were no longer frowned upon if they frequented a pub. The days of the confession-like snug where 'respectable' women drank a discreet sherry were over. Unlike the old public house (that made concessions for darts and cards), the lounge bar was an exotic milieu of live music, dance floors, television, jukeboxes and pool tables. As profit-making establishments, they paid for music and were a welcome stage for local performers. New market trends forced older publicans (who would not countenance music in their pubs) to do a *volte-face*. If older drinking establishments in Ennis stood their ground, the town's lounge bars were now catering for the melodious and non-melodious alike. Even bourgeois sanctuaries like the Old Ground Hotel opened its doors to fiddles and flutes. The arrival of the Fleadh Nua in 1974, with its generous economies of scale, dispensed with the grandeur of these old-world establishments, whose class histories were far removed from the music of the mountain and the bog that now spilled onto their lawns and carpets.[18]

In contrast to earlier decades when there was a conspicuous lack of young players, Clare was blessed with the gift of youth in the 1970s. The postwar baby boom, emigrants returning home, new schools and housing projects all combined to steer young faces towards traditional music. As the baton passed to a new generation, an older cohort made its final exit from the stage: fiddlers Jim Mulqueeny (1975) and Patrick Kelly (1976), concertina player Pakie Russell (1977) and pipers Willie Clancy (1973) and Seán Reid (1978). In December 1973, east Galway accordionist Joe Cooley died after a long battle with cancer. Cooley (1924-1973) had returned home from San Francisco earlier that year knowing he was ill. His homecoming after eighteen years in America was a messianic event.

18 Ó hAllmhuráin, *op. cit.*, 195.

The remaining months of his life were filled with euphoric reunions and sessions in the small pubs of Clare and Galway. A month before his death, he was interviewed by RTÉ in Peterswell. Accompanied by Des Mulkere (whose father had taught Cooley) and Tony MacMahon, Cooley played and talked about his life to Cathal O'Shannon. In the midst of his reminiscences, he delivered his famous edict that Irish traditional music was the only music 'that brings people to their senses .' The 1970s also saw the passing of older travelling musicians who had trod the streets of the town for decades, among them Stevie Carthy and Martin Faulkner. The Dunne brothers, Mick, Hanta and Christy – affectionately known as 'the blind fiddlers' – who played at hurling matches and fairs, also wound down their activities in Clare.

As older players left the scene, economic opportunities brought new musicians and instrument makers to Clare. Among these newcomers was Donegal fiddler Tommy Peoples, who moved to Ennis in 1971. Peoples made a vital contribution to the music of the region. He played with the Kilfenora Céilí Band before joining the Bothy Band in 1975. Access to instruments also improved. English flute player Paul Davis, who lived in Clare in the 1970s, bought baroque flutes and Jeffries and Wheatstone concertinas at Sotheby's and other auction houses in Britain and resold them to eager buyers in Ireland. Clare flute player Seán O'Loughlin (a merchant seaman who spent his later years in Nottingham), Limerick man Patsy Moloney and Galway collector Jim Shields also accessed historic flutes and concertinas. Instrument makers too thrived, among them flute maker Brendan McMahon and bodhrán maker Karl McTigue, both native craftsmen. Their new peers included a global cast of pipe makers: Australians Bruce du Ve and Geoff Wooff; Dubliner Eugene Lambe; Breton Michel Bonamy; Englishmen Nick Adams and Mal White; and American piper and singer Pat Sky, who set up a tin whistle factory with Ennis entrepreneur Michael White in 1980. Master concerts also gave young players access to leading performers. A highlight of the year was the Kilmaley masters' series hosted by Peadar O'Loughlin that showcased a pantheon of stars – sean nos singer Seán 'ac Dhonncha; pipers Liam Óg O'Flynn and Tommy Reck; fiddlers Séamus Connolly and Maeve Donnelly; and accordion players Mick Mulcahy and Paddy O'Brien.

In the youthful flush of the decade, the next generation of Hayes, Droneys and Crehans emerged to take charge of the traditions their families had safeguarded for generations. Mentored by rural migrants, Sonny Murray, Martin Burns and Paddy 'Galway' Keane, hereditary musical families in Ennis – Cotters, Murrays, Hanrahans, Roches, Skerritts, McMahons, O'Hallorans – also shaped the soundscape of the 1970s, playing at concerts and céilithe and tackling the yearly

hurdles of *feis*, *fleadh* and *slógadh*. Junior *céilí* bands dominated life for many of these young players and neighborhood loyalties drove their enthusiasm. Ennis now had two *céilí* band camps, St Flannan's and St Michael's, that reflected the hurling rivalry of the town's two academies, Flannan's and the Christian Brothers – not least, the famous Harty Cup final win by the CBS over Flannan's in 1962.

In the midst of this synergy, recording opportunities unfolded for young players more frequently than for their predecessors. By 1975, Planxty, Dé Danann and the Bothy Band were inspiring a new generation and many set out to blaze similar trails, among them Inchiquin, formed by Noel Hill, Tony Linnane, Kieran Hanrahan and Tony Callanan in 1976. Shortly after, Stockton's Wing, Clare's first super group, was launched. This was the high tide mark for traditional music in Ennis. Evolving from the session scene in Brian Hogan's pub in 1977, the group included banjo player Kieran Hanrahan, fiddler Maurice Lennon, flute player Paul Roche and *bodhrán* player Tommy Hayes. Guitarist Tony Callanan provided harmonic accompaniment before ceding his place to Australian guitarist and didgeridoo player Steve Cooney. Their first major success was a Guinness-sponsored competition in Limerick. Their prize was a recording contract from Tara Records. The rock segment of this contest was won by a little-known group of schoolboys from Mount Temple School in Dublin called U2.

The town was now – finally – retuned for trad.

© Alain Décarie, Montréal

Gearóid Ó hAllmhuráin

Gearóid Ó hAllmhuráin is a leading authority on Irish traditional music. Formerly Jefferson Smurfit Chair of Irish Studies and Professor of Music at the University of Missouri-St. Louis, he is the inaugural holder of the bilingual Johnson Chair in Québec and Canadian Irish Studies at Concordia University in Montréal. A cultural historian, anthropologist, filmmaker and ethnomusicologist, he holds All-Ireland titles in concertina, uilleann pipes, and as a former member of the Kilfenora Céilí Band. His CDs include *Traditional Music from Clare and Beyond* (1996) and *Tracin'* (1999).

His *Short History of Irish Traditional Music* published by O'Brien Press has been a best seller for twenty years. His *Flowing Tides: History and Memory in an Irish Soundscape*, an extensive study of traditional music in Clare, was published by Oxford University Press in 2016. His documentary film *Lost Children of the Carricks* was selected to represent Ireland at the prestigious *Ethnografilm* festival in Paris in 2021.

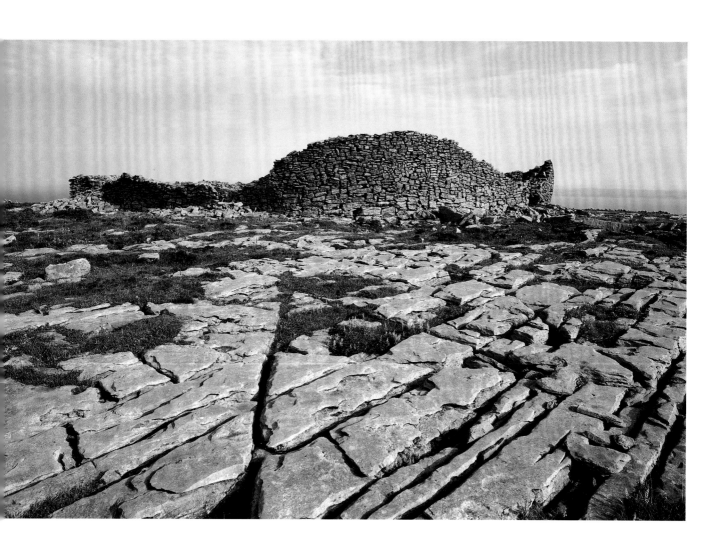

At Fifteen

John Gibbons

Every day of every year of my childhood, the six o'clock Angelus bell rang out across the land. The tolling of the iron bell. A moment in time that caught and held my imagination. Not that I was religious. Far from it. At fifteen, I had stopped going to mass. Unlike many houses at the time, the Angelus was never said in our house. What I remember holding my gaze was the icon. The Madonna and Child. It's 1966 and I'm fifteen years old. A Byzantine image flashes up on the screen: fifteenth century, possible sixteenth century. An icon. I remember instantly sensing its beauty. The Madonna. There was an otherness about her. A profound tranquillity. An aesthetic beauty, although I certainly wouldn't have used that word at that time. That kind of language came later. Words that explain. Aids to understanding. A woman. Serene. At peace with herself. Different from all the women I knew but having aspects of them. I was totally consumed by it. And I still am. An image that has stayed long after the bell stopped ringing.

It was a tranquillity I associated with my paternal grandfather. Another image. Another moment in time. Every evening, he sat by the window. A glass of whiskey, a glass of stout and a cigar. What caught my childhood imagination was his stillness, after a day of endless activity. He had a gentle way of teasing me. Wondering if I ever saw a white blackbird. That kind of thing. A gentleness. And a kindness. And above all else an understanding. It was also my first introduction to alcohol. I used to take away the empty glasses. The glasses not always fully drained. Nor the bottle. I remember the disgust I felt at the first gulp. But I got over that, eventually. The memory of my grandfather is not soured by alcohol. Rather it is of a man, a contented man sitting by a window as the day closes in. Years later, I made a sculpture dedicated to my grandfather, 'Your Story/White Blackbird', which was exhibited at the National Portrait Gallery in London in 2008/09 as part of 'John Gibbons: Portraits.' My maternal grandmother was also an important figure in my childhood and in the same exhibition I dedicated a piece to her too, 'Jane/E/And Still.'

Another image. Yet another cameo from my teenage years. This time an image from *The RTÉ News*, just after The Angelus. An exuberant image. Full of life. An extraordinarily joyous image. A woman. But this time a very different image. This woman was naked. A startling contrast to the iconic image. A naked woman reclining. Her pubic hair. Lush. Unhidden. Nothing left to the imagination, and

yet everything. I had never seen anything like it. I had studied Renaissance art in school. This wasn't Renaissance art. This was a figure reinvented. The pose altogether different. A painting by Picasso. Pablo Picasso. I had never heard of him. But I was overwhelmed by this painting. Such energy. Such invention. I was completely mesmerised and totally consumed by it. Her confidence. Such freedom. Seeing it was spiritually uplifting. I wanted to see it in real life. It was part of an exhibition that was on in Dublin. ROSC. I had never heard of that either. I was determined to go to Dublin. Determined to see this light that had knocked me over.

My parents. We never really talked. We never really communicated. But my mother would smile. Certainly, we never talked about sex. Except once. In the sitting room. It was that talk. Talk about excruciating. I remember once asking my mother why do I have a penis if it is just to pee, it seemed a waste. I was younger then. She smiled and turned away. I also remember walking to primary school one day, past the Fair Green. It was Fair Day. I remember seeing a cow with two hooves sticking out of her rear end. I stopped. I was gobsmacked. Two men were pulling at the hooves as the cow arched her back. Out popped a calf. How extraordinary I thought. New life. And then there were horses by the primary school. I remember we all jumped on the wall to watch the stallions.

At fifteen, I was tall. Tall and lanky. Tall, lanky and a loner. Not in a pitiful way. Not so much a loner. Not that I hadn't friends but I just liked being on my own. I was different. I felt different. In school and out of school. I am dyslexic, not that I knew that then. Really bad dyslexia I found out years later. Reading Shakespeare out loud in class was very painful. Nobody could follow what I was reading. *The Sunday Times*, when it was a decent paper, I could manage. Sentences were short in *The Sunday Times*. I like short sentences. Reading them, I did not fall through the lines. In fairness, I was never reprimanded. Just passed over. Eventually I just wasn't asked to read. Mathematics saved me. I was very good at Maths. Maths, especially trigonometry. There is a beauty in trigonometry.

I was a very curious boy. I spent a lot of time by myself. I was fascinated with nature and walked the countryside where I got to know a lot of farmers. We lived on Lifford Road, then on the very edge of town, often pejoratively referred to by the 'townies' as Piggery View. Something I only learned as recently as last year from my friend Martin McCullough while staying in the Burren. The Burren, my touchstone. But that's another story. I remember the pigs and the field beyond in which vegetables were grown. Beyond that again was the ruin of Lifford House and the wonderful stretch of park reaching down to the Tulla Road and the village of Corrovorrin with its rows of thatched cottages.

As children, we had great freedom to roam. I'd go and explore the swamp and floor plain, walk the Green Road, to the Leg of Mutton Lake behind the Mental Hospital. Some of my earliest memories are of long walks with my mother picking blackberries for later jam-making. Over the years, I worked on a number of farms. I learned to plough with a horse. I learned to ride a horse. I was full of curiosity about all the goings-on on these farms. I remember watching hens in a henhouse. I wanted to know how a hen laid an egg. I crouched down and stayed still. And waited. The first egg came out steamy and hot. I couldn't believe it. I took it in my hand and felt its heat. By the third egg, I had it figured. The air hardened the shell. Later, at tea the farmer's wife said, 'something strange happened in the hen house today.' I had put the egg back under the hen. She produced the egg with my thumb and finger prints fully evident. She smiled and I felt I had been found out.

As a child I was bullied. Terribly. Just picked on. Actually, I was bullied throughout most of my school life. I was seen as different. Difference does not go down well in the school yard. I was awkward around people of my age. People laughed at me. I seemed to get things wrong. I was naive. I remember one day; the Beatles were in Dublin. It was 1963. I must have been thirteen. And somebody said that a car had been overturned the day the Beatles came to Dublin. Thinking the car had been overturned by beetles, I remember saying, 'Jesus, they must have been thousands of them.' More ridicule. I had never heard of the Beatles. There was no music in our house. There was, however, an upside. Determined to find out who the Beatles were, I discovered my love of music, which would become a major influence throughout my life.

Eventually, I decided I could not take any more of the beatings. I decided to join the boxing club in 1961. Colm Flynn had opened a boxing club in Chapel Lane. My mother was horrified and pleaded with my father to stop me. Reluctantly, he allowed me to go. I learned at the club that I could look after myself and grew in confidence. I gained a certain reputation. This only drew further attention to me as others wanted to check me out. Now I attracted a different kind of attention. Nightmarish attention until they eventually got the message and left me alone.

Tournaments were commonplace throughout the county. One in Corofin, I particularly remember. Hearing I was due to box, my Corofin classmates taunted me right up to the day of the fight. My opponent was much older than me, apparently six foot five with a long reach and I was repeatedly told I would get the hell knocked out of me. At first, I ignored the taunts but after two weeks I became very paranoid. I trained like I never trained before. I was determined to be as brutal as I could possibly be. In the ring, he was all he was alleged to be. I used

the ropes. He stayed in the centre. Suddenly, I realised he was frightened. I knew what it was to be afraid. I had learned about fear. So, I just went for him. And I knocked him out in the first minute. He was taken away on a stretcher.

I was horrified. I took up boxing to learn how to look after myself, not to inflict pain on others. I never boxed again. Some months later, I was hitching. He stopped and gave me a lift. I was petrified. It was one of the most stressful journeys I have ever taken. I thought he was going to take me out and give me a good hiding. And this time he would have made mincemeat of me. He didn't. We never talked about the fight. He was a gentle person.

I remember little about hitching to Dublin to see the Picasso painting in ROSC. I asked my friend Michael Behan to hitch with me. Our last lift was from a man driving a bread van. He had a baseball bat at the side of the door. I asked him what it was for. 'For bad men,' he replied. I had only been to Dublin once or twice before and that was with my parents. And then this. I was relieved when we got to Michael's uncle's house.

The Picasso painting was hung high at the entrance. It certainly didn't disappoint. I found the whole exhibition fascinating. Something very new. Apart from the Picasso painting all the other work was abstract, as far as I can remember. I had never heard of abstract art let alone seen it. I went around and around. Back and forth. Not asking anything of the paintings. Just looking. Drinking them in. One I remember. A Kenneth Noland. A very long striped picture. We became friends years later when we met at a residency on Great Jones Street in New York City called Clay Works where, among other things, he introduced me to the NY jazz scene. And then another country, another city, the same Noland painting. I saw it again in a private collection in Toronto. The painting I first saw as a teenager at ROSC in Dublin.

At fifteen, I went to the *Gaeltacht*. Inisheer. My instinct to go it alone stood me in good stead on the Aran Islands. One evening I almost knocked over a German professor of Celtic Studies from Munich as I rushed out the door to get to the bar before the *céilí*. He rebuked me and asked, 'Did I know who I was lodging with?' Curiosity. I foreswore the bar and the *céilí* to be with him. With him, I sat by the fire made of turf and dried cow dung listening as he recorded the *seanchaí*. A man who seldom strayed from the island, perhaps as far as Galway, but whose stories evoked the world.

That summer as I explored the island, I met various people of interest, including a woman close to twice my age. One day she invited me to a cove she had recently

discovered. By the time I arrived, she was already in the water. She waved to me and I waved back. I sat by her belongings and watched. She was alone in the water. Two currachs in the distance. The tide was out; the water ever so still.

From the water, she emerged. A long walk to where I was sitting. Gradually, it dawned on me she was naked. Like a Greek goddess. Naked. Utterly unself-conscious. It was the first time I had seen a naked woman. I stood up as she came closer and handed her her towel. She dressed as one would in the morning. Matter-of-factly. While we chatted away. And then we went on our way. I never saw her again. At least not in the flesh.

Her naturalness. Her ease. No guilt. Free and sensuous. Just two people. And the sea. An extraordinary moment. A clarifying moment. A moment of epiphany. Life could be like this. Free and unencumbered. Different. She and the island *seanchaí*, along with another Gaeltacht family I met a year later, this time in Spiddal, were my true educators. People of depth and integrity. Compassion and feeling.

Not quite there and then, but at fifteen I vowed that one day I would leave this country. To leave an Ireland that was suffocating me. That is how I felt. I felt I could not breathe. Even then I knew I needed to get out and given the first opportunity, I was determined to do so.

School was a nightmare. From the very first day. The Sisters of Mercy. No love. No mercy. No empathy. Cruelty and sadism marked my school days. Vulnerable girls were particularly vulnerable. One in particular on our first day. Crying and her nose streaming from a very bad cold. She did not seem to be one of us. And the abuse that came her way. From a nun. A professed Christian. When all the evidence emerged of Magdalene Laundries, I often wondered was that it . . . was that what so enraged this adult woman?

Weapons of choice varied. As did the levels of cruelty. But cruel it was. One Brother boasted about how be picked hazel sticks and seasoned them up the chimney. His pedagogical tool. A sadist if ever there was one. His specialty: the tips of our fingers and the sensitive points all the way up to the backs of our wrists. Another teacher, another pedagogical tool: a strip cut from a lorry tyre.

At least four in my class suffered egregiously from the violence of the teachers. One boy I especially remember was very severely verbally abused. Mercilessly. He never returned to school. Since then, a life lived in an institution. There were others. Perhaps four in all. All broken, one way or another. Once I intervened and shouted, 'Leave him alone.' It was unheard of. He stopped in his tracks and

revealed, 'I'm fifty-five and if I left, I would not get another job and would lose my pension.' Shocked, I immediately realised that he was serving a life sentence.

A Christian Brother recruited more than likely as a child soldier with no release date. He, too, a prisoner but without parole, inflicting his frustrations on us without any accountability. But all of that understanding came later. That and the weight of the theocratic state that I had felt during my teenage years pressing down on me. Felt but did not understand. Felt but could not articulate. Not then. Not for a long time to come.

We were humiliated. Ours was an everyday humiliation. Random memories that appear randomly. Sparked by the most unlikely events. Once, I was locked in a cupboard which I was told was full of rats. Once, I was forced to clean a blocked drain in front of the whole school yard. Once, I was summoned to the front of the class. At the time I had long blonde hair. A girl in the front desk had red ribbons in her hair. The ribbons were plucked from her hair and tied on to mine. The Sisters of Mercy. My merciless introduction to religion and to education.

Some of which I recounted to my father when in my twenties. 'Why did you not tell me?' he asked somewhat plaintively. 'Would you have believed me?' I asked. He thought about it for a while and said, 'No, I would not have believed you.' He was not alone. The whole country was in denial. Denial and complicit. The state was complicit. These were supposed state schools. Fearful and submissive to an unelected, unaccountable but highly visibly institution. The Catholic Church. And that Church effectively governed the state. I was living in a theocratic state. We were all living in a theocratic state. Is it any wonder I wanted out?

In the midst of it all one young Brother stood out. An extraordinarily intelligent man. A man who fed our curious minds. A science teacher, in a science laboratory. Science made meaningful. No violence, verbal or physical. He taught me so much, not only in my last two years at school.

Eventually, I did get to leave. For London. I tried accountancy. It bored me to tears. Doodling and writing poetry were more my interest. The sister of a member of the progressive rock band *King Crimson* with whom I was friendly first suggested I go to art college. I didn't even know such things existed. Art college? She pointed me to evening classes in Hammersmith, far more interesting than accountancy. In 1971, I worked as a gardener in the Houses of Parliament. I liked growing things. I met the Queen Mother's gardener in St James Park where we all clocked in. She had heard that I was an art student and introduced me to the Croatian

sculptor Oscar Nemon at his studio in St James's Palace. We met. He was obviously desperate for help and told me, 'I will show you how to do things once and once only.' One of the first projects on which we worked was a commissioned twelve-foot high statue of Churchill.

In the studio every day we had wonderful conversations at lunch. One day he suggested that I go to the Tate – I thought he was talking about sugar. I had never heard of the Tate Gallery and he could be very mischievous. I did. In the Duveen Galleries I was astonished to find a collection of contemporary sculpture, *The Alistair McAlpine Gift* to the State. I had finally found work that had a deep resonance with me. I spent hours there and bought the catalogue and found out where everybody had been to art school – all but one went to St Martins. I resolved then to go to St Martins. St Martins was a hive of intellectual activity. Challenging, diverse in its thinking. Demanding and ambitious. All of those things.

Life.

And as for that woman I met as a fifteen-year-old on the Aran Islands? Months later I saw her on *The Late Late Show*. She was talking about her travels in Afghanistan and elsewhere. Her name: Dervla Murphy. In all the years I have often thought about that day at the beach and how in her nakedness she encouraged me. Opened a whole new world for me. And over the years I often thought about contacting her and thanking her. But I never did. It all seemed too complicated. What would I say? And words are not my forte. I'll thank her with this.

And as for my mother and father. My father died when I was 51. My mother lived to be 102. Shortly after her death, I was rummaging in an antique shop in Limerick. I came across an icon. An icon of a Madonna and Child. Just like the icons I first saw on The Angelus as a fifteen-year-old.

With this icon, I will remember thee, Mother.

© Jane Clarke

John Gibbons

John Gibbons was born in Ennis, County Clare, in 1949 and educated at Limerick School of Art, Crawford Municipal School of Art and at London's St Martin's School of Art. Gibbons has produced a body of inventive, poetic, singular work that prompted Michael Harrison, the director of the University of Cambridge's Kettle's Yard, to describe him as 'one of the most distinct and distinguished sculptural voices of the late twentieth century.' Many other significant voices in contemporary art offer similar insights.

His work is represented in major public collections in the United States, Canada and Europe, including, Tate, London; Arts Council England; Art Gallery of Alberta, Edmonton, Canada; The Modern Art Centre/Calouste Gulbenkian, Lisbon; The Museum of Contemporary Art, Barcelona; The Czech Museum of Fine Arts, Prague; The Whitworth Art Gallery, Manchester; Jesus College, University of Cambridge; Syracuse University, New York, USA; Crawford Art Gallery, Cork and OPW, Ireland. He lives in London.

Biography

In the Shadow of the Cathedral

Mick O'Dea

'You are down for 10'clock mass on Sunday to serve the Bishop,' the head altar boy informed me. I turned up at a quarter to ten on Sunday morning with my surplice and cassock in a small neat suitcase. I was the first altar boy to arrive at the sacristy from the changing room. The parish priest and the sacristan were assisting the Bishop with his vestments and attending to all the final details in preparation for his entrance on to the altar to celebrate mass. Five to ten and I was on my own, the only altar boy present. Usually there could be up to ten altar boys present when the Bishop celebrated mass. Realising the others were not coming, and feeling perplexed and somewhat dazed, I led the way as the Bishop ascended the altar. The inevitable happened to this novice altar boy. I did not know at what stage and how often to ring the bell, when to kneel, when to genuflect, when to bring the water and the wine to the altar. In short, I was clueless. The disapproval of the mostly elderly female regulars who occupied the top pews of the cathedral was clearly evident. I can vividly recall their faces to this day. 'Go in peace. The mass is over.' I led the way back to the sacristy from the altar followed by the Bishop. Once inside, he asked me my name and, to his credit, he was grinning. It took me a long time to realise that I had been set up. And not for the first time.

Ennis Cathedral literally dominated my life. Built of ashlar limestone on a site donated by Francis Gore, a member of the Church of Ireland, shortly after the ending of the Penal Laws and on the cusp of Catholic Emancipation in 1828, which followed the election of Daniel O'Connell to the British House of Commons, it took seventy years to complete. This massive neo-Gothic edifice, a mere stone's throw from the backyard of O'Dea's pub and grocery, the home of my childhood, acted as a backdrop, a stage-set to my family's life. At the beginning of the twentieth century, the street name which the Cathedral faced was changed from Jail Street to O'Connell Street. O'Connell Street, the street of my childhood.

Saturday afternoons, under my mother's watchful eye from her bedroom window, I would make my way, from memory something in the region of fifty to seventy paces, to the Cathedral, through the south transept door for confession. Once inside, I would make my way across the church, genuflect at the main altar and exit by the north transept door. Approximately ten minutes later, I would make the reverse journey, still under her watchful eye. Duty appearing to be done.

My first encounter with painting was here in the Cathedral. A large melodramatic image of the Ascension of Christ installed by Joshua Clarke, father of the renowned stain-glass artist Harry Clarke, that dates from 1894, set into the wall above the altar, dominating its east end, caught my childhood imagination. It still does. I can still see myself as a skinny young fella in short trousers, no more than eleven years of age in this darkened cavernous building full of mystery, shadowed by flickering candles with their distinctive scent. On summer Sunday after summer Sunday, the light-filled Cathedral was host to the town's citizens in their Sunday best. On the Feast of Corpus Christi, specially chosen girls wearing their white confirmation dresses walked backwards up the aisle of the cathedral, ceremoniously sprinkling cherry blossoms at the feet of the Bishop as he carried the monstrance with host under a canopy carried by four men to the high altar. One year my older sister Mary was among the chosen. Summer days in Ennis Cathedral. Frocks and flowers. And a lightness that seemed to expand its dimensions that could hardly be imagined in those solitary winter walks within its walls.

I stand staring at the painting behind the high altar framed within a Gothic arch, mesmerised by its scale. Eleven haloed figures, perhaps the most famous or infamous of the disciples, Judas Iscariot, had, it is believed, come to a tragic end at this stage in the story, absorbed in a kind of ecstasy as Jesus is assumed into heaven. Eyes transfixed, they squat looking skyward. Beyond skyward even. Heavenly. Ethereal. The theology of eschatology in full glorious technicolour, its once lustre now dulled by years of smoke and incense. Words that were beyond my childhood world. But words that come to me now as an adult and as I again stand before the altar, gravity-defying images reminding me of the holy pictures in my mother's bulging prayer missal. In this sacred world, the laws of gravity did not apply.

Painting has become my life since then. In addition to that painting, I developed a fascination with the Cathedral Stations of the Cross. On wet winter days, the Cathedral drew me. A place of refuge. A private space. A silence. While the pews call us to sit quietly, the stations give us a licence to stand and wander. Going from station to station. Standing in contemplation in front of each one. The narrative of the crucified Christ. Each stage mapped out in relief. Station after station. Pass by the high altar. And those elaborately carved frames now long since consigned to some refuse tip. An indignity reflecting another indignity. The tenth station. Jesus is stripped of his clothing. And then the final denouement. The fourteenth station. Jesus is laid in the tomb. A story that ends in death. And what a death.

And the Cathedral held other mysteries too. Beyond the reach of most, the steeple remained a place apart, a place of mystery. Our neighbour, Paddy Brennan, was the Cathedral sacristan, allowing for privileged access for his three younger sons, Nicky, Jimmy and Laurence and some of their friends, myself included. Privileged roles too because they got to ring the bell for mass, the Angelus and funerals. But there was another privilege afforded us – access to the steeple through a secret door which formed part of the wooden wall paneling at the back of the organ in the choir gallery, located over the main entrance of the west end. Inside the blacked-out narrow corridor, a large dark dust-covered void revealed itself within the steeple, illuminated by a narrow shaft of light escaping from a slight opening in the floor that lay just above the top of the front door.

The large bell was located on the next level. The thick rope that was attached to it came through a hole in the middle of the high ceiling above, becoming visible only as it emerged from the gloom at above head level. If you dared hang on to the rope when the required momentum was achieved as you rang it, you went shooting up and down, appearing and reappearing with each loud resonating gong. On the next level, large mechanical clock works were neatly installed. The works moved the hands of the clock high outside on three sides of the steeple, enabling all who looked up to tell the time. But for us, the real treat was the 360-degree panorama that enabled us to take in the sweeping vistas that existed or co-existed out beyond the lanes and streets of the town in which we lived. Ennis. Our town.

I have one other memory that access to the steeple provided. The parish priest, Father Carroll, gave permission to my friend Martin Breen, also an altar boy, to locate his darkroom up there. In this darkened space, we marvelled at the alchemy of images that came into existence in the developing trays high above the streets. One portrait by Martin, I remember, is of myself with the clockworks in the background.

Outside of this hallowed space, another world existed. An altogether different world. Just up the road, as you make your way towards Darcy's Corner, there it still is on the left-hand-side. Our house. Once a grocery shop and bar located opposite *The Clare Champion*.

In that public house, we had a very public upbringing. Timetables and pressure were the order of the day. 'Messages' had to be delivered by car and messenger bike. Orders had to be sorted and boxed. At weekends, we ate in relays, one covering for the other in the shop or bar. 'Have Mrs McCarthy's messages been

delivered?' my mother, the ringmaster in the shop, would call out. 'What about the Gleesons? And briquettes for the McMullens.' From the age of thirteen, I could fit six bales of briquettes on my bike. It was manic and frantic and never dull.

Sibling disputes were acted out behind the counter or in the kitchen, all within earshot of a wide cast of players. We had a large country clientele, as both my parents were country people who had emigrated; my father, originally from Darragh, to Boston, and my mother to Birmingham. Mick, my father, returned in 1939, setting up the business with his brother Tom who also lived with us. My mother, Margaret O'Brien, originally from Cappafean in Crusheen, returned after the Blitz in 1947 as the newly appointed midwife to the County Hospital. Our pub was also a townie pub, with many loyal customers who seemed to possess great big personality traits that made them seem larger than life.

In its heyday, the bar would be buzzing, particularly on mart days. Fridays were mart days. Days of great conversations. The price of cattle. The weather. Hurling. Strong opinions. And strong words, too, that occasionally resulted in people being barred.

Songs were sung, the singing of which I remember to this day, in what was up until the 1970s an all-male preserve. Originally from Cavan, Tony Nunan's rendition of 'There is a Rose in Spanish Harlem' stands out in my memory. Frank O'Connell, Maura's dad and originally from Cork, could bring the house to a standstill with his rendition of 'Skibbereen.' And Mickey Kerin could always be relied upon for 'There's a Bridle Hanging on the Wall.' Over time, this all-male domain gave way to couples. Husbands and wives on their night out. Women's singing heard for the first time in the pub. Frances Ball was always good for a song. Irene Tuttle's choice was, perhaps not surprisingly, 'Goodnight Irene'. Sheila Duggan too sang. Sing-song material. Lounge bar stuff.

Singing was, for the most part, confined to certain times of the days and week. Conversations ran throughout the week. Older men living and re-living old conversations. The Civil War, the War of Independence. The First World War and the Second World War. 1966. Coming up to the fiftieth anniversary of the 1916 Rising, the Rising was lived and relived by those who had fought on both sides of the Civil War. The repatriation of Roger Casement's body the year before was a major talking point. My own father's two older brothers, Paddy and Tom, were members of the IRA and had taken the anti-treaty side. They were both in the Mid-Clare Division.

These backroom conversations were part of the soundtrack to my childhood as I played with my toy soldiers and drew. Every week I bought World War II history magazines, *Purnell's History of the Second World War*, *Orbis Publishing History of the Second World War* and *War Monthly* from Myles O'Sullivan's shop in upper O'Connell Street. From the newly-established Ennis Bookshop on O'Connell Street just beside the Gaiety cinema, I also bought *Ballintine's History of World War I and World War II*. Many of these magazines I still have today.

My sister Anne had a subscription to *Time* and *Newsweek* magazines from which I read voraciously about the progress of the Viet Cong leading up to the fall of Saigon. In primary school, we had been warned that in the event of a communist invasion of Ireland we were to rush to the nearest church, open the tabernacle, with whatever means at our disposal, and consume the Eucharistic hosts lest they fall into the desecrating hands of hordes of marauding atheistic communists. To this day, that image plays in my head. Dozens of knee-scarred young fellas in short trousers rushing to the Cathedral, hacking open its tabernacle, gorging themselves in the sacred hosts as commie gunfire is sprayed around the church. Spiritually-sated, splayed, youthful bodies riddled with bullets crumbled before the high altar of Ennis Cathedral guaranteeing eternal salvation.

From drawings, I graduated to making Airfix models. Myles's father had fought in the trenches during the First World War. Once, Myles introduced his father to this kid from down the street who has this obsession with the Second World War. But if we spoke and what we said, I can't remember. From these magazines, I developed a detailed knowledge of Second World War aircraft and tanks. American tanks, German tanks and Russian tanks.

War's public conversations were dominated by men back then, as were practically all public conversations. I don't recall the details of all of those conversations. Now, I wish I did. I was just eight or nine at the time. I did pick up on residual things. I particularly remember Billy O'Halloran talking about a Bren gun and saying it was too accurate. I remember looking up from playing with my toy soldiers and asking him why?

I do not remember any animosity between the men during those conversations. Men who fought on the treaty and anti-treaty side, men who fought as members of the British Army during the First and Second World Wars. The men who fought for the British army were, for the most part, working class boys from the town. Not all. But many were young men in need of a job and possibly some in need of adventure.

Years later, in 2000-2001, I was teaching with the artist Steve Sheehan in the Lyme Academy of Fine Art in Connecticut, USA. Steve was a keen marksman and had spent time in the US navy. He brought me to a shooting range during which he compared the trajectory of a bullet to the trajectory of a line, a reference which brought me back to my primary school classroom in Ennis. My school friend Gerry Molloy, who went on to form the rock band *Bushplant*, shared my fascination with soldiers and play.

That shared fascination centred on the American Civil War, the red coats and the blue coats. All of which had opened a door to art for me as a child. What might have been regarded as mere scribbling on a page by some was tolerated by our teacher, Cyril Brennan. Not just tolerated but actively encouraged. Years later, I came across a primary school report written by Mr Brennan that said: 'Michael has an aptitude for art and it should be encouraged.' My sixth-class report. Many years later, when I was working in the Centre Culturel Irlandais in the Collège des Irlandais in Paris in 2006, I had a knock on my door one evening. It was Cyril's son, also known as Cyril, the then cultural attaché in the Irish Embassy in Paris. I was glad to meet him.

Same school, a different teacher. The circumstances were altogether different. During my last year in primary schooling in the CBS, a teacher beat the living daylights out of me. I walked home for lunch and told my mother to put my name down for St Flannan's College, one of the local secondary schools. I didn't see it at the time, but in retrospect it was a fortuitous beating, insofar as such things exist, one that shaped my life in a way that neither I nor he could ever have imagined. St Flannan's had just appointed an art teacher, Jim Hennessy, who was to inspire many of us who arrived in 1971 to attend art college on leaving in 1976. As far as I know, we were the first to attend art college in the history of St Flannan's.

The printers and journalists of the nearby offices of *The Clare Champion* provided another source for my insatiable curiosity about the world. Visiting journalists and 'people of note' were frequently invited to the bar, known to *Champion* staff as 'the front office.' Our pint quality had a high standing among aficionados, though I noted that a high proportion of professional types preferred spirits back then. Exposure to erudite, protracted discourse and arguments, and some that were not so erudite, could not be avoided in the circumstances. Fortunately for me, I could never get enough of that kind of exposure.

It was a big deal when the 'film crowd' used our bar as a watering hole back in 1968. Disney were filming *Guns in the Heather* staring Kurt Russell. When it was

released, the town and county packed the Gaiety Cinema that was located further down the street until it seemed that there was nobody left who had not seen it. My older sister Mary spotted Kurt and liked the cut of his jib. I like to think that it occurred in the pub. Mary died of a brain tumour in 2016. She was our oldest sister, very athletic and driven. I always looked up to her.

My other sisters too. Anne introduced me to good music before she left for the States, where she hosts *Celtic Cadence* for independent radio station KVMR based in Nevada City, California. In 1996, she founded the annual Celtic Festival that has grown and flourished since then. Clare, the baby in the family, moved to New York in 1984 where she studied contemporary dance with Erick Hawkins who was married to Martha Graham, the pioneer of contemporary dance, before returning in 1989 to join Daghdha Dance Company in Limerick. John, 'The Boss', the oldest of the five of us, ran the pub up to his retirement five years ago. The pub was described once by *The Irish Times* journalist Rosita Boland, who was born in nearby Clonroad, as the Doheny and Nesbitt of Ennis. John values conversation and conviviality, and the pub continued its renown for it. We are close, all of us. Proud of our parents, extended family and the town from which we came.

Side by side with the 1960s allure of Hollywood, an older Ireland continued to cast its shadow. Every year on August 15, the Feast of the Assumption, Éamon de Valera, veteran of the Easter Rising and the War of Independence, President of Ireland, attended ten o'clock mass in the Cathedral before appearing at the Agricultural Show in the Showgrounds in Ennis. I served mass on several occasions with him present. He was 86 years of age in the year of *Guns in the Heather* and almost blind. He took his seat and communion inside the altar railings, away from the general congregation. Afterwards, he was escorted by his aide-de-camp into the sacristy as part of the procession of priests and altar boys where we were formally introduced to him, as we were every year.

My connection with the Cathedral ended with Vatican II-imposed changes to the physical interior of the building. Its mysterious presence was lost forever. A new altar, ambo, font and pillar for the tabernacle replaced the existing high altar. Beyond the Cathedral, the town too was being remade. Out with the old. I also experienced a deep sense of loss at the destruction of the town's great stone mills in Mill Road, the humped back bridges, the network of narrow lanes that led to the river, the workhouse built before the Great Famine and the Market House. All lost in the headlong rush to modernity. Swept away to make way for what some people called progress.

Like my father before me, I have three main preoccupations. Apart from the bar, his were horses, cattle and sheep. Mine are landscape, portraiture and history painting. A triptych of preoccupations.

The men who drank pints of stout on fair days in my parents' pub all those years ago instinctively understood that we are a lucky generation. I too feel that. I was born a mere thirteen years after the ending of the Second World War. A mere thirteen years. History has taught me that I was born into a lucky generation. And maybe in their quieter moments the men who drank in our bar knew that the age-old rift of pro-treaty and anti-treaty didn't really matter anymore. And that knowing had softened any rancour they might have felt. And left me with a profound legacy.

Maybe.

And maybe, there are worse things than ringing an out-of-synch bell during the consecration at mass. Even when that mass is being said by a Bishop.

Maybe that too.

Mick O'Dea

Born in Ennis and currently living between Dublin and Mayo, Mick O'Dea attended the National College of Art and Design in Dublin from 1976 to 1981, studying for a time at the University of Massachusetts, with further studies in Barcelona and Winchester. He is a member of Aosdána, an honorary member of the Royal Scottish Academy, a Fellow of the Anatomical Society, Chairman of the Stamp Design Advisory Committee for An Post and a past member of the Board of Governors and Guardians of the National Gallery of Ireland and past president of the Royal Hibernian Academy.

His work is included in a number of public and corporate collections including The National Gallery of Ireland; The Crawford Municipal Gallery, Cork; The Royal Hibernian Academy; Limerick City Gallery; Cēsis History and Art Museum, Latvia; Trinity College Dublin; Dublin City University; The University of Limerick; Cork Institute of Technology; Glucksman Ireland House, New York University; The National Concert Hall; Government Buildings and Leinster House; Belfast City Hall; The Arts Council of Ireland; The Ballinglen Arts Foundation; Centre Culturel Irlandais Paris; St Patrick's Hospital; St Luke's Hospital; Jury's Hotel Group and Doyle Collection Hotels.

Living in a Liminal World

Isabelle Gaborit

I woke up when I arrived in Ireland.

Having felt disconnected all my life, for the first time I felt connected. Having been lost, having had a sense of lostness, I felt found. Having felt displaced, I felt placed. I was twenty-three years of age when I first arrived in Ireland. I hadn't even planned on coming to Ireland. Ireland had never registered with me as a place. I knew nothing about this country. What I did know was that I wanted out of where I was.

I came into this world in 1970. I'm just over half a century on this planet. And La Rochelle, a seaside town on the Bay of Biscay in Western France, was the place on this planet on which I first touched down. Born there, but I never felt alive there. For twenty-three years, it never felt right. I never felt at home in La Rochelle. My body felt ill at ease in that place. It was a primal feeling, very real. That sense that I do not belong here. La Rochelle is a big sprawling industrial and tourist-orientated city surrounded by flat, equally industrialised farmland, a place to which I never developed any affinity. Of course, it has its own beauty. It's a fortified city, a very rich city, a very bourgeois city. A port city. But not a city for me. It is a reclaimed, tamed landscape. It is very hard to be alone in La Rochelle, close to the sea but hard to swim on your own. The La Rochelle of my childhood was a crowded place that crowded me out.

It's not that I came from an unhappy family; quite to the contrary. We were a regular French middle class family; worked hard and took two holidays a year. My mother worked as a midwife, my father was a wood craftsman. As my parents worked hard, my mother returned to college to study. I, along with my brother, was raised for the most part, by my grandmother. Unlike my parents, who were atheists, my grandmother was a Catholic attached to, what I was later to learn, was not that different to Irish Catholics, Lourdes and holy water. But she was never an institutionalised Catholic. Water too has a holiness for me, but without any formal religious attachments. I never felt the weight of Catholicism that many Irish people talk about. It never touched me or burdened me. There are other ways to live in the world.

As a child, I was very self-sufficient. I was a loner; felt different from other children. I never felt the need of other people's company. A child lost in her own thoughts. I was always drawing. I could spend up to ten hours a day drawing, mostly people. College in Poitiers was not that much different where I studied English, fine art, cinema, sculpture and painting. There, too, I felt alone and I knew I wanted out. I wanted another place and it didn't really matter where. An Erasmus offer suggested Ireland and it seemed it was as good a place as any. Of Ireland, I knew nothing. I had no preconceived ideas, no sense of the place. All I knew, it wasn't La Rochelle and it wasn't France.

I arrived in Ireland, Galway to be precise, in 1993. This was my year, the year of my awakening. Immediately, I felt it. It was that sudden, that transformative. For the first time in my life, I felt whole, at ease with the world. I had found a place where I could blossom. I found a massive connection not just with the place but with Irish people. I think I have a very different sense of Ireland than Irish people have with Ireland. For me, Ireland is a fizzy place. It's the only way I can describe it.

West Clare is my favourite place in the whole world. Kilkee, Quilty, the whole West Clare coastline. There are times in Whitegate, where I am now living, that I catch the smell of salt in the air and I have to go there, go to the west. I love the road to the west, once I get past Ennis to which I have no attachment. But out of Ennis, over the narrow Inch bridge, Kilmaley, Connolly and the undulating road with the sweep of Maghera off to the right until the road forks, the skyline is always changing. Branching left as I drive through Coore, there's a moment of anticipation as I climb the hill just before Mullagh – there it is, the sea. Through Mullagh turning right for Quilty and left past Our Lady Star of the Sea church with its store of stories. How I love the name of that church. Two boreens lead to two beaches: Lurga Point and Baile an tSagairt.

The only decision is which one to take and then I'm in the sea.

I love swimming. I love swimming alone. I love the cold even if getting in is always an ordeal. I love the water on my skin. It has a sensuousness beyond compare. When in the sea I feel as if I am dissolving into the water. I once had a dream where I was a drop of water falling over a cliff into and merging with the sea. That is how I feel when I am swimming. And then those beautiful transient moments when the light catches. The clouds shaping the light as I am momentarily lifted by the sea before sinking back into another world. This time a world of mysterious plants birthed by the sea. And I feel alive again. There are

times I long to be free of all worldly possessions. The swimsuit might just be a piece of cloth but it is a constraining piece of cloth nonetheless. Without it, the immersion in the sea is even more physical, even more sensuous. As if the water wraps itself around my body, envelops me until I am ready again for land. And on land I look out on what the sea has given me with a sense of exhilaration and anticipation too. Anticipation for the next time I will feel that feeling.

Land too holds me. The Burren does that. Land and rock and all those places where the footprints of generations long gone remain. These are liminal places. Past and present fused together in a kind of communion that defies any institutional framing or any institutional claiming. Timeless places of refuge, repose and places of escape too. I am not the first to want to escape. I am not the first to feel the dislocation of restlessness. That I know from being in the Burren and that I feel from being in the Burren. It is an affirming, reassuring feeling. In that reassurance there is a keen sense of our own mortality. It is all around us in the Burren and I feel it. I feel death here and I have known death. Here in the Burren, I do not fear death, nor do I fear it elsewhere. This I know. This is not the land of my birth, but here I will die and here my bones or ashes will be scattered and I too will enter this liminal space between the living and the dead.

I came to Clare in 2011, five years after my daughter was born. Initially, I settled in Mountshannon and later in Whitegate. I was contracted as an artist on a County Council survey of 72 medieval churches in Clare. Simon Large, an English-American who had come to Ireland in the 1980s, was the archaeologist assigned to the project. He, too, had a sense of Ireland being home. It was the summer of 2011. A summer of a huge melting pot of emotions. A summer in which we both fell in love with each other, and through each other this place took on a deeper connection.

Together we encountered the intimacies, the contours, of this ancient land, a land which we had both found in our very different ways but a land that bound us together. Leaving Gort for St Colman's Well in Slieve Carran, a seventh century hermitage for St Colman Mac Duagh, we drove in the direction of Kinvara through a flat plane of limestone, with Mullaghmore on the left. There's a gate by the foot of Slieve Carron where we parked our car and we walked over walls, through a little hazel wood, past a lonely hawthorn tree, as if it was emerging from a rock just on its own. I think it's called Eagle Rock but I can't be sure. In the hills, wild goats cling surefootedly, but to our untrained eyes precariously, to the cliff edges. Another hazel wood and then in a tiny clearing, an old seventh century church with just one gable end still standing is nestling within the woods. St Colman's

Well is still intact. And as with all holy wells in Ireland, a clootie tree beside. Off to the left of the church ruin and easily missed is St Colman's Cave, about fifteen feet long and four to five feet in width. Tradition has it this was St Colman's Bed. Simon, who was quite tall, could stand comfortably within. The whole place is encased in hawthorn. On this day, this was our hidden world.

Here the water has a purity and here too I have a sense of dissolution. It is a most incredible place. Just magic. Pure magic. The place glows. Shines. It is just beautiful. The wild garlic. Here I feel I am contented, however fleetingly it may be. But more than fleeting. In a sense, I am here in a way that I never was in France, in a way I could never imagine being in France.

In this private world we are sheltered, quietened, present to each other. And to a past, our present and our imagined future. Here there is a togetherness and a solitariness. We are together and alone. This is a most spiritual place, a spirituality that spills out of the rocks that leaks from the trees, that is washed through its waters. But here too there are others, all those who have come here, all those who have tied their hopes and dreams, fears and dreads, to this place. It is here that the pagan and the Christian meet and it is here that the age-old tensions fall away, where that destructively binary world dissipates into the streams and the mosses of this ancient land.

Days I remember.

Another day. I remember it as a gloriously sunny day and it was just the two of us. We drove four or five miles out the coast road from Ballyvaughan towards Black Head. And on that day, we set out to locate Tobar na Croiche Naoimhe, or Tobernacrohaneeve. At the imposing Gleninagh Castle, which overlooks Ballyvaughan Bay and which in reality is a sixteenth century tower house, rather than a castle, we parked, hopped over a wall and crossed some farmland. We carried with us all the accoutrements of an archaeological study, cameras, recorder, laptop. We both carried leather satchels. And in those leather satchels there were always flasks of tea and sandwiches. I remember that day there was a bull in the field and despite the number of fields I have walked in all over Clare, I have never got over my fear of bulls. They have that menacing demeanour. Keeping a wide berth, we pushed on.

Almost hidden under a clump of hawthorn trees, we noticed a holy well. We almost missed it as we were looking for another church. It was white, with a Gothic-type arch and a cross on top. What I remember is that it was painted

white or partially painted white. Whitewashed. And in front, a clump of rocks also partially painted white. In my head, it feels like we arrived at midday. It was very bright. We sat on the clump in front of the holy well and had our tea and sandwiches. Later, I remember reading about the well that its waters were reputed as having a cure for sore eyes.

Of that Clare survey what I remember are moments and my memories of those moments. The facts of the survey, I now need to check, go back to the written sources. Memories I can summon. Not always instantly and not always at will, but sometimes in the strangest and most unusual of circumstances, and often when least expected, memories arrive like unexpected guests. And in those moments, the facts and sequences, the chronologies and timelines, are of no consequence. What matters are the feelings and the memories.

I remember just standing by that well: a very vividly white well. I remember stepping over that wall. It had two steps, more rough stone than polished steps on either side. The grass was green, a brilliant green. Days with Simon as if everything stood still. As if everything was in time. Everything was in its place. There's a Greek word that came to mind: *Kairos*. Everything converged. Everything played a part in that memory. Nothing happened. But in that nothingness, everything happened. It was as if there was an alignment, newly painted well, the sky, the grass. And Simon was there. A fusion. Every time I pass Ballyvaughan there is that fleeting moment of recollection. Standing on a hillside looking out over Galway Bay. It's as if life is not linear. I know life is not linear. Just a sequence of moments.

All of this is reflected, threaded through my work, work that resonates in places as far away as the Yan Chao Gallery in Beijing where I exhibited as part of *Is Mise Ireland* and as part of the Irish Ways exhibition in Shanghai. The call of the sea is universal, transcending borders, cultures, ages. Thematically and instrumentally, my work is infused with water. Water that flows from the Atlantic into every nook and cranny along the western seaboard of County Clare and speaks to the people of Beijing and Shanghai who have never known its waters. People who have never felt its coldness and indeed for the most part are never likely to know it. Landlocked people who can only imagine and wonder from a distance at the light refracting from the water of Quilty, the light of the Pollock Holes in Kilkee and the numerous other places of water in which I have been blessed to immerse myself.

This is now my life's work. What lies below. The memories, the history, the colours, the textures, the depths of a place I now call home. The representations may be abstract but the feelings are real. They are mine, personal to me and deeply felt by me.

And Whitegate too is my home. We and other artists who have come here, not just to Whitegate but to Scariff, Feakle, Tuangraney, Tulla and points in between, may be blow-ins, to use that common Irish term with all its coded and not-so-coded meanings, but we too have found homes here. We may be the alternative Irish but we too are Irish. Perhaps even as Irish as the Irish themselves, if at this stage that is not too much of a *cliché*. A question I am often asked is, Are we accepted? It's not a question I give much thought to. I am the woman I am. The woman who drives her car with beeswax in her hair. Perhaps I am, perhaps we blow-ins are exoticised. The French woman. Those people with their hens and polytunnels. The Germans, the English. The French. The artist. Maybe even the pagan(s). Maybe too that day is gone. Maybe there was a time. Now everybody is too busy just getting on with it. A different kind of dizziness.

The truth is I don't care. It is not that I don't care for the people around whom I live. I do. But I don't allow that caring to influence how I live. I live in a liminal space and I love liminal spaces, that grey between black and white. In truth, we probably all do. I love discomfort and I believe we all need discomfort. Life thrives in the cracks and fissures. And people in Clare know that more than most. That is where those irresistible spring gentians bloom, the ever so delicate mountain avens and the all-consuming beauty of those deep purple orchids.

Simon died in 2013. But I don't think of him as dead, he just entered that liminal space. He brought me to Clare and I left him in Clare. His ashes are spread in Mullaghmore and every August I go there. His presence is there but is not confined to there. He now is between worlds. Mid-summer's day he died. Suddenly, from a heart attack, in the early evening. I remember going outside and having a sense of him in the air, a sense of him around me. And that sense stays with me. Of course, I miss his physical presence and his physical comfort. But I don't feel I have lost him. A week after the funeral, I went to the sea, went to Lahinch. The comfort of water. On that day, the weather changed very suddenly. The storm clouds rolled in and rain poured down. And in that moment too, there was an awareness that life is a blessing. Death reminds us of that.

Those of us who have come to live and settle in Clare probably have more in common with each other than with the people we physically live close to. We

have created our own world. Some might even regard it as a sub-culture and there is some truth in that. Our children born here, speaking in the local Clare accent unlike our varying degrees of heavily accented Clare accents, inhabit their own liminal spaces. That's their world; their lives to live. Ours, we have chosen.

I have mine to live and insofar as anyone can predict the future, mine is here. Here in County Clare. And every morning I light a candle to this place. To this place of rock and tree, sea and cliff. This place with its mystical holy wells and with all the rituals that go hand in hand with all of that. Rituals that date back to pagan time, all of this gives solace, comfort, inspiration to this French animist pagan who through the grace of whatever mysterious forces guide our lives, brought me here when I needed a place where I could live, breathe and be at ease with the world.

For this place, for all of us who inhabit this liminal world, I light a candle.

Biography

Isabelle Gaborit

Isabelle Gaborit is a contemporary visual artist, though her preferred medium is encaustic painting. In her studio, located on the scenic shores of Lough Derg, County Clare, she has rekindled the ancient encaustic method of using layers of molten pigmented beeswax manipulated by blowtorch. Isabelle was born in La Rochelle in the south west of France. As a student she gained a foundation in sculpture, drawing and painting at l'Ecole des Beaux Arts in Poitiers, France and graduated from GMIT in 2006 with a degree in fine arts.

Since then she has been exhibiting her work extensively in many centres including: Birr Art Centre, Excel Arts Centre Tipperary, Enniskillen Visual Arts Open, Town Hall Theatre Gallery Galway, Iontas Arts Centre Kilkenny, Dunamaise Arts Centre Portlaoise, the Source Arts Centre Thurles, and internationally, the 411 Gallery, Gallery of the Central Academy of Fine Arts, Beijing and the Yan Chao Collection Gallery, China and the Galerie du Faouëdic in Lorient, France.

She is a former member of Artspace in Galway and G126, and one of the founding members of the Art in Studios trail in East Clare.

A Cry from Within

Tim Dennehy

It's Friday, 26 April, 2019. In my bedroom in Miltown Malbay, I swing my feet out of bed, plant them firmly on the floor, pull back the curtains a little and calm any turmoil within with fifteen minutes of gentle meditation. This routine over, I walk to the window, open it just a jot and look eastwards towards Mount Callan. Wind turbines, those white giants that of late have replaced the coniferous trees on this landscape, whirl in the gathering storm. Dark, black clouds overhang the mountain, matching my morning mood, the landscape drenched in driving rain. Overnight, there were weather warnings; Storm Hannah will be here by evening. Met Éireann has issued a Status Red wind warning predicting gusts of over 100 kilometres, counties Clare and Kerry to bear the brunt.

Still at my window, I remember friends and family who have passed – my brother Pat, taken at seventeen, my mother Nora and brother Michael in their early sixties. My father Tadhg, a short breath shy of his 101st birthday. Loss is ever-present in our lives, visiting early and staying late, but this routine of recollection and celebration of their memory helps the grieving process and puts a face and physical shape on those memories. And over the years I have learned to live with that loss, that celebration and all of that has woven its way into many of my songs including 'Memorial', 'The Parted Years', 'A Winter's Tear'.

From Mount Callan, my eye drifts to the Connolly-Miltown road. About half a mile west of The Hand crossroads and about fifty yards from the public road stands an old Irish cromlech or dolmen known locally as Leaba Dhiarmada is Gráinne – the Bed of Diarmaid and Gráinne. The lovers rested briefly here, rising before sunrise to flee from the wrath of Fionn Mac Cumhaill.

A wet, windy and dark Miltown is now showing signs of life. The Post Office, beside the house of writer and map-maker Tomás Ó hAodha, is now readying to open. Despite the rising wind and rain that is drenching the main street, the town is beginning to stir for it is now after nine. Shopkeepers, with umbrellas raised, unlock their doors and nod a rushed greeting to passers-by. Parents ferry children to school on the Mullagh Road or to Spanish Point. Delivery trucks reverse to the side entrance of the supermarkets with their bleeping caution, and customers are out earlier than usual this morning, no doubt heeding a warning that much of the country will be in virtual lockdown by six o'clock this evening.

Even the crows will have ripped home to Mount Callan long before then for the creatures of the West Clare air know that heady storms, strong gusts and billowing rain can mean danger.

And Pat is never far from my mind.

> May our thoughts be never severed, may we journey on forever,
> May the waters of the Fertha take you gently to the sea,
> And sometimes when the darkness creeps and shawls each fragrant flower,
> I reach for you across the stars, we're young again and free,
> May we hold hands across the stars for all eternity.

West Clare has been my home now for almost forty years. My partner Máirín and I along with our two young sons, Tadhg and Seán, moved from Dublin in 1983. We decided after much thought to live on the west coast between mountain and sea. About half of those years were spent near Markham's Cross, Mullagh, just a short stroll from the house of Martin Junior Crehan, a well-known fiddle and concertina player, composer, storyteller and singer. We bought a house and an acre of land there where I grew vegetables, planted trees, cut turf in Kilmihil bog and brought five-foot logs from Mount Callan, which were cut, stacked and seasoned for the open fire in winter.

Later, we moved to the Ennis Road in Miltown where I now stand and view my beloved Mount Callan guarded by its white sentinels that swirl in the rising wind. But songs like the elegy for my brother Pat, though written in Clare, take me back to South Kerry and to my mother's and grandfather's songs – to Bolus, Cill Rialaig, Kinard East and Cahersiveen, where Pat was taken by meningitis when I was fifteen. He was and always will remain seventeen. Meningitis wasn't unusual in the fifties and sixties and the distance from Tralee and later Dublin probably didn't help. Christmas 1967 dawned and on that St Stephen's Day, known as the 'Wren' or 'Wran Day' in several parts of Ireland, Pat and I along with our brother-in-law Michael O'Connell tramped the country roads singing, playing and collecting money to 'bury the wran'. It was our last day together in the open air. Pat became ill shortly afterwards and left us on 17th February 1968.

> We thought we'd live forever and face each storm together,
> And trace the sacred song-lines from the mountain to the sea.

I cannot say for certain when I first heard the soft voice and relaxed style of broadcaster Ciarán Mac Mathúna on Radio Éireann. I was immediately hooked

and it gave me a key to a much wider, deeper and emotional world of music and song. His bilingual Sunday afternoon series, *A Job of Journeywork*, brought the musical voices of Sliabh Luachra, Clare and many other regions onto our hearth-stone. Kilrush, Kilfenora, Tulla, Doolin and Miltown Malbay became familiar to me through the glorious playing of Elizabeth Crotty, the Kilfenora and Tulla Céilí Bands, the Russell brothers, Peter O'Loughlin, Willie Clancy and a host of other musicians and singers. The music travelled far outside its own parish and had a huge audience among Irish emigrants scattered throughout England and America.

My first journey to Clare in the mid-seventies began in Leitir Mór, Connemara, continued through the beautiful Burren that bridges Galway and the Banner County, and ended in Miltown Malbay. The colours and mysterious spirit of the Burren landscape left me in awe of a special, holy place. I have revisited it many times since and eventually penned 'Cry of the Mountain'.

> O wild pulse of beauty and famed ancient rooms,
> Where the cranesbill and sandworth and spring gentian blooms,
> And the white-throat and wheatear their migrant-song bear,
> And the *pocaire gaoithe*[1] is king of the air.

That August day I camped at Spanish Point and eventually joined a session of music and song which was in full flow in Friel's pub on the Mullagh Road. I immediately felt at home, not just because of the music but I also sensed warmth and welcome there, and an ease amongst players that can only flow from people who know and enjoy their own traditions. Marty O'Malley, set-dancer, singer and unofficial mayor of Miltown, was master of ceremonies and Marty was one of the best at his craft. I heard Mike Flynn, the great local traditional singer sing of love and emigration in 'A Stór mo Chroí', and when Marty gave me the nod I sang Sigerson Clifford's 'The Boys of Barr na Sráide', a song I associate with St Stephen's Day, the friendships of youth and bonds that last a lifetime.

> Ag siúl dom ó Chros Mharcaim go Sliabh Callán
> Titeann nótaí mar dheora sa bháisteach bhog,
> An Sliabh faoi Chaipín Ceo,
> Caisleán an Óir,
> Slán le Sráid na Cathrach…

1 *Pocaire gaoithe* is the beautiful Irish term for the majestic kestrel.

My singing, my composition and my love of music are greatly influenced by piper and concertina player Tommy McCarthy, singer Tom Lenihan, one of the founders of the Willie Clancy Summer School, Muiris Ó Róchâin, and fiddle player and composer Junior Crehan. I was aware of Junior's playing and reputation from my first visit to Clare, but the first time we shared a conversation and a glass of stout was in Gleeson's pub in Coore. Gleeson's was a family-run pub and shop with Nell and Jimmy Gleeson as hosts, and it was here that Junior and friends shared their music and knowledge every Sunday night for well over forty years. Junior was master of ceremonies here, giving the nod to the other musicians when it was time to begin, introducing visiting musicians, coaxing the set-dancers to the floor and teasing songs from the singers at various intervals.

I drove him home that night to his house in Bonavilla and he promised me the gift of tree saplings, for he knew that my acre was bleak and unsheltered from the sea-spray on the wind. And sure enough, when the postman's van pulled into my yard the following afternoon, he bundled out some hedging plants as well as ash, sycamore and rowan saplings. Typical of Junior, a soft, gentle, easy-going man full of music. Twenty years after his death, I was privileged to be part of a TG4 documentary on Junior, a documentary that well captured the man and his music, music rooted in the country houses of the 1920s and early 1930s.

'The country house was the place we learned our dancing, singing, sets, the whole lot,' he tells us in the documentary. Quick to acknowledge his own musical heritage, he continued, 'The older players, if you were interested in music, you'd listen to them and get that way of playing.' What also struck me in watching the documentary was his focus on others. Music was for dancing; he took his cue from them. 'You'd go with the feet, you'd watch the feet; and you'd have to strike up as fast and play better time for them.'

A man of music and also a man of strong opinions. Junior was saddened and angered too when he spoke of the suppression of the house dances through the Dance Hall Act of 1935. 'Our traditions were trampled on. We had nowhere (to go).' If he was despondent at the loss of the house dances and the potential loss of the tradition he so loved, he need not have worried. That tradition is alive and well as evidenced in the documentary, and particularly by the playing of his grandson Eoin Hanrahan. He too pays his dues to his grandfather's playing and playing style. 'Ní raibh aon deifir ar a chuid ceoil.'

On the first anniversary of his death in 1999, I wrote 'Scarúint' in his memory.

Seated by your bedside that Thursday as you prepared to leave
Matt played The Parting of Friends . . .
Later you grasped my hand, your voice surprising me
With its strength when you said,
'Keep singing the songs,
Music, song and dance were my life,
The house dances my university.'

I was fortunate in my timing of that first visit to Miltown in the mid-seventies. The Merriman Summer School that first began in 1968 was in session in Lahinch that weekend. Cumann Merriman is named after Brian Merriman, poet and author of the celebrated eighteenth century Rabelesian poem, 'Cúirt an Mheán Oíche', or 'The Midnight Court'. For years, Merriman was a regular feature in my life. One of the School's stand-out moments was Seamus Heaney's lecture on Merriman in Lisdoonvarna in 1993.

Reputedly born near Ennistymon, around the year 1747, Merriman taught school and farmed for many years in Feakle in East Clare. His 1,000-line poem on the plight of young women without husbands, clerical celibacy (while little is known of his early life, a number of commentators have suggested his biological father was a priest), free love, and the misery of a young woman married to a withered old man. I remember reading it and Frank O'Connor's wonderful translation as a young man in Dublin. It is probably the most famous poem in the Irish language, an astonishing achievement, a masterpiece – word-rich, bawdy, uncompromising. Seán Ó Tuama, himself an Irish language poet of some renown, has described 'Cúirt an Mheán Oíche' as undoubtedly one of the greatest comic works of literature, and certainly the greatest comic poem ever written in Ireland.

Set in a court, the poem is an assembly of women, presided over by Aoibheall, a queen of the *sídh* at Craig Liath, County Clare. It begins as the poet walks out on a summer's morning and encounters a vision...

Ba ghnáth mé ag siúl le ciumhais na habhann
ar bháinseach úr 's an drúcht go trom,
in aice na gcoillte, i gcoim an tslé',
gan mhairg, gan mhoill, ar shoilse an lae.
Do ghealladh mo chroí nuair chínn Loch Gréine,
an talamh, 's an tír, is íor na spéire,
taitneamhach aoibhinn suíomh na sléibhte
ag bagairt a gcinn thar dhroim a chéile.

When Clare FM opened in September 1989, I was invited to present a weekly programme of traditional music, song and poetry that ran for fifteen years. Marking Clare FM's official opening from the Old Ground Hotel in Ennis, I was asked to read a poem on air. This is part of what I read:

> Is dearfa bhím um shíorthaspánadh
> ar mhachaire mhín gach fíor iomána,
> ag rince, báire, rás is radaireacht,
> tinte cnámh is ráfla is ragairne,
> aonach, margadh is Aifreann Domhnaigh
> ag éileamh breathnaithe, ag amharc is ag togha fir.

I'm not sure if the great seanchaí from Cill Rialaig in South Kerry, Seán Ó Conaill, ever heard of 'Cúirt an Mheán Oíche'. It's quite possible, though a century lay between them, that lines of the epic poem reached his ever-curious mind. I like to think of him and his great friend and neighbour, my maternal grandfather Pádraig or Peats Ó Ceallaigh, himself an outstanding traditional singer, trading lines from this great poem. Ó Conaill remains an extraordinary enigma. Though he never attended school and never learned to read or write, he absorbed and presented every aspect of a rich oral tradition so that when Séamus Ó Duillearga of the Irish Folklore Commission visited him between the years 1923-1931, he left with over 200 stories in the Irish language, tales of great length and depth and variation. These were later published in the collection *Leabhar Sheáin Uí Chonaill* in 1948.

My grandfather Peats Ó Ceallaigh wasn't all that interested in stories apparently, but he became deeply absorbed in traditional singing from an early age, amassing a huge store of songs in the Irish language which he sang with a primitive passion right up to his death in 1948. Life in Cill Rialaig and elsewhere on the Iveragh Peninsula in County Kerry was unbelievably difficult in the lifetime of Ó Conaill and my grandfather. Farming a small holding of some twenty-five acres, much of it mountainous and marshy, they eked out a bare existence from a rocky soil. They lived mainly off the sea, a crew of eight in each seine boat in the open wild Atlantic. But both men settled and raised large families. And during those long nights from *Samhain* to *Lá Fhéile Pádraig* they passed the time singing songs and telling stories to their receptive families and neighbours who gathered nightly in Ó Conaill's kitchen.

There's a wonderful book, *Gaelic Grace Notes*, by Séamas Ó Catháin of the Irish Folklore Department in which I discovered a photograph of Ó Conaill and Ó Ceallaigh taken by Norwegian Ole Mork Sandvik, who visited Cill Rialaig in 1927

to collect songs and stories as part of a state-sponsored linguistic project. Both serious, my grandfather almost stern-looking, standing side by side by a sea-facing stone wall outside Ó Conaill's house. A photographic aesthetic of its time. Ó Conaill was taller than my grandfather, waist-coated with sleeves rolled up. In contrast, my grandfather is standing hands by his side almost militaristically, wearing a home-knit jumper and a cap tilted to the side. It is an astonishing photograph that draws me into another life and place. My grandfather would have been forty at the time and my mother Nora a mere fourteen.

A year later, in 1928, two German linguists, Wilhelm Doegen and Karl Tempel, also visited this village and collected some songs from Peats Ó Ceallaigh to which I now listen regularly. When I first heard these songs almost forty years ago I was stopped in my tracks, for here was a singer who embodied his own place in his songs and rhythms. His voice had a primitive wildness and depth of beauty that spoke of the wind on the mountain and the breeze over the sea.

One of the songs I now listen to, 'Bean Dubh a' Ghleanna' ('The Dark Woman of the Glen'), is a beautiful haunting song and a favourite of my father Tadhg and my mother Nora. Both had learned it from my grandfather, a singer they clearly held in high regard. There is little doubt that my mother in particular, who sang constantly and sweetly as she went about her daily chores, made these songs safe for myself and for future generations. I picture her now in the early afternoon in her kitchen in St Joseph's Terrace, Cahersiveen. The cards are spread on the table in a never-ending game of Patience, a dipped Kimberley lies beside a cup of Lyons tea as she hums a warning refrain about the deep and false waters in the Lake of Coolfin. This is Nora.

My father Tadhg could carry a tune also but he was much more the outdoors man where he felt totally at ease. He enjoyed phenomenal health and I never knew him to dodge a day's work and he rarely darkened a doctor's door. Hunting the hare with a pack of Kerry beagles was his passion, and he knew and named every inch of mountain and field on the Iveragh Peninsula. Lily and Fairmaid, his last two beagles, coursed those fields at his side. When Fairmaid died of old age, we dug a grave on a friend's farm near Ballycarbery Castle overlooking the water to Valentia Island. Our silence spoke in tomes of unwanted sadness for we both recognised that this was an end of sorts and that my father too had stepped on to the final furlong. When the end eventually came, after an epic struggle, we readied to bring him on his final journey from Valentia Island Nursing Home to the O'Connell Memorial Church in Cahersiveen. A mountain hare sat in the driveway in front of the hearse for what seemed like an eternity before leisurely pushing off towards the water, ferrying Tadhg's spirit home.

Fragile as a buttercup, the pain in seeing you growing up,
Leave innocence, simplicity behind,
Characters of fiction free, organised in lines of three,
And brushed aside by harsh reality,
Brushed aside by harsh reality.

It's 7.00 am on the last Friday of April 2020 and I place those slightly older feet a little less firmly on the floor. I meditate, recall missing friends and this morning I focus on the present – Máirín, Tadhg and Seán and my grandchildren Saoirle, Cuán and Myles. I hum a verse or two of 'Farewell to Pripyat', a song I wrote for the citizens of that ghost town adjacent to Chernobyl who were forced to leave their homes due to the nuclear disaster of April 1986.

I stand by my open window, Mount Callan to the east. Storm Hannah is a distant memory and even the storm within has abated somewhat, the mood lightened. Like almost all of this month, the weather this morning is dry. The swallow and the cuckoo and the house martin have journeyed to join me in chorus. I stand and I listen.

High above Loch Buaile na Gréine on Mount Callan the *pocaire gaoithe* hovers. He summons a warring cry from deep within, eyeing with intent the voles and field mice far beneath. Then with a piercing cry dips, strikes and soars...

(All the songs quoted in 'A Cry from Within' are taken from *Old Boots and Flying Sandals*, a compilation of original songs and favourite poems by Tim Dennehy, Sceilig Records SRCD 005, 2007. Lines from 'Cúirt an Mheán Oíche' are taken from '*An Duanaire*', *Poems of the Dispossessed, 1600-1900*, compiled by Seán Ó Tuama and Thomas Kinsella (the Dolmen Press in association with Bord na Gaeilge, 1981). The TG4 documentary *Junior* was first broadcast in December 2018.)

Biography

Tim Dennehy

Tim Dennehy is a poet, singer-songwriter, broadcaster and teacher. Born in Ballinskelligs on the Iveragh peninsula, the family moved to nearby Cahersiveen while he was still quite young. He inherited his love of songs and stories and an affection for the treasures of the Irish language from his parents Nora and Tadhg. While living in Dublin Tim co-founded Góilín Singers' Club with Dónal de Barra in 1979. Over forty years later, it still meets each Friday in the Teachers' Club, Parnell Square. On moving to Clare in 1983 he helped to establish Féile Amhránaíochta an Chláir which hosted a very successful festival of singing in Ennistymon, County Clare for many years. He also presented, *Keep in Touch*, a popular programme of traditional music, song and poetry on local radio station Clare FM.

He has six albums to his credit including, *Between the Mountains and the Sea*, a tribute to Cahersiveen poet Sigerson Clifford, and *Old Boots and Flying Sandals*, a compilation of his own original material. He is currently working on a book of his complete collection of original and traditional songs. He lives in Miltown Malbay where he has immersed himself in the local music, dance and song tradition. He continues to perform, lecture and write on various aspects of that tradition. He also facilitates song workshops at music and song festivals throughout Ireland and in London, Paris and The Hague. In the United States, Tim has tutored regularly in Boston College, Milwaukee and the Catskills.

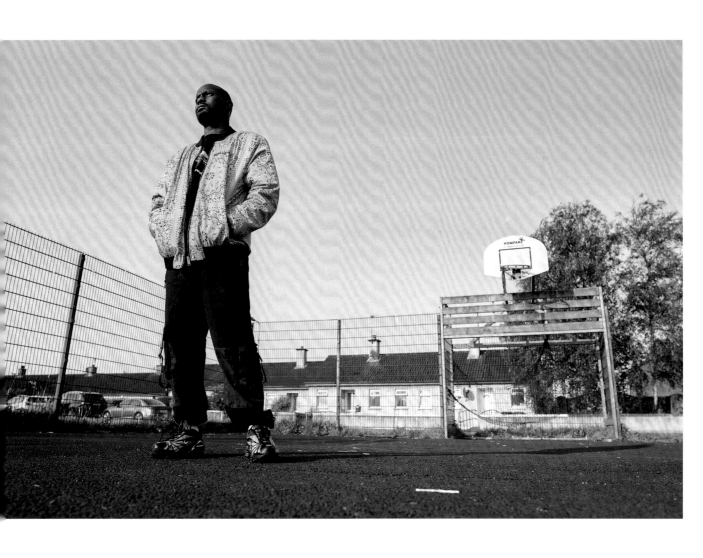

Uncaged

Godknows Jonas

My world shrank in Sheffield. Arriving in Sheffield at nine years of age was one of the most bewildering experiences of my life. My Dad, Godknows senior; my Mom Peggy Kofi and my brother Godwill. We lived in a semi-detached house on Skinnerthorpe Road in a very ethnically mixed area: there were a lot of Pakistani families, Yemeni families, Arab families, native English people, Jamaicans, Somalis and other Zimbabweans. Probably even more diverse than that.

It was tough. In Zimbabwe I had romanticized the UK and the USA. A candy-floss world: sweet and cheerful. I loved Peter Pan. Barney and Mr Bean. It's not that I expected to see Barney walking down the street. It was more like believing I was about to enter this imagined Sesame Street world with big white smiles. Just joy.

I mean I was really excited. Finally going to the UK.

Moving was such a shock. Suddenly, I am in a semi-detached house and suddenly I am not allowed go anywhere. My parents were afraid. There was a number of racial attacks at the time; a young man stabbed to death. My parents were going, 'You're going nowhere.' The world I had imagined did not exist. It was like the tearing of the seams of my innocence.

My innocence made me stick out. Everyone my age was acting like they were ten years older and I couldn't get my head around why. 'Oh, you know, you need to look good for the girls.' I was nine! So, I felt I was playing catch-up. But so too was everyone else. It was as if everyone was trying to find a place for themselves. And not just physically. But probably that too. Everyone was acting out.

Sheffield was largely an indoor experience. PlayStation and VHS music tapes. Those things that now clog our attics. But not Zimbabwe. If my world contracted in Sheffield, the world I knew before I came to Sheffield was the opposite of that world. It was a world without limits, an expansive world.

My name is Godknows Munyaradzi Jonas. I was born in Harare, Zimbabwe in 1990.

I had an incredible childhood. I was so blessed and lucky to have a childhood that any kid would want to have. A childhood that was filled with innocence. Filled to the brim with innocence. I felt like I could wake up in the morning and go wherever I wanted and come back and be okay. I was surrounded by aunties and cousins and uncles, cousins of friends and friends of cousins. Go visit my grandmother. Go here and there. Go different places, I wake up in the morning and feel like I could roam. I always felt the world was mine.

In Zimbabwe, you don't just have one home. You have many homes, many people's homes. I truly lived in a community where it takes a village to raise a child. It was excellent. Not one day did I feel I was in a place that was unsafe for me to be. Even though I was in an urban city. I truly had a beautifully protected childhood. So, that's my memory of childhood in Harare.

We lived in Buduriro township. I never felt this was a small world. Maybe that's what gives me the mentality. I don't feel restricted as a human being. Aunties and uncles were always dropping in and out. And some of them dropping in and out meant five years, some of them two months. Some of them two weeks.

Nelson Mandela put it in a beautiful way in his book *Long Walk to Freedom*: we Africans really look out for each other. There's no such thing as a lost cause. 'You need a new start in life? Go stay for a while with your cousin until you get on your feet.' Your cousins are your family even if they are just remotely related to you.

What's interesting is that intimacy is possible in a large extended family. We think here in the western world that intimacy is only possible in a tightly-knit family. In Zimbabwe, the people who wanted to come into your life, really wanted to come into your life. And the people who stayed away had a reason to stay away.

I left Zimbabwe when I was nine years old. Almost one-third of my life up to now was spent in Zimbabwe. A very joyous time. I was very very lucky in that as a child, I retained my innocence.

Zimbabwe is a gorgeous country. One of my favourite memories that I go back to every once in a while is waking up in the morning surrounded by fields full of apples. Smelling the bacon that my uncle was just cooking outside. The beauty of how vast and gorgeous and lush the countryside was.

Independence was bittersweet. Politics in Zimbabwe is a very touchy subject. Freedom of speech in Zimbabwe is something that is not really there. Even here in

the safety and comfort of Ireland, I still have the sense of, 'Do I mention the man's name?' He was such a bogeyman character and the regime still is. So, it's very difficult. All I know is that when we got our independence, Robert Mugabe played a central role and it was good. There was a time when Zimbabwe was the envy of Africa. But when it got bad, it got really bad. Dictatorship; the same people hanging on to power for dear life.

At the time I left, people still had hope. People were positive about the future. People could speak openly. There was a sense of we can do better. Why aren't we doing better? Let's do better. Things hadn't reached the desperate state that was to come. That optimism has now faded into utter despair. But as a kid, all that passes you by. Power everywhere corrupts. And the corruption of power results in ruined lives and in the case of Zimbabwe a ruined country. That's the legacy we are living with. A country in tatters.

In 2001, my Dad got a job offer with Aerospace in Shannon. We moved in 2001. I was eleven-years of-age. When I arrived in Shannon, I thought and I still think, 'My God, I got my innocence back.' The kids in Shannon of my age were that. Just kids, unlike the kids in Sheffield. Suddenly in Ireland, I could be a kid again in this small made-up town. For the first time in two years I was told: 'Go outside. Go and play. Just go and be a kid.' And, man, it was 100 per cent safe, a vast and stark difference between living in Sheffield and being in Shannon, I found that innocence again. I could be myself again.

I went to St Conaire's Primary School. It was good. I loved it. Much more welcoming kids than in Sheffield. Kids who were happy to be kids. 'You like wrestling? Yeah, I like wrestling.' I was the only black kid in the class; there was another black kid in the school. A couple of other Indian families. Probably something like five of us of other nationalities.

Secondary school came with an awareness. Maybe I have big hands. Puberty is about knowing who you are in your body. That's when I went: 'My gosh! I am black.' Of course, I already knew I was black, but the weight of it, the weight of the world. You start to notice.

Awareness of my blackness around other black people is very simple. There's my Dad, my Mom. There is no weight. But being a lone black in a school in that small town carried its own weight. It's 2003. I'm thirteen years of age and I'm in St Caimin's Community School. I was the only black kid in the school. Here, I was in a uniform in a rugby school with people, some of whom I experienced as

genuinely racist. Now in 2021, we can see foul things happening in the world. I can say that; boy, there was a lot of racism then. And in a systemic kind of way.

I'm thirteen. Someone asks a question that they probably learned from their parents. That's when you go, okay, 'You really do think I am different.' Here I was thinking we are just kids. I'm like, 'He thinks I'm different.'

They take our jobs. They take our houses. They pee in the pool when they go swimming. They live in the houses that the government gives them. The foreigners. Yeah, I was getting that message from other kids. Comments which I knew could only have come from their parents.

Racism from the staff too. Absolutely. From some. Certainly. Micro-aggressions. 'You people.' What you mean, you people? Teachers? Oh yeah. Things of that nature. It's like when someone makes an off-comment about your weight. You go home and you go, 'Hey what did he say about my weight?' Imagine that about your skin. In the moment you don't really react. Because it's not like they've outrightly said something that will make you flip a switch. My friends would have said it to me after class, 'Did you hear what that teacher said to you?' And I'd go, 'Whoa, that's what I heard too.' When the others in the class said it to me it also confirmed what I thought I heard. As if I doubted myself. And it wasn't just one person. It was two or three persons. And they'd go, 'Are you okay?' One of my biggest regrets in school was I didn't go, 'Wait, what did you mean?' That was difficult; having to deal with those kinds of micro-aggressions.

As a way of dealing with some of the racism I experienced in those years, I started writing. I drew from what was always within me, the love of music.

Five years old there was a morning show on Zimbabwean TV called *Afrobeats*; my first introduction to the Congolese artist Pépé Kallé. He had a hit song about Roger Milla, Cameroon's four goal hero at the Italia '90 World Cup, a song that was legendary throughout Africa. I still play it when I'm DJing. I was also listening to Lucky Dube, Take That, Spice Girls. My palate was just wide open. It was like the *hors d'oeuvre* of music. American, English, Zimbabwean, African, all that music came to me as a kid.

Initially, writing did not come easily to me. I didn't have it for maybe four or five years. I was writing poetry, rap, listening to the lyrics of Eminem and learning from him. I was mainly writing about girls. That's what you do as a fifteen and sixteen year old boy. New York in the nineties had a boom-bap sound. In the

southern states they had a trap sound. Different influences at different times: late 1960s, reggae music from Jamaica; 1970s, hip hop from The Bronx; 1980s, New York garage sound, and early 2000, London grime sound. I could take from all of them. At the time, I was also listening to Kanye West: he's my broken uncle. He was one of the huge influences, a kind of turning point. Other influences were Nas, Jay Z, Snoop Dogg and 2Pac. From my African tradition too from what used to be referred to as the negro spirituals of the Deep South of the USA. As a writer you draw from whoever has the most depth. The challenge for a writer is how much depth can you have while entertaining people? Can you be entertaining while retaining depth to your writing and music? How good is your storytelling? How good are the images, metaphors you dream up? The similes. Have you got something to say that is enlightening people, that gives people something new?

My work is very autobiographical. It's a gift. I'm great at describing what's going on inside me. I speak of what's happening in the moment. I rap about the ordinary. I rap about what's happening. And I always like to inject a bit of humour. So, you can smile. You think these things and you smile.

> 11.59 on the toilet
> Same crap
> Different day
> Coming into your life
> From revelation year
> Why does this all feel like a very long day?

Random Acts of Kindness was never a band. It was more of a collective of Shannon creatives. Jason Livingston, a pastor at the London-based A Radical Church came to preach in our church. His is a prophetic voice and he has a passion for God and God's word. My best friend MuRli, who is originally from Togo, was in church that day. Pastor Livingston told us, 'God is ready to give everything you want to Him, what are you going to give back to Him?' I remember we were baffled by this for a month or two and thought: What can we give back to Him. He's our Father. Our God. What do you do? Do good. What does do good look like to a twenty-year-old? See other musicians who want to play music. Bring them in. 'Come along.' We did that for maybe two years That was how Random Acts of Kindness came into being. Fourteen in all. I was a rapper. MuRli was a producer and a rapper. We had Zimbabwean kids, Sudanese, Latvian, Togolese, Filipino. All boys and then Denise Chaila, whose family came from Zambia, joined us.

We were doing gigs in places like the Ennis Street Festival and Ennis Youth Centre where we first met John Lillis, mynameisjOhn. Through John's contacts we were invited to play at Electric Picnic in 2012. I was twenty-two at the time.

I always thought I could do this. My uncle Chinx Chingaira was a celebrated musician in Zimbabwe. A producer as well as making his own music, he was a celebrity in the late eighties, early nineties. He was brimming. He fought for independence, was on television all the time, was doing big galas and gigs, so for me nothing was big. This is what I thought I'd be doing. By the time we finished performing, the field was full of people dancing. And I thought, cool, we've got something; mynameisjOhn felt the same. Myself and MuRli always saw ourselves as big international superstars. I was calling it out. It was time to move on from Random Acts of Kindness. Awkward, yes, but time.

Myself, John and MuRli released an EP in 2014. Now I'm twenty-four. We started gigging, released an EP and formed The Rusangano Family. *Rusangano* means togetherness in the Zimbabwean Shona language. The EP did pretty well. That year we supported Snoop Dogg in the Academy in Dublin. That was probably the first moment that people thought we're capable, that we are musicians who are worthy of respect.

What's next? You do a great album. So, we moved into that space. *Let the Dead Bury the Dead*. In the Bible, Luke 9:20, one of the disciples wanted to go bury his Dad and Jesus said, 'Let the dead bury the dead.' It was like, 'Hey Jesus bro, what did you eat this morning! That's a bit harsh. Give me a break. It's my Dad. I loved the man.' For us, 'Let the dead bury the dead' meant, 'We're going for it'. Walk into your purpose. And that's what Jesus was trying to say to one of the *mandem*. One of the lads. One of the disciples. Your Dad will be taken care of. I'm Jesus. That's what it meant for myself and MuRLi. It also had another significance. Brother John Lillis, his father, was diagnosed with cancer at the time. It was a hard time for him. For John, it meant he's really burying his father. He's really grieving for his father as we make the album. That's weight on a very lovely creative human being. That title had so much weight and gravitas to it. We had no choice but to make a great album. There was so much going into it.

The album won the 2016 RTÉ the Choice Music award. That was big, man. The biggest. One of the best nights of my life, so far. That was out of nowhere for us. It wasn't that we knew we were a shoe-in. It was more like, we are not going to win. Lisa Hannigan is nominated. James Vincent McMorrow is nominated. Girl Band is nominated. Saint Sister is nominated. So many different legends who

were nominated for this coveted prize. We're back stage and we don't know what's happening, and suddenly you hear your name being called and then you go, 'okay, okay, snap, we've really done something special here.' We were the first hip-hop group to win this award.

We wanted to make a difference. *Let the Dead Bury the Dead* made a difference. Every artist wants to make a living from their art. This is what we wake up to and do every day, by the grace of God. Making art, and making a living while making art, is the dream for me. At the moment, I am making money from my creative endeavours. I'm now a celebrated Irish musician. Winning the Choice music award was an amazing boost.

I was born in a Christian family but we didn't really practise when I was growing up. When I came to Ireland, that's when I had an encounter with God. I was eleven years of age. That encounter with God took place at a Christian camp in Newbridge, in Kildare. That was amazing. On the last day in camp, the pastor asked each of us, 'Where are you going to go after you die?' And suddenly, I thought, Yeah, that's the big question. I never thought about that. Okay. Cool. So, I thought I want to get to know God. That's when I would have become a born-again Christian.

Living as a Christian as a teenager is quite difficult. You still have to live in the world. You're thinking girls, the Ten Commandments, and you're going, 'I can't live up to this.' So I'm gonna come back to it when I'm forty. I remember telling my friend, 'yeah, we'll come back when I'm forty-five.' But when God tugs at your heart you go, 'okay.' I started going to Bible studies. That has deepened my faith. I've gotten to know God at a deeper level but I'm still a musician. I walk with Jesus now. The Holy Spirit. The Father Spirit. The Son. I walk with the Word and with the man of Jesus as well.

Walking with Jesus informs my music but I try not to be preachy. I don't like that type of music. No one does. I want people to draw from my music. I try to write music. I just happen to be Christian. I'm a musician who happens to be Christian. There is no contradiction between those two things. That's where my heart is.

This is who I am.

I'm Irish and I'm Zimbabwean. I'm both, 100 per cent. I'm 100 per cent Irish and I'm 100 per cent Zimbabwean. There are of course people who try to tell me I'm not Irish. And there are people who try to tell me I'm not Zimbabwean either. I've

been in Ireland for nearly 18 years. Yeah, man, I'm both. I love being Irish. And I love being Zimbabwean. So, I'm not going to deny either of the two.

I love being from Shannon. I am a Shannon town resident. It's peaceful after a busy touring schedule. Coming home is just great. It is amazing. It is such a blessed place. It's a better place than when I first came. It's much more multicultural. Those barriers that were there have been torn down or torn asunder. It doesn't mean that racism is gone. Racism is still very much alive in small towns across the country and in the country as a whole. And Shannon is no different. I'm lucky. I no longer experience racism. Those micro-aggressions of my childhood don't happen to me anymore.

I'm Godknows. I grew up with you, I'm your friend, I'm your neighbour. But racism is real. It is experienced and just because I am not experiencing it, doesn't mean it's not there.

And I'm here. And I'm not going anywhere.

Biography

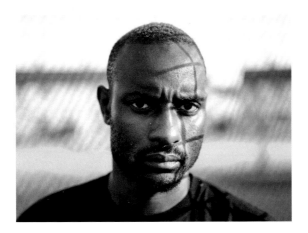

Godknows Jonas

Described by *The Irish Times* as 'the rapper with the all-knowing eye and the flow to turn observations into sharp lines', Godknows Jonas was born in Zimbabwe and grew up in Shannon. He initially came to the attention of John Lillis, aka mynameisjOhn, music project manager with Clare Youth Service, and from which a musical collaboration emerged. Together, they produced what the same newspaper called 'a humdinger of an album by the Rusangano Family, full of energy, vigour, excitement, innovation and lyrical realism.' They were later joined by Murli Boevi, aka MuRli, originally from Togo. Their first album *Let the Dead Bury the Dead*, won the Choice Music Prize in 2016. Entertainment.ie named it among the top 10 Irish albums of the decade 2010-2020. In March 2020, Denise Chaila, Boevi and Godknows formed Narolane Records and the following year released *Water* to 'flesh out the truth of our entitlement to dignity, to joy, to life. To pure water.'

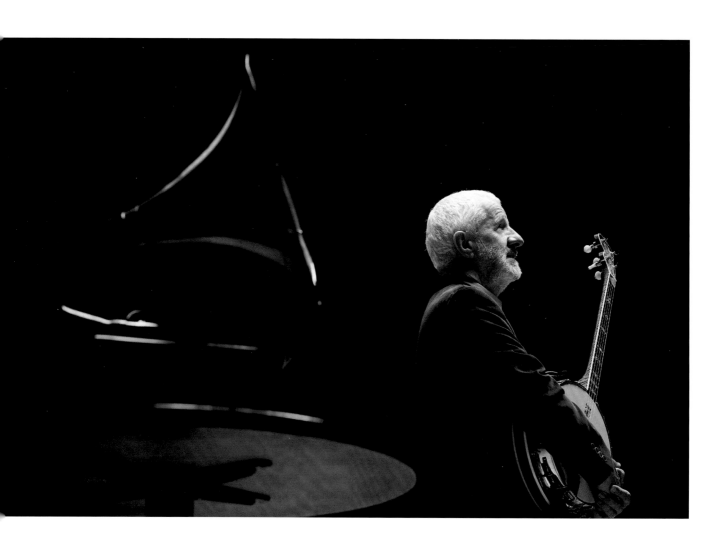

An Ear for Music

Kieran Hanrahan

The place lit up when Tom Tuohy, my granduncle, who was also Paul Roche's granduncle, walked into a room of expectant dancers. He was my granduncle on my father's side and also granduncle to Paul on his mother's side. Jovial and strikingly tall, he had a big presence wherever he went. He came from Lisheen out Ballynacally way, and he played the accordion. His sister, my grandmother Aggie, was Paul Roche's grandmother too. Tom's music was for dancing. 'The Sally Gardens', a lively reel, which has no connection with Yeats's 'Down by the Sally Garden' as some people assume, was his favourite. At the time all people wanted to hear were jigs and reels and he was well capable of playing them. There were many family occasions, more often than not a family wedding, when a bit of *spraoi* was called for. On those occasions, Tom Tuohy was the man to lift the spirits.

This is part of my musical heritage. A country heritage for a young fella who grew up in a working-class estate in Ennis. My mother, Mary Kelleher, came from Tiermaclane and my father, Jackie Hanrahan, from Barntick, just outside Clarecastle. They married in 1954 and moved to St Michael's Villas in 1957. Constructed by the County Council in 1953 at a cost of £100,000, about the same price that it cost to build the County Hospital a decade earlier, St Michael's was at the time outside the town boundary. As a result, it accommodated rural families who wanted to move closer to where they might find jobs. Ennis at the time was no more than a small town. The 1951 census reported that it only had a population of 6,097. Pre-famine Ennis had a population of 9,300 – a loss in the intervening years of almost one-third of its population. This was the early 1950s, a town in decline trying to re-assert itself. The previous year, Hermitage or the Tage, as we knew it, was built by the Ennis Urban Council as part of its urban renewal scheme, which sought to address the appalling overcrowded living conditions in the lanes between the River Fergus, Parnell Street and Abbey Street. Both were working class estates but their origins were entirely different. All of this, of course, passed us by when we were growing up. Awareness came years later. We were all just working-class fellas and girls trying to make our way. Passed by too in terms of having any real significance was the stand-out grotto built in 1958 at the entrance to St Michael's Villas just off Clonroad, testimony to a time, now long gone, of the all-embracing reach of the Catholic Church in Ennis and elsewhere, but to which, for the most part, my friends and I were indifferent.

For the parents of St Michael's, though, it was important particularly in the month of May and other religious feast days, all of which we were very anxious to duck out of and make our escape when we could.

A working-class estate of seventy-six houses with two shops at the top of the villas. Terraced houses set around a rectangular-shaped green area, 'The Green' that served as our Cusack Park, Dalymount Park, Lansdowne Road and RDS where we followed the exotically-named (as we thought at the time) Captain Raimando D'Inzeo, the Italian show jumping rider who, according to Pathé News, cleared 'a breathtaking 7 feet, 1 inch wall' in the Puissance event at the Dublin Horse Show in 1973, sharing first prize of £500 with Captain Larry Keeley of Ireland. (I looked it up.) Even Wimbledon got a look in, thanks in the main to the all-absorbing Björn Borg-Jimmy Connors rivalry.

Eight children were reared in our house. Number forty-six. Three-bedroomed houses that accommodated ten people, even if they were never designed for that number. The many extensions came later. This was the era of big families and ours was no different. Two doors from us were the O'Loughlins, in which there were seven sons. There was a big family of Kierses. Coffeys, Dinans and MacMahons too. Paul Roche's family lived in number twenty-three. At a guess, around the time I was growing up, there were over 100 children reared in St Michael's. Prams and children. Some of my earliest memories of St Michael's.

This was the era of mothers working at home and fathers going out to work. But for many Ennis working-class women, and I suppose for many working-class women throughout the country, some went out to work. Derry's shirt factories, the Sunbeam in Cork, Cleeve's sweet factory in Limerick. Braids was our shirt factory and sweet factory rolled into one. It opened on Station Road sometime before the Second World War and was a big employer. A photograph I came across recently taken in 1955 suggests that there were well over 100 people working there at the time, mostly women, many of whom started as young as fourteen. However, some men were employed to keep the machines going. I remember coming across a YouTube clip from the Clare Oral History and Folklore Group which featured an Eileen Dinan who said the factory kept the town going during the war. They made shoelaces, with the tags on the laces, zips and all kinds of braids, a long way from the high-tech multinational world with which we are now all so familiar.

The men in St Michael's, a mixture of townies and country men, worked in a variety of jobs as plasterers, builders and labourers. Some worked with the ESB,

P&T, CIÉ, and with Clare County Council. The women, the heroines of the Villas, held it all together. Years later, my sister Gabriella interviewed some of them at length as part of her research dissertation for an MA in Sociology in NUI Galway. This is how she described these strong women.

> The first group of young St Michael's mothers established a tight-knit caring community that remains intact today. These young women had limited or no opportunities to develop their skillset outside the home. Consequently, not only did they share their sugar and milk, they shared their own learning as young women and mothers. They became experts in reliance, caring, *cnáimhseachas* and mentoring. They were the financial controllers, teachers, cooks, bakers, seamstresses, knitters, gardeners, lovers, comedians, singers and disciples of their religious faith.

Growing up, St Michael's was a very vibrant place. There was the famous 1966 St Michael's/Ard na Gréine hurling team in which my brother Ger was captain and on which my other brother Joe played. Others from St Michael's at that time – even though I was only eight, I remember – were Sean Dinan, John Leahy, Sean Hahessy and Oliver Skerritt, who has sadly passed away, Jackie Hynes, Martin Corry and a young German lad by the name of Ian Biddulph. I've no idea how his family ended up in Ennis, but at that time there were very few people with, for us, hard to pronounce names. In St Michael's, there were MacMahons, Ryans, the O'Loughlins, Coffeys, Dinans, Roches, Leahys, Hahessys, Howards, O'Flahertys...

Then in 1970/71 the St Michael's Céilí Band started up. There were ten of us in all in the band; my brother Ger was on drums, Joe on the accordion and I was on the tin whistle. Mike, who would later feature as the lead singer in Stockton's Wing, was also part of the band. Mike was mostly off upstairs listening to and singing Leonard Cohen songs. Vincent, Patrick and Michael MacMahon and Paul Roche were also in the band.

One of my earliest musical experiences was playing in the CBS primary school marching band. We played at matches in Cusack Park and I have a memory of playing at a match in Miltown Malbay. There was a big emphasis on music in the CBS. Bobby Burke in second class and Brother O'Shea in third class taught some of us to play the recorder. This was also a time when the school put on quite elaborate school concerts. One in particular I remember was modelled on the 1968 television series *Bring Down the Lamp*. Again, from memory, Mick Hayes produced that show.

Brother Taylor was instrumental in our development as young musicians. Recognising the number of musicians from St Michael's Villas, he established St Michael's Céilí Band. Hearing I was researching this period, Vincent MacMahon sent me a photograph of Michael, Vincent and Patrick MacMahon, Paul Roche with my brothers Joe, Gerard, Mike and myself all white-shirted and dark ties with Brother Taylor.

We honed our musical skills playing on Monday nights for the Old Folks' Club in the Friary Hall and later in the Community Centre. The big event of the year in Ennis was the opening of the West County Hotel by President Paddy Hillery at which we played. Recently, I came across an article which reported that a double room bed and breakfast at the time cost £3.00 or 60 shillings per night. A single room was £1.12.6. Not that we knew that at the time.

In 1970, St Michael's Céilí Band took part in the Clare *Fleadh* competing against the long-established St Flannan's Céilí Band. We came second. It would have been a major shock if a few lads from a working-class estate had beaten the diocesan college. We didn't, but the ever-gracious Father John Hogan, who for years was associated with the St Flannan's College Céilí band, said there was little between us. I thank my buddy Vincent McMahon for his incredibly accurate research and detail on the history of the St Michael's Céilí Band.

All the aforementioned Hanrahan boys played in the St Michael's Céilí Band but both of my sisters, Gay and Jean, younger than I, and younger brothers Adrian and John were equally involved in the tradition through music, song and dance.

At that time Brendan MacMahon was teaching traditional music in The Tech every Monday night. Here, we really developed our repertoire. From Miltown originally, Brendan was a wonderful teacher, a quiet man, a lovely man. He was a flute maker and he also could fix musical instruments. I remember one evening in particular. It must have been winter time, perhaps early spring. We were on our way from St Michael's to the Tech and I remember Paul sliding down the hill in Árd na Gréine. He fell and twisted his tin whistle, a not inconsequential matter. While the tin whistle might have been at the cheaper end of the musical instrument spectrum, it still cost money. If it couldn't be fixed, it couldn't be played. In Brendan's hands, he restored it to its original shape, breathing new life into it where its breath was almost extinguished. Having been founded by the great Jack Mulkere, these Tech classes were formative, essential not only to my own development as a musician but also to the nurturing of traditional music in Ennis. Tom Barrett also played a central role in this nurturing of traditional music.

Ennis might not be a mecca for traditional musicians today, and it's possible that may never have happened had it not been for Jack, Brendan, Tom, Sonny Murray and those classes. Of course one of our great informal mentors was the genial Martin Byrnes whose portrait has pride of place in Cois na hAbhna. Martin was always available to ferry us to the different sessions around the county.

One of the distinguishing characteristics of traditional music is the way it accommodates all ages, all generations. It is truly intergenerational. And in that respect, it is unlike many other forms of music. It was certainly different to the rock and pop world that was also part of my teenage years, but which was a world from which many of our parents' generation may have felt very estranged. It was always my impression that we were a lucky generation in that we had outlets for both traditional and contemporary music. Comhaltas Ceoltóirí Éireann, or just Comhaltas as it was known to us played a profoundly critical role in fostering traditional music.

Scoraíocht, a half-hour pageant of music, song and dance, played a significant role in facilitating the coming together of the generations. Here, I learned much of my stage craft. We all did. I was a teenager at the time. Sets had to be designed and built. Stories written and produced. Songs had to be sung. Music had to be played and dances had to be danced. And it all had to come together in a seamless compelling narrative. One I remember in particular told the story of the wildly adventurous Donnchadh Ruadh MacConmara, who was born in Cratloe in 1715 and was probably most famous for his poem *Eachtra Ghiolla an Amaráin*. It was produced by Niall Behan and performed in the Holy Family Primary School hall. We learned so much from Niall. Oliver Skerritt was part of that production. He was a genius of a step-dancer. Just something else. He would just float across the floor, and that's the sign of a good dancer. And it was said he could dance on a sixpence. Brilliant.

This was our education. Immersing ourselves in our history, our culture, our music.

The Comhaltas sessions in the Queen's Hotel were also critically important in our development. People whose names would later become synonymous with traditional music in Clare learned their craft here: the Cotters, O'Hallorans, Houlihans, Roches, Hanrahans, MacMahons, Dermot Lernihan and Geraldine Carrig. We were the younger generation, the up-and-coming musicians. But we were never too far removed from those who came before us and from them we had much to learn. The Community Centre on a Monday night gave us an

opportunity to play with older musicians, the likes of Sonny Murray, Gus Tierney, Johnny McCarthy and Michael Fitzgerald.

Outside of traditional music, there were other worlds that ran parallel. Worlds where Rory Gallagher sat comfortably with the Bucks of Oranmore. Deep Purple with Drowsy Maggie. Van Morrison with Morrison's Jig. In a way, we personified what many would have thought as two disparate worlds. I remember I had a jacket from that time, a jacket that I loved and used to wear all the time going to sessions. It was a jacket of its time, 'trendy', beige in colour. On it, I had stuck studs I got from Braids factory. They might have been reject studs but they were ideal adornments on my teenage jacket. I also had peace signs stuck on to the jacket. The construction of a nuclear power station in Carnsore in County Wexford was proposed at the time, against which there were huge protests. Peace signs were the order of the day. I'm not so sure how much I knew about the power station but peace signs were a look, an image, and I was happy to go along with that. And there was also the world of disco. And the CYMS hall, in Chapel Lane.

Double maths on a Monday morning. Just back from Listowel on Karl McTigue's minibus where Peter Skerritt and I won the All-Ireland under eighteen duet competition in 1974. While we were in competitions, it never felt competitive. If you won, well and good; if you didn't, well and good too. There was no pressure. The beauty of that time was the camaraderie, the friendships, the going away from home. Weekends on the Aran Islands. Athea in County Limerick, Kilgarvan in County Kerry, Ballincollig in County Cork. Places that young Ennis people would never have been to except for the music.

It wasn't just places outside of Clare that we would otherwise not have visited but within Clare too. Music brought us all over Clare. Newmarket-on-Fergus, Bodyke, Corofin, Lisdoonvarna, Doolin. This was the mid-seventies and traditional music was taking off for young people all over the county, Comhaltas County Secretary Pat Liddy blazing a trail throughout.

All the while my interest in traditional music was deepening. I had moved from playing the tin whistle and mouth organ to the banjo. In 1971 at a *Fleadh* in Toonagh, I heard Enda Mulcaire play the banjo and I was captivated by the sound. I was really taken by it. Its origins lie in the New York tango scene at the start of the twentieth century; the first tenor banjo was made in 1912. Gradually, it was incorporated into the Irish musical tradition. Jimmy Ward played the banjo with the Kilfenora Céilí Band and was the first man to tune my banjo. The banjo became my instrument of choice.

The mid-seventies were also a time when people formed groups because everyone was forming groups. Noel Hill, Tony Linnane, Tony Callanan and I formed Inchiquin around this time. In 1977, Tommy Hayes, Maurice Lennon, Paul Roche and I won All-Ireland titles at the *Fleadh* in Ennis, and out of that and the remnants of Inchiquin, Stockton's Wing emerged.

I left Stockton's Wing in 1990. It was an important moment for me and marked a change of direction. These were my family. Maurice Lennon always described us as a band of brothers. And that's what we were. It's just that sometimes there comes a time to leave. That's it. Nothing more. By the late 1980s I had lost interest in the travel and it was time to seek new challenges. Music still holds me. Playing just transports me. It's a zone where no one else can enter. Playing on my own, I'm on my own. The outer world shut out. My own world. Eyes closed, carried by the movement of the music. It is about the notes, the harmony and flow of the notes and then how they all come together as a whole. Playing with an ensemble is an altogether different experience. It's no longer about the individual but the chemistry, the warmth, the connection, a world of its own, beyond analysis. It's about a moment in time, the musicality of a moment in time, a once-off that can never be repeated.

The beauty is that I'm still learning. And that's the tradition from which I come. The teacher who never stops learning. And there is so much still to learn. I'm lucky. I have a good ear for music. I read music but not very well. They tell me Pavarotti couldn't read music very well either. And Paul McCartney could neither read nor write music nor could any of the other Beatles. And my guess is Tom Tuohy couldn't either. In the tradition I come from, a good ear is all important.

Neither my mother nor my father played music but each had an innate understanding of music. They loved dancing sets. When we were starting out all those years ago at home in St Michael's Villas, they would know if we were in tune or in time. They both had a good ear for music. That's part of my inheritance from them.

A great saying that. A good ear for music.

I wish to dedicate this essay to the memory of my mother Mary and my father Jackie.

Kieran Hanrahan

Born in St Michael's Villas, Ennis, Kieran Hanrahan is a musician, teacher, artistic director and broadcaster. A former All-Ireland champion on tenor banjo, he is an acknowledged pioneer of the tenor banjo in Irish traditional music. In 1977, he co-founded the internationally renowned trad/folk group Stockton's Wing. Prior to that he co-founded Inchiquin, and the Temple House Céilí Band. He is an Assistant Lecturer in Music at the Conservatory of Music and Drama at the Technological University Dublin. He is currently chair of the Expert Advisory Committee of Culture Ireland, Director of the National Folk Orchestra of Ireland, Director of Scoil Éigse and Artistic Director of TradFest Temple Bar. Since 1991, he has presented *Céilí House* on RTÉ Radio 1.

Living in the Wind

Eavan Brennan

I am angry with Edna O Brien. It's important to me that you know that. And I'll tell you why.

I have always felt the want of belonging somewhere. I always felt that I existed in the space between where things belonged. Not really from this, not really from that. Not from Clare, not with that accent mixing Rathgar and Sandymount. That accent in Clare is, 'Where are you from, England?' Almost not even Irish, never mind not from Clare. But not from Dublin either where my parents emphatically are from. If you're from Dublin the question invariably will be, where did you go to school? Terenure College for my dad, RaRa rugby and back slapping black and purple recognition. Roslyn Park for my mum, model student of a widowed mother, achievements in sport and school, family dotted everywhere around Sandymount, Ringsend and Irishtown.

But where am I from? Not from Clare, not from Dublin. From the theatre. Yes. I have memories back into the smoky pools of a three and four-year-old of black floors and piles of curtains, of people speaking loudly, crying and the thumping music of the cues that shook my body too hard and made me feel scared. Theatre people all over the country will still say, 'Paul's daughter! I knew you when you were "this" size.' I remember being in Red Kettle, in Waterford, in the lighting box in Druid Lane, backstage in the Abbey, in the bar afterwards trying to talk to actors, to be clever about plays, flashes of stories told long ago, asleep in the back of the car on the long drive home from festivals my father was adjudicating. Yes, I come from the theatre. But the currency of the theatre is talent, and I have none. No, don't make that face; I have ability, I have training, I can do it, but I am not a sparkling attractive talent. I am not one of those charismatic, effortless starry people. I'm not. So, from the theatre maybe, but not belonging to the theatre.

We moved out of Dublin when I was four. To Bellharbour in North Clare, where a new brother joined the family and then briefly to Galway to Tarrea Pier where another brother arrived, and finally to Mountshannon where, from the age of seven, I was to spend the rest of my childhood. I vividly remember this last move as the first time I ever saw my mother crying. From Sandymount, to Ringsend, to Bellharbour, to Tarrea Pier, we had always lived by the sea. This was the first move inland and not all the great expanse of the tideless, freshwater Lough Derg

could fill for her the miles between Mountshannon and the seashore. I love the sea and I always have. But I never belonged to anything like that. I remember that moment so clearly.

I started saying I was from Clare only after I left. Until then I side-stepped by saying, 'well, my parents are from Dublin, but I grew up in Clare.' It's a cumbersome answer to a simple question and when you start trying to say it in secondary school French, to a Japanese aerialist, it becomes somewhat irrelevant that you aren't sure what tiny part of a tiny island in the Atlantic ocean you are allowed to claim as your home. So, I just started saying Clare. *C'est dans l'ouest, il y a des grand falaises de Moher.*

I first saw that Japanese aerialist in *Perchance to Dream* by Footsbarn Theatre on George's Dock in Dublin. I feel with the experience of that show the way people feel about the most magnificent food they have ever eaten. I remember how it looked, how it sounded, how it smelled and how it pounded need into my chest. I need to be here. With this polyglot pirate wandering crew who danced so easily from Hamlet in English to Romeo in French to the trumpet and violin to the aerial silk and afterwards behind the bar to serve wine and chat. I loved them all before I spoke to any of them and there was no other possible thing for me to do but find a way to belong here. Buy a caravan, sweep a stage, climb a tent and belong, belong, belong.

Astonishingly, they were happy for me to do that and away I went through Portugal and Spain with their beautiful *A Midsummer Night's Dream* and later with *L'Homme Qui Rit* by Victor Hugo, one of the best things I have ever seen and certainly one of the productions I am most proud to have been involved in. I cried every single night at the last scene. Gwynplaine and Dea have loved each other since he as a boy found her as a baby in the snow crying in the arms of her dead frozen mother. During the story he leaves, and they are reunited only at the very end, seconds before she dies. She completely collapses and crumbles into panicked begging; she has never been able to live without him and now she cannot die without him. With only seconds to go she has no bravery to tell him she will be fine or he will be fine, there is no peace or acceptance in her – she begs him to follow her. '*Viens me rejoindre le plutot que tu pourras, ne me laisse pas trop longtemps seule mon doux Gwynplaine.*'

Moving from place to place, from country to country with our caravans and tent, eating together, days of work and very few days of rest, I found belonging. I have a good strong body and a good temperament for working hard, new people, new

places, late nights and travel. Sometimes travel was easy like pulling up to the queue for the ferry in Calais all together with our vans, caravans and cars and pulling out tables and chairs to sit in the sun and eat *saucisson* and cheese and pass the hours away until boarding. Sometimes travel was hard like driving down windy roads in Cornwall, at the dead of night, squeezing huge trucks and long vans along narrow lanes trying to find a field in the middle of nowhere where we were all supposed to sleep. At the end of the lane where the field was, with head torches waving like mad at everyone not to miss the turn, no electricity, no heating, only wine to keep us warm and a flight to Amsterdam the next day.

Sometimes shows were easy like the huge roar we received as we paraded into Shakespeare's Globe in London and a thousand people cheered us on. Sometimes shows were hard, loud rain on the tent making it hard to hear, water running in and flooding the ground, hostile neighbours who didn't like the sight of caravans parked up, sick of each other, sick of work, sick of the show. But never was there a better theatre apprenticeship. Learn to drive, learn to hitch a caravan, learn to put up the tent, hang the lights, build the stage and the dressing rooms, do the shows, man the bar, take it all down again, pack it up and on to the next one.

You belong to the company which belongs nowhere and everywhere. You do mad things like inviting the entire population of the Victoria Inn pub back to the campsite bar. Or like bailing a company member out of custody from the night before and arriving to the theatre with them just as the curtain goes up. Or crawling under the seats in the middle of the show, plugging and unplugging to find the light that is making the whole rig trip its switches. It's frightening, boring, frustrating, exhilarating and fulfilling.

Living in the wind obliges you to become who you are. It's not always a pleasant feeling either. And all whirlwinds blow themselves out eventually. So, when disappointment and heartbreak climb to the top, when what you see through the tent door doesn't make you proud any more, when all the people who were your crew feel the same and move on too, when you are at the limit of what you can bear, and you need a safe place to break and bury and grow again, where do you go? Because the place where you decide to go then, that is the place you should call home.

When I was eleven, I remember existing in terror. Not feeling safe in my bed, in my house, in my school. A mother and her baby had gone, a priest, sightings on the road, in a barn. Anybody might be taken, none of us felt safe. 1994. A few years later a book raked it all over again. I really wished it hadn't. I really wanted

to forget it. If you're not from here, you probably won't remember that case, but if you're from here... you'll never forget it. It has become part of who you are. So, I tell people I'm angry with Edna O Brien so they can understand that I belong. That I remember what happened, because I was there. Because that's where I'm from. I'm from Clare. Because my formative experiences happened in Clare, my first kiss in the tiny woodlands above the river at the end of my lane, my first huge loss as a schoolfriend left us way too soon, my first go at producing a show in sixth year at Scariff Community College.

I am a 'rocks in the spray of an icy sea kind-of-girl, a wild storms hair whipped rain on the beach, wind on the top of a mountain in bare feet kind-of-girl.'

I don't need to belong.

I try so hard to never look like I'm trying, but I can't read 'Postscript' by Seamus Heaney out loud without crying. I feel Clare in my bones with all its Burren rocks, soaring cliffs and surf, all its soft sun on the twinkling lake, green fields, 'will ya sell me that pony?' as you ride by taking turns; one on the bike, one on the pony until Morgan's lane and then swap, it's my turn!

Maybe I was made elsewhere, maybe I have the dust of elsewhere on my soles, but I grew up on the shores of Lough Derg, punctuated by summer weeks in Inis Oírr. I have salt air in my blood, I have rocks and trees and green rolling fields in my heart. It feels like summer when you hit the top of the hill in Caherkinalla between Kilshanny and Doolin where you catch your first glimpse of the sea. When I feel 'home' it's coming over the bridge in Killaloe, or down through the hills in Killanena, or the straight stretch on the Broadford road into Bodyke, sun catching the lake as you come around by Duceys, nearly home now, almost there.

Biography

Eavan Brennan

Eavan Brennan is a writer and performer from East Clare. Having studied at École Jacques LeCoq in Paris she became a company member with Footsbarn Travelling Theatre and toured with them throughout Europe with their productions of *A Midsummer Night's Dream* by William Shakespeare, *L'Homme Qui Rit* by Victor Hugo and *Sorry* by Pierre Byland as well as various parades and cabaret performances including *A Shakespeare Party* and *Christmas Cracker* for Shakespeare's Globe in London. Returning to Clare, she founded WayWord Theatre with Siobhán Donnellan and Ruth Smith and authored and performed in their first outing *Get the Boat* which played at the Limerick Fringe '18 and transferred to Soho Playhouse NYC for a five-week run. Other Irish performances include *Hysteria* by Terry Johnson for B*spoke Theatre Company, *The Stuff of Myth* by Roger Gregg for Crazy Dog Audio Theatre and several productions with Lambert Puppet Theatre. TV and Film include *Ros na Rún, Adharca Fada* and *The Clinic*.

My Grandmother's Hands

Susan O'Neill

I have my grandmother's hands. And Nana Lizzy had big hands. Man-sized hands on a woman's body. As had her mother Susan after whom I am named. Big hardworking hands that were warm and safe, my mother tells me. Nana Lizzy married Vincy Neylon. They owned a butcher's shop in Parnell Street, Ennis. Number 16. M.V. Neylon over the door. Just near the Height, backing on to Chapel Lane. My oval face and hazel eyes, part Neylon, part O'Neill, but I have my grandmother's hands. Years later, I imagined I saw those very same hands, those very same eyes, while singing at the National Folk Festival in Canberra. Waiting at the bar until my show was due to start, I met with the formidable Australian multi-instrumentalist and singer Marcia Howard. Prior to going on stage, I was having a gorgeous conversation with her while thinking 'something is happening here'. There is something about this woman. It must have been mutual. She invited me to sing with her without ever having heard me and moments later I joined her to sing to thousands, singing harmonies over her uplifting gospel sounds.

I had the same feeling when I met her brother Shane. This type of feeling is beyond kindred spirits, shared interests. Shane's 'Solid Rock' has become a classic Australian anthem for the rights of Aboriginal people. Australian musicologist Ian McFarlane described it as 'a damning indictment of the European invasion of Australia'. So, we had that in common. A sense of the unfairness of what has happened to the Aboriginal peoples and a determination that wherever we are, music can contribute to the creation of a better, fairer, more just world. And then I discovered a Neylon connection. A connection that still hangs in the air. Dots that may never join up. But those hands still speak of possibilities to me. And ones that might yet yield more than possibilities.

I was six when my parents moved from Dublin to Ennis and for a year we all lived over the shop. My mother Helen, my father Jim and my grandparents Vincy and Lizzy. This place with its white tiles interspersed with occasional red ones, sawdust floor and an array of saws and knives. A butcher's shop of which I have just the loveliest of memories. The whole family pitching in when needed. From eight in the morning until six in the evening. This was a place where neighbours met, people from all over the town, a place where local news of births, deaths and marriages were exchanged. All that and more. All life was here.

Death, too, but at the time that didn't seem to register. Hanging carcasses of meat. Invariably, four lifeless carcasses hung on the front window of what was for a short time my childhood home. Grandad Neylon, slightly balding, glasses halfway down his nose attending to all his customers. A word for each. In my memory, I sometimes see him in a striped blue and white coat that went down below his knees. Other times I see him in a brown coat, handkerchief stuffed into his top pocket. Butcher chic but hardly a description of its time. In his big hands, bone became butter. And the sound still resonates in my head.

A long corridor led to a room at the back. This was a house with secrets with its very own bar of sorts. It was small but he had an official licence. Grandad drank very little but he loved a bottle of stout, and if he came in winter cold and wet, Nana Lizzy would make him a hot toddy. Here, too, two beautiful terrier dogs were kept. Upstairs, on the first floor in this three-storey building were the kitchen and the parlour. One for everyday use, the other strictly reserved for special occasions, Christmas and Easter. On days when we ate in the parlour, the good cutlery was taken out and we wore our Sunday best. In the kitchen fires burned but not in that special room, the parlour, at least not until those designated days.

Our home was on the second floor so lugging turf and coal up the stairs and cleaning out the fire was a demanding and time-consuming task. To light the fires, we had our own homemade fire-lighters, suet from the shop wrapped up in an old newspaper. Bedrooms were unheated, heated blankets and a hot water bottle for bed our sole comfort. With the lingering smell of bacon and cabbage, the kitchen/living room was the family focal point where we had our meals, watched television and every night said the rosary.

The parlour, unheated, was my favourite room. This too was a room of secrets, where Christmas presents were hidden. Perhaps other stuff too. And despite the cold that sometimes seeped under my skin, I spent hours in it because the parlour had a piano. Here, I would sit and play and play, I didn't feel the cold. The notes and their vibrations were the pull. Sounds that warmed me. I remember lifting the top of the piano while playing a note and sensing its vibration. Spent hours searching for notes that conveyed a sense of happiness, sadness too; once played lost in a twinkle of a note. I spent hours fumbling through the darkness of what a note could be. And then experimenting with different combinations of notes, sensing how they made me feel. Notes whispering their dissonance into the air. The piano became my year-round childhood companion. A piano that never judged. A piano that responded to my every touch.

I couldn't hack music lessons. They were too formal for me. I had spent hours and hours making my own sounds, creating my own music and had zero tolerance for being told how to play the piano. The brass band was altogether different. My father, who played the tuba, suggested I join. Kieran McAllister was teaching classes in the Tech on Monday nights and I was happy to go along. In Ennis, the McAllisters are synonymous with the brass band. Incredibly, all four generations of the McAllisters played in the band at one time. Christy, Bernard, Kieran and Gary. Christy was the oldest playing well beyond the age of ninety, and Gary the youngest playing drums at the age of thirteen. Bernard, a lovely wise man who was a teacher from whom I was lucky to learn, played the B flat base.

I remember the first night I went to the Tech. I was given a cornet. His teaching method was simple yet so effective. Take the instrument in your hand, blow into it and make a sound. At first touch, brass instruments are cold and at first touch it felt alien in my hands. Strange. My fingers didn't fit in places the instrument seemed to demand. Did I tell you I have big hands? I remember the first sounds sounding horrendous, even comical. The classroom echoing with what must, in retrospect, have been a cacophony of discordant sounds. Brass instruments being warmed up. However, over weeks and months the sounds I was making from the cornet warmed up too. Round warm sounds emerging from my body through this most beautiful of instruments that gradually felt at home in my hands.

A year later, I joined the band. It was like the coming together of a beautiful jigsaw, first, second and third trumpets, cornet, fugal horns, euphoniums, trombones, tubas, B flat bass, and E flat bass and drums. Up to then, I had been learning on my own, practising parts and then that ground-breaking moment when it all came together. I was no longer an individual musician. Finding my way musically, I was part of a community of musicians, each leaning on the other, filling spaces in other musicians' pauses, in the process creating a harmony, a once-in-a-moment moment that can never be repeated. That's music. That's band music.

At this time, I was listening to whatever music records were lying around the house. My mother had started practising Reiki and had a pretty extensive classical collection. From an early age, I loved classical music. Mozart was my favourite, but Chopin and Bach too. One of my favourite things to do as a child was to hang upside down on the back of the couch listening to Mozart. As a child, it fueled my imagination and transported me to another world of limitless possibilities. My father had other musical interests and they too became mine. The Beatles, the bawdiness of Guns N' Roses. And Madness. One of the best

covers by any band, Labi Siffre's 'It Must be Love' with their distinctive brass riff. Then there are the two minutes and fifty-five seconds of poignancy in 'Cardiac Arrest' with its opening heartbeat rhythm and its brass and xylophone interlude. Not forgetting the joy to dance to the harmonica and saxophone-infused 'Baggy Trousers'. My Dad introduced me to these songs, highlighting the textures and clever use of lyrics.

The brass band repertoire encompassed all kinds of music. Ours was an eclectic mix. Swing, popular music, music from films and more. Old war songs that reflected the naive exhilaration of youthful exuberance marching to war, as well as the inevitable darkness of war's insatiable appetite for young lives. The aching loneliness of the trumpet call of 'The Last Post' a stark reminder of all of that. There was other music too. Ennio Morricone's sparingly beautiful 'Gabriel's Oboe' from the 1986 film *The Mission*. The street ballad 'Wearing of the Green' from the 1798 Irish Rebellion was a regular feature on big days. Another favourite was 'The Villager' which is a traditional brass band quick march.

In a seamless way that I hardly noticed, I learned musical notation from Kieran McAllister. Even though the band was founded only in 1971, there seemed to have been multiple lifetimes worth of cases of old music that sat waiting to be used in the band's music room. Really old beautiful pieces that could have been there for I don't know how long. Music that smelled of musk. Music I loved. Old music to which our bodies were giving new life. Music we brought to the streets of Ennis. St Patrick's Day was our big day out. Dressed in royal blue jackets, black collar with gold trimmings, white shirts, black dickie-bows and black trousers. Not exactly teenage girl *chic*, my platform shoes my only acceptable concession to the fashion of the day.

Starting in the Tech, the route took us over the Club Bridge, up Abbey Street mindful of the cobbled streets, past the Height, up O'Connell Street stopping outside the Cathedral. On another occasion the band played for the homecomings of the Clare hurling team. August 2006 was my swansong with the team. Beaten by Kilkenny's 2-21 to Clare's 1-16 in the All-Ireland semi-final.

Musicians learn from musicians. All music is circulatory. We are in a constant cycle of learning. And that was my experience in the band. Girls and boys in equal number. Old and young. Ours was anything but a segregated space. And then on those special nights, the coming together. Something really special happens then. Magical moments of suspense, then it passes. No sadness there, as instinctively we know there will be other moments, different of course, but equally as moving.

And some of these moments were way into the future, moments that this teenage girl growing up in Ennis could never have envisaged. There were many that I remember. Others have drifted from my immediate consciousness with occasional sudden reminders from the most unexpected sources. One was in Australia with Sharon Shannon.

I first met Sharon in Glór Theatre in Ennis and the following year at the *Fleadh*, where I sang a six-minute rendition of 'It's a Long Way from Clare to Here' ending with Sharon's trademark exuberant smile and one big, warm, generous shout-out of 'Well done, Susan, absolutely gorgeous, absolutely amazing,' right at the very end. A truly memorable moment. How could I not have been bowled over by it? For me, it was a perfect coming together and for two years we toured all over Ireland, from Belfast to Kerry. Every single weekend. That is when we weren't touring elsewhere. In 2018, we toured Australia starting at the four-day World of Music, Arts and Dance Festival (Womad) where, along with the Gypsy Kings and the amazing African singer Angelique Kidjo and the Central Aboriginal Women's Choir, we played to tens of thousands of people in the fifty-hectare Botanic Gardens in the heart of Adelaide. On this tour, as well as singing, I played the cornet in her band.

Since 2018, I have returned to Australia on three occasions. At various festivals, I bumped into Marcia and Shane Howard, a cyclical happening. And last year having talked family history and Neylon family connections, Shane and I had the 'do you have my hands?' conversation as we matched our hands, palm against palm. His and mine matched. It may not be the most scientific of tests, and in all probability would not stand up in a court of law, but ours was of a different order. I had found kindred spirits in both Marcia and Shane, our matching hands reinforcing this bond.

Back in Ennis as a fifteen-year-old, I took guitar lessons in the Youth Centre on the Kilrush Road. While there, I saw an advertisement for a Gospel Choir audition that specified only those eighteen years of age or older could apply. Auditions that were to take place with Fiona Walsh as Director in St Joseph's Church. At that age, I wanted to sing at every opportunity. Sing. And sing out loud. The first time I ever heard Gospel, I knew and felt this was my sound. I wanted it around me. I rang the number on the advertisement and immediately plunged headlong into pleading to be let in. 'I'm begging you. I'm really begging you to be let in,' I implored. 'Calm down, whatever your name is,' was her reply. I began again. 'I'm begging you.' She relented and I was in. This was different from my brass band world. Mostly women from all over Clare, there were but a few men. This was a

non-audition choir. Classically trained Fiona Walsh would accommodate anyone who wanted to sing. Here, people who wanted to sing but were shy or lacking in confidence shed their inhibitions. And here, I heard for the first time the human rights anthem 'Something Inside So Strong' penned by British singer, songwriter and poet Labi Siffre.

> The higher you build your barriers
> The taller I become...
> The more you refuse to hear my voice
> The louder I will sing...

Down the street from where my grandparent's butcher's shop once stood is Frankie Considine's place. Two doors down and across the street. Number 15 Parnell Street. Better known as Fafa's to locals where some of Clare's finest musicians find a corner adjacent to the bar from which beautiful sounds flow. A corner that at times felt like the epicentre of my world. The melancholy of a slow air, healing the spaces it is allowed to enter; a speedy solo from a concertina setting a lively tone; followed by fiddle and flute, staking their claim on the room; guitars, whistles, accordions all joining for the finale. The intensity of the music silencing even the most whispered of conversations. Tonal synergy, calling out to all bystanders to join in the dance.

I first learned the power of music in this intimate communal setting; the way in which musicians instinctively segue from one tune to another and how musicians pick up on the mood of their listeners. Slow air, fast air, as we all breathe in the same air. A synchronicity of moods. After a slow song, an uplifting tune would always follow, a celebration of the dark from which musicians instinctively rescue us lest the darkness overwhelms. Light and shade. This is what I've learned. This is how I now sound-sculpt my own gigs.

Late nights, sharing, singing, laughing. endless *craic*, the dissolving of barriers throughout the peaks and troughs of the session. Light and shade. But more than that. For the next few minutes musicians and listeners are as one. Each in the moment, and in those moments I feel I am falling in love with something that words can never capture. Moments broken in the end by someone calling 'two pints please.' A *whisht* goes up. Someone is called upon to breathe words into a song and a *ciúnas* gradually descends. Song's end and the musicians are off again. And more pints called.

Working behind the bar, collecting glasses, occasionally I am the one called upon for a song. The ultimate cross-over. Barwoman and singer. Standing in the middle of the floor, empty glasses at hand or behind the bar hand on tap, I'm happy to take the floor, happy to have my voice heard in what for me is this cherished space. Happy to sing when the hush is called. Eyes closed, feeling the heat of the room, the spirit of the moment.

'What'll I sing? Carrickfergus, Spancil Hill or The Tennessee Waltz?' 'Sing whatever you want. You sing. We'll follow.' No expectations. Starting as a solo piece the musicians gradually join in, everybody in the pub in the chorus. Moments to cherish. That's where I realised the power of sound. It just simply is. You only need to listen with an open heart.

These are the moments I cherish. Songs that have been sung by generations of people before me become mine for those fleeting ephemeral moments and then return them to the ether where other singers, other musicians, will briefly make their own of them. And for them, too, those moments will pass.

As the song nears its denouement, clapping breaks the tension. The palette of the room is cleansed.

Fafa's on Parnell Street, up the street from Grandad's and Nana Neylon's place, is where it all began for me. Both dead now; Grandad Neylon took his leave from this world in 1998. As did Nana in 2010 on my birthday. I am not the kid that arrived in Ennis at the age of six. Maybe yes and no. In some ways I have changed. In others not at all. I don't eat meat for one. That I have a vegan diet, I'm sure my Nana would understand. As well as having big hands, she had a big, warm generous heart. As had my grandfather, a big warm generous heart. My inheritance. To have a big warm generous heart, now that's an inheritance.

I'm working on it.

Susan O'Neill

From Ennis, Susan O'Neill is a critically acclaimed singer/
songwriter, performer and one of Ireland's brightest
emerging talents. Her first album, *Found Myself Lost*, was
one of *Hot Press* magazine's Albums of the Year. Her husky
vocals combined with her guitar technique, loop pedals and
trumpet, have wowed audiences from Stradbally to Sydney,
Glasgow to Glastonbury, Manhattan to Milwaukee, and
beyond. She toured Australia and New Zealand with Sharon
Shannon and accompanied King Kong Company on their
European and Irish tours.

The enigmatic singer-songwriter honed her musical skills as
one of the youngest members of the Ennis Brass Band and
gained her first gospel influences with the Really Truly Joyful
Gospel Choir. A recent collaboration with multi-platinum,
award-winning artist, Mick Flannery, *Baby Talk* claimed
RTÉ's folk song of 2020. A duet album is to be released in
2021. She is currently working on an exploration of different
art forms within unique spaces. The first series, *The Space
Between*, will be launched in 2022.

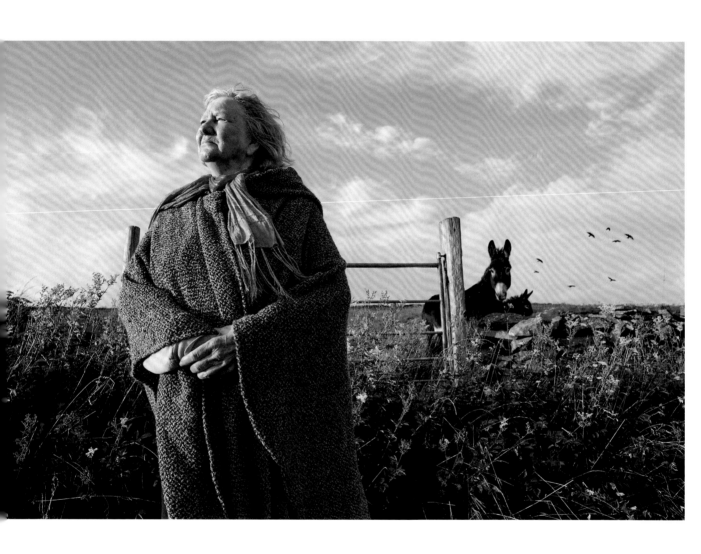

Forever Coming Home

Jessie Lendennie

When my son, my husband and I arrived in Ireland in 1981, we were greeted at times with 'and how long have you been home?' This caused a pause; the question was both puzzling and comforting. I loved the assumption that we belonged here and had just been away for a while. As if Ireland was the home that everyone returns to at some point in their lives.

Like many Americans I grew up with knowledge of my Irish heritage – in my case, a great-grandfather. He and his brothers were printers in Northern Ireland and left for the United States in the mid-1800s. The first country I heard about outside America was Ireland; reinforced by the prominence of Irish descendants in America (and, of course, St Patrick's Day!)

The American myth of Ireland celebrates Ireland's timeless landscapes and stories. Yet tradition solidifies, and centuries of stone erode slowly. Incorporating elements of change is gradual.

I'll tell a story about how I was drawn to a place that is familiar in its essence and how I felt the experiences of my earlier life in other countries blending with the part of myself that was always in Ireland. The story is about how everything that was essentially me was here when I arrived.

I believe this story is reflected in the lives of many people, including the writers and artists who now call North Clare home.

When my husband and I decided to leave London for Ireland, the decision was based on us both being writers and wanting to find a place to live where creativity was valued. For us, that was Ireland. I'd been teaching in London and many of my colleagues were ex-pat Irish. They all advised against our move, citing the poor economy and less than poor job chances. That made absolutely no difference to me once I focused on a new life where writing and the arts were celebrated.

We chose Galway for its lovely aspect and charm, even though empty buildings lined many of the streets. It had the feeling of a city just waking from a long, restful sleep. That was summer 1981.

My ex-colleagues were indeed wrong in their dire predictions for our future in Ireland. I loved Galway during my fifteen years there. I loved that it was on the verge of finding its poetic voice. That within weeks we had found a writing workshop that was just starting up, based at UCG (NUI, Galway). That workshop led to everything I've done in Ireland in the forty years since. From a photocopied pamphlet – Poetry Galway – that contained poetry and stories from workshop members to The Salmon International Literary Journal, we focused on publishing poets from the west of Ireland, and The Salmon quickly gained a great reputation. In The Irish Times. Eavan Boland, one of Ireland's most important poets and mentor to many women writers, wrote, 'The Salmon is beautifully produced ... a singularly heartening and attractive little magazine.'

Publishing poetry in the West of Ireland was unusual at a time when so many talented people were getting their university degrees and heading off as quickly as possible. Yet, the time was right. And it was time for Irish women poets to come forward.

I had a particular interest in creating a wider publishing platform for women poets. There were many superb poets in Galway at that time: Eva Bourke, Rita Ann Higgins, Mary O'Malley, Joan McBreen, Anne Kennedy and Moya Cannon went on to make their mark in Irish literature. Publishing books was a natural progression from The Salmon Journal, and it was thrilling to bring these vital voices to light.

My fifteen years in Galway were a tremendously important time for me, and for the arts. The drain of creative talent started to reverse itself. The 1980s were bustling with innovation. As well as the writing workshop, my husband, Michael Allen, and I set up the Poetry Co-Operative, working with Poetry Ireland to bring Irish and international poets to read their work with poets based in Galway. Poet Gerald Dawe's 'Writing in the West' was a weekly feature in the Connaught Tribune, and his literary journal, Krino, appeared in the 1990s; Michael Gorman's superb poetry collection Waiting for the Sky to Fall was published in 1984. Through the Poetry Co-Operative my husband and I organised an international poetry festival, 'Laughing Out, Lashing Out'. It was a forerunner of the Cúirt International Literature Festival. Street theatre with Macnas and small theatre groups like Punchbag added to the burgeoning arts scene, joining Druid Theatre and the Galway Arts Festival as Galway rose to embrace its creative potential.

It was an important time for me, but there were also personal difficulties, including the breakup of my marriage, and in 1994 I looked for a place where

I could have space to breathe spiritually and emotionally and, again, I made a decision that exceeded expectations: I found a house in a wonderful spot half a mile from the Cliffs of Moher in a most glorious part of Clare.

Among the well-known towns in the area such as Doolin, Lahinch and Lisdoonvarna, I loved the less well-known Ennistymon. An old market town it had, at that time, a timeless feel as if it was resting to get its breath back and move on. I'd been to Ennistymon in 1978, after a visit to the Cliffs, where all you had to do was walk across a field to face the expanse. We visited Stephan Unglert's superb bakery in Ennistymon, renowned in the area (as it is to this day). In the early 1990s I had a literary association with Ennistymon, editing an issue of the *North Clare Journal*, published by a group of North Clare writers who held regular writing workshops in Ennistymon. The group included Jacqui Hersey, who had come from London and been part of the Derry House Co-Op and Kilshanny leather, and later opened the first health food shop in Ennistymon; Ilsa Thielan, who came to Doolin from Germany in the 1970s and established a legendary restaurant, Ilsa's Kitchen, and who is also a well-respected photographer and poet. A key figure in the workshop was Knute Skinner, from Washington State, who bought a cottage in Killaspuglonane, Lahinch, in the 1960s and spent summers there until he and his wife, the writer Edna Kiel, retired and came to Killaspuglonane for good. I had known Knute for many years, having published his poetry in *The Salmon International Literary Journal* and then his poetry collection *The Bears and Other Poems*. At the time, I didn't have any thoughts about living in North Clare but when I decided to leave Galway, Clare was on my mind.

And it was amazing to me that I found a wonderful spot on a hillside near the Atlantic, half a mile from the Cliffs of Moher. Again, timing was in my favour and my daughter-in-law Siobhán Hutson Jeanotte and I were able to avail of the rapidly developing technology of the internet. At the time, there was only a landline dial-up connection to the internet, but it enabled us to bring Salmon to this wonderful unspoiled place and carry on as if we were producing books in the middle of a city. Perfect. Salmon was the second publisher in Ireland and the first literary publisher to have a website. All from Knockeven, half a mile from the Cliffs of Moher.

Meanwhile, Ennistymon was becoming a home for visual artists. The Courthouse Gallery on Parliament Street was established in 1997 as a space for artists to work, and ten years later it opened as a beautiful gallery space, hosting exhibitions from Ireland and abroad. Kathryn and Michael Comber were instrumental in highlighting the visual arts, and that encouraged many artists to come to the area.

It was exciting to see the gradual creative opening of Ennistymon, changing focus to expand creative entrepreneurship; market days becoming showcases for a different sort of growth. Visual artists standing back, considering the environment, the landscape, with a network of creative connections. This isn't new, of course. Writers and artists have been drawn to Ennistymon and the otherworldly character of the Burren, the Cliffs of Moher and the Aran Islands for centuries. Yet in recent years, these places are defined by creative work and innovative activities.

In 1977/78, I worked at the National Poetry Society in London. The Poetry Society was established in 1909 and was the prominent institution for poetry and poetry activities in England. Its journal, *Poetry Review*, set the standard for English poetry. At the time the Poetry Society was housed in a beautiful Georgian building in Earl's Court Square, with space for offices, readings and accommodation.

The 1970s were the well-documented poetry-revolution years in England. There is an excellent book about those times, *Poetry Wars* by Peter Barry, which is an account of the six-year battle between the Poetry Society establishment and the many poets who felt that the Poetry Society and its journal, *The Poetry Review*, espoused a far too narrow view of poetry, stifling creative freedom. It was an invigorating time, and I was lucky to witness it first-hand.

I had just finished university and was beginning to publish my own poetry in journals, so when a job came up at the Poetry Society it seemed perfect. My job was to assist with organising poetry readings outside London. During that time, revolutionary fever grew and began to involve physical protest in the Poetry Society building. The grand piano was broken, books were strewn around the library, and I often came across poet-protesters sleeping here and there. These protests caused the housekeeper, who had been with the Poetry Society for forty years, to quit. She had a flat on the top floor of the building and since my son Tim and I were looking for a new place to live, the Poetry Society directors offered us the upstairs apartment. In return, I would be responsible for looking after the house and running the regular reading events. It was challenging but, for me as a poet, it was liberating too, particularly at that time.

One of the more focused people at the Poetry Society was Ian Robinson. He was a poet, publisher and lecturer at the Kingston College of Art. Some of my best memories of that time are chatting with Ian as he ran the huge old lithograph printer in the Poetry Society basement, turning out copies of his literary magazine, *Oasis*. After I moved to Ireland, Ian and I gradually lost touch, and then

I heard that he had died in 2004. I regret that he never had a chance to visit me in Ireland. However, he and I were to connect in Ennistymon in a way neither of us could have imagined.

In 2012 an opportunity arose for Salmon to take on a bookshop on Parliament Street, Ennistymon, from Gerry Harrison, who had brought his huge stock of books from London and settled in the area. We had been delighted when Gerry set up the bookshop. After a year, due to health problems, he decided to give someone else the opportunity to take on the bookshop. At that time, Siobhan and I were looking for more space for Salmon. We had outgrown our home office, where Salmon books were stacked to the ceiling. When Gerry let me know that he was selling his stock and looking for someone to take over, I knew this was our chance to have not only a terrific, new and secondhand bookshop but, with some renovations, a home for Salmon, with office space, writing workshop and seminar space, and a large walled garden for literary events.

One day, when Gerry and I were going over the stock, I picked up a book, opened it and saw the words 'Ian Robinson, London 1978' handwritten on the flyleaf. 'This was owned by my friend in London!' I exclaimed. When Gerry said that he had bought the collection of books from Ian's widow and confirmed her name, I was stunned at this wonderful serendipity. That my friend's carefully collected library would come to me here in this small Irish town years and hundreds of miles later confirmed for me that I was, indeed, in my creative place; here and forever coming home.

Oh La La Breton Café
Ennistymon, County Clare

Crocheted light hangs with the sun
In the café window
Touches the face of a soft afternoon
Drifts with the honied scent of crêpes
Across a golden lion on a scarlet sky

Here, the air is the breath of stone centuries
A river crossing, a gathering
And if I look into the shimmering morning
Past the bridge, just beyond the first turn
I can see the best part of my past

Returning home from far away

Jessie Lendennie

Jessie Lendennie was born in Arkansas, USA. After years of travel, she settled in Ireland in 1981. Her publications include a book-length prose poem *Daughter* (1988), reprinted as *Daughter and Other Poems* in 2001 and *Walking Here* (2011). She compiled and edited: *Salmon: A Journey in Poetry, 1981-2007; Poetry: Reading it, Writing It, Publishing It* (2009); *Dogs Singing: A Tribute Anthology* (2010); and *Even the Daybreak: 35 Years of Salmon Poetry* (2016). She is founder (1981) and Managing Director of Salmon Poetry.

Her poems, essays and articles have been widely published and she has given numerous readings, lectures and writing courses in Ireland and abroad, including Yale University; The Irish Embassy, Washington D.C; The University of Alaska, Fairbanks and Anchorage; MIT, Boston and Café Teatret, Copenhagen, Denmark. She is currently working on a memoir, *To Dance Beneath the Diamond Sky.*

Return to Mars

Harvey O'Brien

I don't remember saying goodbye but when I returned, I felt welcome.

The Mars Cinema, Kilrush, closed its doors in 1991 ending 71 years of film exhibition in the town. In 2014, shortly before the death of my father, I asked permission from the current owners to go inside and take some photographs. It didn't make me sad when I stood in the dusty lobby with the scattered detritus of unfinished repurposing – a few ruined seats, old doors leaning against the wall, bags of broken wood, half a mirror, a wheelbarrow – somehow The Mars knew I was there and it was happy to see me. We were both very different now, but we still loved one another, I think. I went in with a friend that year, a documentary filmmaker and also an academic like me. He was working on a film about old cinemas in the US and had seen a lot of abandoned theatres. Even he was shocked at what little remained of the living, breathing place in which I had spent my childhood and become that which I remain – a lover of films.

In 1994 I wrote an academic history of The Mars and its predecessor, The Palace. Aidan Cahill, former manager of both cinemas, wrote a flattering piece in *The Clare Champion* about it, calling me a 'Kilrush man.' Funny, I'd never thought of myself that way. My Dad, Tom O'Brien, was a Kilrush man, raised in Carnanes and late of Moyne on the Killimer Road just beyond Ballynote Cross. He had left Kilrush for England, Canada, and eventually the U.S., where he married a girl from Brisla, Cooraclare, Nora Harvey, and I was born and named for them both. When we came back for good in 1975, I was a Yank child and a bit of a stranger. The farm on Syney's Hill in Moyne was where I grew up, and where like any farmer's son I did my jobs, but The Mars was where I lived. It seems almost excessively obvious that after a childhood spent watching films with the devotion expected of a fanatic, I should become first of all a journalist writing about cinema, then an academic teaching film studies, and by the standards of the hardworking people of West Clare like my farming father, probably still living in the clouds. But The Mars wasn't just an escape, it was part of what connected me to the world, and I mean that in several ways.

When I wrote my piece, I interviewed a lot of people who told me their stories of going to the cinema in Kilrush long before I was even born. The details were different, but the essentials were the same. Margaret O'Dwyer, known locally

as Maggie May, then one of the town's oldest residents, told me that when she was a child, she didn't really care about the films themselves, she just wanted to be inside with her friends, sharing sweets and having fun. Growing up two miles outside of town, going to The Mars was a great chance for me to see mine. My Dad told me he made money to get into The Palace by trapping rabbits and selling them at the Creamery. A similar cost-benefit exchange between me and him for doing the jobs seemed reasonable. I was told the story of The Sevenpenny Procession, or The Cowboys on Parade, a group of avid cinema goers from the east end of town who grew in number as they made their way up from St Senan's Terrace and Grace Street through Moore Street towards John Street where The Palace was situated and where they would occupy the cheapest seats for sevenpence. They knocked on one another's doors as they proceeded and were heard loudly discussing what they had seen as they walked home afterwards. The cinema in Kilrush was a social centre where people gathered and shared experiences to be talked about afterwards for hours, days, weeks and lifetimes. It was the same for us as kids in the seventies and eighties, and I'm still talking.

When I stood in the dusty lobby, the contours of Pat Tubridy's design were still there. He and his brother Murty, farmer's sons from Ballykett, had founded The Palace in 1920. Like other cinema venues, it was used for music and theatre as well as film. Pat became an engineer, and in 1950 The Mars was built on Frances Street to his designs as an ultra-modern, multi-purpose building with removable seating for 600 downstairs on a 3,310 square feet ballroom and seats upstairs on the balcony for 250 more. When it opened, the old price structures and social divisions of The Palace remained. Seats were 1/8, 1/3, and 8d depending on what you paid for your comfort; sevenpence now raised to eight, but the strata remained. At The Palace, shows were often held until 'Mrs. Desmond', wife of Desmond Glynn, the miller and town notable, arrived to take her seat on the balcony, irrespective of the scheduled start time. But by 1975, The Mars was advertised as a 'comfortable mini-cinema' with only the balcony in use – no more strata, just maybe favourite seats.

For one and all, the path swept around to the left of the box office, up the stairs and through the curtains. That's where I spent my time, only barely aware of the closed-off dark downstairs that was rarely used then, but which through the 1950s and 60s had housed not only the bulk of the cinema audiences, but dancing, theatre, ballet and even opera.

In 2017, The Kilrush and District Historical Society invited me to unveil a plaque and give a lecture. The plaque marked the site not just of the cinema, but of the

Kilrush Operatic Society, which performed from 1951 to 1966 in the building once referred to by producer Harry Powell-Lloyd as 'the most westerly opera theatre in Europe.' The Society began with modest operettas like *The Student Prince* in 1951, but moved up to *Faust* and *Carmen* in the early 1960s, before over-reaching with an ambitious twin season production of *La Traviata* and *Don Pasquale* in 1966, the same year the Lichtfield Report referred to West Clare as an economically retarded area and a year before Paterson's Stores, one of the last reminders of Kilrush's prosperous port and market town past, burned down. Veronica Dunne sang at The Mars, as did Kilrush native Kitty (Katherine) Ryan. Kitty also sang from her window on Burton Street and in Market Square: the global and the local stage become one. Joe Kiely also sang at The Mars as a boy soprano. His mother Peggy was the pianist at The Palace. My own cousin, Edel, is part of that long story of the performance of the grandest of arts in Kilrush, and its home was this same building where I watched Clint Eastwood and Bruce Lee kick ass.

When I did my research, several of the older folk spoke of the decline of cinema. To them, the coming of more violent films, of censorship ratings and adult content was the end of their preferred experience of the silver screen. They said 'the rough crowd' took over, and I found this interesting because I guess that included me. We didn't watch Errol Flynn or Gene Kelly. We didn't have to imagine what the leading ladies looked like under their clothes. Blood ran red and the volume was loud. My mother took me to see *Star Wars*, and tried vainly to close her eyes as things exploded around her in cinematic stereo. My girl cousins from Frances Street tried to stop me seeing the bad bits in *Jaws*, only for me to protest that I'd already seen the film on the plane from New York. My friends and I watched *Mad Max 2* at a birthday party, and got tickets to the cinema for being altar boys that we redeemed for whatever we wanted, not just what was appropriate. But to us, The Mars was every bit the dream theatre as it had been to the previous generations in more genteel or glamourous days. It still opened windows to worlds beyond our experience, and perspectives unimagined outside its walls, all of which we shared with each other while getting on with our everyday lives.

When I returned to the ruin, the ticket booth was still there. So many nights in the 1970s, I'd been dropped at that booth, supplied with home-made popcorn and soda stream cola, my mother checking what time the film was over so I could be safely collected. It still had the Leadmore Dairies sign, promising Twist Kup, Super Softy, Super Choc, Jolly Bar, Super Split, and Golden Cone. Inside were traces of Jack McGrath, the box office manager and cinema shopkeeper with whom I had had many a chat about what was playing and what was coming up – a crucifix, a holy medal, a rosary, a prayer card – his private world that I never saw until now.

Of an evening, you'd often wait on Jack as he made his way over from St Senan's. The Mars was my church and we met here. He was a film buff, the first I ever knew. Here I learned that film had a history and that others before me loved it too.

Jack was dead by the time I started my research in 1994, as was Hughie Sullivan, the last in a line of projectionists stretching back to the legendary Thomas Moore in The Palace whose fondness for alcohol occasionally resulted in mixed up reels or even casual cancellation of ongoing shows. The art of cinema ultimately relies on the person throwing the images on screen for you to see. Hughie was often at the hearing end of shouts of 'focus' in my day, though he (and others) were otherwise unseen maestros lining up the reels and switching the projectors with a diligence taken for granted in the digital age. Hughie died in the projection room while the show went on. The ambulance took him away while *Teenage Mutant Ninja Turtles* played to the house. I like to think, by telling these stories of the dead, part of them is still alive, and that was something of the feeling I had now, being in their domains more than twenty years after they were gone; places I'd never been in a place I'd never left.

My filmmaker friend Peter was keen to see the projection booth. He had found many interesting artifacts over the years of shooting his documentary, including neglected but extant equipment that would still run with a little care. We went up the too-bright stairway, always dark and forbidden when I was young, to where the two Westar projectors had faithfully operated for forty years. In 2017 a photograph surfaced of projectionist Mickey Honan standing beside these pristine machines, proud and ready. The Palace had had a single projector, powered at first by Bill Conway's tractor, later switched to the mains supply. No expense was spared when The Mars was built and those state-of-the-art projectors would still have been good in 1991 if properly maintained. But they were gone. The room was bare. Broken glass and trailing electrical cables evinced that incomplete afterlife where the room's original purpose no longer mattered. There were some rusted fixtures on the walls, sliders fixed now forever, a broken fuse box, a discarded pair of glasses. These last I placed with reverence looking out into the auditorium, forever in focus.

The auditorium was in ruins – no seats, no screen, a carpet of leaves blown in through the partially collapsed ceiling re-wilded by angry swallows. It's not your space anymore, they said, as they swooped and twittered at me, the invader. But I didn't invade: I was invited. This place and I are old friends. It's just been a while. Again, I was not overwhelmed by sadness when I stood where I used to sit. I was amazed by details like the colour of the walls, painted in peach, purple, white

and yellow that I never saw in the low-light gloom behind the heavy sound-proof curtains. Now the light of day streamed into a space from which it was previously expressly forbidden lest it dispel the kingdom of shadows. I walked on the *ad hoc* proscenium, where once the odd passing rodent had provided a target for cigarette butt flickers, and realised how the refurbishment in the 1970s had worked, blocking off this area entirely and making small what was, in fact, a huge space. Through the holes in the wall that had been behind the long-gone screen I could see another world again – the much larger parterre.

I made my way into that space with some bewilderment. My comfortable mini-cinema was merely an attic to the cathedral. I knew the statistical detail from my research, but my only memories of this part of the building were a recollection of a sale of work or something happening once and only vaguely. This was The Mars Ballroom – 'Co. Clare's Leading Dance Centre' – that heaved through the showband era before young people become mobile enough to drive to Lahinch or Ennistymon. Before the traffic went out, it came in, with buses from Quilty, Cree, Doonbeg and Kilkee bringing young dancers to the Mars in proverbial droves. The Maurice Mulcahy Band were the first to play here, followed by The Dubliners and The Saints, among others. In 1966 The Mars hosted a show by Dickie Rock and the Miami Showband, fresh from Eurovision. The streets of Kilrush were 'black with people', I was told. It was before my time. Now a lonely disco ball still hung from the ceiling. A dust-encrusted drape lay bunched on the floor as if someone was sleeping it off underneath. No footfall but ours.

The stage was still there, proscenium arch painted blue, if flaking, on stage left, the space still open and inviting not only singers and musicians, but magicians, comedians and theatre groups both local and touring. Anew McMaster, Maureen Potter, Jimmy O'Dea and Paul Goldin all once stood there. Theatre companies and musical societies from Dublin and Limerick played to packed houses here. Singing groups from Covent Garden and Sadler's Wells performed here. The Mars was a destination. The Kilrush Dramatic Society, which performed at The Palace, had lapsed in the 1940s but reformed in 1953 and played at The Mars. Among their first productions was Boucicault's *The Colleen Bawn*, performed four miles down the road from Ellen Scanlon's grave. The Society moved to the Town Hall from 1957. Demand at The Mars was so great it probably made more sense to seek a less expensive venue. My only stage experience in Kilrush was in the school play where I played the captain of the guard and improvised keeping my soldiers in line by poking one of my friends with a spear in the less lofty venue of the CBS. I stood on the Mars stage now, nodding to the theatre ghosts, offering my respects. Backstage were even more discoveries – cloak rooms and band rooms,

one still containing a shattered piano, front casing long gone, strings rusted, keys partially discoloured making it look like the instrument was giving a goofy, apologetic, gap-toothed grin. You're not seeing me at my best, it said, but once upon a time, I rocked this place. On the wall a scribbled heading 'The Top Ten', but no listing anymore. In the back, stored firewood, broken and empty equipment boxes, a shovel leaning against a wall bearing a sign exhorting 'silence'.

This was all part of the building I didn't know. The Mars really was a vast structure, and out back gave access to the stream running behind the town out into the estuary. The Palace had been served by the West Clare Railway. Films would arrive by train in the evening, and it was said that you only knew the show was definitely on when you heard the wheelbarrow making its way up from the station. The river served no such function for The Mars. Kilrush Port was gone by my time, though we did occasionally go to Cappa to see a cargo ship unload after Mass in the 1970s. I even remember watching the last full-time residents leave Scattery Island.

The rear of the building did seem to be an alternative point of entry, though. The walls there were covered in tags, and not just the mindless scrawls and territorial markings of wannabe gangsters or professions of devotion to Iron Maiden and ZZ Top. Here also were names and initials in love hearts and other remembrances of times spent dancing and romancing that had nothing to do with me – Houlihan, Gorman, Lynch, Dotsy, A.O'L. loves B.T. 1966; the etchings of occupation and preoccupations probably now long subsided.

When I gave my lecture in 2017, I shared images of these markings, and I think they brought smiles to a few faces. That was fair enough. The point was to rekindle the sense of connectedness between a place we took for granted and the town that outlived it. So much of the social and cultural life of Kilrush, and even West Clare, revolved around this building and its predecessor in its day that it seems inconceivable it should pass away without a thought. Yes, there were many competing pleasures and duties, and though I was away at school and then college, I was as active a consumer of home video through the 1980s as the next man, possibly more so, and none of that ever stopped me going to The Mars. I was at some quiet screenings through the late 1980s. I remember once sitting down and knocking over part of a row of seats. Worried I'd caused damage, I went out to tell Jack. 'Don't worry about that,' he said, 'sure, that happens all the time.' I don't remember the name of the last film I saw in The Mars, but I first missed the place in the summer of '91 when I had to drive all the way to Ennis to catch a screening for a review I was writing for a magazine. Instead of five

minutes up to town, I drove for forty minutes to catch a film with strangers (and my brother, in fairness, the same one I'd been 'taking' to the cinema since he was six).

When I left The Mars this time, I said farewell. I touched the walls. I breathed in the air. I had a good look around and came away with photographs and video. Even the swallows had gone quiet by the time I was ready to go. I thanked Mrs Nolan for her time and for her permission to come here, and told her I would share some of the images when I'd had a chance to go through them. I showed them to my Dad that same evening. Twelve days later, he was gone. One photograph in particular I shared even further and wider. It was an image from the rear of the auditorium where that partially collapsed ceiling brought the inside and the outside together; a scene of ruin and decay bathed in bright light that made it melancholy, but not a misery. In that image I saw the story of my grief, but also still found joy in memory. What's gone is never really gone so long as you can feel it. It was later shortlisted for a photography prize, and again *The Clare Champion* covered my documentary of this part of my life and the life of Kilrush intertwined.

A last reflection: the name of the cinema came from Pat Tubridy's entrepreneurial spirit and fondness for an occasional after-hours tipple. Pat was a member, along with several other town notables, of the exclusive Toler Street Gentlemen's Club, founded in the Vandeleur era in a building which, when it went on sale in the 1960s, was described as 'situated between Church and State', being located between St Senan's and the old Bridewell. Pat, I was told, was convinced that one day humans would travel to Mars, and carried a note upon his person listing people who would sign up to go there with him when the time came. This list was produced at the Gentlemen's Club on more than one occasion, I was told by people who would know, and at other places as well, even when Pat was out of town. When it came to the naming of the new cinema, it was either a bet or a dare, depending on who told the story, that he would name it for this dream. I was lucky in 1994 to still have access to Kathleen 'Dodo' Kelly, Pat's daughter and for many years the manager of the cinema when her brother, Colman, the original heir apparent, left to work for Mayo County Council. Dodo did everything behind the scenes, including ferrying film prints between Kilrush and Kilkee (where her father-in-law, Dr Jack Kelly, owned The Arcadia) while also maintaining a full-time job as a teacher. She was still there in 2017 when I unveiled the plaque, and she wrote me a lovely letter afterwards thanking me for keeping her father's dream alive. I thanked her for mine.

Harvey O'Brien

Born in the United States and raised in Kilrush, Harvey
O'Brien teaches film studies at University College Dublin.
His writing has been featured in numerous international
books and journals on topics ranging from the history and
politics of film to horror, animation, and documentary. He
is a former member of the Board of Directors of the Irish
Film Institute and former Associate Director of the Boston
Irish Film Festival. He has lectured at several institutions
including UCD, DCU, NCAD, Trinity College, and NYU
Dublin.

He has spoken at international conferences and venues
including the Uherske Hradiste Summer School in the
Czech Republic, the University of the West Indies in
Trinidad, the Kennedy Centre in Washington, D.C. and
the Harvard Film Archive. He reviewed Irish film and
theatre for many years in *Irish Theatre Magazine* and *Film
Ireland* and wrote as a freelance journalist for *The Evening
Herald*, *The Irish Press*, and *The Sunday Independent*. He
is a frequent guest contributor to local and national radio.

The Graveyard Mass

Ruth Marshall

The men carried a table, a cloth, a vase of flowers,
along the shore path to the roofless ruin of *Teampall na Marbh*,
the 'graveyard church', for the annual island mass.

Families with a Scattery past came over from Cappa Pier.
The priest too, worried though he was to be back in time
for an important All-Ireland match on TV.

Although I was curious, the tradition was not my own.
I have no idea what they did there: neither at the mass nor the hurling.
While they made their prayers, I played host
to a party of women on a tour of the island's past.
I told them the place's stories of misogyny, while the priest, I assume, told his.

They say, in the days of the saint, a woman was buried between the tides.
Waves washed her bones. Not even in death was she welcomed ashore.
The place was never kind to women. There was hard work,
strong arms from rowing. But they made the best butter in the county.

When the tour was complete, the Graveyard Mass was over.
The women left on the same boat as the priest,
still checking his watch to be sure he'd not missed the match.

That night, I imagined an island girl in another kind of communion,
having hasty sex against an old church wall, daring infertility
and an unhappy marriage by lying with her lover in St Senan's Bed.*

*Leaba Sheanáin, or St Senan's Bed, is a twelfth century church ruin, said to be
the site of the saint's grave. Tradition says that any woman who dares to enter
Leaba Sheanáin will be unable to bear children. But, on the other hand, a few
women have told me quite a different story.

Biography

Ruth Marshall

Ruth Marshall is a Scottish poet, storyteller, and crafter living in rural East Clare since 1986. Her poetry is published in journals and anthologies in Ireland and the UK. She was co-founder of the Poetry Collective in County Clare. With the help of a mentorship awarded by Munster Literature Centre, she is currently preparing her first collection for publication.

Editor of *Network Ireland*, a holistic magazine for seventeen years, Ruth now works as a creative facilitator, combining arts, heritage, seasonal traditions and personal transformation, with people of all ages and abilities. She also works as an OPW tour guide on Scattery Island and Ennis Friary in the summer months.

Her books include: *Celebrating Irish Festivals* (Hawthorn Press, 2003), *Clare Folk Tales* (The History Press, 2013), and *Limerick Folk Tales* (The History Press, 2016).

Lisdoonvarna

Shelley McNamara

Imagine a place with three mineral water springs, sulphur, iron and magnesium. Every summer visitors flooded to this place to drink the waters, to bathe in them, to dance, to sing, to fall in love, to feel healthy and happy. As children we observed the routine. Christian Brothers and priests arrived in May and June, farmers, single men, single women and families arrived in July, August and September. In the mornings, as we walked up Sulphur Hill on our way to school, we would meet a procession of people walking down this hill heading for the sulphur baths and the pump house.

The beautiful bath house spans what we called the brown river Gowlaun. It is a two-storey building with terrazzo floors, Art Deco-type glass, steel and black leather furniture. Ladies' baths occupied one floor and gentlemens' another floor. The baths were so deep that each one had a large rope suspended over it. In my memory, they measured about seven feet long by three feet deep. This rope was to assist the user to get out of the warm soothing sulphur water having soaked in it for half an hour. All bathers had their own private room with an elegant tall window flooding the room with light. Nice local ladies or gentlemen assisted in the ritual and when the time was up they would come and wrap you in a blanket, like a baby, lay you down on a day bed and suggest that you go to sleep. The skin tingled with the after effect of the sulphur water and sleep descended instantly. One left refreshed and energised. Stiff bones and muscles were loosened up and pain was relieved.

After the bath, the visitors proceeded to the pump house with its marble and copper counter, taps serving cold or warm sulphur water, and smartie-coloured timber chairs. The acrid, eggy smell of the sulphur was considered familiar and 'normal' to the seasoned local and visitor alike.

Mid-morning, when the bathing was finished, the dancing started. The piano and the accordion occupied a spot inside the pump house during inclement weather, but mostly the players located themselves outside on an apron of space beside the river. The music flowed through the air and the dancers waltzed their way to lunchtime. The ground around the sulphur wells is elevated and forms a kind of amphitheatre overlooking the outdoor dance floor. The setting is beautiful with natural soft hillocks and meandering paths. Along the main path descending

to the river edge, a beautiful series of little terraces are made, each with a seat and a flowerbed. This comfortable vantage point attracted families and children who sat and played for hours, entertained by the clanky music and the energetic swirling waltzers. Ladies wore dresses with wide skirts which sometimes rose to waist level as they were twirled like spinning tops by their partners. Good dancers attracted partners like bees to a honey pot, and over the days and sometimes weeks of holiday-making, reputations were made and celebrated. As we returned from school walking down Sulphur Hill, the bathers and the dancers were coming up the hill for lunch in their hotels and guesthouses.

Sulphur Hill and the main footpaths were paved in big yellow slate slabs which came from Luogh Quarry in Doolin. The grass was at waist level as one walked down the hill and the elevated adjoining field was retained by stone walls. This gave a lovely feeling of enclosure as did the little recesses made in this stone wall where benches were snugly positioned. The hill was designed to be a social space and operated as such. The main hotels were extremely stylish, with grand dining rooms, ballrooms, conservatories and bars. There were four large hotels and four medium-sized ones and practically every house in the town operated as a B&B during the high season. The waiters and waitresses wore black and white uniforms and addressed everyone formally, including children who were addressed as 'master' and 'madam'. The meals were served using grand silver, and linen tableware, in elegant, light-filled rooms. As children, we loved this atmosphere and especially enjoyed the big silver soup spoons which seemed so enormous and were so challenging to manage without spillage and mess. The food was delicious, with green and orange soups, pea soup and lobster bisque, and my favourite, fresh salmon in a creamy sauce.

In the middle of the park stood the pavilion, also called the town hall. This is a wooden structure, its roof and walls clad in corrugated metal painted green with some touches of red. Smartie-coloured wooden chairs here too served to seat audiences for visiting and local drama companies. There was great excitement when these performances came to town and a sense of the metropolitan visited upon us.

Afternoons were spent walking around the town park, visiting The Magnesia and Iron Wells. The Magnesia Well was a twenty-minute walk from The Sulphur Well and much more rudimentary. It consisted of a little grotto by the same brown river with a little concrete canopy under which the water dripped from a rocky mossy outcrop. Cups were left on stone ledges and were used by all and sundry to collect and drink the water. Walking a further twenty minutes around

the park one arrived at the iron well where the same ritual was carried out before continuing to the town square.

The same big slate slabs formed long grand stairways down to the same brown river, making it easy to negotiate the significant slopes and level changes. Each stair tread was about three-feet deep and six-feet wide with a tiny riser formed simply by the two-inch thickness of the stone. The slabs of slate were laid like stepping stones to gently guide you up and down to the river edge. These generous dimensions allowed little groups to stop and chat and no opportunity was lost in encouraging social interaction. Visitors could also choose to be taken by bus to spend the afternoon in hostelries by the sea where the dancing resumed.

All dispersed and disappeared again to their various residencies for their 'evening tea'. Then, the whole population of visitors and locals spent the rest of the evening moving around the local pubs, and the bars and ballrooms of the various hotels. The dancing started up again and continued late into the night. Sing-songs and storytelling were interspersed with the dancing. The more extrovert personalities assumed roles of master of ceremonies, and these characters returned year after year to retrieve their positions. People of all ages and genders, from all walks of life, from all economic backgrounds, from all corners of the country and beyond, joined in this organically structured repeated daily routine, which had developed seamlessly over time. The result of this particular mix, or you might say concoction, of dancing, singing, bathing, drinking and socialising was that a socially liberating momentum built up whereby the shy, the old, the lonely, the socially skilled and unskilled were made to feel at home. A sense of excitement, fun, romance and erotic entanglements combined with health and wellbeing. Farmers suffering from rheumatism, stiff bones, tired bodies resulting from the hard physical work of the harvest months, were renewed by the restorative qualities of the spa. Those suffering from social isolation were buoyed up and carried by the wave of conviviality created by the repetitive daily routine.

This place is Lisdoonvarna, the spa town where I grew up in the 1950s and the 1960s.

In later years, reading about the spa towns of Europe, I realised that this idea of the daily routine was not unique and was a common ingredient, presumably for the same reasons. However, my impression is that the Irish democratic version had its own layers of eccentricity and unexpected social adjacencies which may have differed from the wider European model.

In 2010, I visited a town in Northern Italy called Boario. I was there to give a lecture and arrived in the mid-afternoon. There was a park with white pavilions and couples waltzing to soft easy music which was floating through the trees. I was astonished by the melancholic nostalgia that this scene generated in me and was stopped in my tracks to observe the scene before my eyes. I had no idea that I was coming to a spa town, Terme di Boario, and the force of the atmosphere brought me right back to Lisdoonvarna; not-so-young couples dancing in the afternoon in the open air. Located in the Alps with a similar range of mineral waters, I discovered that the routine was similar to that of Lisdoonvarna. Health, wellbeing, music and romance all brought together in one menu of activities.

Seeing some of the graceful dancers I was reminded of my big uncles who danced like angels and held me, and all their dancing partners, in such a way that one felt as if floating on the waves of the music, free of all gravitational forces. It is hard now to imagine that the waltz was considered sinful and vulgar when first introduced in Vienna in the seventeenth century. But when one thinks about it, the sensual unison of two bodies moving to the rhythm of music is not unlike the mating rituals of so many of our animal co-inhabitants of this world. And isn't it a beautiful idea to combine physical health and wellbeing with emotional and sensual wellbeing?

I often think of Lisdoonvarna and the Boarios and spa towns of the world, with their simple recipe for bringing people of all ages together, as a kind of phenomenon which highlights how compartmentalised our society has become.

Thinking back on Lisdoonvarna, it is the small details that are symbolic of the values at that time and are the ones that remain in the forefront of my memory. The stone footpaths, not concrete. The seats in stone recesses or paired with a flowerbed. The apron of space by a river which became a stage for people to show off, to be seen. The rudimentary green and red corrugated metal pavilion which exuded a sense of promise and magic. The grassy mounds and soft terraces made for sitting or lying on. There seemed to be a sensitivity of thinking behind the making of these small gestures. They invited human occupation. They invited enjoyment. These lessons have stayed with me.

Music was everywhere in County Clare. Hours spent in pubs listening to exquisite playing was almost the norm. The winter evenings where the small community of locals talked quietly was an antidote to the summer mayhem. One sometimes had the luck to witness unforgettable events. A four-corner set danced by four men in a Doolin pub. The small audience went dead quiet. This dance was old and sacred

and beautiful, danced by men in their working clothes and working boots. Four figures apart, moving in a geometric pattern. Many years later I was reminded of this event when I saw a Greek man dance alone in a small bar.

The enormity of the sea and the cliffs was brought home to me one evening in the same pub, when two friends arrived, shaken and pale as sheets. They had been out in their home-made currach, caught in the fog, and drawn by the currents to the base of the black cliffs expecting to be sucked into one of the underground caves or bashed against the rocks. Seasoned, experienced boatmen, one could see the fear in their eyes, traumatised by the immensity of this heroic unforgiving sea and landscape.

Rock is abundant in County Clare. Both my parents come from Carron, at the heart of the Burren. My father's father was a tall, Giacometti-type man who recited poems to us in beautiful Irish. We were too young to appreciate this properly but could not miss his expression and personification of a strange and ancient past. Being a self-taught mason and carpenter, my father would touch or stroke the materials of stone or wood with a knowing hand. He understood the grain, strength and capacity of these materials in such an intimate and physical way which sadly I have never reached.

I grew up in the environment created by my parents with my father building up his business as a builder, my mother, with her big heart, providing for the team of workers who lived in the house with us at the early stages. There were three uncles who came from Carron to work on the building sites. The house was full, busy, great for children but perhaps not so great for my parents. My uncles participated in the Lisdoonvarna routine of dancing, singing and socialising and this was not always conducive to doing a hard day's work. The builder's yard surrounded the house. Vans of men left from the garage early in the morning and retuned late in the evening. Timber was stored, a joinery was built, concrete blocks were made by hand and in the middle of all this my mother had her hen house! My sister stole nails and bits of wood from the joinery and made guitars which she would play on top of the turf shed which she took to be her stage. She also stole concrete and using soap boxes we made our own concrete blocks.

My first summer job as an architectural student was in an engineer's office in Limerick. This meant that I travelled to Limerick every day with the team of men who were working on a site where my father was building an office block. The seats consisted of planks of wood on some kind of support. Sometimes materials for the site were interspersed with us passengers. I loved this as I had known

these men since I was a child and they were always patient and kind even when we were a nuisance. I observed at closer quarters the effect that hard physical work had on them. Their hands were rough and dry from handling cement and plaster. Their bodies moulded and bent from carrying heavy loads, their skin showed the wear and tear of being out in all weathers.

I saw for the first time, in the engineer's office, a section drawing through columns and beams and wondered what all the black dots and lines were. They were of course the steel reinforcing bars. I felt foolish and inadequate. Waiting for the van to leave in the evenings, I watched big muscular steel fixers on the site, sweating in the summer heat, and working like skilled weavers with the muddle of steel bars and rods. I knew nothing about construction and building and worried about my ability ever to come to terms with its complexity.

At a different time and scale, the enormity of the heroic rocky landscape of County Clare seemed to have invaded my being. Living in London after graduating from university, I felt completely lost, not knowing how to find my way in architecture. On the occasions when I returned home on a holiday, there was a certain place I would go to walk to the top of a familiar rocky hill overlooking the Atlantic. There I felt anchored again. I rarely do this now. This rocky place is so deeply embedded that I almost don't need to revisit it. This connection at a vulnerable time of my life cannot be repeated. An accident of time and geological change stripped this place of its earth, exposed its limestone core with its creases and crevices carved away by the rain. This results in an atmosphere which is at times unbearably strange, even frightening, a presence of some kind of archaic world we no longer understand.

Discussing this phenomenon one day, my husband Michael Kane, who has introduced me to so many literary worlds, referred me to C.G. Jung's *The Archetypes of the Collective Unconscious*. There is a wonderful line in this work which somehow describes this mysterious overlap and compression of time when he says:

> The unconscious psyche is not only immensely old, it is also capable of growing into an equally remote future. It moulds the human species and is just as much a part of it as the human body, which though ephemeral in the individual, is collectively of immense age.

This perception of time is at the core of architecture. We reach into the ancient past in order to discover the future. Time is not linear in architecture as in life.

Another anomaly about this karst geology is that it has the same form as a dense city when viewed from the air. The deep channels appear like streets, the straight diagonal cuts like avenues or boulevards, the ragged edges like lanes and alleyways.

I realise from this process of remembering distant and recent connections with County Clare that I have inherited a love of stone, a love of crafted walls and artefacts where you can feel the personality, skill and love invested by the maker, a respect for workers, a respect for the physical and cultural integrity of each place, a radical belief in a democratic, non-judgmental approach to fellow human beings. These values are lodged at the very core of my collaborative work in Grafton Architects. The connection with County Clare, with the heroic sea and landscape, with the culture, musicality, skill, wit and humor of the people, has equipped me to confront the daily challenges and encounters of practising this wonderful phenomenon of architecture.

© Morley von Sternberg

Shelley McNamara

Shelley McNamara, co-founded Grafton Architects with Yvonne Farrell in 1978, having graduated from University College Dublin in 1974. She is a Fellow of the RIAI, International Honorary Fellow of the RIBA and elected member of Aosdána, the eminent Irish Art organisation. Teaching at the School of Architecture at University College Dublin from 1976 to 2002, she was appointed Adjunct Professor at UCD in 2015. She has been a Visiting Professor at EPFL, Lausanne in 2010-2011. Shelley held the Kenzō Tange Chair at GSD Harvard in 2010 and the Louis Kahn Chair at Yale in the Autumn of 2011. Currently, she is a Professor at the Accademia di Architettura, Mendrisio, Switzerland.

In 2018, Shelley and Yvonne jointly curated the Venice Architecture Biennale with their manifesto entitled *Freespace*. They were awarded an honorary degree from NUI Galway and from Trinity College Dublin. Both went on to receive The James Gandon Medal from the RIAI in 2019, the highest personal award given to an architect in Ireland. The practice was presented with the 2020 RIBA Royal Gold Medal in London, it is given to a person or group of people who have had a significant influence 'either directly or indirectly on the advancement of architecture.' Shelley and Yvonne were selected as the 2020 Pritzker Prize Laureates, the award that is known internationally as architecture's highest honour.

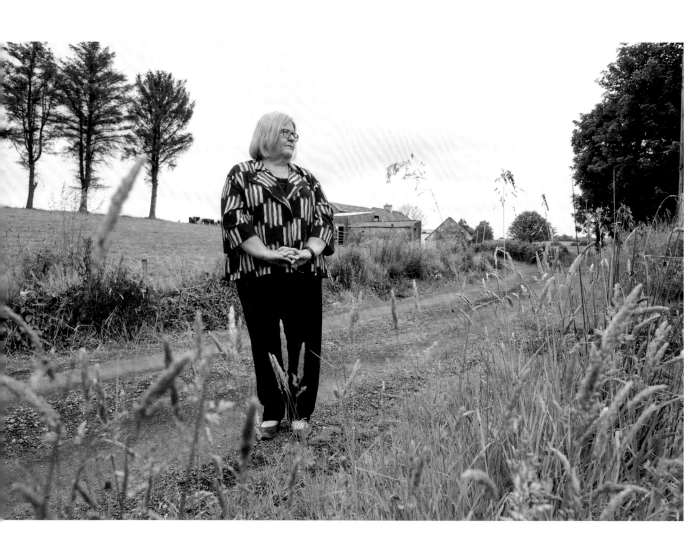

Trailblazing Banner Women

Geraldine Cotter

The (in)visibility of women in society and in the narratives of the past has been the subject of much discussion in recent years.[1] I am not a feminist scholar and by no means have I all the answers, but I am a woman, a musician, researcher, wife, mother and grandmother. Focusing on the twentieth century, I will reflect on the lives of pioneering Clare women and on my own lived experience.

It is clear that there are, and always have been, significant numbers of women playing traditional music, but they have not always been publicly visible. For example in County Clare women had a strong association with playing the concertina, but for the most part in the privacy of their homes. While there is no quantitative evidence of how many people in general play traditional music, or specifically how many women do, nonetheless the perception exists even today that it is a male-dominated arena. The *Fair Plé* movement was founded in 2017/18, to highlight issues around the representation of women, particularly in relation to public performance.[2] Unquestionably up to the late twentieth century, there were many factors which restricted women's full participation in society and consequently their freedom to engage musically, especially in public.

It is impossible to look at the role of women's involvement in traditional music in the twentieth century without first acknowledging earlier social values. The position of Irish women in society was very different to what it is now. However, because of positive changes in legislation, we now have more rights today than the women of the past. Society then was, and in many ways still is, patriarchal.

In this essay I consider the lives of a group of women who happened to be traditional musicians and whose lives spanned the twentieth century. I am particularly interested in how these women negotiated the challenges of the society in which they lived.

1 Recent movements include: Waking the Feminists campaign (2015-2016) focused on the under-representation of women in Irish theatre; Sounding the Feminists, founded in 2017 to promote and publicise the work of female musicians.

2 This movement in turn spurred a number of academic and other events, which continued the conversation on the representation of women in traditional music, e.g. Women and Traditional Folk Music symposium (2019) NUIG; Sounding the Feminists Symposium: Women in Popular and Traditional Music in Ireland (2018) DKIT; Fem Fest (2019) MIC, Limerick; ITMA International Women's Day; Radio Broadcasts highlighting the work of women performers.

Mrs Elizabeth Crotty née Markham (1885-1960) was born in Gower, a few miles from Kilrush. She learned to play music as a child and in time played at local house dances. In 1914 she married Miko Crotty and bought a pub in Kilrush. Like other women of the time, her music-making was confined to the home, which happened to be a pub and a well-known hub of traditional music. While she was well-known locally, she did not gain wider recognition until the 1950s, aged in her sixties.

A series of serendipitous events led to her becoming an influential person in traditional music. Sadly, Mrs Crotty developed a heart condition, which ironically enough appears to have signalled a turning point in her musical life. Her medical condition did not curb her musical activities. Her horizons were broadened at a time when people did not travel far, and during her regular visits to Dublin for treatment, her access to performance opportunities were expanded. For example, she frequented the Pipers Club in Thomas Street, the Oireachtas competitions and other events, and recorded for Raidió Éireann with Mrs Kathleen Harrington née Gardiner in the early 1950s.

Following the founding of *Comhaltas Ceoltóirí Éireann* in 1951, new settings and opportunities for performing, and even just being part of a social event outside of the home, emerged for women, for example Mrs Crotty attended many *Fleadhanna Cheoil* throughout the country. She was a founder member of the Clare branch of *Comhaltas* in 1954 and was elected the first President of the County Board, a position that she held until her death in 1960. She was relatively unknown nationally until after the first of many RTÉ broadcasts made by Ciarán MacMathúna from 1955, by which time she was aged 70. Following these broadcasts, Mrs Crotty became a household name and synonymous with the music of County Clare, and of course with the concertina. In 1959 she used her influence as part of a deputation from *Comhaltas* to approach the Clare Vocational Education Committee requesting the setting up of classes for traditional music. These commenced in 1961 and were the first of their kind nationally to be recognised by the Department of Education. Sadly, she did not live to see the success of the initiative.

There were many tributes paid to her following her untimely death aged 75. President Éamon de Valera sent a telegram of condolence to the family; in the 1960s a group of Clare people in Dublin named a music club in her honour; in Michigan, the Crotty Doran Branch of *Comhaltas* is named after her and piper Johnny Doran; in his RTÉ radio series *Our Musical Heritage*. Seán O'Riada considered her 'one of the finest concertina players I have ever heard.'

Éigse Mrs Crotty (1996-2009), a festival in Kilrush, celebrated Mrs Crotty's legacy. I believe that it is remarkable that Mrs Crotty became so renowned and influential, considering that she did not come to public prominence until the later years of her life.

In some ways, the life of Mrs Ellen (Nell) Galvin née McCarthy (1887-1961), born in Ballydineen, Knockalough, was comparable to that of Mrs Crotty. In the same way, she began playing fiddle and concertina at a very young age, and as a teenager won fiddle and concertina competitions at the Thomond Feis in Ennis. She moved to Moyasta after getting married to Patrick Galvin in 1917. Like Mrs Crotty, she did not gain wide recognition until 1937 when, aged fifty, she became the first Clare woman to broadcast on 2RN, the predecessor of Raidió Éireann. She was subsequently recorded during the 1950s by Breandán Breathnach and by RTÉ.

The name Kitty Linnane née O'Dea (1922-1993) was synonymous with the Kilfenora Céilí Band from the early *Fleadhanna Cheoil* wins of the 1950s until her death. She played piano and acted as manager of the band for over forty years, a highly rare if not unique position for a woman. Although less well known, between them, piano players Molly Conole and her daughter Phil McMahon acted as tutors to the bands for a period of nearly a century, helping to maintain the distinctive sound of the band. All three piano players had a level of participation which was at odds with the norm elsewhere. I can only surmise that their ongoing achievements strengthened their roles.

Largely unknown and from the same locality, Mrs Bridget McGrath née Lynch (1880) gained a reputation as a composer of tunes, many of which have made their way into repertoire, for example 'Mulqueeney's Hornpipe'. She was a concertina player, seldom heard outside her home, except on the rare occasions she played with her brother John Joe, one of the founders of the band in 1909. According to her cousin Gerry McMahon:

> … she slept with a pencil tied to the end of her bed. She would wake from a dream with a tune in her head and so as to remember it in the morning, she would scribble the notes of the tune on the wallpaper beside her bed. Then, when she got up in the morning, she would pick up the concertina and play the notes written on the wall.

I find this scene so inspiring; that she felt the music so viscerally. It was in her deepest subconscious.

Kitty (Catherine Honora) Hayes née Smith (1926-2008), born near Moy, was surrounded by traditional music, in a home well-known as a venue for house dances.[3] She began playing on her father's concertina when she was eleven and played at house gatherings at home and locally until 1948, when she married well known flute player Josie Hayes. His sister Babbie married renowned Sligo fiddle player Paddy Killoran, who was a regular visitor to their home. Like others of her generation, once married, although she retained her interest in music, her life revolved around caring for others: her parents-in-law and her seven children. She also took care of the farm when her husband was performing with the Laichtín Naofa Céilí Band. Her daughter Angela Connaughton recalls that:

> The roles of women in the home, particularly in the farming
> community, extended far beyond the perceived 'supportive' role …
> it was understood and accepted by them both that he (her husband
> Josie) would always be available.

Likewise, in his 1990 research of Clare concertina players, Gearóid O'hAllmhuráin found that for male players 'oral evidence shows no particular change in their music-making before or after marriage … male players tended to enjoy a full and uninterrupted life of musical activity'. According to Angela, her mother felt no resentment that playing music was more a 'man's world' and in fact 'she felt very much a part of it and indeed felt privileged to be a part of it … she loved Josie's music and was always very proud of him.' Over time, music sessions increasingly relocated to pubs which were the domain of men and where women were excluded.[4] According to Angela, 'it was not usually customary for women to accompany their husbands to the pub. Kitty reflected that there was, therefore, no such expectation, or feeling of missing out'. Angela recalls one occasion, however, when Kitty felt envious of Mrs Crotty. On a rare visit to Kilrush, she heard her playing with Josie and Paddy Killoran. It was considered acceptable for women to play at home, and of course Mrs Crotty lived in the pub where the music was being played. In general, though, rather than feeling it as a restriction forced upon her, Kitty Hayes accepted it as part of life and had no expectations, as was the generally tacit acceptance by women at the time of working restrictions placed upon them once they got married.
From the mid-1970s, it became more socially acceptable for women to enter pubs and she began going to Nell and Jimmy Gleeson's pub in Coore, a well-known venue for music sessions.

3 The movement from homes to public settings following the Dance Hall Act 1935 impacted on women.
4 Before 1970, some pubs refused to allow women to enter at all, some allowed women only if accompanied by a man, and very many refused to serve women pints of beer. In 2000, the Equal Status Act banned gender discrimination in the provision of goods and services.

It became an important social outlet for Kitty, especially following the passing of her husband in 1992, and sadly a few years later when her son Joe, a musician, also died. Joe had bought her a concertina and encouraged her to return to playing, which she did with gusto, recording two CDs, performing at festivals, appearing on TV and radio programmes, including *Sé Mo Laoch* (2006), a programme which celebrated her contribution to traditional music.

So, how has my own life compared to the experiences of these women? Máire Ní Chaoimh considered that growing up in a musical family was a major factor in facilitating women to play music. I was lucky that music has always been at the centre of life in my family and all seven of us learned to play music, and in fact my mother succeeded in teaching all 22 of her grandchildren. The commitment to music started with my maternal grandmother Bridget Lernihan née Conlan (1888-1960), who incidentally was not a musician herself. However, she instilled an expectation in her two daughters, Mary O'Neill née Lernihan (1916-1962) and Dympna Cotter née Lernihan (1928-2013), that they could have an independent income by pursuing a career as professionally qualified piano teachers, which they both did. This was very astute of her in that it was socially acceptable to teach piano even as early as when my aunt began in the late 1930s. Mam taught piano in West Clare and in Ennis for over 60 years. Both of my parents instilled in me a belief that I could be anything I wished to be. I was very lucky in starting my adult life at the cusp of change for women, as feminism evolved and as legislation began to improve women's lives generally.

I distinctly remember hearing the strong voices of feminist campaigners on the *Late Late Shows* of the 1970s and there was a groundswell of activity; it was an age of possibility, full of expectation for women. I am not sure that as a teenager I fully understood the significance. I was happy living life day by day in my own little world playing music and travelling wherever it led me. Be that as it may, I was single-minded and determined that I would be a musician and music teacher, and although I was considered shy and not exactly oozing with confidence, I cannot remember ever feeling any doubt that it might not happen. Growing up as a teenager in Ennis in the 1970s was very special; musically it was emerging as a hub of traditional music and there was no shortage of performance opportunities especially through *Comhaltas*. My recollection is that there were very few girl musicians my own age performing on stage, although that imbalance was not evident in music classes, which I referred to earlier.

Personally, I never felt that I was disadvantaged as a young girl and I acknowledge how privileged I was to have been mentored by many iconic male

musicians, and can say with sincerity that I have never felt that I was treated differently by them because of my gender. Maybe I was just lucky that there were not too many piano players playing traditional music at the time. Women had a strong supportive role in *Comhaltas* but generally they were in the background; involved in catering, arranging accommodation for visiting musicians, as Kitty Hayes did, but in a more public community-based context. I wonder if they were unhappy or just tacitly accepting of these roles. Of course, as a teenager, through *fleadhanna* and other events, I got to know and to perform with many women musicians from Clare and elsewhere. However, at that time, the opportunities that came my way were predominantly coordinated by men.

For a period of years when my children were young, like generations of women musicians before me, I stopped performing in public. Anecdotally, women have found it challenging to commit to professional performance engagements when children are young but, in my case, I had every support from my husband John to continue if I so wished. I can say with certainty that I felt no pressure, nor did I make a conscious decision to stop. Considering that I did continue to teach fulltime in school, I can only surmise that in my case it may have been more to do with a lack of time or energy than a decision consciously made.

My return to playing in public was done very intentionally however, following a random comment from someone who queried, 'are you a musician, like your children?' It came as a shock to me because music was a fundamental part of my life. The comment left me feeling I had lost part of my identity and became the catalyst for me to take stock of my life in music. Considering that I was not subject to the legally embedded and socially accepted restraints of earlier generations, my life as a performer in many ways has not been particularly different to theirs, except that my return to public performance was at a much younger age. Above all, of course, I had a choice and was free to have a career as a teacher, and there were no legal or social constraints to limit me.

To say life has changed for women musicians since I was a teenager in the 1970s is an understatement. Over time, opportunities to perform at a professional and semi-professional level have emerged for many musicians. Personally, I feel very grateful to have enjoyed decades of friendship, music making and touring with many talented women. In County Clare at this time, women are role models and at the forefront of many spheres of engagement in traditional music: performers at local and international level, as recorded artists, as composers, as performers on radio and television, as presenters of programmes on various media, directors of documentaries, as journalists, as music therapists, as festival organisers,

owners of music shops. Women are also leaders in the field of music education in various settings: at primary, post primary, third level, private schools of music, providers of master classes, leaders in online and blended contexts, and in academia as researchers with published works. In addition, in recent years traditional musicians who happen to be women have gained major awards in recognition of their contributions to traditional music.

Discussions around gender can be divisive. I genuinely believe that most men support women. They are our husbands, fathers, brothers, partners, uncles, friends and not a homogenous group who are knowingly depriving women of equal opportunity. Changes in society take time. Men and women have had very defined roles; older generations of men were expected to be strong providers and defenders of women, and women in return were the keepers of the home with a strong nurturing role. Both roles were embedded in society and backed up by legislation. We do not live in a utopia, and while society is taking stock of how people are treated generally and becoming aware of unconscious bias, I acknowledge that there are challenges in the representation of women, especially in the professional sphere. Everyone in society needs to be aware of inequity and stand up for fairness. This collective duty will ensure that everyone, regardless of gender, age, ethnicity or sexual orientation, can enjoy access to opportunities in traditional music. Through reflecting on the lives of Mrs Crotty, Mrs Galvin, Kitty Linnane, Molly Conole, Phil McMahon, Bridget McGrath and Kitty Hayes, it is possible to reach a new understanding for what it means to be a female musician of your time.

I wonder what the women of the future will make of our lived experience?

Bibliography

Connaughton, A. (2019) *The life and music of Kitty Hayes*, presented at Concertina Cruinniú, Miltown Malbay.

Cotter, G. (2016). *Transforming tradition: Irish traditional music in Ennis, Co. Clare 1950-1990*, Ennis.

Curtis, PJ. (1994). *Notes from the Heart*, Dublin: Torc.

Ní Chaoimh, M. (2020) *Kitty gone a' milking: Women in Irish traditional music*, presented at Concertina Cruinniú, Miltown Malbay.

Ó hAllmhuráin, G. (1990). *The concertina in the traditional music of Clare*, unpublished thesis (Ph.D.), Queens University.

Ó hAllmhuráin, G. (2016). *Flowing Tides: History and Memory in an Irish Soundscape*, New York: Oxford University Press.

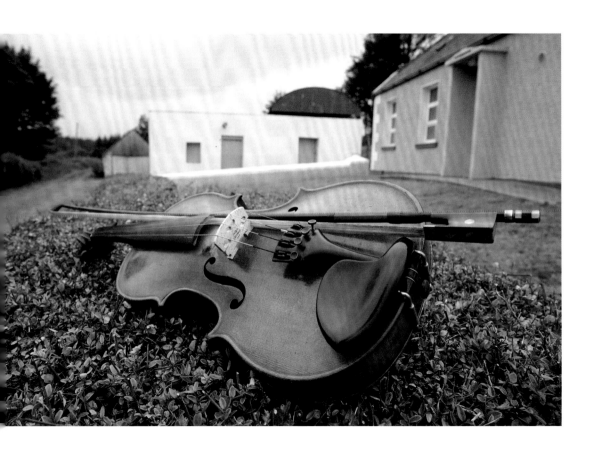

Geraldine Cotter

From Ennis, County Clare, Geraldine Cotter is a
tin whistle and piano player, composer, arranger,
teacher and researcher, currently lecturing in Music
Education at Mary Immaculate College, Limerick.
In 2019, along with her brother Eamonn, she was
subject of the TG4 documentary *Sé Mo Laoch*. In
2017 she was presented with the MÓRglór Award
for outstanding contribution to traditional music in
County Clare. Her publications include *Transforming
Tradition: Irish Traditional Music in Ennis, County
Clare 1950-1980* (2016), *Rogha: Geraldine Cotter's
Choice* (2008), *Geraldine Cotter's Tin Whistle Tutor*
(Ossian Publications, 1983) and *Seinn an Piano*
(Ossian Publications, 1996), the first tutor for Irish
traditional music for piano. She has contributed
articles to *The Companion to Irish Traditional Music*
and *Encyclopaedia of Music in Ireland*. Geraldine has
recorded over 30 albums, including her debut solo
album *Piano+*, and is presently completing an album
to be released by Raelach Records.

How Deep Shall We Dig?

Michael McCaughan

'Clay is the word and clay is the flesh' – *The Great Hunger*, Patrick Kavanagh

Starting Out

I was a young teenager when I first became interested in rebellion and revolution. In my bedroom in Blackrock, County Dublin, Kevin Rowland sang and I listened. 'You know the only way to change things is to shoot men who arrange things.' The right type of guns, of course, in the hands of the warm-hearted, selfless and incorruptible idealists, killing in apologetic fashion.

There is nothing more certain in life than a certainty acquired at the age of sixteen. I had a poster of Czech dissident Jan Palach on my wall but it was many years before I fully understood where he was coming from. My sister had a poster of Che Guevara on her wall. She told me years later that back then she believed he was the lead singer with The Doors. Knowledge arrived in haphazard fashion. Che spoke of a new society, *el Hombre Nuevo*, forged from the materials of revolution, leaving all human frailty behind.

Cuba was the living proof that a revolution, if it was to last, must be fair and equitable but also tough and implacable. The revolution rebooted society and ensured happiness for (almost) all. The good triumphed and the bad went to live in Miami where they ran drugs and sawed people's legs off for non-payment of debt.

These certainties were confirmed by repeated listening to stirring Latin American anthems, like '*Venceremos!*', but the spirit of defiance leaked on to Top of the Pops, in Abba's classic 'Fernando', with its talk of drums, rifles, freedom, a night full of stars and no regrets. As my friends filled in their CAO forms, I was quietly applying myself to a career as a soldier of destiny in a Latin American *sierra*. The war at home, just up the road, didn't trouble me too much. The drunken singalong of the Wolfe Tones was no competition for the epic tales of Chile's national bard, Victor Jara.

Nicaragua

I arrived in Managua, Nicaragua on July 18, 1985 on the eve of the sixth anniversary of the Sandinista Revolution. I had just turned twenty-one. The

Clash's 1980 album *Sandinista* fired my passion, transporting me from dreary Dublin to the exotic tropics, my imagination soaring toward a new world, tangible, already underway. The Sandinistas overthrew a tyrant, Somoza, in 1979, dissolved state institutions and started over, creating the new woman and man. The new government announced healthcare and education for all, land was redistributed, the death penalty abolished, polio eliminated and in 1984, internationally-supervised democratic elections legitimised the armed victory through the secrecy of the ballot box.

I carried a letter of support from the Irish Nicaragua Support Group, endorsing me as a trustworthy friend of the revolution. Before I left, one of their members (Hi Val), took me aside and quietly advised me to cut off my Mohican, give up the 14-hole doc martens and remove my two earrings, one, an upside-down cross, the other, a feminist symbol.

I spent a summer in Nicaragua, a shy but watchful observer of a small nation walking proud on the global stage. The Reagan administration set about destroying this fragile emerging state, combining economic and military aggression. I fell in love with this dream of a better world and its mind-altering proposition – that revolutions happen in the here and now, not just in history books.

I returned to Ireland, keen to start the work, but floundered. Colombia's M-19 guerrillas insisted that '*la revolución es una fiesta*' but I found little to celebrate. If a poster was designed to suit 1980s Ireland it might have featured a giant Catholic cross to which Bernadette Devlin was nailed. The vibrant campaign against numerous miscarriages of justice (Birmingham Six etc.) and the powerful campaign against the apartheid regime in South Africa, occasionally lifted the gloom. For most people, there were mortgages to pursue, jobs to find and failing that, the inevitability of emigration.

Drink was consumed, talk was cheap and nothing ever changed.

In 1990, the Sandinistas were voted out of office and the revolution died in the years that followed. Sandinista supporters like myself found plenty of excuses – 'voters had a gun to their heads', etc. In hindsight, the revolution failed to address fundamental issues of national identity as potential supporters were alienated and the temptations of authoritarianism eroded much of the initial popular support.

Perhaps most people simply wanted a quiet life and fatigue won out in the end. Love is blind and my deep emotional attachment to Nicaragua prevented me from seeing any of that. In Ian Maleney's memoir, *Minor Monuments*, a character remarks, 'we all see things not as they are, but as we are.'

For us passionate Sandinistas, the revolution was made flesh not just by the literacy campaign or the distribution of land, but by the fervour and *alegría* of the mass gatherings on July 19, outpourings of hope and celebration, spiritual sustenance. There was a longing in us, a hunger for something greater than the sum of our small lives. When it ended, we felt orphaned, suffering a loss akin to a bereavement.

As I reflect back on my time in Nicaragua, I am always drawn to a single memory. It was a hot afternoon and I wandered, lost, in a tough neighbourhood. I began to feel anxious, a little panicky as the atmosphere had that hint of menace which arises when a white, wealthy gringo (all gringos are wealthy) loses their moorings, tempting fate. A young girl appeared at my side, maybe twelve years old. She took my hand and walked me to her parent's house, a simple shack occupying a few square metres of muddy terrain. Initial surprise gave way to laughter at the rescue operation and the entire family drilled me with questions. It was a rare treat for the locals to sit down with one of the countless *gringos* wandering their country in search of some essential truth.

We drank a leisurely *cafecito* after which I was accompanied to a nearby bus stop. In the years that followed I worked as a journalist in Latin America where, in addition to having the time of my life, I was also beaten, stripped, robbed, arrested and shot at, but that small exchange stayed with me more than all those dramatic events. After all the books and songs and rallies, the heated late-night discussions, passionate romances and frequent tacos, this small act of decency returns to me again and again.

In 1998 I learned that Sandinista leader Daniel Ortega had been routinely abusing his adopted daughter Zoilamérica Narvaez for three decades, a litany of terror recounted in the victim's 50-page affidavit. Ortega and his powerful allies smothered the story. Many Sandinista supporters chose to shrug their shoulders, to deny or dismiss the abuse as a private matter, the patriarch's privilege.

In 2018 I learned that the findings of a 1983 report into sexual violence, undertaken by the Sandinista women's organisation AMNLAE, had been suppressed, too inconvenient for a movement which preached gender equality. It

found that Sandinista militants engaged in the same wholesale domestic violence as occurred in Somoza's time. The New Man looked a lot like the Old Man. I didn't need a report to tell me that, as I heard it every time I walked down the street in Managua (or Mexico City or Bogotá) where men routinely insulted women of all ages, groped them on public transport and committed barbarous acts behind closed doors.

The AMNLAE report disappeared, the researchers sidelined and ultimately pushed out of the movement.

In the meantime, I grew up a bit, continuing my romantic pursuit of rebellion and yes, I could still see promising signs everywhere, if I looked hard enough. There should be a medical term for this condition, for delusion never dimmed by the stubborn refusal of reality to play along. Ireland was a place I returned to each year, recharging batteries worn down by the relentless march of the neoliberals and the Narcos. Meanwhile, the region's progressive leaders (Chavez, Evo et al.) fatally damaged the popular cause as one-time political outsiders discovered, while in office, that the presidential throne fitted only their backsides, advising us to trust them, that no one else would do, *de veras* and in perpetuity.

One notable exception is Pepe Mujica, Uruguay's one-time president, a former guerrilla who transformed the presidential office into a place of dignity before departing on schedule.

In January 1994 a rebellion was launched in Southeast Mexico where indigenous Zapatista rebels declared war on the *malgobierno*, demanding *tierra y libertad*. The Zapatistas were unlike any other rebel movement I had known, embracing sexual diversity, rejecting guns even as they wielded them and advocating a system where 'everyone is the government' and political leaders are at the service of the community. That system is rooted in the indigenous assembly and the *cargos* (jobs) distributed on an annual basis. The *cargo* comes from the verb *cargar*, to carry, as every member of the community is expected to 'carry' their fellow villagers by taking their turn at a range of community jobs.

The assembly was a regular discussion space in which ambiguity and evolving consensus replaced simple vote-casting. The discussions were in Tzeltal, a language which connected the villagers to their ancestors, the Maya, caretaking the same land for thousands of years. There were audible Vincent Browne-like sighs when the *cargos* were distributed, demanding work on top of the rigour of the *milpa*, the daily cultivation of small plots of corn and beans. There was

little to rhapsodise at 5.00 am each morning when the metallic ring of swinging machetes passed by my bunkhouse as I laid low and hoped no one would drag me out to the fields. Occasionally, I was handed a machete and obliged to share a morning in the *milpa*. My presence cheered up the villagers, who whooped and giggled at my sad effort to keep up with the others. Once in a while I was invited to fire a weapon, a reminder that this autonomous territory was defended by bullets as well as beans.

An Bhoireann – ag teacht abhaile

As we entered a new millennium my attention shifted homewards and a series of fortunate events took me to a field in the Burren. I arrived into a world of healers and hippies where spiritual teachers were held in high esteem and personal transformation viewed as essential to political change. My sixteen-year-old self would likely have cringed in embarrassment had he seen this coming up ahead. Yet in a county where the GAA, Church and tidy towns held sway, I found myself contained within a community largely autonomous from the mainstream, a parallel universe reminiscent of the Zapatistas.

I was confronted with a new challenge: my nomadic, freewheeling lifestyle came face to face with obstacles which never troubled the rebel apprentice; I needed to buy land rather than watch others occupy it, I needed to secure a bank loan rather than celebrate a bank heist, and I also needed to learn to drive. For me, a steep learning curve lay ahead as the footloose anti-capitalist adventurer who fell to earth. I thought I had a free pass on these mundane matters, but before long I was donning the suit and talking to The Man, in polite fashion.

My neighbours built their own homes, grew food, fixed cars, danced Flamenco, sailed boats and raised confident kids. It made me laugh, thinking back to the Argentinian Montonero guerrillas who demanded that their militants have a very particular skill set: evading surveillance, driving getaway cars, robbing banks, targeting state repressors, a European language desirable but not essential.

It was a difficult transition but at evening-time as I walked by a neighbour's house, the smell of woodsmoke and the barking of *los perros* took me back to a Zapatista village. A whole new life had begun.

On March 19, 2020, as the dreaded virus spread like wild fire, I was sent home from my part-time job. That afternoon I began to dig. I had no plan and little experience but I knew I had to grow food. It felt like my life depended on it.

The weather agreed as damp springtime ceded to Mediterranean warmth with sunshine from dawn to darkness. The rain declared a ceasefire which lasted three months. The outdoors beckoned. As the virus body count rose, my life acquired meaning amidst the seeds and weeds on an acre of land surrounded by sycamore and beech, tangled in brambles and ferns, overgrown and unkempt. I apologised to the earth each day and encouraged the flowers. I built raised beds, planting early crop potatoes along with kale, beetroot and lettuce. I trimmed raspberry canes and started in on the brambles, a decade of laziness ceding to purpose and anxiety. I came in from the garden later and later in the evening, unaware of time as a Wednesday in March became a Friday in May and a Saturday in June.

I was an imposter with a shovel but as time passed and I tuned in to the natural world around me, the garden directed my attention from one task to the next. The rake, hoe and shovel soon fitted my hands better. My arms ached each night as I fell into bed, exhausted but at peace. I was never done as one task led to the next, a patch of wildflowers here, a *crann daire* planted there.

I ventured out only to collect my toddler from his mother's house. Féile arrived, blissfully unaware of the crisis, skipping down the field, enjoying the freedom of a wild, natural playground. He took his small spade and bucket and began to dig alongside me. Féile and myself speak Irish together but being unfamiliar with the terms, I found a whole new *stór focal*. I was not simply translating the names of plants, trees, veg and flowers but opening up a portal into an unseen world. The Irish language shaped and gave meaning to the ground beneath my feet, word-shapes and sounds with roots going back 2,000 years.

On one occasion I needed a liquid feed for the more sensitive plants and was advised to buy a seaweed solution. Days later, a friend from the Gaeltacht arrived and broke off branches of comfrey before tossing them into a rainwater barrel. Within a fortnight I had a liquid feed. I looked up the word comfrey and found 'lus na gcnámh briste,' the 'herb of the broken bones.' Sure enough, when cars and hospitals were out of reach, comfrey once formed the basis of a homemade splint. It may yet fulfil the same purpose.

I joined the Irish Seed Savers Association, an organisation long accustomed to general indifference and reflexive *béalghrá* (mouth-love = lip service), now overrun with panic buyers and overnight converts. First, we emptied the shelves at Lidl and Aldi, then we emptied the seed shops, finally acknowledging that food did indeed grow in the soil rather than in large trucks. A small Burren field became a universe. I had no social media and relied on weekly newspapers

alongside Raidió na Gaeltachta, bringing news of great suffering but also great solidarity and cooperation. My neighbours shared seeds and tips and plants and banter. After a lifetime digging elsewhere, across swathes of Latin America, the time had come to dig where I stood. Observers spoke of a return to simpler times, but this felt like a glimpse into the future, a twenty-first century compromise involving remote working, speedy internet and a degree of self-sufficiency.

I knew I was lucky and privileged.

Ah, that word, finally.

Soon after I moved to the Burren in 2003, I became involved in the Corrib gas dispute in North Mayo. Here was a campaign which raised all the issues I had reported on in Latin America: the many meanings of 'development', 'progress', 'consent' and 'community engagement'. All that was missing was brutal state repression but that too came in time. I was amazed, one evening, to sit in on a weekly community assembly in a hall with a hearth and a fire, where opposing viewpoints were robustly expressed, a sulk here, a walkout there, voices raised, the walkout's return, some laughter, doubts expressed and decisions deferred. It was slow and unwieldy, but everyone was included.

The Corrib gas issue was sold by government, Church and most media as a vision of the future, of oil, gas and employment versus self-centred backward-looking yokels. There's no accounting for some people, and for others there seemed to be nothing but accounting – a fantasy of risk-free economic growth.

Ireland's future, if there is one, will resemble the Corrib campaigner's demands to leave fossil fuels in the ground and pay attention to farming, fishing, habitats and people. The Irish language was to the fore as Micheál Ó Seighín and others explained the dinnseanchas pertaining to Lake Sruth Fada Con and its environs, mutant messages underwater, old wisdom informing new dreams waiting to be born. The neighbourhoods of Poll an tSómais, Inbhear and Ceathrú Thaidhg became occupied territory as police vehicles, helicopters and finally a navy warship came to ensure the safe arrival of the future.

At home in the Burren there was peace and total silence as meditation began, along with tai chi and sea swimming. There were no short cuts on this journey in pursuit of greater self-awareness. I discovered ambiguity and doubt and some uncomfortable truths, reading Hannah Arendt, Albert Camus, Arthur Koestler, Rebecca Solnit, Anna Burns and Eduardo Galeano.

John Moriarty, in speaking about change, wrote of the need to remain 'vulnerable to further experience.' Our answers to big questions are necessarily limited to current knowledge and as soon as certainty arises, Moriarty says, 'there is no further growing.' There isn't a day that passes without a reminder that I am and remain white, male and privileged. This is no cause for lamentation or denial but for awareness and responsiveness. My activism, if that is even a thing, is dedicated to undermining and disappearing that unearned privilege just as the Zapatistas, in their armed manifesto, said they 'bore arms that aspire to becoming useless.'

There is another type of privilege: Féile, my son. It is a privilege to be his parent, to watch him grow and to surround him with love. This is privilege earned afresh each day. From a bedroom in Blackrock to the wide expanses of Latin America and now a field in the Burren where a toddler digs up na fataí and hope lies all around us.

Deireadh

Biography

Michael McCaughan

Michael McCaughan is a parent, writer and researcher living in the Burren. He worked as a foreign correspondent in Latin America for many years, primarily with *The Irish Times*. He currently works part time with Clare County Council as Irish Language Officer.

He has lived in Mexico, Colombia, Argentina and Venezuela, with a particular interest in Mexico's Zapatista movement. He is author of *True Crimes: Rodolfo Walsh, the Life and Times of a Radical Intellectual* (LAB, 2002), *The Battle of Venezuela* (Seven Stories, 2005) and *The Price of Our Souls: Gas, Shell and Ireland* (Afri, 2008), which chronicles the Corrib Gas controversy in County Mayo.

In Colombia, McCaughan investigated Smurfit Carton de Colombia, a company owned by Michael Smurfit. That story, published in *The Irish Times*, sparked a public campaign to improve worker conditions and safeguard the lands of indigenous people displaced by the company's operations.

In a previous life he 'joined' radical anti-abortion group Youth Defence, working undercover inside the organisation before publishing an exposé in *Hot Press* magazine in 1992.

His most recent book, *Coming Home* (Gill 2018), follows the author's journey into the Irish language, one *focal* at a time, offering an accessible guide to *an Ghaeilge.*

Nancy

Frank Blake

When asked by people why I decided to be an actor I can never seem to offer up the romantic one-line polished answers that I so often hear from my peers. Sometimes I try out the usual responses: witnessing a definitive theatrical performance, a jaw-dropping trip to the cinema or the one I am loathe to hear, 'I couldn't do anything else.' I think the reality is that despite not actually trying out the discipline itself until I was in my late teens, it is something that I was always exposed to in some form, indeed we all are, whether it be a neighbour telling a story, a fight in the school yard or the great theatre so many of us attended each week: holy mass. There is drama in everything we do if we care to see it.

As I look back now, I still can't quite put my finger on any exact point where I decided this is what I want to do with my life, but what illuminates those moments for me are the small changes of wind which set me on this particular course. I see how important a small act of kindness or a few gentle words of encouragement here and there can be and how fortunate I was to have positive influences visit me.

I grew up in Tuamgraney, East Clare. We lived in Drewsboro, a leafy hollow off the main road to Scariff. I was the youngest of three boys, which of course brought with it both perks and perils in equal measure. Being the youngest by four years, I was deemed by my brothers to be too young to accompany them on their escapades, an anchor to the wildness they sought out. Fair enough. When I tried to tag along with the older lads on their adventures I would often be chased home like some stray dog. If I proved stubborn or stupid enough to hang on, I very quickly found myself becoming the butt of all their fun. I soon learned...

Company being hard to come by in a small village, I became creative in thinking up my own solo crusades, no problem for any child; I could be whoever I wanted. Jumpers became goalposts as I morphed into Roy Keane at the gable end, by lunchtime I was James Bond at the wheel of our Zetor tractor which was putting in an equally brilliant performance as an Aston Martin DB9, then sticks became swords as I fought to the death with fellow gladiators in my Roman Colosseum, the bog. Any one object I laid my eyes on as a child had infinite possibilities, all thanks to my great fellow in arms, my imagination.

Another great companion of mine throughout my youth was our neighbour, Nancy. Nancy was an elderly woman who lived in a small bungalow at the end of our avenue as it joined the main road. Her character was built on immense kindness and generosity, traits which one can only aspire to. As a child, I often had to be corrected when I used to tell people that Nancy was my grandmother, apparently just being old and nice to me were not sufficient criteria for the title. She fell somewhere between a friend and a guardian. A wise elder I could confide in but also a great source of craic.

Living on the main road and being of a generous disposition, Nancy had a constant stream of visitors throughout the day. I'd sit in the corner and listen to local news and stories from the teachers, nurses, priests, shopkeepers and bus drivers, to name but a few, who would call in every day. Being a placid child, I was very much contented in being a fly on the wall to these conversations without the worry of having to make any input. I began to learn the social currency of storytelling; if you had a good story you were always welcome, and even more so if you hadn't a good story but you could make it. I learned this on one occasion when those famous wise words were imparted unto me after I questioned the truth of a particularly tall tale: 'Frankie Boy,' Nancy said, 'Never let the truth get in the way of a good story.'

She was a curious individual with an open heart that led her into the strangest of situations, often with me in tow. I recall one afternoon bursting into her sitting room: 'Nancy, Nancy! There's a circus in the next field.'

'I heard that all right. Come on and we'll have a look.'

We walked out to the road and Nancy lifted me up on the wall so I could peer over at the encampment. I couldn't believe my eyes. The big top, zebras, camels, fellas on stilts and other such things I thought incredibly exotic at the time. 'It's like America,' I imagined.

As my eyes scanned across the field, a door burst open on one of the large caravans and a hairy, burly man framed himself in the doorway, the ringmaster. This leather-clad man leaped out and made a beeline for us as I signalled to Nancy to let me down so that we could abort our spying mission. As he got closer, I felt my blood run cold and readied myself to be fed to the lions. His arms outstretched, he boomed, 'Nancy me aul' flower. Good to see ye!'

Unsurprisingly, the ringmaster greeted her as an old friend. 'And this is the fella you were telling me about. Do you want to have a look?'

The man picked me up with his shovel hands and set me down in what felt like the Serengeti. He led me around the animals and big tops as Nancy stood watch at the wall.

He brought myself and Nancy in for tea and biscuits in his caravan. I watched in awe as he shared his biscuit with a parrot perched on his shoulder. Despite the obvious ridiculousness of the situation, Nancy chatted to this man the same as if he was a bus driver or the parish priest. As we exited the field I got distracted and came face to face with a camel. Again, I was raised up by shovel hands and found myself suddenly straddling this camel as the ringmaster led us around the field. Most people go to the desert to ride a camel, with Nancy I just had to hop the wall.

It was through Nancy too that I had my first experiences with theatre, or rather 'the drama', as they'd call it at home. The annual Clare Drama Festival would take place in the local Community College hall. Every night over two weeks, amateur dramatics groups from all over the country would come and unleash their play on us for one night only before packing up and moving on to other far off places to do it all again. There was great sport in it; it was a place where the sensibilities of theatre and GAA married wonderfully, as of course, there was an All-Ireland final to be contested every year. 'I'd say this one might get to Athlone' being the highest compliment that any play could receive.

The simple school hall was now transformed into what I thought at the time to be the height of glamour and sophistication. Thick heavy curtains of burgundy hung from the walls to enhance acoustics, local farmers became tuxedoed ushers as they tore tickets upon entry, squeaky school chairs filled the floorspace now covered in linoleum to protect the basketball court sleeping underneath our feet. Sitting up near the front, stage right, four rows back you would find myself, in amongst a group of ladies of a certain generation, each one a die-hard drama festival attendee. Boiled sweets and playbills would be passed around as I took in the chatter all around me; post-mortems of the previous night's show, predictions of who 'might get to Athlone', previews of this evening's performance as someone whispers of a cousin who saw it in another festival in Ennis the previous week, 'but I'll say no more and let ye figure for yerselves.' The fire announcement would be made, the curtains would be drawn and off we'd go.

It was in this school hall that I was introduced to the canon of great Irish playwrights like Tom Murphy, Brian Friel, Martin McDonagh and Marina Carr.

One particularly memorable performance for me was seeing Kilmeen Drama group (legends of the amateur circuit) take on Conor McPherson's *The Weir*, a play in which five people in a rural pub tell stories over the course of a night. That's it. The whole auditorium was enchanted by the play, none more so than myself. As each character told their haunting story, the stakes escalating with each one, I could almost feel them reaching into my soul, their hauntings becoming mine. Leaving the hall that evening I looked up to the night sky and was further frightened to see only a sliver of the moon. Without the safe passage offered by the moonlight, I was sure I would be kidnapped by spirits of the night, which were awakened in the seance I had just witnessed. Such was the power of these plays to me.

Exposure to great writing such as this began to open my eyes a little wider in school, particularly and naturally enough in English class. Shakespeare was no longer inaccessible archaic nonsense to me; I hung on to every word Hamlet spoke, imagining myself telling my own drama festival players:

> ... to hold, as 'twere, the
> mirror up to nature, to show virtue her own feature,
> scorn her own image, and the very age and body of
> the time his form and pressure.

Poetry was no longer learn-by-heart rhymes but the height of human expression. Heaney, Yeats, Boland, Plath and the man I was particularly taken with, Kavanagh.

> Clay is the word and clay is the flesh ...

Poems about bachelor farmers and land feuds and bogland. Things I could recognise. I began to realise art didn't have to lie in faraway lofty things, it was all around us as the man himself so finely put it:

> Till Homer's ghost came whispering to my mind.
> He said : I made the Iliad from such
> A local row. Gods make their own importance.

My classmates would attend the drama festival from time to time but I would find it terribly disheartening if they were not interested in the show. In a hopeless attempt to impress a girl I fancied in school, I asked her if she would like to accompany me to a play one night, a sort of date I suppose. At the interval, I turned to her.

'Well, what do you think?' I says.

She shrugged, 'Boring enough.'

She didn't come back for the second half; that was the end of that.

Thankfully, I was never bullied for my theatrical interests but at the same time I knew it might not be wise to advertise it. As long as I kept it to myself, I was safe enough. You wouldn't find me missing hurling training for 'some aul' play'.

I did try little bits of acting myself whenever the opportunities eventually arose in my late teens, my stage debut coming in a community production of *Jesus Christ Superstar*. I was given four roles – a leper, an outraged villager, an angel of some sort and one of the guards who nailed Jesus to the cross. In a wise directorial decision, all my characters remained silent.

Despite my walk-on parts, the feeling I had standing in the wings realising that any second I would step out on stage in front of hundreds of people was an almost out-of-body experience. When I got out there, in whatever character I was supposed to be portraying, I can only imagine I was pulling off nothing more than a 'very frightened boy' as I willed my legs to carry me to the other side of the stage to my exit while the leads did the heavy lifting downstage.

A couple of years later whilst doing my Leaving Cert I took on another role in the community musical, this time one of the leads. Surely now I would leave myself over-exposed to bullies and be savaged in the schoolyard. The morning after the first performance as I made my way to my 9.00 am English class, I spotted 'the boyyys' in the school hall and readied myself for an almighty slagging. As I neared the classroom door my nervous system braced for impact but nothing … the very same boys laid down their arms and erupted into a disjointed chorus of 'Hon Blake!', 'Some voice boy!, 'Where'dyougetyermoves' as I received a flurry of slaps on the back and the

odd encouraging kick up the hole, a slightly confused but veritable vote of confidence if ever there was one.

Though it was something I was permitted to have an interest in, to think of acting as a career was just being ridiculous. As my Leaving Cert exams approached, I felt I could no longer keep up the charade of wanting to study psychology. In my hour of need I was once again visited by my wise elder. I will be eternally grateful to have had someone like Nancy in my life as an ally, a confidante and a guiding hand when I needed it. Indeed, it was to her I first confessed, as it felt at the time, that I might like to pursue a career as an actor.

'Oh,' she said, pausing for a moment, 'and how might you do that?'

'I don't know really. I didn't get called for an interview for Trinity so I could do a drama course somewhere else, Galway maybe,' I mumbled sheepishly before chancing: 'There's another place in Dublin called *The Lir* but that's very hard to get into, you'd have to have done loads of acting for that.' Nancy considered me for a moment as my cheeks began to burn with the embarrassment of this admission.

She lowered her voice and turned to face me. 'There's no reason those people are better than you. If you want to go there, then you can go there.'

'Maybe,' I said, 'maybe,' trying to downplay my wild ambitions. She didn't push me, knowing I'd probably crumble if questioned further. She just let those words sit.

The next day when I called in to her on my way home from school as I often did, she had a newspaper cutting placed on the table in front of me. 'Look at that.'

An advertisement for a production of Tom Murphy's *A Whistle in the Dark*, Druid theatre company's latest production. 'You may go to that place in Dublin for acting and when you're finished, I'd love if you acted with them,' she said. 'Take that with you and go in and get your dinner.' And off I went in our avenue, studying that bit of newspaper the whole way home.

Sadly, Nancy passed away before I finished my actor training and she could see me on stage. I was in college in Dublin when I heard the news of her passing

and had to swiftly make arrangements to get down home to Tuamgraney for the funeral. I caught a lift with another local, John, a vet now living in Dublin who had also been looked after by Nancy in his youth. The whole journey down we traded stories of her kindness and indeed of how much we had heard of one another through her.

At the funeral, her son, when giving the eulogy declared how he may have been Nancy's only child but it never felt like that as she regarded the other children she took care of so highly, naming both me and John, my travel companion from Dublin, amongst those whom she always talked of. Tears began to roll down my cheeks as I finally surrendered my *faux-stoic* appearance to be what I truly was, a boy mourning. I had meant so much to her and she had meant so much to me. Typical of many a relationship of this kind, unfortunately, we had never shared those kind words with one another. However, I am comforted to know that I'm sure she felt that love. I know I did.

Nancy was buried on Holy Island, an old monastic site on Lough Derg. Transporting the coffin from the old Mountshannon pier on that blustery November morning was a mammoth effort. When we got to the other side, we were not in our dress shoes and funeral jackets but overalls and wellingtons as we were shin deep in muck, the hill so steep only four of us able to carry the coffin. My shoulder ached as I felt the weight of the coffin under me climbing that hill, but I shrugged off every offer of relief from fellow mourners. I was proud to carry her every step of the way as she had done for me one time.

A few years later, having graduated from the very same Lir Academy I had once thought unattainable, I found myself waiting in the wings of a theatre in Manhattan about to make my New York theatre debut in a Druid production of *Richard III*. As the hum of the audience quietened and the famous opening soliloquy rang out on stage, I took a moment to smile and think of Nancy, as I prepared to make my first entrance.

> 'And so, when I cast my mind back to that summer of 1936, different kinds of memories offer themselves to me. But there is one memory of that Lughnasa time that visits me most often; and what fascinates me about that memory is that it owes nothing to fact. In that memory atmosphere is more real than incident and everything is simultaneously actual and illusory.' Brian Friel, *Dancing at Lughnasa*.

Frank Blake

From Tuamgraney, Frank Blake is a past pupil of Scariff Community College. He graduated from The Lir Academy in Dublin in 2016.

Theatre credits include:
14 Voices from the Bloodied Field (Abbey Theatre/Croke Park), *Hecuba* (Rough Magic), *Theatre for One* (Cork Midsummer Festival), *The Glass Menagerie* (Gate Theatre), *Asking For It* (Landmark), *Dublin by Lamplight* (Corn Exchange) and *Richard III* (Druid Theatre/Lincoln Centre Festival).

Frank has appeared on screen in productions such as *Normal People*, *Sanditon*, *The Passion*, *Cherry*, *Game of Thrones*, *The Frankenstein Chronicles* and *Valhalla*.

He is a grandnephew of the writer Edna O'Brien.

The World that Nurtured Me

Martin Hayes

I grew up in a locality of small farms on the side of Maghera Mountain in the parish of Killanena in North East Clare. In my early childhood more than half the households immediately around our end of the parish didn't have running water and many didn't have electricity either. Agriculture for many people in the area had barely moved past the point of subsistence. There was also a number of houses, including ours, that fortunately had electricity and running water, so we felt affluent and among the privileged, even though we weren't what you'd call prosperous. From today's perspective, looking back at the life styles of those households without electricity and running water, it wouldn't be a stretch to say they had more in common with the medieval world than the twenty-first century. You could technically say it was a peasant lifestyle. The core of my life and music has been to uphold the values and artistic and musical insights of that world. This was the world into which I was born, the world that nurtured me and the world that remains central to who I am despite having lived far from that reality most of my life.

Despite the years of distance, I don't have nostalgic feelings for Clare because with the exception of a few years I've mostly stayed in close contact with the county; in any case, the music I play is inextricably linked to County Clare, the place is always with me. There is a connection there that never goes away. The music keeps me deeply connected. I carry this music and I feel it comes out of the soil and the land of Clare, out of the people, out of the way of life, out of its history. And I feel quite loyal to it and protective of it. What I feel for the place and the music is a deep, sweet melancholy; a melancholy that was for me the gateway into a world of music. You hear it clearly in the music of fiddlers such as Junior Crehan, Martin Rochford, Paddy Canny and Bobby Casey. It simultaneously has a sweetness and sadness that just feels good to experience. Melancholic music has a feeling of profundity for me; it doesn't make me feel sad, and it touches my soul and makes me feel completely alive and joyful as if the very deepest part of me is awakened by it.

Born in 1962, I grew up in a situation where playing the fiddle seemed like an ordinary activity. My father played the fiddle in the Tulla Céilí Band. He took the bookings for the band and they would occasionally gather in our kitchen if they were rehearsing for a recording or a broadcast. Lots of musicians were coming

in and out our door for as long as I can remember. Music seemed like a very normal and natural part of life. Our house is in the townland of Maghera where the RTÉ transmitter was being erected the year I was born. Despite the presence of this beacon of modernity, we remained relatively isolated at the far end of the parish of Killanena, bumping up against the parishes of Feakle and Tulla. It's a mountainous area with lakes, valleys and many beautiful vistas. There is some good arable land but there is also a lot of rushes and wet land in that locality.

Our house was a typical rural cottage with three windows and one door in the front. An extension with two bedrooms, a kitchen and bathroom was added at the back of the original cottage just before my father and mother got married. A stream flowed right beside it. The house is on the side of the mountain and would have been very exposed except that my grandfather had planted a lot of trees around the house to provide shelter. The core farm around the house is roughly sixty acres. In my early childhood the farm provided a lot of the food that arrived on the kitchen table. Extra money was made from the sale of a few cattle, and money was also earned from selling milk to the creamery. This was limited to how many cows could be milked by hand at that time.

In the early years of my childhood we had ducks, hens, sheep, pigs, cattle, calves, cows, two horses and a donkey. We had a garden full of vegetables: cabbages, lettuces, carrots, parsnips, turnips and potatoes. We killed a pig each year, salt-cured it and stored it in a wooden barrel to provide a year's supply of salty fat bacon. There were lots of fruit trees, various apple trees, plum trees and gooseberry bushes. We cut turf in the bog each year and had a supply of turf and timber for the open hearth fire place.

We were very close to being self-sufficient. My mother was a skilled baker and a great woman for knitting. I wore jumpers knitted by her right into my teenage years. It would have been considered insane to throw out a sock just because it had a hole in it. She darned socks and she also sometimes patched our clothes.

Growing up we were comfortable, certainly not affluent, but there was no sense of poverty either. On a farm there was always healthy fresh food available, but there was also always a lot of work that you were expected to help with. Things changed fast in the seventies when Ireland joined the EEC and with it came the push to modernise. With the Department of Agriculture leading the way, specialisation became the order of the day. We transitioned from a mixed farm with eight cows to eventually having nearly forty. We became a dairy farm. Before that time the farm was much more biodiverse. Farming was

environmentally healthier before modernisation arrived, but it was also much more labour-intensive. Modernity with tractors and milking machines reduced the amount of manual labour, and for the first time farmers had some money and the opportunity to make a fairly decent living.

My mother, Peggy MacMahon from Crusheen, was a strong, independent, free thinking and powerful woman. It's not the conventional image of Irish women in the 1950s and '60s, but that was how my mother was. Following a brief one year stint in the nuns, and working in the Mental Hospital in Ennis, she lived in England for seven years. There, she spent a lot of time in regular English society with regular English friends. She was a reader. Our home had books you wouldn't expect to find at the time in a rural farmhouse. She had a supply of regular paperbacks, some books on eastern mysticism and even a copy of D.H. Lawrence's *Lady Chatterley's Lover*, along with Edna O'Brien's books which were all banned in Ireland at the time. She was also a great user of the library. There was a library that operated out of the old school beside Kilclaran Church each Sunday after mass.

She didn't play an instrument. Like most people of her generation, she was aware of traditional music but wasn't deeply connected to it. She was around traditional music but it wasn't her primary interest. She had a record player that came back from England a few years after she was married. And with that came a collection of her records: The Shadows, Cliff Richard, the chart music of the era, all kinds of things. She met my father at a *céilí* in The Queens Hotel in Ennis on a trip home from England.

At the time, my father was living in the home cottage with his father and mother and his younger brother and sister. He was the oldest son. Getting married was a complex proposition. He didn't have the resources to build another house, so he built an extension to the house. His sister Philomena was seeing my father's close friend, the fiddle player Paddy Canny. She and Paddy married the same day as my mother and father in a double wedding. My father's sister moved out and my mother moved in. My grandparents died within a year, and then about eight years later my Uncle Liam left the house to marry and eventually built a house close to the church in Killanena on a farm that he inherited.

The beautiful Lough Graney sits in the middle of the parish. There are two churches, one on either side, the curate lived on the Killanena side and the parish priest lived on the Flagmount side. Parish boundaries never meant much to me. I could more easily identify the different atmospheres and feelings among the

different townlands. The music didn't heed the parochial boundaries either. The townlands of Maghera, Glendree and Magherabawn were contiguous townlands in the three parishes of Killanena, Tulla and Feakle. This is the location that I most identify with and is where a lot of the music and playing styles of East Clare were preserved intact. I'm often described as being from either Feakle, Tulla or Killanena. I'm from Killanena, but in truth I identify with all three parishes.

Northeast Clare is a beautiful countryside, unknown to a surprising number of people even in County Clare, largely because it is not on the way to anywhere. When many people from Northwest Clare travel outside the county they typically travel through the Burren or along the coast towards Galway, whereas everyone else goes through Killimer, Limerick or Killaloe. Everybody coming into the county who are typically heading towards Ennis or the coast of Clare must come either to the south or north of Lough Derg leaving a large swathe of East Clare unexplored.

Northeast Clare had a particularly rich musical culture which I think survived due to its relative isolation. Regionalisation of Irish music styles was a product of isolation. Each locality would invariably produce some unique musicians who set a standard, whose playing style might be imitated by others and whose stylistic influence would merge with other local styles that were then passed on generation, after generation undergoing continuous modification by different musicians over time. When recorded music and modern transportation arrived, a wider cross-pollination of musical ideas began to occur. A regional style of music is never absolute or monolithic; at best it's an approximate definition of the collective styles of all the individual musicians of a locality. I could hear at least two distinct stylistic strands of music happening in East Clare along with a number of individual musical outliers. One common style was rhythmic and related to its functionality: wren dances, house dances or dances in the school houses. There was also a slower, more lyrical and intimate listening music that was a more private kind of expression and was shared only with other musicians and with a small number of discerning listeners.

We had both set dancing music and listening music happening in our house. It would not be uncommon for sets to get danced in the kitchen or for an evening of quiet sharing and listening with some visiting musicians who might arrive unannounced. Music houses were known to people of the music world as in safe houses of another time were known to political revolutionaries on the run.

This music was not widely understood. It was much more nuanced and expressive than was imagined by the wider public. Much of society, and in particular the educated class, couldn't imagine how the music of the peasantry

could really have any significant depth, artistic value or subtlety. It was painful to me to observe this widespread ignorance towards something that I felt was so deep and beautiful. Later I would question whether my strong belief and love of the music wasn't just some sentimentality on my part. Over time, as I began to discover a wider world of music, my appreciation and love for traditional music only became more profound. I'm not exaggerating when I say that Willie Clancy's pipe playing of the air 'The Dear Irish Boy' is easily just as profound and deep as the finest music of Bach or Miles Davis.

Among the older musicians I knew growing up there was a sophistication in the way they talked about music; they appreciated the value of one subtly placed note, a slightly flattened note or the emotional impact of a well-constructed variation in a tune. Their understanding and appreciation was very subtle and nuanced. I spent a lot of time talking about music with my father. We talked about other musicians, about what was going on within the music, what was a good tempo, what was a nice variation or a good key for a tune. There were other conversations too. Ita MacNamara, Mary and Andrew MacNamara's mother, lived in Tulla and spoke very deeply about the music in a way that spoke to and validated its emotional possibilities and value.

I played a lot with concertina player Mary MacNamara in those teenage years; she was the only contemporary with whom I shared this kind of musical connection. Tony MacMahon's brother Brendan, who also played the accordion, was a friend and we spent time together in our living room just playing tunes and talking about music. He was in his fifties or sixties and I was just a teenager at that stage, but there was no generation gap, we were just friends who shared a musical passion. Many of the older musicians, such as fiddler Martin Rochford, concertina player John Naughton and tin whistle player Joe Bane, were local musicians who fell into that same category where we just felt a kinship and friendship centred on a musical connection and understanding that was blind to the age gap between us.

I learned a lot by being around my father as a young child listening to conversations between him and his musical colleagues. My father, flute player Peter O'Loughlin, fiddlers Paddy Canny, Vincent Griffin or Martin Rochford might sometimes be sharing musical opinions and preferences while I was just there taking it all in. Many of these old players were very encouraging to me. Sometimes Martin Rochford would say to me, 'I have a lovely tune for you' or the fiddler and politician Dr Bill Loughnane would ask me to play in some local concert he was organising. The accordionist and television producer Tony MacMahon was a hugely important figure in my musical development. Since

my early childhood I had always loved his music. He recognised that as a young teenager I was quite connected to this old understanding of the music and he encouraged me to stay with it. His support meant a lot to me at the time. The subtle sophistication embodied by people largely regarded by outsiders as rough, unrefined and peasant-like had a profound impact on me.

I saw old, hardened-looking farmers with their caps and black suits experiencing and expressing subtle musical sensitivity, consciously communicating a world of feeling that went to the heart of the music. I took that on board and I didn't care what the rest of the world thought: They're right, I'm going with them. And I don't care what my contemporaries think. For whatever reason the music culture of the time seemed to be largely dominated by men, which clearly warrants a separate discussion beyond the remit of this contribution. The music nonetheless allowed many of these men to demonstrate a vulnerability, a sensitivity, that they may not have felt free to reveal in other parts of their lives. They may have lived aesthetically-deprived lives in many respects, insensitive to lots of things, but in this music they were able to explore and connect with a world of deep feeling and beauty.

In the way in which Junior Crehan constructed a tune there can be no doubt whatsoever about the depth of his feeling, warmth and sensitivity. Not just Junior, but lots of musicians had this quality. It takes a degree of refinement to recognise in a melody the one essential note, to recognise its quality over other notes and its importance to the melody.

These musicians would have largely felt misunderstood by the wider public. Their understanding of the music almost ghettoised them into feeling like they belonged to a secret society comprised only of those who truly understood and loved this music. They would meet, play and talk amongst each other about the music in ways that the outside world wasn't aware of. This was their own intimate world of subtle detail and beauty. Dubliner Tommy Potts, a kind of John Coltrane of Irish music, was a regular visitor. There was a purity not just in his music but also in his musical intention. Every year he came to meet and play his music for his friends in County Clare. He would visit Paddy Canny, Seán Reid, Peter O'Loughlin and our house where he would stay overnight.

As a musician, Tommy Potts operated at the highest musical level, comparable to the best of any genre. His sense of the music and his obscure process was such that often even musicians didn't fully appreciate what he was doing. We would all sit around our kitchen on the evening he would visit our house. Tommy Potts

would hold court and play his music while we all listened in silence. My effort as a performer and as a teacher has been to translate my experiences of the music of people like my father, Paddy Canny, Tommy Potts, Joe Bane and Martin Rochford and try to express as mine this sense of feeling that I first experienced in their music.

I started playing the fiddle at about seven years of age. I made only very modest and intermittent progress in my first few years. I wasn't showing much promise for a long time. But eventually, I knuckled down and I think by the age of thirteen I had more or less managed to establish the style of playing that formed the basis of what I do even to this day. At thirteen I had really begun to experience the feeling of music in my heart and in my body. Throughout my teenage years I just tried over and over to access this way of playing, I just kept trying to dig deeper and deeper.

One of the things musicians like Junior Crehan, Martin Rochford, Bobby Casey, Paddy Canny, my father and John Naughton did was to play for themselves. In my early years I would sit in a room and try to lose myself in a fantasy world of music and go into the feeling of that music in a very private way. Later, as a professional performer I sought to turn that experience outward, to express outwardly what I had first experienced by journeying inwardly. That has really been the central effort of my musical journey.

The language of the musicians that surrounded me growing up was mostly centred on the intangible elements of the music; the soul, the deep feeling, the melancholy, the joy of the music, and its heart-opening qualities. It wasn't about dissecting techniques, mimicking or learning about someone else's triplets or figuring out their bowing style. It was about carrying the deeper feelings of music. The old musicians felt this very strongly and I took that message on board as the fundamental meaning and purpose of the music.

The expression of feeling had become the most important side of music for me. For a number of years, however, in my early twenties, I lost my way and strayed away from the music. In my late twenties and thirties I reconnected, attempting to understand it even more deeply. I spent a lot of time thinking, a lot of time reading, meditating, attempting to become a free thinker, opening myself up to a different understanding of the world. I was aware of a psychological space, a state of mind, a relaxed free way of being from which music can flow. It's always possible to just play a few tunes in a competent manner but to play from a source of true feeling with some consistency is a different matter.

Technical virtuosity was never a central pursuit for me musically. In the world of this music there can be some very special moments that are not directly dependent on technique. I was fortunate enough to be around old musicians often enough to witness those instances of musical transcendence every now and again. While playing, you can suddenly hit on a moment of real music when things somehow start to flow. You become consumed by the feeling of it but the problem is that it's intermittent. Nowadays my efforts are largely a philosophical and psychological effort to more consistently play from a place of freedom and emotional depth. I had learned early on how to get there some of the time, so the big question for me was how can I access that on a more regular basis? Where do I need to get to as a human being in order for me to have that access?

I learned a lot from other music forms. When I lived in Chicago, I went to blues clubs, jazz clubs, funk music clubs and folk clubs and witnessed other musicians getting to the highest level. I met with all kinds of musicians and started collecting and listening to lots of other kinds of music – Indian, jazz, bebop, 70s fusion, classical music, Chinese music. I became a reader, reading everything from Rumi to the Indian Upanishads. In the writings of Alan Watts, I discovered the Zen Buddhist approach to being consciously present in the act of doing. I've tried to bring this way of thinking and all that I've learned from listening to a wider world of music into how I play and think about traditional music.

In the moment when I put the fiddle under my chin, I try to surrender, I aspire for that moment to be the greatest moment of musical expression I've ever experienced. I want that every time but of course it only happens some of the time, it can't possibly always happen, but over the years it has happened with a bit more regularity. In the process of playing, I am continually attempting to free myself up to simply let the music happen. When music is really happening it has a life of its own, almost as if the musician is just a bystander and the music flows through you. I don't want to give the impression that every time I sit down to play the fiddle, that it becomes a moment of transcendent beauty. I'm describing a process that I attempt to implement, a way of being that I try to access. This is something I achieve with varying degrees of success from night to night. I'm describing my approach and telling you what I think is the most important element for me. I simply want to experience the music at its deepest as often as I possibly can.

Being true to the music is a personal truth and it's a personal integrity. Only you yourself can fully know how much integrity is in what you do. When anything is done with integrity, it's fine. It's when it's lacking integrity, when it's manipulative, clever or superficial that it can be damaging to the tradition.

Traditional music is not overly complex or multilayered, it is just simple enough that it provides a lot of freedom and is just complex enough to offer some challenge and variety. If you're a writer, you might sometimes want to say the most you can with the simplest and most direct sentence. With melodic construction, it's the same thing. Writing a simple, beautiful and direct melody is a far more challenging and complex process than writing a dense and complex tune. In simplicity there is nowhere to hide and every note has to count. Among musicians there is often a tendency to overlook the simple as if it is of lesser value. Simplicity is often the result of distillation, the disregarding of the superficial and unnecessary in favour of a lasting beauty that can stand the test of time, something that outlasts the fleeting and changing fashions of musical taste.

Traditional music is a treasury of beautiful melody. The central element is the melody itself and this is the key to finding freedom of expression in the music. In my opinion we shouldn't try to use the melody, we should attempt to be used by the melody. We shouldn't try to bend melody to simply meet our own ends but instead see how it can naturally speak for us with our playing, simply being there to support and express the melody. These melodies can draw feeling and expression out of us if we open ourselves to them and allow them into us. When we engage with and see the tunes as beautiful melodies with the capacity to deliver a world of deep feeling, they have the potential to become universal in their expression, not just some obscure idiomatic form of music that requires a special knowledge in order to be understood. Honouring the beauty of the melody offers a lot of options and therefore a lot of freedom.

County Clare has a very significant reputation when it comes to traditional music. In the mid-twentieth century, the county seemed to have a larger critical mass of musicians than most counties in Ireland. Along with this came a wider general public interest and knowledge within the county which made many of our best players feel at least somewhat valued. It was still a music followed by a minority of people, it was in decline and largely shunned by the emerging more educated middle class and mainstream media who were shockingly ignorant of its value and were at best patronising toward it. Nevertheless, in County Clare traditional music had a sizeable body of support compared to other parts of the country. It wasn't just the number of people who liked the music that was fundamental to its ability to thrive in Clare. The most notable thing for me in my early years was witnessing the subtlety of understanding that many of these musicians expressed. People like John Kelly, Tony MacMahon, Junior Crehan, Bobby Casey, Joe Ryan, Peter O Loughlin, Paddy Canny, Martin Rochford, Francie Donnellan and my father PJ all experienced this music as a truly deep and rich emotional

expression. They loved the music, they spoke with a sense of reverence about the beauty of the tunes and the subtle inflections that creative musicians were able to add to them. It was almost a sacred thing to them, something of real value, something away beyond the stereotypical simple evening of fun and drink in the corner of a bar.

Of course there is nothing wrong with having a few casual tunes and some fun in the corner of a bar. A session in a pub, a *céilí*, a recording, a house party or a concert, all have their place. None of these manifestations are definitive ways to experience the music in themselves, and none of them can be regarded as being exclusively the real or the best way to hear this music.

There are many self-appointed authorities and lots of strong opinions about the right and the wrong way to approach this music – I suppose I'm one of those people myself – but in the end the authority for me lies with the tune and what it asks of me. Underlying all of the different ways we experience and express this music is the undeniable richness and beauty of the melodic line itself.

Biography

Martin Hayes

From Killanena, Martin Hayes is a virtuoso
fiddle player who has toured and recorded
with guitarist Dennis Cahill for over twenty
years. He has collaborated with musicians in
the folk, classical and contemporary music
worlds including Bill Frisell, Ricky Skaggs,
Jordi Savali, Brooklyn Rider, the Irish Chamber
Orchestra, the RTÉ Concert Orchestra and many
of the great traditional Irish musicians. Martin
performed for former President Barack Obama
at the White House, also performed with
Sting and Paul Simon and founded the ground
breaking Irish-American band The Gloaming.
He was TG4 Musician of the Year (2008), BBC
Instrumentalist of the Year (2000), received
the Spirit of Ireland Award from the Irish Arts
Centre in New York and an Honorary Doctorate
of Music from NUI Galway. He is one of five
Cultural Ambassadors for Ireland appointed by
the Government in 2019.

Coming Full Circle

Mary Hawkes-Greene

The dull nausea of travel sickness accompanying the interminable series of twists, turns and bumps on the Corofin road marked my inauspicious introduction to the Burren. It was August 1981, my first summer in Ireland since I was fourteen. Wanderlust and a thirst for the exotic had lured me from my home in Askeaton, County Limerick every chance I got. From au pair positions in France and Italy as a student, island hopping in Greece during teaching holidays, a year as a volunteer on a kibbutz in Israel, solo adventures in the Far East, my sights were now set firmly on my next odyssey – a year in South America and a life living abroad. Summer 1981 was set for experiencing the Galway Races, the Rose of Tralee and all the fun events I had missed out on – before setting off again. So here we were, my home-loving sister Anita introducing me to one of her favourite spots, Ballyvaughan, with promise of an exciting weekend at an international wine and food festival.

Rounding yet another stomach-churning bend, the narrow road suddenly opened out to reveal a moonscape of sculpted rock edged by stone walls carrying the eye to the ocean beyond. Nausea slowly dissipated as I became increasingly enchanted by this strange landscape.

Brass bands from Alsace-Lorraine played up and down Ballyvaughan's sun-drenched main street; wine producers from France and Italy dispensed 'tasting' samples consumed with abandon from pint glasses, evening came alive with big band music and feasting in the large marquees. This was not the Ireland I knew.

Lively strains of a trad session lured us into Hyland's Hotel Bar where a friendly barman poured our drinks. Clad in faded denim, this tanned Adonis looked more like a Spanish wine producer than filler of frothy pints. Our gaze locked on more than a few occasions across the busy bar and Michael, who I was later to learn was the son of the hotel proprietor, joined me when the crowd had gone. Conversation flowed easily as we drove through the now deserted village to Bishop's Quarter, the nearest beach. The moon was full, the air balmy and the ocean beckoned.

> As the sun went down on the ocean and the night our time did steal
> We swam out in salty heaven, it was too good to be real

We walked, talked, and swam effortlessly in the shimmering sea . . .

> We were strangers out on the ocean,
> Somehow shyness stayed ashore . . .
> 'Water Ballerina' by Luka Bloom

A blissful weekend ensued. Monday dawned, time to bid farewell to this dreamlike episode. A nonchalant 'see you again' belied the internal turmoil that was anchoring my feet to the footpath outside Hyland's. I was off to see the world, exciting places to discover and life to be lived in some exotic location far away. Little did I know that I was no longer master of my own destiny – the Burren had already cast its spell and enraptured me.

Solo adventures to remote islands in the Philippines and Southeast Asia on subsequent summers failed to break the spell – and so I finally succumbed and understood the wisdom of Michael's words: 'The Burren is the best place in the world you could live in, Mary. You just don't know it yet.'

The exotic Shangri La I was seeking was right there in the elemental moonscape of the Burren and its people.

May 1986

With toddler Diarmaid by my side and baby Roisin in arms, I stand outside the doorway of the partly restored Newtown House watching Michael skilfully rebuild the stone wall lining the avenue of our recently-acquired dilapidated home. Resident kestrels swooped in and out of the roofless deserted shell of Newtown Castle. Combining the running of a guest house to finance the repair of this old house with my much-loved teaching position in Gort, while Michael also worked full-time in his family hotel, was taking its toll. A desire to restore the castle over our lifetime was a worthy aspiration that seemed this evening like an unlikely pipe dream. Michael approached, his gaze fixed on the rock still in hand as he slowly and deliberately delivered his message:

'We will have an art school here Mary, with students from all over the world, degrees will be conferred in Newtown Castle. It will be the greatest little art school in the world.'

'Dream on, Michael,' I replied dismissively. And he did.

The ensuing years morphed in a maelstrom of frenetic activity and undulating emotions. Glimmers of hope, dashed expectations, voices of encouragement, sniggers of cynicism, breakthroughs and serendipity. But the Burren was always there as the constant to support and sustain. Any disappointment could be neutralised by a walk and a swim at Bishop's Quarter beach or a hike up Blackhead. What artist wouldn't want to study here? We ventured forth to the US with our beautiful new brochure, images of the Burren stone wall, adopted as our logo, solidly grounding us in the innate creative talent and tradition of its wall builders. Seamus Heaney's beautiful poem 'Postscript' adorned the centre fold, interleaved by two elegant transparent pages. We were, after all, offering space, time and inspiration in a location that had the power to 'catch the heart off guard and blow it open.' An act of faith was required to imagine the buildings promised by the artist's impression of what the Burren College of Art would look like, and the detailed curriculum awaiting accreditation. The call was subtle and would be heard by artists seeking to connect with the powerful elemental landscape Michael held within his being, transfused down through the ten generations of Burren family that preceded him. It was the call heard by St Colman in his cave at Eagle's Rock, the call heard by scholars and the multitude of artists, poets and philosophers drawn to the Burren throughout the ages, it was the ineffable call to essence, to return to source – the source of imagination. It was the call that had captivated me at first glance.

July 1994

A piper heralds the arrival of President Mary Robinson, who leads a procession of US art school presidents and Irish academics at the official opening of the Burren College of Art and the restored Newtown Castle. Her inspirational address applauds the 'Celebration of the Impossible' and welcomes the revival of the Brehon and Bardic tradition of learning in the Burren and its continuation for future centuries. The stonemasons and craftsmen who had restored Newtown Castle to its former glory in ten short months of dedicated work were among our guests of honour – true artists to the core. The enormity of our accomplishment crystallised in a brief moment of satisfaction, to be swiftly dismissed by our toddler Caoimhe impatiently tugging at my new frock, hastily purchased for the grand event in a dash to Galway that morning.

Thirty US artists proudly displayed their work in progress as students on our first summer school. International college presidents, artists and faculty marvelled at the award-winning college design, the space and light-filled studios; the more circumspect academics, in true Irish form, wondered at the audacity of it all and speculated on how long the college would survive. Friends and family shared

our moment of hope and triumph; the community of Ballyvaughan, two invited from every household in the village, raised their collective glasses to toast this new enterprise that would bring artists year round to the Burren. Chris Droney and Eugene Lambe led the musicians and the party began. Students, villagers, presidents, academics joined the fun as the Burren College of Art partied into existence on July 23, 1994. Sets were danced, songs were sung, and celebrations continued late into the night. The ghosts of the O'Loghlens and O'Briens kept watch from their newly roofed and restored Newtown Castle, the drawbridge connecting the traditions of the sixteenth century to a new era of creativity and prosperity in the Burren.

July 15, 2001

Sunshine streaming in the bedroom window heralded a glorious Sunday ahead and a rare family day off to celebrate our seventeenth wedding anniversary. Michael, passionate as ever about the local GAA, was off with Diarmaid to cheer on the Ballyvaughan team playing a championship match in Quilty. Quick goodbyes, 'see you later for dinner, good luck to the team', and Roisin, now thirteen and Caoimhe nine, joined me for our girls' day out. The ocean sparkled in the morning sun as we headed out the Coast Road past Fanore beach, eyes peeled on the ocean and then excited shrieks 'there she is' as Fáinne, the mystery dolphin, came into view in the little cove she had begun to frequent. Various stories circulated about her appearance here – that she had been rejected by her pod, that she was in search of her pup that had been washed up on shore. Whatever the reason, Fáinne was in high spirits today as she swam close in, leaped, dived and frolicked with us. Sea, sky, dolphin, human, family all converged in a blissful few hours when we were all as one.

> Ballerina, ballerina, water ballerina
> Ballerina, ballerina, water ballerina
> I watched the ballerina dive and dance down to the floor.

That Luka Bloom song again; it captured the moment as we sang along, windows down, all the way home, blissfully unaware of how our world had changed forever.

July 19, 2001

I had held it together until then, but tears streamed uncontrollably down my face when from the rear gallery came the strains:

> As the sun went down on the ocean
> And the night our time did steal
> We swam out in salty heaven
> It was too good to be real

Our great friend Luka had magically appeared and was singing our song at the funeral mass. The mile to Bishop's Quarter's cemetery seemed long. The crowd snaked back all the way to Ballyvaughan as hundreds walked behind the coffin that carried Michael to rest with his ancestors in the graveyard overlooking the beach, the beach that had sealed our fate together sixteen years earlier. Seán Tyrell sang 'Cry of a Dreamer' as the coffin was lowered.

> There's not a prayer for the one
> Who's love for life no longer lingers.

Chris Droney and Eugene Lambe's rousing set of jigs and reels sent Michael dancing into the next world. He was indeed a mighty set dancer.

An abundance of food, drink and stories followed and it was proclaimed a great funeral indeed; *flaithiúil* and generous as Michael would have wanted. That evening, when the crowd was gone, the sea called again. Children, family and a few close friends piled into the college minibus and we headed to Fanore. A casual onlooker would have assumed this was a celebratory family gathering as we ran, swam, played ball, laughed and hollered, liberating ourselves momentarily from the empty aching numbness on the horizon. Once again, the sea and Burren hills held us in its comforting embrace, acting as ever as a solid, grounding presence.

2020

> So, I left her a silver dolphin
> In a place where she might see
> So that one day, out in her swimming
> She might remember me.

The morning swim at Bishop's Quarter with the sisterhood of the Ballyvaughan bathers is now a daily ritual. Swimming year round was not a conscious decision, but each sunny swim begged another as days drifted to autumn, then to Christmas. I greet Michael as I pass the graveyard on the drive to the beach and hear him laughing at the utter daftness of swimming in the cold winter. Picking our way furtively over the pebbles down to the moonlit sea at 7.00 am on frosty

January mornings, slowly succumbing limb by limb to the ice-cold water, being rewarded by a day-long sensation of tingling aliveness sustains me through the darkest days until spring becomes summer again. Shivering my way back to the car, my mind often wanders back to my first glimpse of the Burren, to the lure of the limestone hills, to that first moonlit swim in salty heaven, to the cloak of magic and belonging, a love that gradually enveloped me.

It's as if life has come full circle.

I live in *Shangri-La*. The Burren is home.

Biography

Mary Hawkes-Greene

Mary Hawkes-Greene is an educator, traveller and adventurer. These combined passions resulted in teaching positions in Ireland, France, Italy and Israel and culminated in Ballyvaughan, where she met and fell in love with local visionary, Michael Greene. Together, they established the Burren College of Art in 1994 and worked in harmony until Michael's sudden death in 2001.

Mary continues to lead the college, now recognised internationally as a centre of excellence in fine art education with a focus on art and ecology, and on creative leadership. All programmes are based on the founding principle of providing time, space and inspiration in the Burren – the powerful source of creativity – and the adopted home that Mary loves.

Finding My Tribe

Mark O'Halloran

I'm incredibly proud of *Adam & Paul*. It's a complete piece of work. It's not often that you get to do work where you both enjoy the process, are enriched by the process and you still love the product at the end. *Adam & Paul* was a life-changing event. It's a rare thing in your life when you can say, 'Yeah, you can't argue with that.' It was my first outing as a screenwriter and it pretty much spoilt me for the rest of my life. In my life there's a before *Adam & Paul* and after *Adam & Paul*. People took to it, which was a delight.

A script presents itself to me as a sort of crisis. Something I have to figure out in my own life or in what's happening around me. I've always been interested in outsiders and the idea that you can be completely removed from your society and yet be living in the midst of it. In *Garage* (also directed by Lenny Abrahamson), I wanted to write about male loneliness, especially the isolation of rural men. Essentially, that is the story of *Garage*, in which Pat Shortt plays the leading role about a man who is adrift. Of all my films, it is closest to Ennis. The community in *Garage* is, of course, much smaller, but the same darkness is there in both.

At the time of writing *Adam & Paul*, I was living in Dublin's North Inner City and for the first time in my life I was confronted with the world of heroin addiction. What struck me was how invisible those street addicts were, despite their obvious visibility, despite their gaunt features, their disconnectedness from the world around them. It appeared to me as if everyone in the city was able to block them out of their minds, was able to step over them on the pavement, oblivious to their presence. Being from the west of Ireland, I was quite shocked. I'd never seen heroin addicts before.

I've always kept diaries of things I saw or experienced. I consider myself an observational writer, someone who records the world around them. The scenes of street addicts I saw on a daily basis I found both funny and sad; two women fighting over a choc ice or a lad falling over in O'Connell Street in slow motion. Those images were burned into my mind.

I engaged with homeless people and began to realise for the first time that homelessness is a full-time job. That's what they were telling me. Trying to find something to eat. Trying to find somewhere to have a shite. Trying to

find somewhere to sleep. Moving all the time. Always trying to find ways of negotiating with life. Scenes that ultimately seeped into *Adam & Paul*. In one such scene one of the lads needs to urgently take a shite and finds a doorway in a laneway. The other goes in search of toilet paper and the only thing he returns with is a discarded Tayto bag. There's an indignity in that but a search for dignity at the same time.

I'm really interested in hopelessness. Addiction. People who have fallen into despair, fallen into spaces where there is no wriggle room to move upwards and outwards. I think these are things worth writing about. These are stories worth telling. What marks us out as human beings are the stories we tell. And we tell stories all the time. It is our way of making sense of the world. At the time I wrote *Adam & Paul*, the Celtic Tiger was roaring and I found it incredibly vulgar. Poverty still existed but people tried to ignore it. I wrote about these things in the television series *Prosperity* also; prostitution, addiction and hopelessness.

My own story is an altogether different one I suppose. I was born in 1970, the eighth of what eventually would be ten children. We were raised in a three-bedroomed house in Ard na Gréine, Ennis. Six boys and four girls. By the time I was born, my oldest sister was twelve. There were eight of us at that stage. Twelve people in a small house. At times it was crazy. My Dad was very much a man's man. He enjoyed sports, music and singing. Both my parents worked outside the home; Mam in a bookie's office and Dad in the P&T. They wanted more for their sons and daughters. At times I have described my family as working class but I'm actually not so sure about that now. I think social class in Ireland is less clearly defined than in England, for example. And our family, like that of our neighbours, was typical of that crossover.

At home, there was a girls' room and a boys' room and Mam and Dad's room and we had the television room and the kitchen. Sometimes there were six boys sleeping in that room and it wasn't enormous so there was a desperation to find some space for yourself within that but also the bit of *craic*. Every night before we fell asleep, we listened to records of my older brothers: *Hotel California* and Queen. Big *Greatest Hits* records, which were a delight to listen to.

Television was an important part of all of our lives. Around Christmas time, there were films like *Chitty Chitty Bang Bang*, *Willy Wonka and the Chocolate Factory*, all of that. There was the communal nature of sitting and watching something and these communal ways of receiving culture were important. Television introduced me to Laurel and Hardy. I grew up watching Laurel and Hardy and

I've remained a fan of their films. There are elements of Laurel and Hardy in everything I do. Particularly in *Adam & Paul*.

I just loved their gentility; these two isolated male characters dancing through the urban landscape. A lot of the male figures that I grew up with were John Wayne-type characters, the cowboys and the strong men. I warmed to and saw something of myself in Laurel and Hardy, men who were ineffectual, who weren't able to fight. But they were genuinely getting on with their lives and supporting one another. I also liked that they were so funny. They are very very funny.

Way Out West is one of my favourite films of all time. I've watched it hundreds of times. There is a wonderfully long sequence where one of them is being tickled accidentally while a whole bunch of people are trying to get a copy of a will out of his inside pocket. It is just one of the most glorious things I have ever seen. There is a way of reading them as a proto-queer coupling in some ways. In the films, they sometimes play their own wives. Sometimes they sleep in a bed together. There was all of that going on in a very innocent kind of way. I didn't read them in that way at that time. That came later.

Growing up in Ennis I was terrified of my own effeminacy. I thought I was the only gay person on the planet. I can be quite effeminate. As a kid, I was painfully so. I think it would have been pretty obvious to a lot of people that I was homosexual. Yet, I was constantly policing where I put my hands, how I said things, how I crossed my legs. This constant body policing that I subjected myself to was the backdrop to the film Viva. Directed by Paddy Breathnach, it's the story of a young Cuban drag performer who, after reuniting with his estranged father, comes to terms with his own sexuality. In the film, drag effeminacy is performed as a strength, as an act of empowerment.

I completely reject the idea of male effeminacy as weakness. The drag mother Mama says in that film: 'You think I don't fight my own fight? This is how I fight my own fight!' She's a warrior. She's the one who actually cares. In the film, I was exploring what constitutes strength: the contrast between macho fist-fighting strength and the power of proper self-realisation. While exploring those kinds of issues in Viva, I was also exploring my own past, I guess.

I remember saying to my mother when I was very young that I was never going to get married. And I wondered what it was like for a mother looking at this quite effeminate young eight-year-old telling her he was never going to get married and she going, 'yep, I can tell.' I was aware of who I was and when homosexuality

was explained to me I was going, 'that's me.' Before I even knew what sex was, I knew what my orientation was. It's the way you think. It's the way you look at the world. Yeah, I was aware certainly from the age of ten.

There were one or two lads in the town who would have thrown the word 'queer' at me quite willingly but I was a strong person. I grew up in a family of very strong personalities. I was quick-witted. I was able to look after myself. I didn't care whether people liked me or not. I got on with it.

In school you didn't get any positive message about homosexuality. That was for sure. Insofar as it was mentioned at all it was in the context of sinfulness. Even at a young age, I thought that ridiculous. We had a Christian Brother who was also the principal who told us that 'any society or civilization that had embraced homosexuality collapsed thereafter.' He told us the Greeks and the Romans collapsed because of homosexuality. Even then I thought that ridiculous.

I think every teenager growing up is susceptible to loneliness. It's a confusing time for kids. The need to find your tribe, whether it is your sports tribe or your rock and roll tribe, is very important. What happens for the homosexual kids is that they can't see their tribe. And so, they try to fit into other tribes. And in that way, they end up performing a role of themselves in a weird kind of way. It has a big impact but by the time I had gone to drama school, I had found my tribe and I was all right. I came out to my friends when I was eighteen or whatever and they were not surprised. I was surprised they were not surprised.

My formative years were the late seventies, into the early eighties. And 'The Height' played a significant role in the life of the town. The Height is at a confluence of a number of streets in Ennis: O'Connell Street, Abbey Street, Parnell Street and Bank Place. At its centre is this incredibly tall statue to Daniel O'Connell with a plinth at its base. The town's 'ne'er-do-wells', the rock and rollers known as 'the Hairies', would sit on this plinth and watch the world go by. I think my mother and father thought it was an awful thing to do. I wasn't a 'hairy' but I was into rock and roll.

There weren't many of us really, but I did enjoy sitting on that plinth. I wanted to be counter-cultural in my own small Ennis way. I was really interested in the lads who were into rock music or the Teddy Boys or the Boot Boys or whatever. I was interested in that kind of culture. I was kind of a Goth with bad haircuts and black clothes for about five minutes. My sense of humour was too well honed to be a Goth for longer. Of course, we were targeted by others from the town.

I remember one guy was threatening to beat me up once and he said, 'I'm going to kick your head in, you Echo and the Bunnymen wanker!'

I got into The Smiths. I really liked Siouxsie and the Banshees, that kind of strong post-punk music, but the Smiths had a biggest effect on me. They were literate and definitely counter-cultural. David Bowie too. We had David Bowie's *Greatest Hits* at home and I absolutely loved it. In 1985, the Jesus and Mary Chain happened and that changed us too.

Ennis might have been a provincial town but it was also possible to gain access to counter-cultural books and magazines. As a town, it veered between a number of things. Fridays or Saturdays, the town was always full of farmers who came with their cattle for the mart or the market. We lived close to the mart and great droves of cattle used to arrive on Fridays. So, it always felt agricultural. Ennis too had its own 'high' society, its coterie of solicitors, doctors and other luminaries who would regularly appear in the social columns of *The Clare Champion*. The respectable face of the town. In that sense it wasn't a homogeneous society. But one thing was clear: homosexuality didn't fit into it. Also, rock and roll didn't fit into it. I wanted big cities. I wanted to engage with another world.

Literature opened up many other worlds to me. I really wanted to read the big books quickly. So, I read them before I was ready for them, I suppose. I remember struggling through *Ulysses* when I was eighteen or nineteen. Not taking any of it in. I did like *Dubliners* though. Allen Ginsberg and the Beatnicks. Jack Kerouac's *On the Road*. Robert Pirsig's *Zen and the Art of Motorcycle Maintenance* and Kurt Vonnegut Jr.'s *Slaughterhouse-Five*.

All of which I would first have read about in magazines like *Hot Press* and *The New Musical Express*, and all of which were available in the public library in Ennis. At seventeen years of age, I found a copy in the library of Edward White's *A Boy's Own Story*, a gay coming of age novel. It blew my mind. White is a great diarist and literary stylist and I loved that book.

Growing up in Ennis, it was virtually impossible to imagine myself as a writer; I had this idea you can't be a writer if you come from Ennis. In those days in small-town Ireland saying 'I want to be an actor' was like saying you had two heads. I think that's to do with the way that art and literature were taught in schools. It was taught as exceptionalism. These people were exceptional. They were recognised as exceptional from an early age. They produced this work and there was an inevitability about their doing so. The idea that a kid from Ennis could

stumble into this work, or that you would try to, was beyond imagining. Artists were 'other people' who didn't live in Ennis. We had a well-established way of knocking too. I think that may be gone now but back then if a person put their head above the parapet you pulled them down. That has been part of small-town life for a long time. You will always be from the family you are from. If they didn't do it, then you shouldn't do it. In school, creativity wasn't fostered or celebrated.

At seventeen I ran out of Ennis. I needed to get out. In a way I suppose my sexuality set me free. I was stepping out of all of those norms of society. I was fending for myself. I wasn't letting anyone else down. I wanted to see the world. I wanted to see London. I wanted to experience rock and roll in New York. I wanted to go as far away as possible. I didn't feel pushed out. I chose it. I chose it because I needed to be myself. It was about figuring out my own sexuality. My family are always in Ennis. That connection is always there and you are always going back, but I didn't want to live there.

A whole new world opened up for me when I left Ennis. I met Tom Murphy who played alongside me in *Adam & Paul*. Tom was an amazing character. I met him when I was about twenty-three. I was understudying him in a play when we were touring Great Britain and we got together when I was doing that. He was my first proper relationship. We became adults together. He was also the first person who believed in me. He was a very acclaimed actor, a very well-established artistic voice in Dublin from a very young age. He had acted since he was twelve. He thought I had interesting ideas. He liked what I wrote. He was the first person I showed any writing to. And he encouraged me. He believed in me, which was quite transformative. We also had great fun together.

Tom was my best friend, had been my lover, was an incredibly important artistic touchstone in my life. When he died it was shattering. Really shattering. It happened really quickly. I had been visiting him in the hospital. He just wasn't at his best; he was suffering and he found my being there upsetting. He suggested I go away and walk the Camino. (He was politely getting rid of me, I suppose). I set off on the walk and we used speak to each other every day or text each other every day. And then, when I was about two days out from Santiago, the texts stopped coming and by the time I got home he was already in a coma. His decline was very unexpected. He was dead within a week of my getting back. It was really shocking because it was so sudden. He died within eight weeks of being diagnosed, I think.

Grief is a strange thing. I had been through it before. My brother died. My Dad died. Tom was different in that he was a chosen family and a loved one I had found all by myself. I always thought I was going to grow old with him and be his friend for a long time. It hurt and it was devastating. It took me years to put my life back together again.

Time passes and time heals. At fifty years of age I now feel that I have found my voice again. I can do whatever I want to do. I'm very free and open about that. I am very relaxed about who I am.

Mark O'Halloran

Mark O'Halloran is a writer/actor from Ennis, County Clare. As an actor he has worked with all the major theatre companies in Ireland, most recently in the acclaimed productions of *The Importance of Nothing* with Pan Pan Theatre Company and *The Shadow of a Gunman* with The Abbey Theatre Dublin. On screen, he has appeared in numerous films, most notably as one of the eponymous heroes in *Adam & Paul* for which he also wrote the screenplay which won him a European Film Award. He played the lead role of MP in *History's Future* for which he was nominated as Best Actor at IFTA awards 2017. Most recently he played the role of *Craigy* in the TV series *The Virtues* for Channel 4. He also appears in *Darklands* and *Dead Still*, as well as the upcoming Sky Italy TV series, *Devils*.

Mark's writing credits also include *Garage* as well as the television series *Prosperity*. He also wrote *Viva*, a Spanish language feature set in Havana Cuba for which he was shortlisted for an Oscar. His latest screenplay *Rialto* premiered at the 2019 Venice Film Festival. Mark's work has been seen at Cannes, Berlin, Toronto, Telluride and Sundance film festivals. For the stage he has written the play *Trade*, named as best play at the Irish Theatre Awards 2012 and most recently contributed text to the award-winning theatre production *Lippy*, winning a Fringe First at Edinburgh and two Obie Awards in New York. He co-wrote *Beckett's Room* for Dead Centre Theatre Company. He is currently adapting Sally Rooney's *Conversations with Friends* for the BBC and Hulu. In 2020, Mark was nominated as Best Supporting Actor for *The Virtues* and Best Screenplay for *Rialto* at the Irish Film and Theatre Awards.

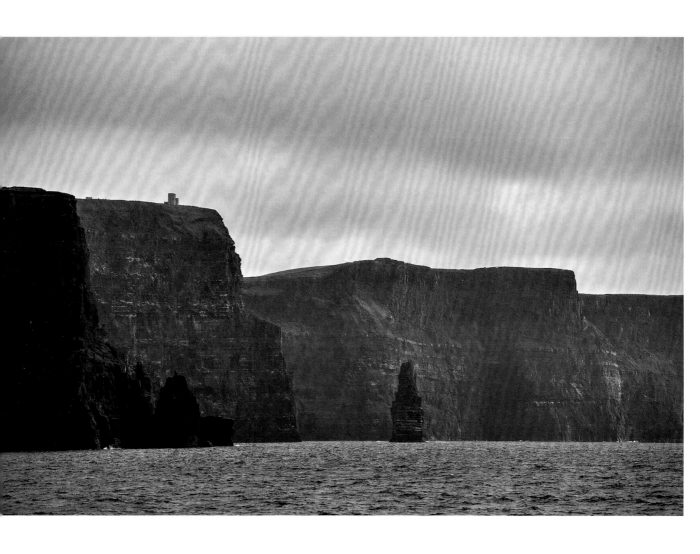

Stone Mad for Music

Sharon Shannon

I am a country person, a farmer's daughter from Corofin/Ruan, County Clare. My parents' names are Mary and IJ. I have two sisters and one brother. Garry is the oldest, Majella is second, I'm third and Mary is the baby.

Looking back to my earliest memory, I can vividly remember the excitement of learning to walk. Maybe it's just a dream but it feels very real in my mind. I remember my brother Garry, my sister Majella and my mother with their arms outstretched. I remember all the praise they gave me when I managed to take the two or three steps towards one of them and fall into their arms. I was probably somewhere between one and two years old. It is still one of the most exciting feelings in my whole life and that includes adventures as an adult such as sky diving, bungee jumping and paragliding!

My father used to be a dairy farmer. He went to the creamery in Corofin every morning, and he dropped Garry and Majella to school by 9.00 am. I remember huge commotion in the house every morning with my mother trying to get Majella and Garry out to school. And as soon as they were gone, I remember instant calmness... my mother would put me on her lap and we'd sit at the dinner table and she used to sing songs and read stories to me, and best of all she used to scratch my back for what seemed like hours. I loved every second of it. It was pure bliss.

I also remember my mother teaching me the alphabet, how to count and write. My fourth birthday was June 8, 1972 and I was due to start school that year. I loved my mornings at home with my mother so much, I wasn't looking forward to starting school at all, but eventually the day came in September 1972 with the usual morning panic stations. My life as I knew it was about to dramatically change because this time I was going in the car with Garry, Majella and my father. My mother had to stay at home to mind Mary.

From the outside, school looked like a scary prison to me. My brother Garry took me by the hand and walked me up to the door of junior infants' class. We were greeted by the teacher, Mrs McCavitt. She asked me my name, and of course I said, 'Sharon.'

She replied, 'Shay-ron,' that is how to pronounce it, your name is 'Shay-ron.' She took me into the classroom and introduced me to all the rest of the children as 'Shay-ron.' I hated my new name, but of course I was too scared to correct my teacher. I would have given anything to be back at home sitting on my mother's lap having my back scratched.

And my initial impression of the school never changed. The inside of the classroom was just as cold and prison-like as the outside. We had tiny little wooden desks. Two kids per desk. There was a spare place beside a little girl called Bridget. She was a very timid little country girl with a permanently snotty nose, the same as myself. We became great friends. We weren't exactly the cool kids.

Apart from school, we had a fantastic and idyllic childhood. We had great freedom on the land, running and climbing and playing with one another and with neighbours' kids and interacting with farm animals and training the pets to do tricks. My father is a huge animal lover and he taught us that animals always respond better to praise and rewards, rather than brute force.

We did annual summer trips to the beautiful beach town of Lahinch and to the Burren, Black Head, Corkscrew Hill, Gregan's Castle in Ballyvaughan and sometimes Doolin. There was usually blue murder in the back seat with the four of us playing a game called 'turns', squashing each other against the side of the car.

We used to look forward with great enthusiasm and excitement once a year to some sort of a carnival day in Corofin, with bumpers and swinging boats, candy floss and various stalls selling knick-knacks and gadgets.

Sciortán is the Irish word for a tick, a blood-sucking parasite, pronounced 'shkirtawn'. They often attached themselves to us when we were doing the hay in summertime. One day my sister Majella picked off one and put him into a matchbox to keep as a pet. Of course, she wasn't serious, this was just pure devilment. She named him 'Tommy' after our neighbour, Tommy Murphy. On August 16, 1977, Tommy the man, Tommy the Sciortán and Elvis Presley all died on the same day. Even though we were initially sad to hear the news, we eventually did endless laughing, discussing the possible conversations in heaven between Elvis and the two Tommies. We acted out scenes of Elvis singing 'Hound Dog' while doing his pelvic movements. And Tommy Murphy (who was hard of hearing) asking him the whole time to repeat himself. We had great laughs at the

thought of Tommy the *Sciortán* chancing his luck at attaching himself to Elvis's backside and adding to his gyrations!

We spent most of our time outdoors when we were kids. My father used to breed Connemara ponies and we trained them to jump. Mary and I did a lot of competitive show jumping as teenagers. We were lucky that we had very good ponies to work with. It was a big obsession for me. And we were lucky that it was also a huge passion for our father IJ, so he gladly nurtured our love of ponies and horses.

We often had pet lambs and pet calves and pet kid goats also. I loved the farm animals just as much as I loved the so-called 'companion animals' such as cats, dogs and horses. To me, all the animals were companions. We once had a pet calf with a dead leg which had to be bottle fed. I loved that little calf so much. He was very affectionate and he used to follow me around but something made me feel that I should hide my compassion and empathy for him because he was a farm animal.

I remember being asked by Garry what I was going to call him, and my reaction was to try to pretend that I wasn't too attached to him, so I said the word, 'Nothin'. Garry thought this hilarious, so then the calf was called 'Nothin'. A few months later, I came home from school one day and 'Nothin' was gone. I never asked where he was or what happened to him but I guessed that 'Nothin' and the other calves had been brought to the cattle mart in Ennis to be sold and slaughtered for meat. I was broken-hearted but I kept it to myself, otherwise I would have been teased.

I'm very passionate about environmental issues and the horrifically cruel and terrifying plight of farm animals once they are sold, especially for live export. I use every possible platform to talk and write about them. I feel animal rights and welfare issues need more media attention. The environmental stuff is at last getting the huge media attention that it needs. But alas, the plight of farm animals and all the dark and shocking secrets of the meat, dairy and egg industries are still not making it on to mainstream media, but in the meantime, social media is helping. These poor animals have no voice. If they did, I'm absolutely certain that they would agree 100 per cent that these horrifically dark secrets need to be put out in front of consumers. All of us, as consumers, need to be made 100 per cent fully aware of the cruelty that we are enabling when we buy unethically-sourced meat, fish, dairy and eggs. Excuse the digression, but activism in that particular area is very much part of my adult life.

Okay, back to my childhood years. Among our neighbours, we had lots of eccentric characters who probably influenced my life.

One was a bit of a genius called Bernie Daffy from Ruan. He made his own plane and used to fly it around the neighbourhood around fifty or sixty feet up in the air. It was like a deckchair with wheels and wings. And he would pull a string on it like a chainsaw to get the engine going and he would push it down the hill of a field and hop on to it and miraculously it would lift off. It was both fascinating and hilarious at the same time.

Another neighbour in Corofin called James Tierney made his own submarine. He made it out of two tar barrels and apparently there was only room for himself inside in it!

Both my parents were stone mad for music and dancing and they instilled their great love of music in us. Thanks to them, all four of us started playing music at a young age. When I was around eight, they sent my brother Garry to tin whistle lessons in Corofin and he taught the rest of us the whistles at home. Garry was and still is a brilliant music teacher.

When Garry was twelve or thirteen, he went to secondary school in St Flannan's College in Ennis and he joined the St Flannan's Céilí band. The school band was being mentored by a lovely man called Father Joe McMahon. Father Joe was very laid back and he was well-loved by all who knew him. His nickname was 'Daddy Cool'. I have some great memories of Garry and myself hanging out with Father Joe. We played many sessions here, there and everywhere, even while travelling in the car, the three of us playing whistles. Father Joe would be driving and playing the whistle at the same time, steering the car with his elbows.

It was through Father Joe that we discovered Stockton's Wing. That's when we got our first Stockton's Wing album. It was the most gorgeous and coolest music we had ever heard. We played their albums non-stop at home and learned all the tunes and arrangements inside out. Those fantastic musicians were like Gods to us and still are.

Around this time, early 1980s, it was Garry's idea that we all take up different instruments. Garry took up the concert flute, Majella took up the fiddle and Mary the banjo. I chose the accordion because I had lovely memories as a small child of my Auntie Kathleen's husband, a big jolly man called Eamonn from Liscannor. He played a small *Hohner* button accordion. I loved the sound and the look of it. I was

absolutely fascinated by it, especially the movement of the bellows. To me there was something sort of magical about the instrument. I have a vague memory that my first accordion was bought in a music shop in Ennistymon, but I have a very clear memory of the sense of excitement I felt when I got it.

I had another Aunty Kathleen on my father's side of the family. She lived in the Station House, about a mile outside Corofin on the Ennistymon Road. It was the original Corofin Station House for the West Clare Railway. There's a lot of history and a magic vibe in that house. Auntie Kathleen was a gifted cook and a great entertainer, and she ran it as a guesthouse. She used to invite us and our first cousins Ann and Myra from Willbrook to entertain her guests. They are fabulous singers and musicians. I have great memories of these sessions which were absolutely brilliant *craic* and we discovered the music of Planxty and Christy Moore through Ann and Myra.

Also, around this time, we started going go to local *céilís* every Friday night at the parish hall in the nearby village of Toonagh. They were run by an amazing man and great musician, Frank Custy. They were our first experiences of socialising and innocent childish romance, and they were the highlight of our week.

Donegal fiddle player Tommy Peoples, who lived in Toonagh, was a huge influence on me. I listened to his records and tapes non-stop, especially one album, *A Mighty Session* where he played with Matt Molloy and Paul Brady. I was also hugely influenced by Matt Molloy, bands like De Dannan and The Bothy Band and, as mentioned, Stockton's Wing. We four Shannon siblings, together with the Custy family and Tommy Peoples and his daughter Siobhán, were part of a *seisiún* group with *Comhaltas Ceoltóirí Éireann* and we did one or two shows per week at various locations in County Clare.

We all worked hard at our music and still do to this day. Nobody can pick up an instrument and immediately be able to play it without a lot of hard work. For somebody to be able to play any musical instrument to a high standard, it takes thousands of hours of practice, no matter who they are or how naturally 'talented' they might be.

A man called Gearóid Ó hAllmhuráin, an amazing person from Cahercalla in Ennis, had a huge impact on our musical lives. He formed a band called *Dísirt Tola* in 1982. The four of us Shannons were in the band with other young musicians from Clare and Dublin. We toured England and America several times from 1982 until 1987. We used our gig money from our concerts and *céilís* in Ireland to buy

a sound system, flight tickets and boat tickets so that we could tour abroad. In 1983, we recorded an album called *Dísirt Tola* in Windmill Lane in Dublin. We supported The Chieftains at the Jet Club in Ennis in 1983 or 1984.

I also did some touring in the mid-1980s in America and England with Comhaltas Ceóltóirí Éireann. In my early teens, it would have been out of the question to even consider a career in music. Back then, not as many people were playing Irish music for a living, especially not women. In my late teens, I was playing seven nights a week in Doolin with some brilliant musicians who played professionally, including Eoin O'Neill. He told me I'd have no problem becoming a professional musician. So, I was very very happy to take his advice. At eighteen, I was perfectly happy to be playing in the pubs; that was enough to keep me happy for the rest of my life. But one thing led to another and I eventually transitioned from the pub gigs to performing on stage and recording albums.

Doolin is a magnet for musicians and tourists from all over the world and from all walks of life. Living in Doolin was my first taste of other musical influences. During my time there, I learned lots of new tunes from other countries and cultures. I learned in Doolin that fiddles, flutes and pipes and most other traditional musical instruments can fit in very well with any type of music. Most of all, I loved hearing a bit of Irish music mixed up with rock and roll. Some classical music pieces sound gorgeous on Irish instruments. I loved experimenting with different genres and mixing them. But at the end of the day, Irish music is my first love musically, and it's the type of music I understand best. I'll never stop being blown away by it.

I feel that I have been very lucky. So many people gave me amazing breaks and one lucky break always leads to another. I've made friends for life through music. I am extremely grateful for every second that I have in this thirty-year musical journey. I feel extremely privileged and lucky and honoured to be able to make a living from doing something that I enjoy so much.

Music is extremely powerful and the effect that it has on people is the most beautiful thing about it. Technically, it doesn't have to be particularly 'good' or 'bad'. It makes us more aware of our senses and can give us an incredible sense of euphoria. It is an extraordinary healer of sadness and grief. Some of the most euphoric times of my whole life have happened to me while playing music in sessions.

I'm often asked if a person's soul can express itself in fast music. Tommy Peoples, my idol from a very young age, totally and utterly bared his soul when he played

music. To my ears, his music will always be absolutely out of this world. There is an unexplained melancholy and raw emotion in his music that is incredibly beautiful and absolutely heart-breaking. Tommy's music always had me completely transfixed and could bring tears to my eyes even when he was playing fast reels at ninety miles an hour. There's something extraordinarily special and mysterious about it, something that all the technicality and the thousands of hours of practice in the whole world would never be able to tap into. Some might call it magic. Some might call it the supernatural. Some might call it divine. It definitely felt like Tommy's music was connected to something otherworldly.

On the whole, it's a really great feeling when both the audience and the musicians are lifted up together at the same time to a different level of consciousness. Sometimes, there are some very extra special magical moments at shows and informal sessions and even during recordings. Moments like these are totally unpredictable but are cherished by all of us. Music, not just Irish music, gives us a natural high. It is a language all of its own that brings people together and is one of the most positive and beautiful things in the world. I feel that the unexplained vibes in music, the ones that give us the shiver down the spine or the goose bumps, can connect us somehow to the mysteries of whatever is beyond the thin veil between life and death.

I hope to have many many more years of music-making and listening.

© Emilija Jefremova

Biography

Sharon Shannon

Sharon Shannon is an accordionist who has achieved legendary status throughout the world. A native of Ruan/Corofin, she is renowned for her collaborations across all music genres, Hip Hop, Cajun, Country, Classical and Rap. She has recorded and toured with The Waterboys, John Prine, Steve Earle, Jackson Browne, The RTÉ Concert Orchestra, The Chieftains, Shane McGowan, Willie Nelson, Nigel Kennedy, Kirsty MacColl, Bono, Adam Clayton, Sinéad O'Connor and Imelda May. Sharon has been hugely influential in promoting Irish music in the USA, where she has collaborated with John Prine and Steve Earle, in Canada with Natalie McMaster, in Japan with the Kodo Drummers, in Malawi with the Umoza Street Children Programme and most recently recording and touring with Seckou Keita, the kora master from Senegal.

A prolific composer, her 10 studio albums are testament to a fearless adventurous spirit. In 2018 she recorded a traditional Irish music album with Irish rugby star Robbie Henshaw and the Henshaw family and friends. Her last studio album was *Sacred Earth* (2017) and she released a double live album, *Live in Minneapolis*, in early 2019. Sharon has since marked 30 years in the industry with 30 new and previously unreleased tracks. She supports many charities and is a well-known animal lover and campaigner. She is also an Ambassador for Missionvale Ireland, supporting education and poverty relief projects in South Africa.

Of Your Arrival

Michael D. Higgins

Of Your Arrival
(For Fiadh)[1]

With others leaving
You arriving,
In the first year of that decade
When the world is sighing,
You part of that hope
Which many are seeking,
Brings joy.

On the edge of Spring you came,
Reminding us
Of nature's lessons
Of Renewal
Of how the harsh winter,
That holds its own purpose,
Makes way for new life,
In constant reminder,
That new flowers are coming,
From seeds of what was there,
Making the stuff of celebration,
That is unending
In this time and space
We share together
As we welcome
Your arrival.

1 Fiadh Higgins, the first-born grandchild of Michael D. Higgins, was born 'on the edge of Spring' 2020.

Biography

Michael D. Higgins

Michael D. Higgins is President of Ireland.
An academic, poet, former TD, Senator and government Minister, he is one of Ireland's leading public intellectuals. He has published four collections of poetry, and a number of books on current affairs, including this year's *Reclaiming the European Street: Speeches on Europe and the European Union, 2016-2020*.

Born in 1941, and reared on his uncle and aunt's farm near Newmarket-on-Fergus, in County Clare, he was educated at Ballycar National School; St Flannan's College, Ennis; University College, Galway and Indiana University, Bloomington, USA.

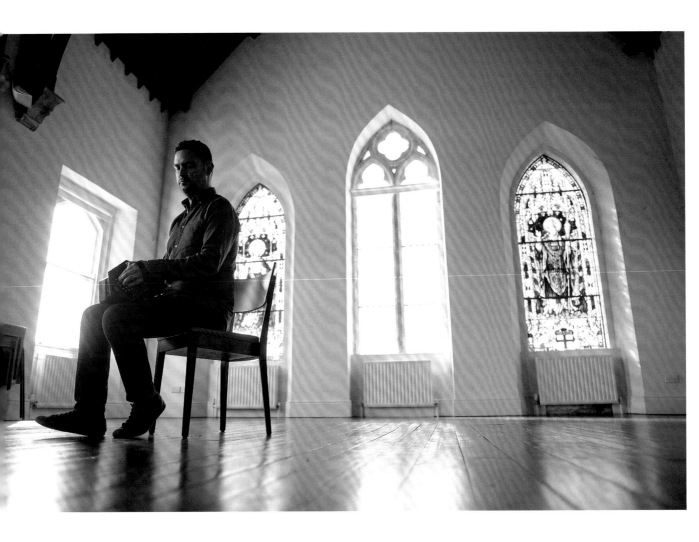

Place and Identity in the Formation of a Traditional Musician

Jack Talty

> To know fully even one field or one land is a lifetime's experience. In the world of poetic experience, it is depth that counts, not width. A gap in a hedge, a smooth rock surfacing a narrow lane, a view of a woody meadow, the stream at the junction of four small fields – these are as much as a man can fully experience. – Patrick Kavanagh

Any consideration of the significance of place to a young traditional musician growing up in County Clare could not conceivably overlook the well-rehearsed and seemingly ubiquitous 'Home of Irish Traditional Music' label bestowed on the county. A meaningful interrogation of the origins and validity of such a label would warrant a separate discussion, but it is fair to say that such perceptions of County Clare as a musical region has instilled in me varying levels of pride, conviction, responsibility and creative inspiration. Just as an ethnographer gains objectivity and perspective by observing cultural practices as an outsider to that culture, I'm sure that external observers could offer much commentary and speculation as to what it must be like to grow up as a young musician in County Clare. For me, however, these formative years have been spent learning traditional music through the lens of a tacit and implicit enculturation that I am only beginning to appreciate fully now as an adult. Furthermore, drafting an essay of this nature has been a welcome opportunity to unpack many thoughts that have been previously confined to 'shop talk' with other artists or with journalists writing a feature on a particular forthcoming album or performance.

My preoccupation with my native county and its influence on my creativity could be cynically dismissed as some kind of fetishisation for any number of motives, but it is my view that we ought all endeavour to connect with our places as sources of inspiration and solace, irrespective of where that place is, or whether or not we are indigenous to that place. The 'Dig Where You Stand' movement is an established framework that, at its most general, encourages learning about place and its history as a vehicle for cultural change, or even artistic creativity. I have always felt that traditional musicians and communities have retained connections to place in ways not mirrored in wider society. In addition, it is entirely feasible that the general *placelessness* lamented by some commentators

265

can be mitigated by observing the dynamics of the Irish traditional music community, both in Ireland and overseas. I return to this point later.

Place as a Physical Space: Growing up in Lissycasey

My earliest recollections of having an awareness of place, and its relationship to my identity as a traditional musician, are primarily rooted in memories of musicians from my locality, many of whom made the concertina their instrument of choice. In Feenagh, only a few fields from my parents' house, was the home of Gerald Haugh, a concertina player who contributed a number of important recordings of concertina music to *Irish Traditional Concertina Styles* in 1977. Dympna O'Sullivan lived in Frure, just a few fields north of where I grew up. Paddy Halpin, another neighbour and close friend of my paternal grandfather, also played concertina, and I recall frequent trips on his yellow tractor that would invariably lead to my pestering him about the intricacies of his Lachenal concertina, in a way comparable to how I imagined my schoolfriends might interrogate their favourite celebrity. Pádraig Rynne, another renowned concertina player, grew up and still lives in Caherea, just seven kilometres east of where I grew up in Lissycasey. The ubiquity of the concertina in my locality undoubtedly shaped my sense of place and belonging as a young aspiring musician, albeit in a more physical and geographical sense perhaps.

Closer to home, like many traditional musicians, my most concentrated early engagements with Irish traditional music took place in a familial environment. In addition to the many local musicians referenced heretofore, I was fortunate that I had regular access to Noel Hill, my uncle and arguably the most eminent exponent of Irish traditional music on concertina. Noel's sister Colette, my mother, also played concertina very well for the brief period that it maintained her interest. Their mother, and my grandmother, Margaret, or Maggie-Anne, was a concertina-player, as were two of my grand-aunts, Delia Hayes, and Katie Finucane. Although they were not related, Delia was an aunt to my maternal grandmother, while Katie was the aunt of my maternal grandfather, Sean Hill. It is quite possible and likely that the history of the concertina in my family extends farther back than Hayes and Finucane, but further research would be required to trace this to any significant degree. My grand-uncle, Pádraig A' Chnoic, commonly referred to within family circles as 'High Paddy' to distinguish him from his young nephew Paddy Junior, was also a noted concertina player, enthusiast and collector of Irish traditional music. Paddy was also heavily involved in the establishment and development of Comhaltas Ceoltóirí Éireann. In more recent years, various cousins of mine have also played concertina to a high standard.

266

Reflecting on my lineage as a fourth-generation concertina player evokes additional layers of thoughts on place, but perhaps these extend from the physical realm to one that is more ritualistic and non-material. Nevertheless, it is a manifestation and interpretation of place and identity that has had a profound impact on how I view my life as a traditional musician. In more practical terms, I suppose this historical and generational lineage has instilled in me a desire to continue the tradition of concertina playing and to transmit my concertina music to my children one day. Although not exclusively linked to physical or geographic place, this connection to the region inhabited by my predecessors illustrates how place and our associated feelings can occupy a space within our psyche as traditional musicians. Traditional music can often be the family photographs that we carry around in our minds, ever accessible, rather than tucked away in an attic or spare room for occasional reference.

Traditional Music Communities of Practice

My secondary education at St Flannan's College in Ennis marked another important milestone in my musical trajectory as it introduced me to a network of new friends with whom I would later tour many parts of the world. This formative educational milestone also located me in a type of community that was not confined to my immediate locality at home. Although relatively close to my home in Lissycasey, St Flannan's College would ultimately become the first community of practice that I would inhabit. I would later become familiar with such a concept through the work of Étienne Wenger, who describes communities of practice as those communities or cohorts unified by common interests and practices rather than by physical or geographical proximity. I've always found Wenger's observations on community interaction particularly applicable to my experiences of the Irish traditional music community in Ireland and elsewhere.

My preconceptions of Flannan's were mainly formed through my uncle Noel, who had been a past pupil, and I remember him relaying many musical anecdotes to me from his time there. I was also familiar with the excellent recording that the school produced in 1981 featuring musicians such as Noel, Tony Linnane and Garry Shannon, as well as numerous students who were studying there at the time. The school undoubtedly did take pride in its traditional music history, and although perhaps less visible than its celebration of its hurling and football achievements, important efforts were made during my time there by Father Joe McMahon, Garry Shannon and Fionnuala Rooney to encourage students with an interest in Irish traditional music to meet and share tunes on a regular basis. Many hours were spent in the school's 'music room', although I can't claim that our ambitions to congregate there were solely artistic. Likewise, the time

spent in the church housed within the school were as much a diversion from schoolwork as anything else. The hours of rehearsal that we purported to be undertaking for various religious events would have prepared us for innumerable Vatican conventions. Our musical activity while at St Flannan's may have been fragmented and extra-curricular, but it certainly proved to be another pivotal place in which I explored my identity as a traditional musician in an environment that carried historical significance, both in a real and imagined sense.

As a consequence of friendships made during my first year at secondary school, I subsequently joined groups and céilí bands tutored by Denis Liddy in Barefield National School. This was a formative experience for me because it introduced me to a number of musical experiences in the form of international touring at a young age, as well as competing successfully at national Comhaltas Ceoltóirí Éireann fleadh competitions. Although music competitions still mean very little to me, attending county, provincial and national competitions with my friends was a significant aspect of growing up as a traditional musician, and many lasting friendships were made through attending these festivals. Of course, another essay may be required to interrogate the concept of playing for 'another parish', as it were, in a place other than my area. Readers may be disappointed to learn that the rationale behind this betrayal of my village can be simply explained; there were no comparable groups or bands to join in Lissycasey at that time.

Place as a Conceptual Construct

From a young age I can remember associating the feeling I now know as melancholy with musical expression. More specifically, the melancholy wasn't merely a feeling, but it had a visual representation in the form of what I saw as a dark, powerful and arresting evening sky, made dynamic and evolving with the consistent moving of dark, heavy clouds. Unusually, I never associated this skyline, or the melancholic emotion that accompanied it, with any depressive connotations. Conversely, it stirred feelings of euphoria and an appreciation of something I perceived as otherworldly. As somebody who has been very fortunate not to have experienced depression or mental health challenges, I suspect that my perceptions of melancholy are viewed through a somewhat privileged and sheltered prism. Nevertheless, I can still feel the power of that vastness when I visualise that intense scene. A similar image of a skyscape and mountainous terrain features, perhaps unusually, on the homepage of Raelach Records, a record label that I founded in 2011. I've experienced similar feelings through the work of filmmakers such as Lars Von Trier, in films such as Melancholia (2011), in which stark and intense imagery is accompanied by the music of Wagner.

Exceptional traditional musicians such as Tommy Potts and Tony MacMahon are widely referenced as artists who have demonstrated a deep embodiment of melancholy and self-reflection in their music. However, it is my view that much of the great traditional music that we hear, although ostensibly vibrant and vivacious dance music, emanates from a similar creative impetus, even if we do not speak about such music in these terms. I hear grief and sorrow in many great recordings of Irish traditional music, irrespective of the fact that the performance in question is that of a set of reels or jigs, for example. I have always been particularly drawn to such music, and I have often wondered if I was earnestly interpreting something that wasn't actually present in the music. However, I'm certain that there is some merit in my hypothesis.

Given my obsession with the melancholic scenes that I remember when looking into that sky over the field beside our house, and its connection to how music (including Irish traditional music) made me feel, one can only imagine my excitement at discovering the work of Dublin photographer Colman Doyle. A renowned press photographer, formerly of the *Irish Press*, Doyle's work spanned hugely significant political and social events. My first introduction to his work was the photography that accompanied the sleeve of *Aislingí Ceoil*, an album released in 1994 by Noel Hill, Tony MacMahon and Iarla Ó Lionáird. I subsequently familiarised myself with much more of Doyle's work and delighted in the starkness and intensity of his photography, and how it resonated with my feelings about Irish traditional music in ways that I thought I had only imagined. The work of photographers such as Christy McNamara and Maurice Gunning has also inspired similar feelings in me, and their focus on place, people and landscapes continually connects the sounds of Irish traditional music, as I hear them, with the scenes and imagery of place and memory, as I visualise them.

Understandably, much popular and academic discourse has sought to deconstruct and untangle nostalgia and place-based identity formation with a view to challenging and interrogating phenomena that are invariably perceived as somewhat idealised, romanticised and, in some cases, excessively politicised. While such pursuits are welcome and insightful, I feel that space should also be devoted to acknowledging the more positive and creatively inspirational by-products of evoking memories of place and the role of nostalgia and romanticisation. Although acutely aware of our potential to conceptualise place and its effect on us in subjective and idyllic ways, we need not be discouraged from drawing inspiration in whatever means is available to us. To paraphrase the popular expression, we need not let the truth get in the way of some creative inspiration!

Such preoccupations with the influence and significance of place have existed in parallel with my interests in other genres of music and artforms. For example, the connection between the music of Sigur Ros, and the environment in which they grew up, portrayed in their film *Heima* (2007), impacted me in a significant way. Although a fan of Sigur Ros, I believe the imagery and importance of place presented in *Heima* has possibly influenced me far more than their music has. As I reflect on that film now, I realise that it was one factor that influenced my decision to establish the group Ensemble Ériu in 2012 with my schoolfriend, Neil Ó Lochlainn, a musician and composer I first met when we began secondary school at St Flannan's College. In a way, the origins of that band can be indirectly traced back to our hiding out in the school's music room, but I remember trips to Neil's home in Ballyvaughan, and the impression that the Burren landscape made on me at that time, as being seminal developments in forming a collective of like-minded musicians who would at least attempt to explore sympathies between our immersion in the traditional music of County Clare and curiosities that we had developed in other genres of music and artforms.

I appreciate now that the music that I envisaged for that project was rooted in the imagery of the Burren landscape. In a sense, I was making an attempt to localise *Heima* in a personal soundscape that was shaped by something global. This ethos was reflected in the album cover of Ensemble Ériu's eponymous debut album, released in 2013. The cover image is an unmistakable vista of the Burren that features grikes, clints, limestone pavements and karst hills. However, the image is stylised to represent an act of interpretation and creative inspiration. Again, this artwork served to portray the combination of local learning and appreciation with global curiosities. Subsequent work and albums with Ensemble Ériu have continued to focus intently on our local environment and the traditional music and musicians of County Clare, while also localising influences that have shaped our artistic approaches along the way.

Duala

While the preparation and development of this piece of writing has been a cathartic and thought-provoking exercise, it has coincided with another piece of work focused on place and County Clare, namely *Duala*, an audio-visual installation and film that I created with photographer and filmmaker Maurice Gunning. Commissioned by the Irish Traditional Music Archive and the Clare Arts Office, *Duala* sought to offer time and space for a practitioner of any artform to respond creatively to archival materials relating to County Clare, housed at the Irish Traditional Music Archive in Merrion Square in Dublin. *Duala* explores the universal themes of place and memory through the prism of Irish traditional music and musicians.

Importantly, the project provided an outlet to allow the many feelings that I have about place to converge into one concentrated artistic response. As a concertina player who plays instrumental music, many such feelings that I have had about place over the years, and how they directly relate to my identity and creativity as a musician, have largely remained unspoken in the metadata that accompany being a practitioner of Irish traditional music. As a musician who often performs repertoire associated with my place, I often speak about my place and refer to past masters associated with that place, but rarely do I have the opportunity to artistically comment on what place means to me.

Duala, an Irish word that translates as 'strands', integrates archival audio and video footage with original music and videography, and focuses on the centrality of place (Clare, in this instance) to identity formation in the psyche of the traditional musician. Just as this short essay has been an enlightening opportunity to reflect on what place means to me and the creative process, the *Duala* project has been a cathartic journey in artistically interrogating much of the nostalgia and potency that we frequently attach to the places that we inhabit. Archival material presented music and visual footage of past generations of musicians and the places that they frequented, while original music and videography responded to the concept of belonging to a place, and the effect that has on a traditional musician's identity. Contributions by well-known musicians interviewed for the piece offered insightful commentary on what place means to them. The premiere screening of *Duala* took place in Glór Theatre in Ennis on Culture Night, 2020, and the second screening was followed by a Q&A session with Maurice Gunning and myself, moderated by Siobhán Mulcahy of the Clare Arts Office.

What is particularly relevant about the post-screening discussion is the way in which the audience responded to the themes uncovered throughout the film. I do not mention this in a self-congratulatory manner to suggest how successful the piece was; instead, my rationale for discussing this is to highlight the appetite that audience members had to speak about place and to engage with the subject material of the film. Our lengthy discussion covered topics as varied as displacement, overseas diasporas and the potential of Irish traditional music to assist us in rediscovering our connection with place and our locality in society today. At the time of writing, plans are underway to schedule additional screenings of the film, which will undoubtedly provide further opportunities to discuss the importance of place and the memories that we attach to it.

Beyond Physical Places

Consolidating and communicating my feelings about place in this essay has stirred many thoughts that have lingered in my subconscious, obscured by the activity and bustle of everyday life. While some of these concepts have been unpacked in the process of making the aforementioned *Duala*, this writing exercise has been a welcome and enlightening exercise for me personally. While we need never presume that feelings about place, memory and nostalgia are the preoccupation of artists and creatives exclusively, thinking about place, however implicitly, has been an important element of my identity as a traditional musician.

Places and landscapes can have striking and beautiful visual features, but I now appreciate that this is not what instils inspiration in me. I've been fortunate to witness many beautiful scenes and places all over the world, from Iguazu Falls to Chilean sunsets and multiple international 'must-see' attractions. Closer to home, I've often marvelled at the scenery encapsulating areas such as West Kerry and wondered what it must be like to wake up to herd sheep every day while overlooking panoramas as spectacular and compelling as *An Fear Marbh* on a clear and sunny day. What these wonderful places lack, however, is a narrative and history associated with our personal memories; these are not my places.

As I walked around Ennis before writing these concluding paragraphs, I recall nostalgic and wonderful memories with attachment to some key moments in my life. Each time I visit Glór Theatre, I'm reminded of how privileged I was to perform there regularly as a young emerging musician. Each time I return to play there takes me right back to those earlier times. Peculiarly, notwithstanding my fondness of Ennis as a place and the memories that I associate with it, I had never noticed that it is also a visually attractive town. This surely points to the metaphysical attachments that we make with our places. They are not just locations with utilitarian functionality; they carry our memories, our histories, and shape our futures. As the American conservationist Alan Gussow said, 'a place is a piece of the whole environment which has been claimed by feelings.'

Biography

Jack Talty

Jack Talty is a traditional musician, composer, record producer
and academic from Lissycasey in County Clare. He has
contributed to over 80 albums as a performer, producer,
arranger, and engineer, and in 2011 he established the
traditional music label, Raelach Records. In 2015, Jack and
Ensemble Ériu were awarded a Gradam Ceoil TG4
collaboration award. He was appointed Traditional Artist in
Residence at UCC in 2018, and as the inaugural Creator in
Residence with Maurice Gunning at the Irish Traditional Music
Archive in 2019. Jack is a board member of Glór Theatre,
Ennis, and of the traditional arts advocacy organisation,
Trad Ireland, which commissioned him with the support of
the Arts Council, to publish a report entitled *Navigating the
Traditional Arts Sector in Ireland*, in November 2020. Jack's
academic work has been published by Oxford University
Press and he was awarded the Irish Research Council's
Government of Ireland Postgraduate Scholarship Award for
his doctoral research from the University of Limerick. Jack is a
Lecturer in Irish Traditional Music at University College Cork.

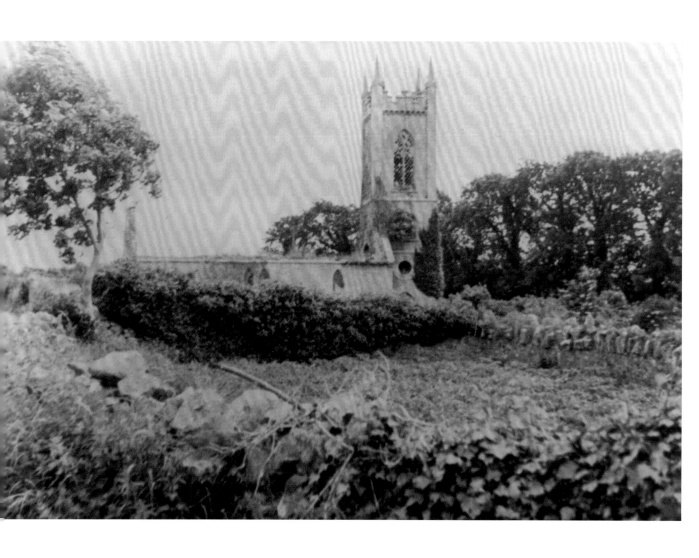

Never was a shade

Gerald Barry[1]

My earliest memories are flying through clouds and the floor of Fawls Bar in Ennis. The cloud memory is possibly being a baby lying in the window behind the back seat of a car and looking up. It would have been driving from or to my grandmother's house in Bealcragga, Kilmaley. I feel it was from. The house was on a hill surrounded by high trees and I remember the wind. My parents sometimes drank in Fawl's Bar and would put me on the floor under the table. The floor was mosaic and I could study it because my face was lying on it. Years later I met the architect Tom de Paor and I told him about the floor and he was astonished because he'd also been put under a table there by his parents and knew the floor well.

Another memory is sitting on my father's lap in Clarecastle and hearing him mimic black dockworkers in Lagos. He'd got into some trouble in his job - probably to do with drink - and got a Radio Officer job on a British merchant ship. He'd go from Clarecastle to Dublin to Hollyhead to Hull to Lagos and would be away for months. I'd be dying for him to come back and on the day of his arrival I'd stand at the door looking down the street watching for every bus and after a few came without him I'd run in and wail to my mother If he doesn't come today he won't come tomorrow and then he won't come at ALL!! It became a sing song joke at my expense in the family. Everything was life or death.

There was no music in our family. My mother's brother was Paddy Murphy the concertina player, a quiet man and a wonderful player. As a small child I remember sitting behind a semi circle of people around the fire in the Bealcragga kitchen - scorching at the fire - arctic in the upper kitchen - watching them like they were on stage. When I was in bed in the garrett I could look down into the kitchen way below and watch and hear him and other musicians playing around the fire.

My mother had two sisters, Margaret and Kitty. I couldn't pronounce Margaret as a child and only managed Ago - pronounced Aago. So she became Ago. She worked in Mulqueen's Drapery in the Market in Ennis. My mother was sent to the Ennis Coláiste but didn't like it and refused to go back. Kitty was crazy. When we'd visit her she always said the same thing at the end - she'd rap her knuckles on the car roof and say See ye at Whit! My brothers, sister and I would chirrup it in the car waiting for her to say it and then she would.

1 Publisher's Note: The author has asked that his essay be printed without any editorial input or changes and we have acceded to his request.

We didn't have a car and didn't drive. Occasionally my father would take a fancy and hire a hackney car with driver and we'd go on an excursion - my father and him in the front and us in the back. They'd see a pub and stop and go in for a drink. Then we'd continue and they'd see another pub and do the same. This went on and on and by the time we were coming home in the evening they were completely drunk.

Both my parents had fine ears and were wonderful mimics. They had a stormy relationship. Our house was a bit of a war zone in that regard. Even as a child I knew you had to tread lightly often, but you'd never win, the mood swings were so random you'd inevitably step on a mine. My father had a fantastic sense of nonsense and would sometimes sing. Sometimes my mother and I would stand in the hall looking out the window on the empty road waiting for a local to pass. We used it like a cinema screen. One would appear and in the seconds it took them to walk across the window frame she would shout out a phrase associated with them getting their manner and accent exactly right. You only had a few seconds to do it in. We lived at what was then the edge of the village. For some reason - I never figured out why - we weren't really part of the village - village life. My oldest brother was an exception probably. He was a force of nature, a Leader of Men. He'd go to houses and play poker and when he'd return we'd quizz him - what happened - what were they like - what was said. He might as well have been returning from a jungle expedition. Our house was I think part of what had been the Protestant church world. It was joined to another house - two thick blocks of houses. Whether it's true or not our house may have been some kind of school and the one next door may have been some kind of vicarage. I don't know. Right outside our kitchen window were the gates and avenue to the Protestant church. It wasn't our land but we treated it as if it were and spend a lot of time in it. At the top of the avenue was the church, no roof. I was in love with it and spent my childhood sitting in the bell tower dreaming. There were soldiers' helmets in the rubble of the nave. I presumed from the civil war. Later when I went to Dublin I came home one day to find the church gone. Just an empty site. I was heartbroken. Someone had blown it up to get the stone. I went into our house and cried to my mother WHY WHY as if it was her fault.

I spent most of my childhood in an altered state. Mary's Annunciation was nothing - Annunciations were an everyday occurrence with me. I had so many visions I've forgotten most of them. The drug causing these was my imagination and the landscape. I'd lie for hours in fields crags trees. Where our house in Clarecastle is now bears no relation to what it was. All the fields are gone and built on. All ugly.

When I lived in Cologne people were amused by my address, Clarehill, Clarecastle, Co. Clare. A few years ago a friend from Cologne came to Ireland with her husband and she was determined to see this Clarecastle. They went there and she texted me "It's very disappointing." Made me laugh. Only a German would do that.

I've had to tell so often how I discovered music it's become a bit numbing. I think before I happened on music I was always aware of it without knowing. As a boy I'd go to Sunday mass. I'd look up at the choir gallery to see who was playing the harmonium that day. It was shared by two women, one plain, one exotic. The plain one played plainly and the exotic one gave pleasure. When I saw it was the plain one I'd be irritated by boredom and when I saw the exotic one I knew I was in for a treat. Because I knew her playing and knew the hymns, I knew that at a certain moment in a hymn she'd do something extraordinary which would set my heart racing. The hymn would begin, I'd wait for the moment, and then it would come, and she'd do the thing, and I'd be incredibly happy and moved. The thing was a strange harmony she used at one point. That moment marked me for life.

There was no record player piano or television in our house - just a big radio high up on a window sill. We had hardly any money. The house was freezing with very thick walls which wept in winter. Going to bed you'd have to hold yourself in not to touch them. My mother would put hot water in my father's whiskey bottles in socks to take to bed. I had two main annunciations which fixed my life. The first came one evening through the radio. I turned it on and it slowly lit up, I was going along the dial, London Paris Hilversum Luxembourg. Then I heard a woman singing. I was transfixed. I knew a major thing had happened. I was filled with fire. Ecstasy. My mother was making bread and I turned to her to tell her what had happened to me. She looked at me and I opened my mouth but couldn't speak. What had happened was so beyond anything I knew I didn't have the words. I didn't know what they were. She waited to hear and I was there openmouthed and silent and finally turned back to the radio dial and she went on making bread.
A whole year went by without my saying anything. The second and final event happened a year later. I was wandering in the local churchyard and went into the church and looked up at the choir gallery and went up the stairs. At the top of the stairs I looked into the gallery and saw the harmonium. It was closed and looked exactly like a rectangular piece of furniture, a chest of drawers. A flash went off in my head, literally, like a cat belted on the head in a cartoon with sparks coming out of it. I knew everything in that moment and knew what my whole life would be til death. It was that simple and clear. It was a hot day

but I ran all the way home to tell my mother what had happened. I panted into the kitchen and she was there making more bread. She looked at me and said What!?!? I was out of breath and blurted out I'm going to be..... I'm going to be..... but as I didn't still know what the words were I couldn't say composer - I'd never heard the word - but this time I knew how to describe it. I said something like Music!! I'm going to be Music!! You must do something!! She just laughed and ignored me. She didn't know what to make of it and we had no money so that was it. A long battle started and I wore her down with tears and all kinds of emotional attacks and finally she gave in and I began. I then became unstoppable. I took piano lessons tho we had no piano, I got a disgusting job and saved up and bought records tho we had no record player. I used to take the records out of their sleeves and smell them - use my nose as a stylus going round and round, study the advertisements on the back and be thrilled by seeing the names Vienna Berlin Paris. My yearning was so great I became one with these records as objects and entered them completely. I couldn't hear them but I knew them as well as my body.

My piano teacher was Patsy Callinan in Ennis. I saw her for 30' each week. I got her to agree to teach me for 15' and play my records for the other 15. Both fifteens were zapped in intensity as I drank in everything. After a while she rebelled and said 15' wasn't enough and she needed 30' for teaching so I lost my record half. I wanted to enter a piano competition but she forbade it so I entered in secret. I played the famous Chopin Nocturne in Eb and a piece of my own. I got a scissors and cut up a Mozart sonata in long strips and stuck them together in a different order so it was very disjointed and said it was mine and as the adjudicator didn't notice I came second and got a medal. I took a piano exam in an upper room in a place called Harmony Row near the Ennis Bridge. I thought how extraordinary to live in a place called Harmony Row. I became an itinerant looking for people with a piano and sought out a Mrs Hanley and asked her to play something for me. She played the first movement of Beethoven's Sonata No 10, Op 14 No.2. If someone from a distant galaxy had appeared in the room at that moment I couldn't have been more astonished. That such music could be written and that it could be played.

My oldest brother found this fever very funny and seized on things like Sonata in D Minor. On a Saturday morning when we'd all be in bed he'd come running up the stairs shouting SONATA IN D MINOR!!!! and grab me and try and pull me out of bed and I'd shout to my mother HELP!! MAKE HIM STOP!! Once he beat me up when I was about 11 and he was about 16. We were rolling around on the floor and he pummeled and punched me and then walked off. I decided I'd punish him by pretending to be dead. So I lay there for hours and when anyone would tiptoe up to look at me I'd hold my breath and look dead. Then I'd hear

them tiptoing away. After hours of this I smelled my mother cooking and I was exhausted so I got up and went downstairs to join them and they were chattering away and noone made any reference to what had happened.

Early on I decided clearly that my reason for being was writing and avoiding work. Avoiding work became a religion and I was good at it. I knew my life was dreaming, never working. I cycled up and down Ailesbury Road in Dublin and went into each embassy and applied for money. The first to give it were the Dutch so I went to Amsterdam, the next were the Danes so I planned to go to Copenhagen but the Germans offered at the same time and I betrayed the Danes and went to Cologne instead. When I ran out of money in Germany I asked the Austrians who said yes, so I took the 13 hour train journey from Cologne to Vienna every month to pick up the money. Someone once asked Mauricio Kagel, my teacher in Cologne, What was he like? Kagel said "He was the most expert person I ever met at extracting money from people."

This avoidance of work and having to live simply sometimes got me in trouble. Once I stole 12 bottles of vintage champagne and ended up in court - packed - and when the judge asked the policeman in the box what was the charge the policeman looked embarrassed and muttered 12 bottles of vintage champagne Your Honour - he'd never had to say those words before - and the judge said I see, and mulled, and he and the policeman looked at one another and then the judge looked at me and said Do you have a solicitor? I said No I don't. He said "Don't you realise I can send you to jail for this?" I wondered what the safest answer was and opted for "No I didn't realise that." Then he said Come back next week with a solicitor. I came back with the solicitor and the court was packed again and the solicitor and the judge had quiet exchanges which I couldn't hear and I was made pay something into the court poor box and left with a muted rebuke from the judge.

My parents had good deaths. My father fell out of bed and died. My mother said she heard a thump and there he was dead. I was in London at the time for the premiere of my orchestral piece Chevaux de frise at the proms. Then my mother died on the opening night of my first opera The Intelligence Park at the Almeida Theatre in London. I wondered did I have some occult power which caused someone to die whenever I had a prestigious outing and if I wanted to kill someone could I do it by arranging a very very prestigious outing. I saw my mother in a nursing home in Ennis and never saw her again. I was standing at the bottom of her bed and suddenly she sat up and stretched her hands out to me and said "Look! The hands of death!" The day she died she said to my

brothers around 6 Has Gerald's opera been performed yet. They said No it's not until 8. The opera ended around 10 and she died shortly after. I got the call and wondered should I go back - it would mean missing the run of performances and the opera meant everything to me - my mother knew that - but I thought I must go back. I sat with her alone in the Ennis Mortuary and took photographs, but the photographs didn't look right and I didn't feel right taking them - robbing her image - I deleted them - I thought it better to remember.

© Betty Freeman

Biography

Gerald Barry

Gerald Barry was born in Clarecastle in 1952 and has written the operas The Intelligence Park, The Triumph of Beauty and Deceit, The Bitter Tears of Petra von Kant, La Plus Forte, The Importance of Being Earnest and Alice's Adventures Under Ground. Alice was staged at Covent Garden in 2020 and his new opera, Salome, on the Oscar Wilde text, has been commissioned by the Los Angeles Philharmonic, the Southbank and Dutch Radio. He is currently writing a Double Bass Concerto for the Berlin Philharmonic to be premiered in June 2022. He lives in Dublin and in the Burren opposite the Aran Islands.

(The music I heard on the radio in Clarecastle when I was 11 was Handel's Ombra mai fu sung by Clara Butt in 1917. It can be heard on youtube. After the opening prelude the action begins in the aria. Handel wrote it for a Castrato. Butt sings it like an animal - half woman, half man. Through the colours in her voice she changes gender all the time, from cavernous dark to bright.)

4ᵗʰ April

Peadar King

Every year on the fourth of April I listen to the sublime voice of Marvin Gaye singing the evocative and hauntingly beautiful *Abraham Martin and John*. On this day, it is how I start my day. The song: a paean to Martin Luther King Jr. And to Bobby Kennedy too. Lives intrinsically linked, for better and for worse. Because on that day 53 years ago, Dr Martin Luther King Jr, born Michael King in 1929, his name was changed to Martin when he was four years of age, was assassinated by white supremacist James Earl Ray in Memphis, Tennessee. Within that song I hear again and again the searing sadness of his leave-taking and the loss of this utopian visionary, needed now more than ever, along with the possibility of what might have been.

And it's a song that evokes not only the shocking violence of a single bullet that stilled a 39-year-old voice renowned not just for its mesmerising cadences hollowed out of a profound religious belief rooted in the psalms of the Old Testament, known at the time as Negro spirituals, but also out of a belief in the possibility of liberation from the hatreds that had, at the time, infused the souls of the majority white population of the United States of America. And for us all. 'Free at last. Free at Last. Thank God Almighty I'm free at last.' Words that mark his tombstone, his final resting place in his home city of Atlanta, Georgia. It's a song I share with LaTrenda Walker whom I literally stumbled across in the Mason Temple Church in Memphis forty-five years after Dr King's death, the church in which he preached his final sermon.

April the fourth. A date marked on a calendar. Not in Memphis, but in the townland of Kildeema in the parish of Kilkee, in 1964. I was six years old. It was a Saturday. That I remember. I also remember that it was a warm spring day. But on weather, memory is fickle. At the time we had lambs, lots of lambs. Calves too. And the first airing the calves got was when they were allowed graze the grass margins of the avenue to our home. Woe betide us if they broke through the wire fence to the well-field below; there was no getting them back. Spring days on Saturdays.

Saturdays too involved bringing weekly supplies to our neighbour Catherine McInerney. Catherine, or Cat as we knew her, widowed from mid-life, lived in her own silent world. By the time we got to know her, she was bent over and

profoundly deaf. Each Saturday we brought her potatoes, milk, bread and meat. An already well-read *Clare Champion* too, her only connection to the outside world. That and the monthly *Messenger*. But carrying all that stuff back the avenue, past the big tree, left at the gate, past Papa's garden, was an unwelcome chore and one we wrangled over as to whose turn it was. Once there, our only way of communicating with her was through written notes, a challenge for any six-year-old, and as she got older her weakening eyesight made that even more difficult, and with age her patience waned. I remember once being berated for my bad writing. Now, I think perhaps she had a point.

What wasn't of interest to us at the time was Cat's interesting back-story. Born Catherine Houlihan near the Bridges of Ross, of which she was intensely proud, like many of her contemporaries she emigrated to the United States. At what age, to which city, and to whom is lost to us now. As is how she fared in a country where no Irish, no blacks (NINB) need apply, I have no idea.

Equally lost is when and why she returned. But return she did. And it would appear she never regretted the decision. 'I struck oil,' I remember my father quoting her when she met and married Siny McInerney, with whom she shared her new two-bedroomed home with his sister Maria-Nelly and his brother Marty. A phrase, perhaps an unwitting *hommage* to her years in the States. They didn't have children, something that must have pained her. 'Siny was old, don't you know,' the only other phrase I remember my father ascribing to her.

If that were the case, we were far too young to notice, not to mention understand. She was an old woman whose life was shadowed by silence in a house without electricity or running water. Our visits punctured by long pauses. Long pauses over a smouldering open fire, as we fearfully looked out for rodents we had imagined must have been lurking in her thatched stone-cold house. But the house also held hints of a previously prosperous life. The parlour from a different age. The table laden with china, coloured sugar bowls and an oil lamp. All gone now bar one chipped egg cup.

My family must have received some of the china. I have a memory of square china plates with embossed country scenes. But we were a big boisterous family and things didn't last long. What remains: one chipped egg cup. On visits home, I inevitably reach for that egg cup at breakfast time. And even in early mornings wonder about those who previously tapped out their breakfast from this cup. Catherine, Siny, Maria-Ellie, Marty and who knows who else? Perhaps the parlour was out of bounds even for those who lived there, as would have been the case

in many Irish households at the time, and as I was to discover years later in a number of West African households too. The parlour: a British colonial bequest that stretched across its empire now long gone like its empire too.

All of that was for later. On Saturday, fourth of April 1964, my older sister Mary and I were left to our own devices. Tired of writing notes sitting on the deep recess of a whitewashed window ledge, Mary circled Saturday the fourth of April on a calendar that featured spring lambs and said we will always remember this date. The fourth of April.

I have. And I do. One in particular.

On fourth of April 2013, I joined the march in Memphis, Tennessee commemorating the 1968 sanitation workers strike led by Dr King. On the previous night, I heard Dr King and Coretta Scott King's oldest living child, Martin Luther King III, speak at the Mason Temple church. As I went to take my seat, I stumbled and fell across two very startled African American women. They were as gracious as they were amused at my misstep. Fortuitously, it proved as good a conversational opener as one could imagine and LaTrenda Walker, one of the two African American women, was a conversationalist for sure. A comic moment in an otherwise sombre occasion. Because it was here that Dr King preached his final sermon. He hadn't intended speaking that night because he had a cold. But urged by the congregation, he rose to speak. And in doing so called upon all his rhetorical skills. His soaring incantatory call-and-response oratory in full flow. And then, inspired by the New Testament *Book of Revelations*, came the prophetic moment:

> Like anybody I would like to live a long life. Longevity has its place. But I'm not concerned about that now. I just want to do God's will. And He's allowed me go up to the mountain. And I've looked over. And I've seen the Promised Land. I may not get there with you. But I want you to know tonight, that we, as a people, will get to the Promised Land. And so, I'm happy tonight. I'm not worried about anything. I'm not fearing any man. Mine eyes have seen the glory of the coming of the Lord.

Six hundred miles away in Minneapolis, Robert Kennedy who, as Attorney General in 1963 authorised a wire-tap on the phone of Martin and Coretta Scott King, heard of Dr King's assassination as he was about to speak to a mainly African American audience as part of his bid for the Democratic party nomination

for the presidency of the United States. Standing on a truck, visibly shaken and relying on impromptu notes scribbled on a piece of paper, Kennedy spoke of the death of his brother killed too by an assassin's bullet. Curiously, he was wearing his dead brother's overcoat on the night. Included in his grief-laden speech was a quote from the Ancient Greek poet Aeschylus, apparently his personal favourite:

Even in our sleep, pain which cannot forget
Falls drop by drop upon the heart,
Until, in our own despair,
Against our will,
Comes wisdom
Through the awful grace of God.

When weeks later Robert Kennedy died from an assassin's bullet, I remember I cried on hearing of his death, which in retrospect I don't claim to understand. I was ten years old at the time. I remember later that evening my mother being nonplussed at my sense of loss. As well she might have been. Ours were worlds apart. His, the son of one of the richest and most famous families in the United States, if not the world. Mine, a peasant world, although it is possible many might bridle at such construction. A peasant society where petit bourgeois aspirations, 'a dry shoe job', were not uncommon and entirely understandable. We were a neighbourhood of labourers and small-to-medium-sized farmers. Leaving, for many, was inevitable. But even within peasant societies, there are markers of difference. The size of the farm was one. To the outside untrained eye, barely a discernible difference. Within, markers were unacknowledged but nonetheless real.

Years later, while filming in Latin America, I first encountered the words campesino and campesina, the Spanish for peasant. Invariably, Latin American peasants are proud of their association with the land. Proud to be campesinos/ campesinas. They wear their self-designation as a badge of honour and, as far as my untrained eye could discern, without distinction. People of the soil, of the land. Peasants who struggle against the autocratic landed class, against the greed, oppression and authoritarianism of the owners of the means of production, to borrow that telling Marxist phrase.

And I too have learned to be proud of my rural origins, that I too come from country stock. Come from the land. It took me a long time to know that, to feel that. It wasn't how I perceived we were made feel at the time. Town life, privileged over country life. For years that was the norm in Ireland.

Even *The Riordan's*, the rural serial drama of our childhood, the term soap opera did not exist at the time, that ostensibly sought to affirm rural life, could not do so without creating the gauche stay-at-home-on-the-farm character of Benjy, while his more urbane (and always better dressed brother Michael) was the successful engineer who left home. Still to this day the word urbane and its association with sophistication grates. Not in Latin America. And I like to think, no longer in Ireland either. One form of distinction that has fallen away.

With the world in turmoil, we too had our own milestone in 1968. My parents eventually overcame what they had long perceived as the nefarious influence of television, initially rented and eventually purchased our first set from Michael Gleeson in Kilrush. At the age of ten, my world opened up and out. And what a year. On the fifth of October, 1968, yet another iconic image from that eventful year made its way via the small screen into my world. Gerry Fitt MP, bloodied from the batons of the RUC, marched with about 400 other members of the Derry Housing Action Committee (DHAC), supported by the Northern Ireland Civil Rights Association (NICRA), to highlight what I later discovered the BBC described as 'alleged discrimination' against the Catholic/nationalist population.

The following year Bernadette Devlin crashed onto our screens. Her intelligence. Her clarity. Her sheer gumption. At twenty-one years of age and the youngest ever member of the British parliament. Smoking on *The Late Late Show*. Wearing mini-skirts. Loud. Pregnant. Single and defiant. Casting furtive glances at my parents, I was gobsmacked. And smitten. They, less so. No more whispered voices. Hers was a clarion call for speaking up and speaking out. Shush no more. These were heady days. Devlin was the ultimate icon but she was not trapped by others' perceptions or other people's need for heroes. To this day, she remains one of the most authentic, if infrequently heard voices in the country. However fleetingly and however partially, television gave us some of the extraordinary personality and courage of Bernadette Devlin. She certainly pricked the conscience of the other side, which of course was our side. Suddenly television had thrown open once-unimagined worlds and possibilities for my ten-year-old self.

During the mostly barren boarding school years of my teenage years in St Flannan's College, Ennis, the outside world was largely shut out from our world. There were compensations. Leaving Certificate Geography opened up my first interest in the sub-continent of South America. Even in that pre-visual age, barely discernable photocopied images from an old Gestetner of ant-like tin and silver miners swarming all over places like Potosí in Bolivia made a striking impact.

At the time, little did I think that I would visit Potosí to make a documentary on life in these very same mines. Our geography teacher, Father Pat Malone, had a passion for South America. Later, he worked as parish priest in Kilkee. On the occasional visit home, I attended mass along with my parents. His sermons: always well-grounded and challenging and his politics and social commentary always left of centre. Perhaps his teaching of the colonial experience of South America rubbed off on him, too, and years later would carry through in his sermons in a rural parish in West Clare.

The morning after the Mason Temple church service in Memphis, LaTrenda Walker and I met for breakfast of grilled tomato on slices of English muffin and hash brown croquettes topped with poached eggs, mushrooms, red peppers and grits, that most ubiquitous of southern dishes. It seemed as if questions welled up from my childhood and teenage curiosity. 'What was it like back then?' 'What was it like growing up black in the South?' Emmet Till? The fallout from the 16th Street Baptist Church bombing in Alabama? John Lewis? His autobiography *Walking with the Wind*, a sublime account of life in the South during the forties, fifties and sixties remains for me one of the most memorable and moving books I have read.

The outline of all of these stories I knew. Hearing them sitting across from LaTrenda in Denny's Diner on the forty-fifth anniversary of the death of Martin Luther King was to know them in an altogether different way. In retrospect, I wondered what she made of my curiosity. Yet another white man dining out on black people's oppression? Perhaps? If that were so, she hid it well. Rather, she patiently answered my questions until it was time to join the march of commemoration. Along with the others who gathered that day, the now aged and dignified black men who participated in the original march, we stopped in front of the balcony of the Lorraine Motel where at 18.01 hours on the fourth of April 1968 a single shot rang out fatally wounding Martin Luther King Jr and from where his son Martin Luther King III paid tribute to his life.

Five days after his assassination Dr King's body was entombed in Atlanta, Georgia. His casket carried on a farm cart pulled by two oxen. One of three services was held in Ebenezer Baptist Church, Montgomery, Alabama, the obsequies led by his lifelong friend Rev. Ralph Abernathy who was standing beside him on that fateful day in Memphis. An estimated 100,000 people lined the streets, mostly in silence, but the occasional strains of the great civil rights anthem *We Shall Overcome* could be heard.

Four years after Dr King's assassination in the spring of 1972, Catherine McInerney's body was entombed in a vault on the southern end of the pre-famine Kiltenane cemetery on the opposite end to where my six-day-old brother Martin was buried in an unmarked grave twenty years earlier. I have no recollection of her funeral. It is unlikely her coffin was carried by two oxen or two donkeys for that matter, although the latter would not have been inappropriate. I probably was in boarding school at the time. Nor is there any record of what her final words were or what was said at her funeral mass or who said mass. My father, who had an encyclopedic day and date knowledge of her family, has since left us and now it's too late to ask. Curious to know her precise date of death and if by any chance she died on the fourth of April, I checked the Kilkee parish archive. She didn't. At the age of ninety, she died nine days earlier on the twenty-fifth of March. Close but not close enough. Transatlantic coincidences only stretch so far.

But in age-old tradition, all her neighbours would have been there standing respectfully by her coffin. And a priest would have prayed that timeless age-old prayer of final recommendation, and one in which I can hear the echo of the soaring rhythmic intonation of the Rev. Martin Luther King.

> May the angels lead you into paradise;
> may the martyrs come to welcome you
> and take you into the holy city, the new and eternal Jerusalem.
> May choirs of angels welcome you
> and lead you to the bosom of Abraham;
> and where Lazarus is poor no longer may you find eternal rest.

The Eucharist would have been celebrated in her memory, most probably in Lisdeen Church, and her remains carried to the family vault in the walled graveyard opposite Bansha National School that straddles the parishes of Kilkee and Doonbeg where, along with my sisters, brothers and neighbours, the Purtills, Linnanes, Madigans, Russels, O'Mearas, O'Sheas, Linnanes, Haughs and Reids, I walked to and fro for eight years. Now her vault is overgrown with ivy, her name, if it ever was inscribed, no longer legible. The mud-and-stone home that she left for her final journey is now a pile of rubble, the thatch long gone: briars and nettles signaling nature's return. The chimney stack, however, stands defiantly against the ravages of time. Outside, eight posts stand like lonely sentinels: posts that once housed winter's scythe-cut fodder for their few cows and calves. The roof long since gone.

I have this memory of her sitting at the front door of her house on a sunny Saturday. As we rounded the corner, there she was, oblivious of our arrival. At the time I wouldn't have thought so, but in retrospect she must have been a very composed woman, mindful long before mindfulness became yet another form of commodification, quietly sitting there looking out. Day after day. In winter, her view on the outside world framed by a small single-pane sash window that refused to open, its opaqueness growing year-on-year.

If she were lonely, she never said. Not that I remember anyhow. Equally, and I wouldn't have thought so at the time, but in retrospect she was also quite a striking woman. I can remember the outline of her face. Hair, iron-grey in colour parted in the middle and tied in a bun at the back in the traditional style. Her lined face olive with brown eyes. Eyes to my childish gaze that seemed to dart from one stopping place to another. Her mouth seemingly in constant motion. Of what she wore I have no recollection, bar one silk-green headscarf, a relic perhaps of her earlier life. Perhaps too the traditional cross-over apron or the nylon housecoat that had become more in fashion, if fashion is the word. Of what shoes she wore, I have no reconciliation. Those details have long faded. Just a face framed in memory. A life that had its own dignity. One that will never be reflected in the lingering lyrics and music of Marvin Gaye or any other artist for that matter. But a life that nonetheless had its own dignity.

In life and in death, irrespective of fame or infamy, celebrated or otherwise, all lives matter. Catherine McInerney and Martin Luther King. Shared lives. Shared humanity. Shared time on this planet. As Dr King reminds us, we may have all come on different ships but once here, we're in the same boat. When the boat goes out who knows? What we know is that both are now interred in their similar final resting places. One celebrated. One (almost) forgotten. Their final resting places.

Beyond that I cannot say.

Dedicated with gratitude for the life and love of Martin Luther King's namesakes, my brother Michael, 1963–2018, and in remembrance of our older brother Martin, who in 1952 briefly graced this world with his presence.

Peadar King

Originally from Kilkee, Peadar King is a documentary filmmaker and non-fiction writer. For the past two decades, he has filmed in over fifty countries across Africa, Asia and The Americas as for the award-winning RTÉ Global Affairs series *What in the World?* He regularly contributes to *World Report* (RTÉ Radio One) as well as other radio stations. He has written for a number of other publications including *Being Irish* (2021). He is author of *What in the World? Political Travels in Africa, Asia and The Americas* (2013) described by Noam Chomsky as 'a remarkable ... illuminating analysis' and by Nobel Laureate José Ramos-Horta as 'at times stark, at times despondent, at times bewildered at the way needless suffering and abandonment continues to be the fate of millions of people.' His latest book, *War, Suffering and the Struggle for Human Rights*, was described by *The Irish Times* as: 'A call to humanity in a world full of atrocity.' He is currently Adjunct Professor of International Relations in University College Cork.

Photo Index

Thomas Lynch
Graveyard in Moyarta, Carrigaholt...6
Steel Vault door in Moyarta graveyard15
Gable of Vault in Moyarta graveyard16

Rachael English
Community Centre, Shannon ...18
Finian Park, Shannon ..26

Brian Mooney
Finavarra, New Quay ...28
Compass Jellyfish at Finavarra ...30

Tommy Hayes
Irish Seed Savers Orchard, Capparoe, Scariff32
Irish Seed Savers, Capparoe, Scariff39
In the garden of Tommy's home on the edge of Feakle Village...40

Sarah Clancy
Early Medieval Church Ruin at Oughtmama, Bellharbour..........42
Overlooking New Quay and Bellharbour52

Niall Williams
In the garden of the home he shares with his wife, Christine in Kilmihil...54
Stone feature of a dove on shed..61
A selection of garden tools in shed ..62

Naomi Louisa O'Connell
At deserted village in Fanore, Ballyvaughan64
Lintelled opening of stone house at deserted village67
Road out of deserted village...68

Gearóid O hAllmhuráin
View of the Turnpike, Ennis ..70
Frank Custy's session tune list & notes at Toonagh Hall80

John Gibbons
Caherdooneerish Stone Fort, Fanore, Ballyvaughan..................82
Old boundary railing at the back of the former Our Lady's Hospital90

Mick O'Dea
Interior of Clock Tower in St Peter & Paul's Cathedral, Ennis.....92
Ascension of Christ painting in St Peter & Paul's Cathedral, Ennis..........100

Isabelle Gaborit
Pier near Rinskea, Whitegate...102
Pier near Rinskea, Whitegate...109
In her studio at Rinskea, Whitegate.......................................110

Tim Dennehy
Near Leaba Dhiarmada is Gráinne, west of The Hand...............112
Turf, west of The Hand...120

Godknows Jonas
On basketball court in Inis Ealga Estate, Shannon122
Basketball Hoop, same location...130

Kieran Hanrahan
Auditorium at Cois na hAbhna, Ennis132
Auditorium at Cois na hAbhna, Ennis.....................................140

Eavan Brennan
Nash's Lane, Middleline, Mountshannon142
Sandycove, Mountshannon...146

Susan O'Neill
On the stairs of her grandparent's old home on Parnell St, Ennis148
Newel post of stairs touched by many hands through the years156

Photo Index

Jessie Lendennie
Knockeven, Cliffs of Moher..158
Her home at Knockeven, Cliffs of Moher ..164

Harvey O'Brien
Interior of the old Mars Cinema, Kilrush..166
Interior of the old Mars Cinema, Kilrush..174

Ruth Marshall
Teampall na Marbh, Scattery Island ..176
Graveyard at Teampall na Marbh ...178

Shelley McNamara
At the Spa Wells, Lisdoonvarna ..180
Art Deco windows in Bath House ...187
Sulphur Bath with pulling rope..188

Geraldine Cotter
Ballydineen, Kilmihil...190
Former home of Mrs Nell Galvin in Ballydineen, Kilmihil198

Michael McCaughan
At his home in Cooloorta in the Burren..200
Shoes of Michael & Féile ..208

Frank Blake
Drewsboro, Tuamgraney..210
Knockaphort Pier, Mountshannon ...218

Martin Hayes
Avenue of his old family home in Maghera, Killanena.....................................220
Outbuildings at his old family home in Maghera, Killanena.............................230

Mary Hawkes-Greene
Interior of Newtown Castle, Ballyvaughan ...232
Wall built by Michael Greene close to Newtown Castle...................................238

Mark O'Halloran
Lysaght Lane, off Parnell Street, Ennis..240
Mural on Chapel Lane, off Parnell Street, Ennis ...247
Harmony Bridge, over the River Fergus, Ennis ...248

Sharon Shannon
Cliffs of Moher taken from base of Cliffs ...250
The River Fergus at Bealacana, near Ruan ...257
Good luck horseshoe on Bealacana Bridge, near Ruan258

Michael D. Higgins
Railway track at Ballycar, Newmarket-on-Fergus ...260
40 shilling fine notice at railway line, Ballycar, Newmarket-on-Fergus..262

Jack Talty
In the Old Chapel at St Flannan's College, Ennis ...264
Near the Cascades in Lissycasey ...272

Gerald Barry
St Mary's Church of Ireland, Clarecastle, courtesy of Paddy Murphy......274
Gerald Barry's house in the Burren ...280

Peadar King
Where the hayshed stood at Catherine McInerney's house in Kilkee......282
The ruin of Catherine McInerney's house ..291

Front Cover
Caherdooneerish Stone Fort, Fanore, Ballyvaughan
Back Cover
At Finavarra, New Quay; Bealcragga, Kilmaley; Moyarta, Carrigaholt